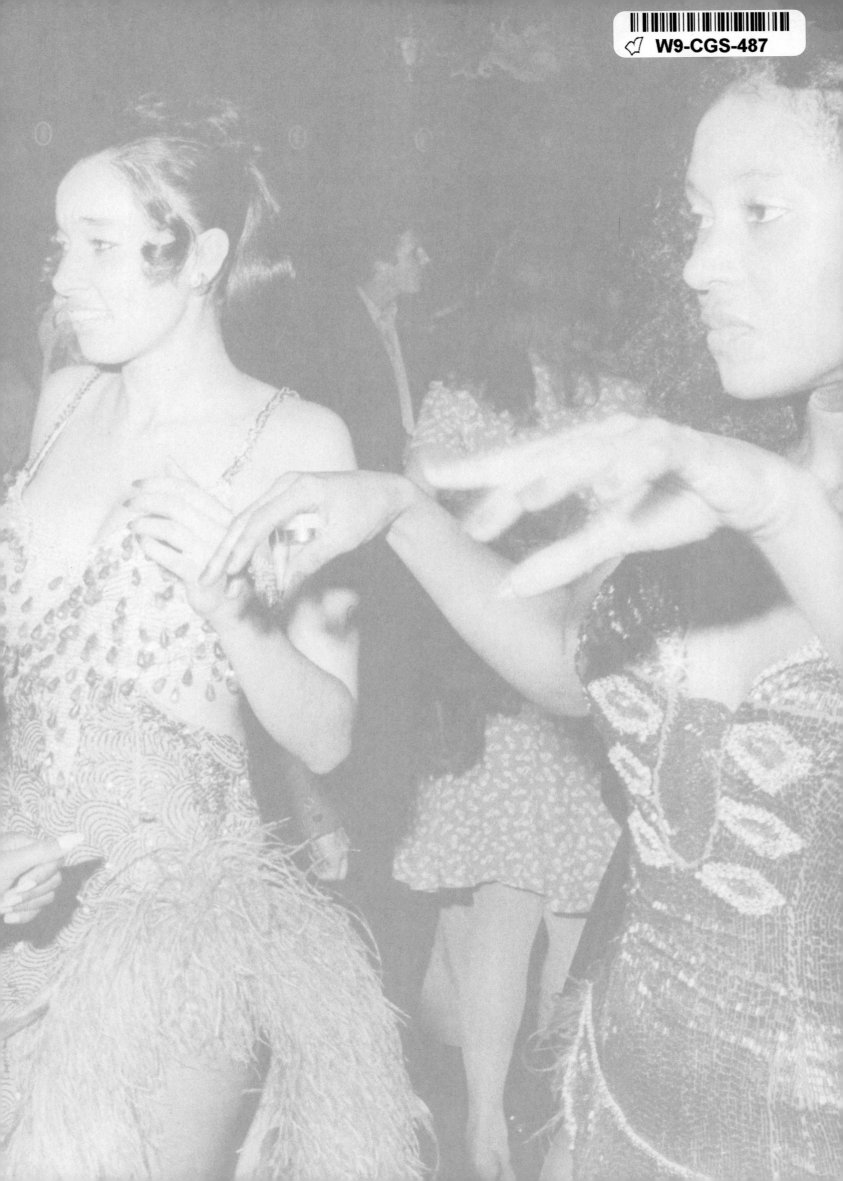

GRIT AND GLAMOUR

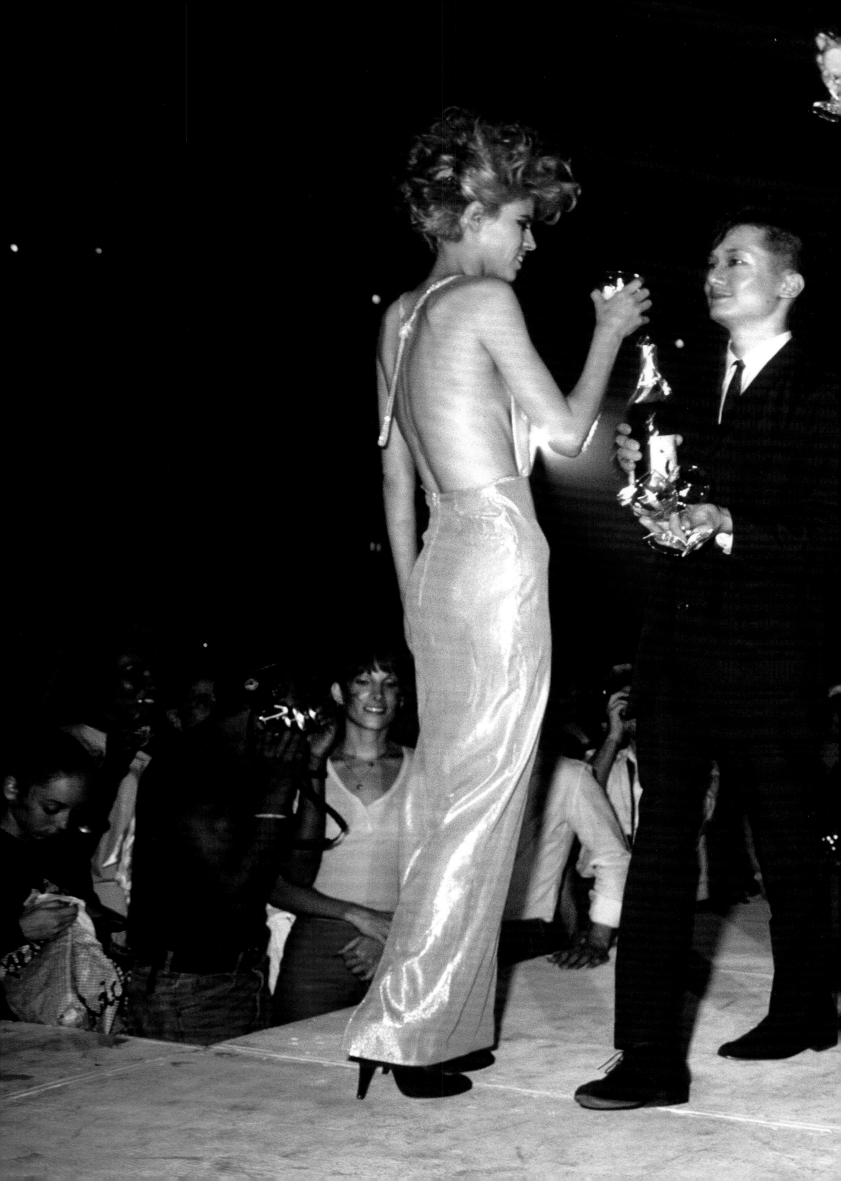

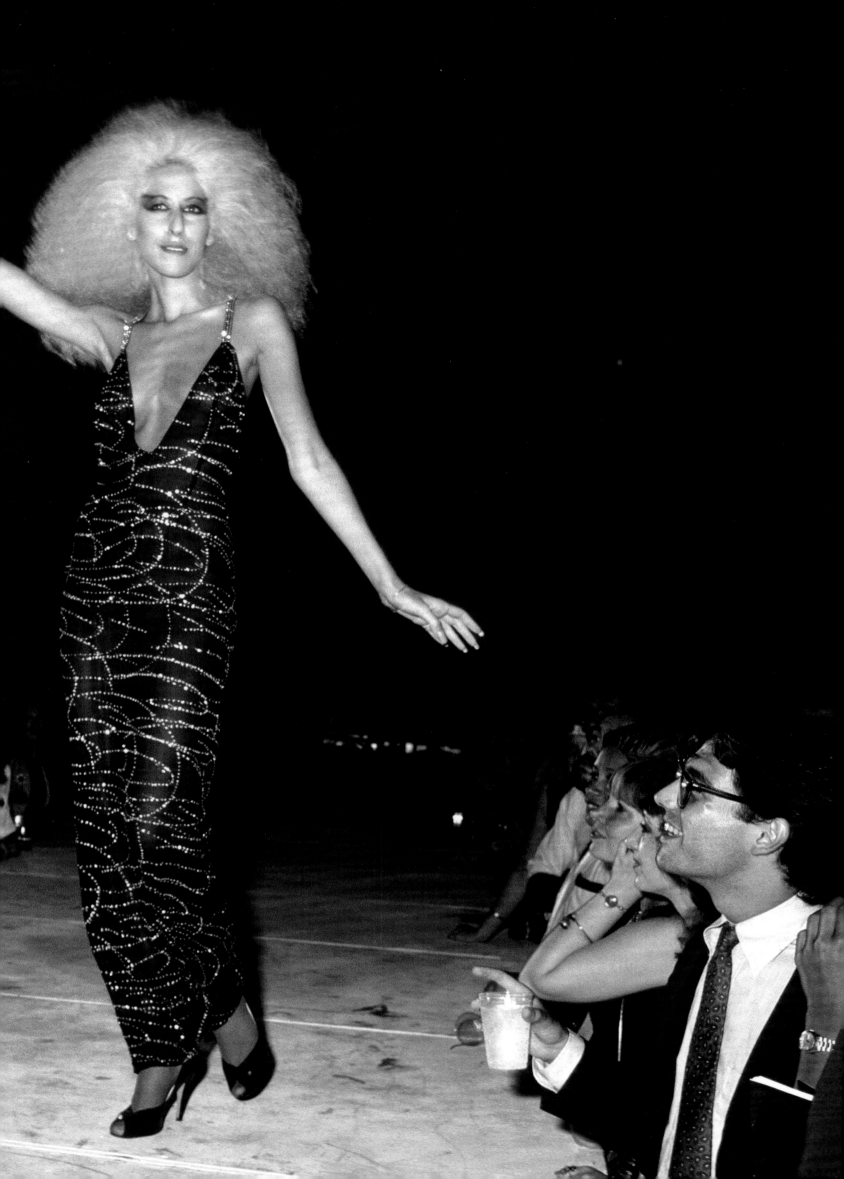

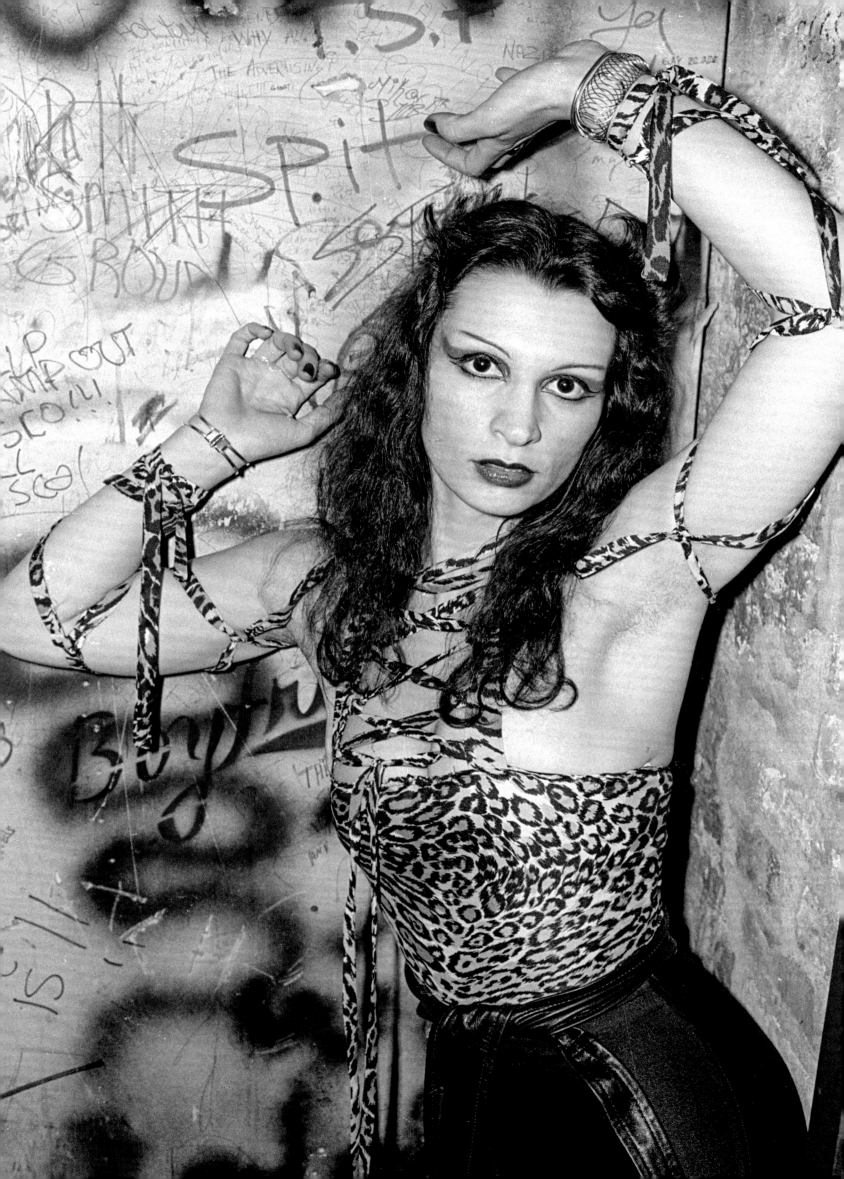

GRIT AND GLAMOUR

THE STREET STYLE, HIGH FASHION, AND LEGENDARY MUSIC OF THE 1970s

PHOTOGRAPHS BY
ALLAN TANNENBAUM

WITH TEXT BY
PETER OCCHIOGROSSO

FOREWORD BY
DEBBIE HARRY

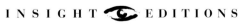

INSIGHT EDITIONS

San Rafael, California

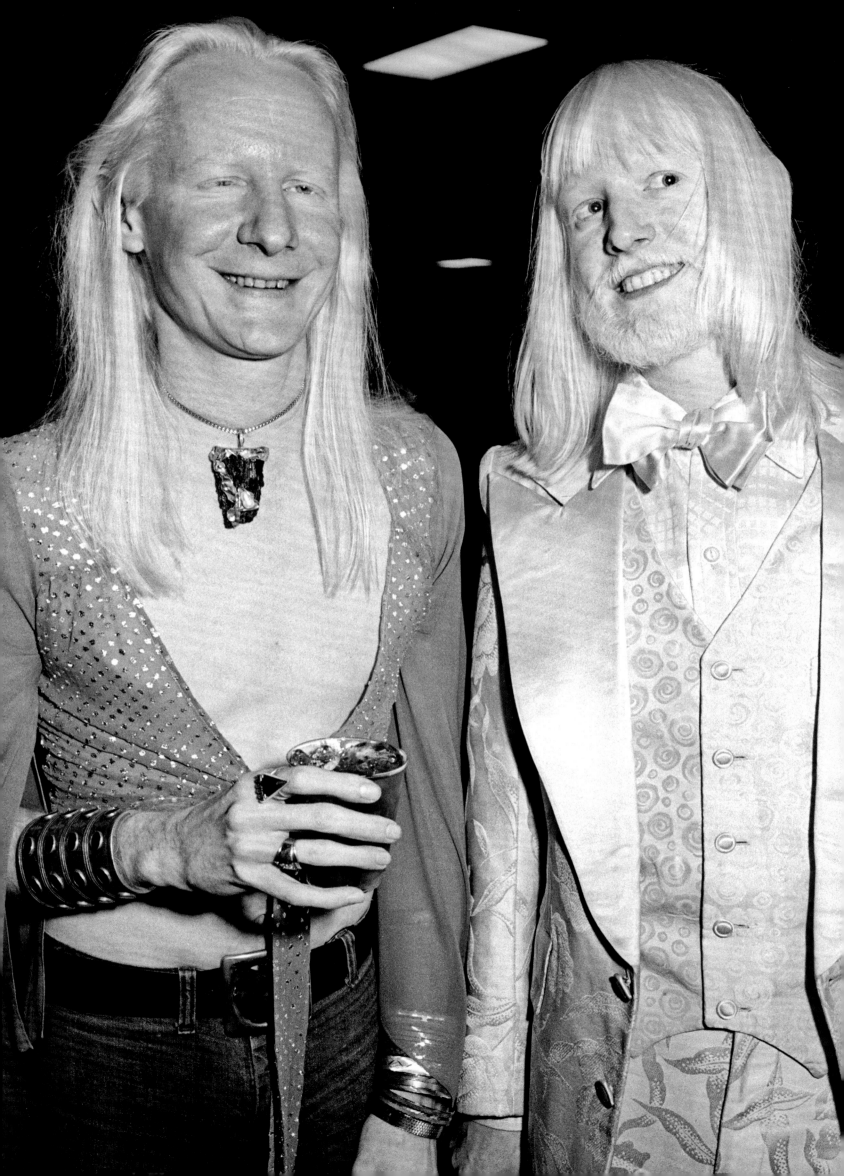

CONTENTS

FOREWORD

by Debbie Harry

ALLAN TANNENBAUM might have been a quiet, watchful kid. He's tall and laid-back, but he's one of those people with a determination that infuses his work. He was one of the photographers who always showed up in the early shows and had his pictures published in the *Soho Weekly News*. As a documentarian, Allan loved it all and still does. You can see in this epic catalog of NYC streetlife and nightlife a genuine affection for everyone in the neighborhoods and in the clubs and elsewhere. It's kind of important now to keep a photographic record of the bohemian lifestyle that was once the sole property of NYC and San Francisco. A time of poetry and literature and bongos and folksingers. And in a way, even though Tannenbaum's work comes from more recent times, there is a sensation from those times that carries through as he tells us what he has seen during his wanderings in NYC.

I can't speak for anyone but myself, and my style was adventurous, to say the least, and at times just awful. Nevertheless, it was not driven entirely by the norms of that time. We all were kind of throwbacks, using the looks of the '40s, '50s, and '60s and messing them up with modern fabrics and attitude. My best looks were directed by fashion designer and artist Stephen Sprouse, and this has given me some credibility to this day. Mostly we all dressed as sexy and dangerous as possible, though now I think it all looks pretty normal. Maybe then we just felt differently. Individuality was the most important thing, like when Arturo Vega arrived in town and remained unknown, unrecognizable except for a Mexican wrestler's mask, which he never took off. So now we have all been unmasked by Allan in his latest collection of '70s style. Sort of a delicious mess, isn't it . . .

OPPOSITE: Debbie Harry of Blondie poses in the photo studio, 1978.

PAGES 2–3: Models Lucile Reader, Benjamin Liu, and Jenna Torres from the new wave agency La Rocka on the runway at Bond International Casino in Times Square, 1980. The women wear fashions designed by Charles James, America's first couturier.

PAGE 4: Designer Natasha Adonzio models her own fashions backstage at CBGB in 1977.

PAGE 6: Musicians Johnny and Edgar Winter attend the 1975 subway platform premiere party for The Who's *Tommy*.

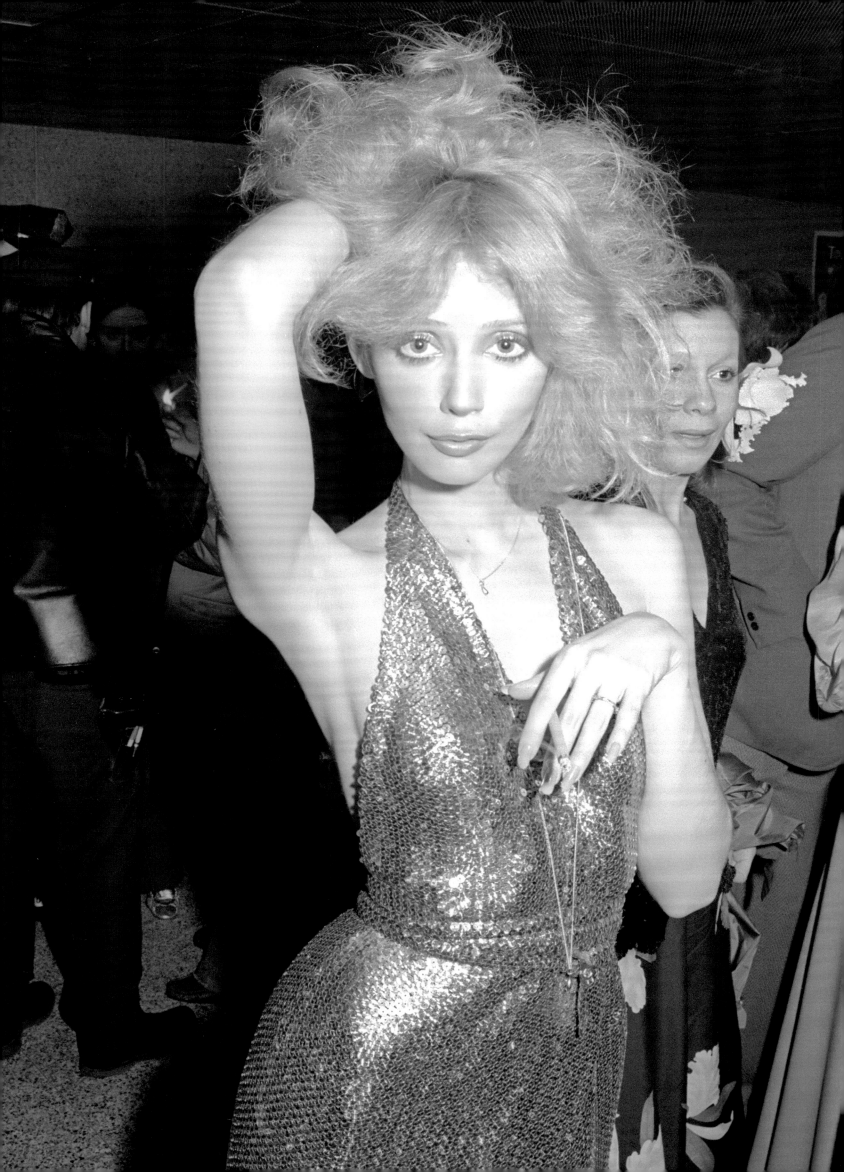

WHEN I FIRST STARTED photographing in the mid-1960s, I had no idea what I wanted to do or where it would take me. San Francisco was a good place to learn, however, with a city rec center where you could develop your film and make prints for a $10 yearly membership. The city itself was photogenic, and with the advent of the hippie scene and inexpensive rock shows there were plenty of visuals. Foreign films were a passion for me, and while finishing my BA in art at Rutgers University, I saw Michelangelo Antonioni's first English-language work, *Blow-Up*. I was fascinated with the lifestyle of fashion photographer Thomas, played by the late David Hemmings, and I liked that he did documentary work as well. After I saw the film twice more, the die was cast. This was what I wanted to do. I even got a Hasselblad 500C camera, like the one Thomas used in the film, for my graduation.

While studying filmmaking as a graduate student at San Francisco State, I used that Hasselblad and my 35mm camera to take still photographs. Frizzy Mary, a Haight-Ashbury girl who lived with the band Blue Cheer, became my main actress and model. She's in my first film, *No Satisfaction*, made in 1967, and was the subject of my first fashion shoot. The first time I brought my camera to a rock concert was a Jimi Hendrix show at Winterland in 1968. It took me a few years to find photo work back in New York City, and the job I landed as an assistant in a fashion studio lasted exactly half a day. It wasn't until I became the chief photographer at the *Soho Weekly News* in 1973 that the universe of New York City opened up for me.

SoHo was really an art center back then, and the paper covered the art world, SoHo, the music scene, nightlife, showbiz, politics, and fashion. Soon I got a loft where I could set up a photo studio. The '70s were a very hedonistic time, and people dressed the part, whether they were on the street or at the latest club. Annie Flanders became our style editor, and she stressed that style and fashion were two different things. One could have lots of style without worrying about the up-to-the-minute fashion trends. On a person without style, fashions could look ridiculous.

In my photo coverage, I made sure to notice how people looked in terms of what they wore and the message they were trying to convey with their style and attitude. Whether the subject was young Latinos in Central Park, rock bands backstage, or trendies in the clubs, capturing the style of the moment was essential. Looks of the era were eclectic, from nostalgic to modern, but the overriding ethos seemed to be an individualistic notion of style that fit with the ever-changing trends. One can see this in the faux glamour of Studio 54, the funky look of the downtown artist at the Mudd Club, and to the nascent punk style of CBGB on the Bowery.

Many new designers sprang from this fertile ground downtown, with styles and shows that were truly avant-garde. Betsey Johnson was a seminal figure in this new scene, and her clothes and shows had an exuberance that one doesn't find today. Elio Fiorucci also had this sense of color and fun, and Larry LeGaspi was way ahead of his time. The way fashion shows were presented in venues like Studio 54 and Bond generated much excitement and fun, especially compared to the staid and formulaic shows of today.

Alas, the *Soho News* folded in March 1982. I had had eight years of *Blow-Up*. My 1960s bell-bottoms and T-shirts had given way to shiny double-breasted satin jackets, which gave way to skinny mod ties. It was time to move on with my photography, but I had amassed an extensive archive of how the denizens of New York City presented themselves visually to the world, which this volume will bring back to life. I'll let the experts I've recruited for each section of the book further explain what it was all about.

—ALLAN TANNENBAUM

OPPOSITE: A guest at the premiere party for The Who's *Tommy* poses in a shiny, slinky dress in 1975.

PARALLEL STYLE LINES

I loved the seventies. It was between the pill and AIDS, and everyone enjoyed an amazing amount of freedom and exploration in so many ways—artistically, emotionally. —Diane von Furstenberg

AMERICAN CLOTHING STYLES in the 1960s were often about fantasy, but hippie fantasy ran a limited gamut, and the most significant trends came from Europe, especially London's Carnaby Street. British hippie and mod styles from independent boutiques and designers led by Mary Quant, Foale & Tuffin, and Biba dominated the '60s scene, even in the US. By contrast, New York City in the 1970s and early '80s spearheaded enormous changes in clothing styles, led by both iconic couturiers and independent designers, as well as do-it-yourself designs that grew out of the world of rock and pop music. These design innovations, though, appeared to run simultaneously along parallel paths that sometimes crisscrossed but often remained separate.

On one side were the looks that many found as commercial and depressing as the tired, bloated arena rock of Emerson, Lake & Palmer, Foreigner, and Journey, later influenced by the rise of disco. Those styles ran to flared bell-bottoms, wide lapels and wider ties, polyester leisure suits, Qiana shirts, maxi dresses, platform shoes, and the ubiquitous women's jumpsuit.

Meanwhile, on another track, a whole new world of style was opening up. Fresh designers like Betsey Johnson in America and Vivienne Westwood and Zandra Rhodes in England—all three of whom were born just two years apart and turned thirty at the dawn of the '70s—were breaking fashion rules and creating clothing designs that the old guard found either too feminine and whimsical or overly dramatic and even freakish. At the same time, artists, musicians, entertainment figures, and street folks were throwing together unpredictable assemblages of style on their own: do-it-yourself with a vengeance. Components ranged from the retro torn jeans, T-shirts, and leather jackets of punk rock to the parti-colored patterns of hip-hop, soul, reggae, and post-psychedelic rock 'n roll, followed by the futuristic look purveyed by stores like Parachute, which opened in SoHo at the end of the '70s.

It probably all began with the gender-bending look of glam from American rockers including the New York Dolls (inspired in part by the drag queen styles of New York's 82 Club in the East Village), and their British counterparts Marc Bolan and David Bowie. Of course, when the New York Dolls dressed in women's clothing, complete with dresses and feather boas, they made it plain that they were goofing on drag (although some observers took

it literally and assumed they were gay—which came as a surprise to the notorious ladies' men like Johnny Thunders, Jerry Nolan, and David Johansen). Bowie, meanwhile, was clear that he was not only androgynous but also bisexual. At the same time, the New York punk poet-rocker Patti Smith wore essentially men's clothing with bohemian attitude.

As the '70s progressed, the glam look pioneered by the Dolls and Bowie took on an even more sensual spin. Not about to get lost in the ambisexual fog, women who wanted to be straight about who they were started donning underwear as outerwear. Bustiers and lace bras, slips and assorted lingerie, worn alone or on top of other clothes, turned up in discos, rock clubs, and gala hotel parties alike—years before Madonna would become famous for wearing them as part of her stage act.

The natural cottons and leathers of the previous decade gave way to shiny synthetics that stretched and swelled to emphasize every delectable curve. Here, too, the styles followed parallel tracks. Lingerie as outerwear might be as likely to show up at CBGB on the Bowery as uptown at Studio 54 or Infinity. A music culture in which anything went helped to generate a style culture that mixed and purposely mismatched different idioms, from glitzy disco glamour to gritty punk and hip-hop, and jazz both retro and futuristic.

You'll find it all in the dazzling array of styles depicted in these pages, drawn from the archives of Allan Tannenbaum's straight-ahead, declarative style photographs: the music scene, nightlife, arts and entertainment, high-end design, the do-it-yourself look, street style, and more.

OPPOSITE: Patti Smith and Tom Verlaine of the band Television at a birthday party for Frank Zappa, 1974.

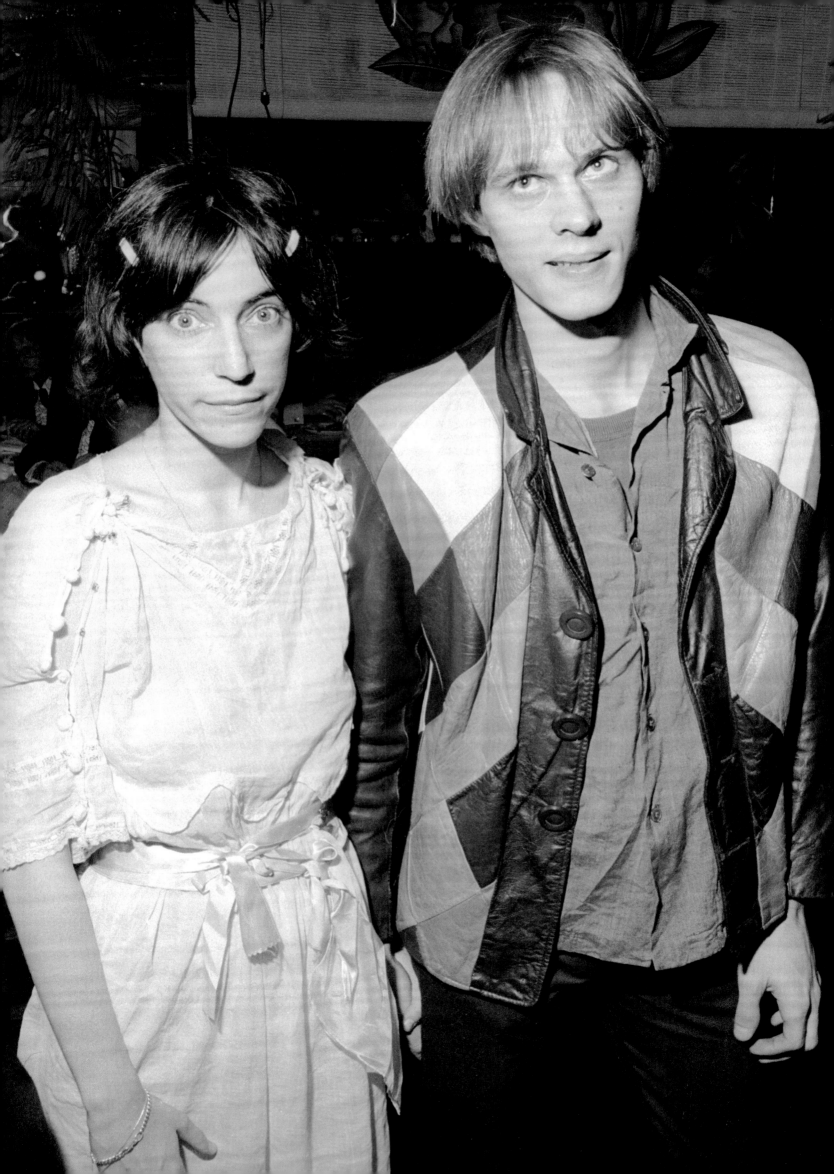

MUSIC

The clothes were a part of it as far as we were concerned, even before the music. —Paul Cook of the Sex Pistols

THE WILD CREATIVE POWER OF NEW YORK STYLE—which has fueled both rock 'n' roll and fashion for decades—can be traced directly to the music scene and the energy bursting out of Downtown Manhattan in the 1970s. And yet opinions differ about just what the defining moments of '70s music were, and who was responsible for the rise of punk rock, new wave, no wave, hip-hop, and their many variations. The veteran rock journalist Lisa Robinson once wrote, "Nearly everyone would agree that in early 1972, when the New York Dolls performed every Tuesday night at the Oscar Wilde Room of the Mercer Arts Center in the Broadway Central Hotel, the 1970s New York rock scene was officially born." I'm not so sure that was the absolute moment—the previous year the Stooges had played the Electric Circus on St. Mark's Place and Iggy Pop threw up onstage, but he wasn't *from* New York. Still, the New York Dolls certainly invented their own look, changing from show to show, often as a matter of necessity.

The Dolls' bassist, Arthur "Killer" Kane, described playing at a bathhouse in Brooklyn where there seemed to be "no audience because all the guys stayed in their cubicles having sex with someone, so we didn't know what to do. . . . We weren't sure how to dress for the bathhouse, so the first night we went feminine. I wore hot pants." Since the patrons didn't seem to appreciate the femme look, Kane said, "The next night we came back in leather and chains and got more interest. Everyone came out of their little cubicles to watch us."

From the beginning, the Dolls were intertwined with New York clothing styles. Their rhythm guitarist, Sylvain Sylvain (whose family, the Mizrahis, had been forced to flee Egypt during the Suez Canal crisis of 1956), had worked at a men's boutique featuring hip and hippie fashions. Called the Different Drummer, it was on Lexington Avenue at 63rd Street, across from an old brownstone whose sign—"New York Doll Hospital, Since 1900"—inspired the name of the band he eventually formed with David Johansen, Johnny Thunders, Arthur Kane, and drummer Billy Murcia (who would be replaced by Jerry Nolan after his drug-related death). Sylvain also worked alongside Murcia for a fashion company called Truth and Soul, which regularly received orders from the popular clothing store Paraphernalia.

OPPOSITE: The Clash may have been the quintessential British punk band, but they loved coming to New York, and found a lot of their favorite togs in East Village shops. They had art school backgrounds and could dress in purposefully paint-spattered clothes—sometimes done at a local car paint shop. Yet they also knew how to put together outfits that may have looked random but were assembled in classic do-it-yourself style. Pictured here, from left: Topper Headon, wearing a jacket and shirt by Alex Michon. At one point the band set her up in their Hell's Kitchen headquarters with a sewing machine, patterns, and scissors, and she designed clothes for the band from 1977 to 1983. (She now codirects a London art gallery.) The jeans are from Trash and Vaudeville, a shop that started creating clothes for rockers of many descriptions in 1975 on St. Marks Place in the East Village and is still in business. Paul Simenon is wearing a motorcycle jacket that he got in Hollywood and that had been worn in the movie *The Lords of Flatbush*. His pants are from a blue suit by Teddy Boy tailor Jack Geach. Mick Jones has on an Alex Michon vest with a French paratrooper's pin and jeans from Trash and Vaudeville. And Joe Strummer is wearing the official Clash T-shirt designed by their sometimes-manager Bernard Rhodes, with white belt from Trash and Vaudeville.

SUBSEQUENT PAGES: The Ramones perform at CBGB on February 22, 1977.

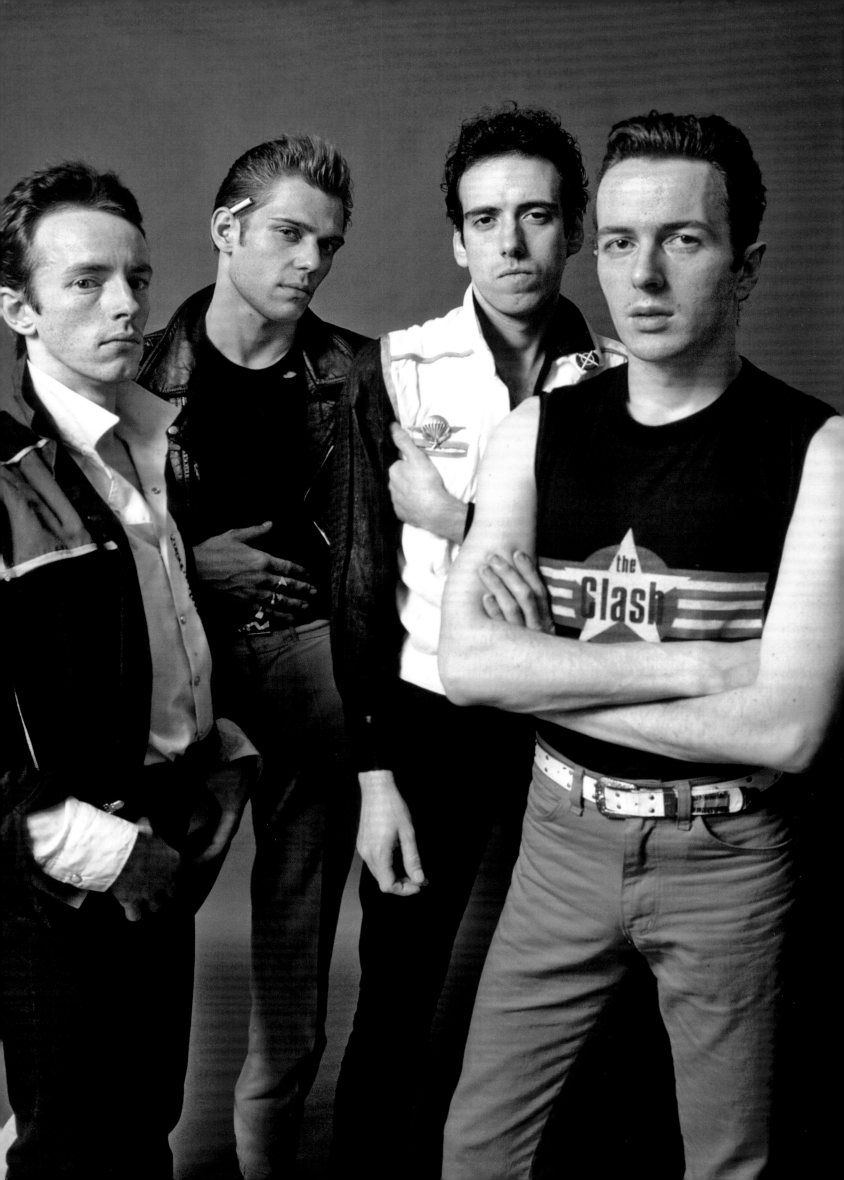

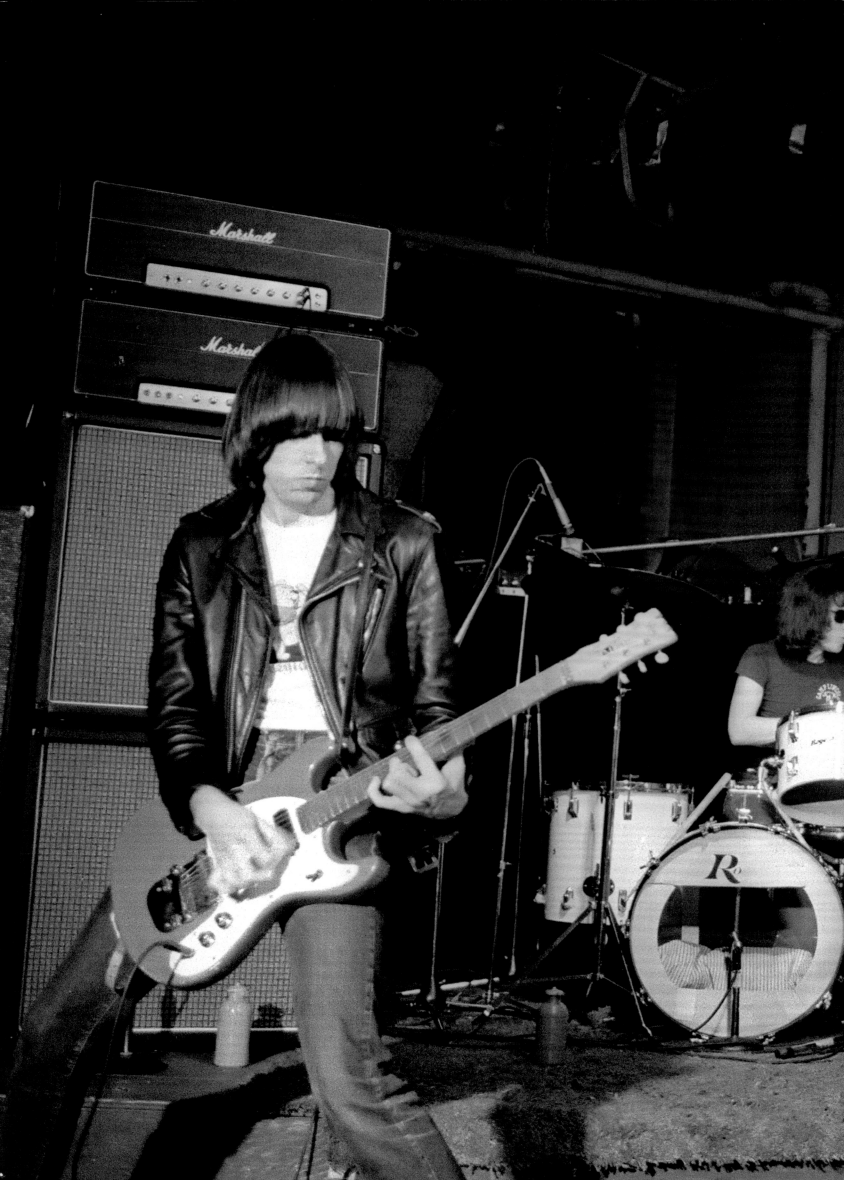

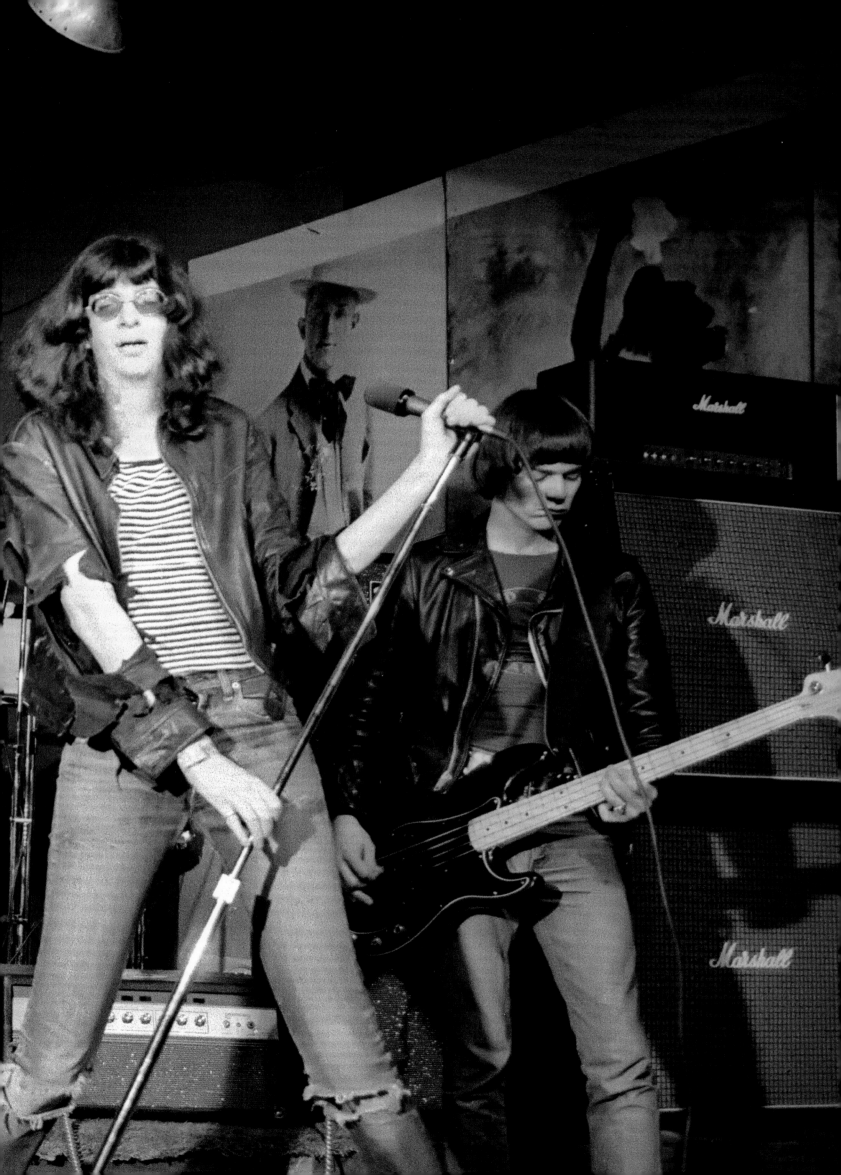

PUNK AND NEW WAVE STYLE

Musically speaking, the Dolls did influence the New York rock scene, and punk in particular, by offering an alternative to overblown '60s rock of the REO Speedwagon variety. Their shows at the Mercer Arts Center and elsewhere in New York were seen by future members of the Ramones. The Dolls' look was influenced by the drag queens of the 82 Club (they returned the favor when they played there in 1974 as the East Village club was attempting to attract a glam rock audience). But that look wasn't what carried the new style wave to the rest of New York, and then to England and back again. According to the late Malcolm McLaren, British impresario-cum-clothing-designer and boutique owner, the new look began with Richard Hell. "This was not someone dressed up in red vinyl. Wearing bloody orange lips and high heels," he said, a clear reference to the New York Dolls, whom McLaren managed briefly at the end of their run. "Here was a guy all deconstructed, torn down, looking like he'd just crawled out of a drain hole, looking like he was covered in slime, looking like he hadn't slept in years, looking like he hadn't washed in years, and looking like no one gave a fuck about him. And looking like he really didn't give a fuck about you! He was this wonderful, bored, drained, scarred, dirty guy with a torn T-shirt."

McLaren claimed that he took Richard Hell's look and attitude back to London with him, along with a love for Hell's iconic song "Blank Generation," and created the Sex Pistols, merging the band with the "No Future" sensibility of Britain's emerging punk scene and coming up with songs like "Pretty Vacant" and "Anarchy in the UK." Working with his girlfriend and business partner, the emerging fashion designer Vivienne Westwood, he helped to define the styles of British punk. At their shop on King's Road, variously called Sex and Seditionaries, among other names, they drew upon inspirations from bondage, brothels, bikers—and Richard Hell. Sex Pistols drummer Paul Cook put it this way: "We used to shop in Malcolm's shop before we even had the idea of forming a band."

The only problem with McLaren's chronology is that most rock fans in the mid-'70s—unless they hung out on the Bowery—probably hadn't heard of Richard Hell, despite the fact that he played briefly in the quintessential early punk bands Television, the Heartbreakers,

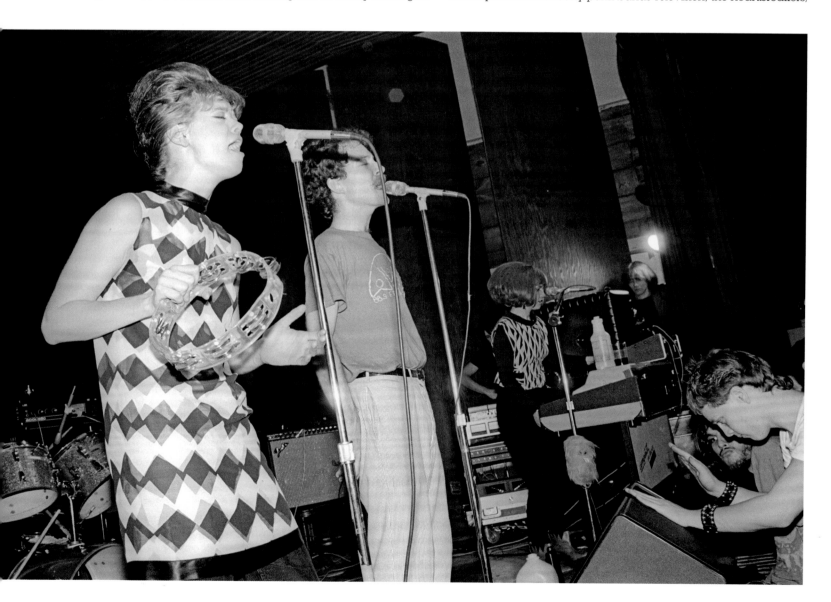

ABOVE: New wave band the B-52's perform at Irving Plaza in 1978.
OPPOSITE: Richard Hell performs with the Voidoids at CBGB in 1977.

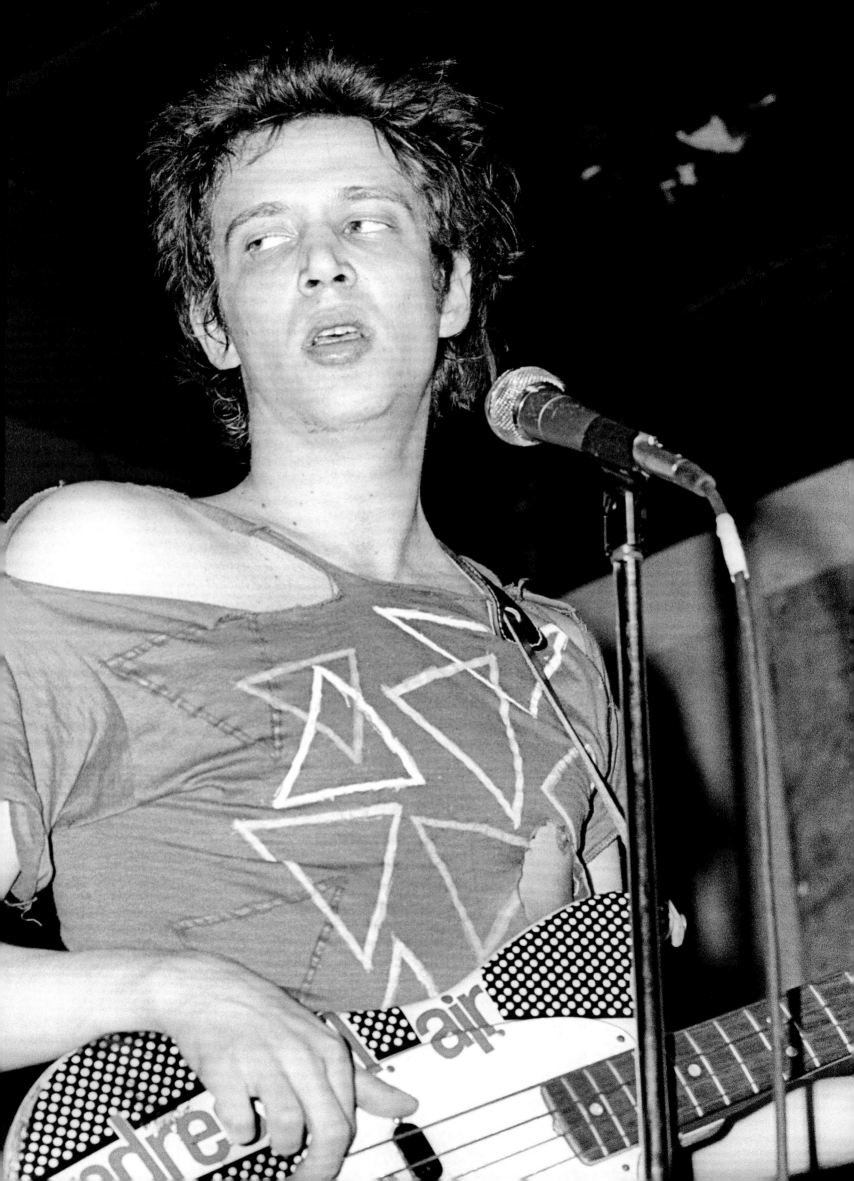

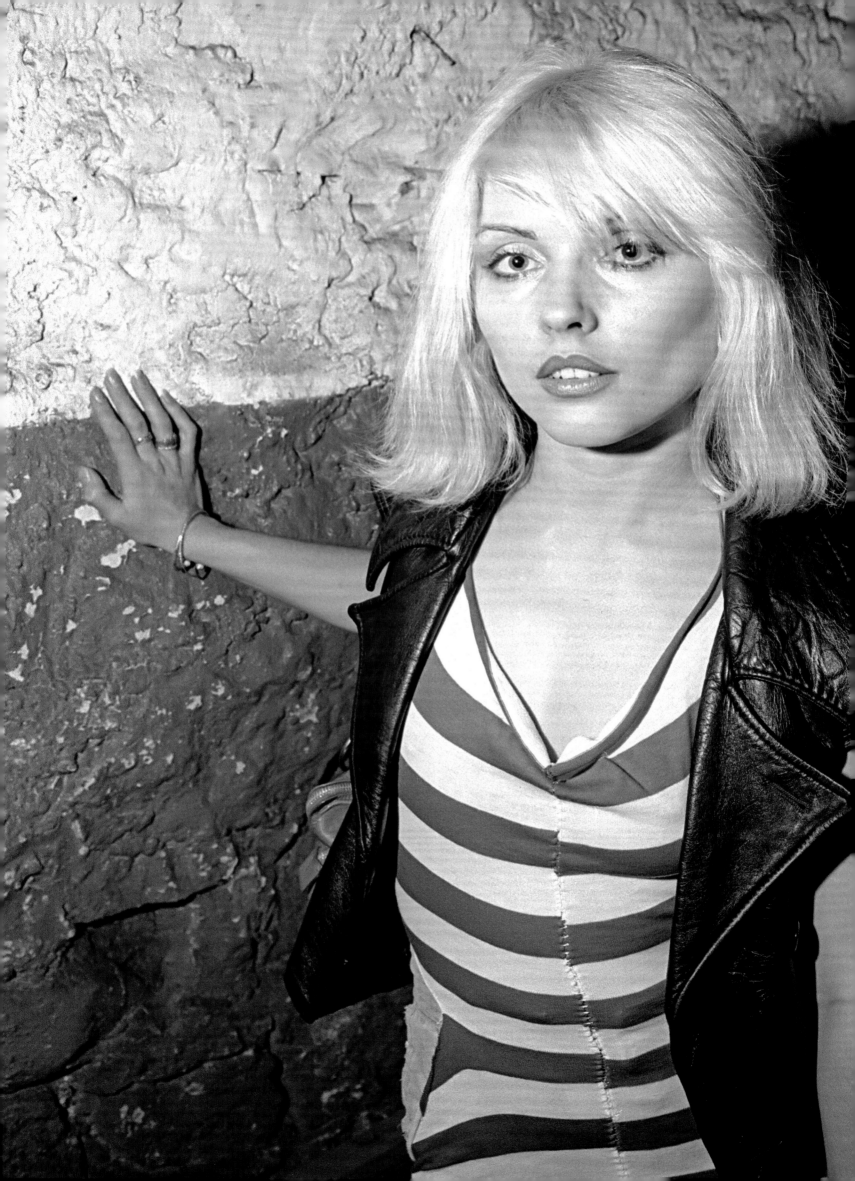

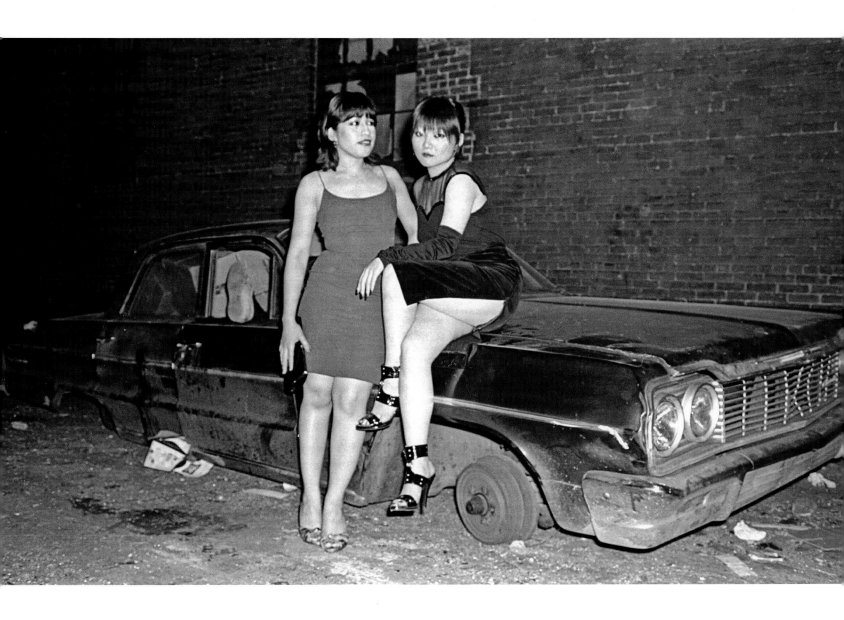

and Richard Hell and the Voidoids. What McLaren had to say describes the British punk look, but it doesn't really apply to New York.

There, the credit goes to the Ramones. Like Hell, the band from Forest Hills, Queens, never had a hit record. But they toured England in 1976, where they were seen by members of the Sex Pistols and the Clash and helped jump-start the nascent British punk scene. Even the venerable British music journalist Jon Savage, who wrote the defining history of the Sex Pistols and punk rock, *England's Dreaming*, has said, "The sound of UK punk was the Ramones." While Richard Hell wore ripped and written-on T-shirts, the Ramones wore jeans so frazzled they looked ready to disintegrate. Still, they didn't dye their hair neon pink or wear dog collars or garments made out of plastic trash bags.

What was striking about the Ramones, musically and stylistically, was actually how *reactionary* they were on certain levels. Punk was originally viewed as ragged and anarchic, radically new and different in a way that downtown poet-rockers loved and parents everywhere abhorred. But the Ramones' punk was as elemental as early R&B, or the Beatles at the Cavern. Only they weren't playing the blues; almost all their songs were originals from the get-go, unabashedly white with purposefully inane lyrics and titles, like "I Wanna Be Sedated," "Now I Wanna Sniff Some Glue," and "The KKK Took My Baby Away." Garage bands like the Castaways or Sam the Sham and the Pharaohs had that feel in the 1960s, although they couldn't carry it on for song after scorching two-minute song the way the Ramones did. The great jazz saxophonist Charlie Parker helped to create bebop by taking the swing rhythms and riffs of Kansas City (where he grew up listening to Count Basie and Lester Young) and *speeding them up*. The Ramones did much the same in a different context. They may not have sold millions of records, but after they played in the US and UK, most new rock 'n' roll got a lot faster.

ABOVE: Lou Reed's future wife Sylvia Morales and Mudd Club co-founder Anya Phillips in a lot next to CBGB on the Bowery, 1977.

OPPOSITE: Debbie Harry of Blondie backstage at the Wayne County Legal Fund Benefit, May 30, 1976.

SUBSEQUENT PAGES: The Sic F*cks perform at CBGB 2 on Second Avenue, 1978.

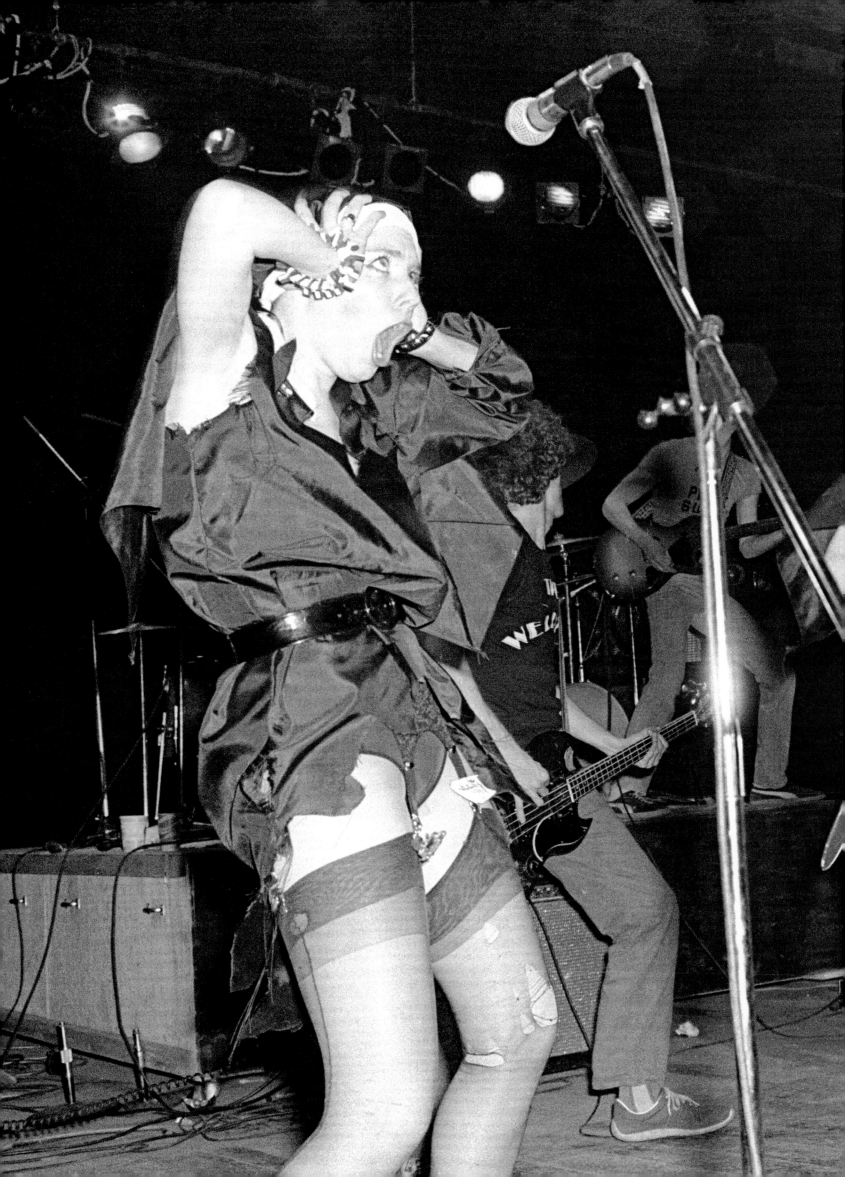

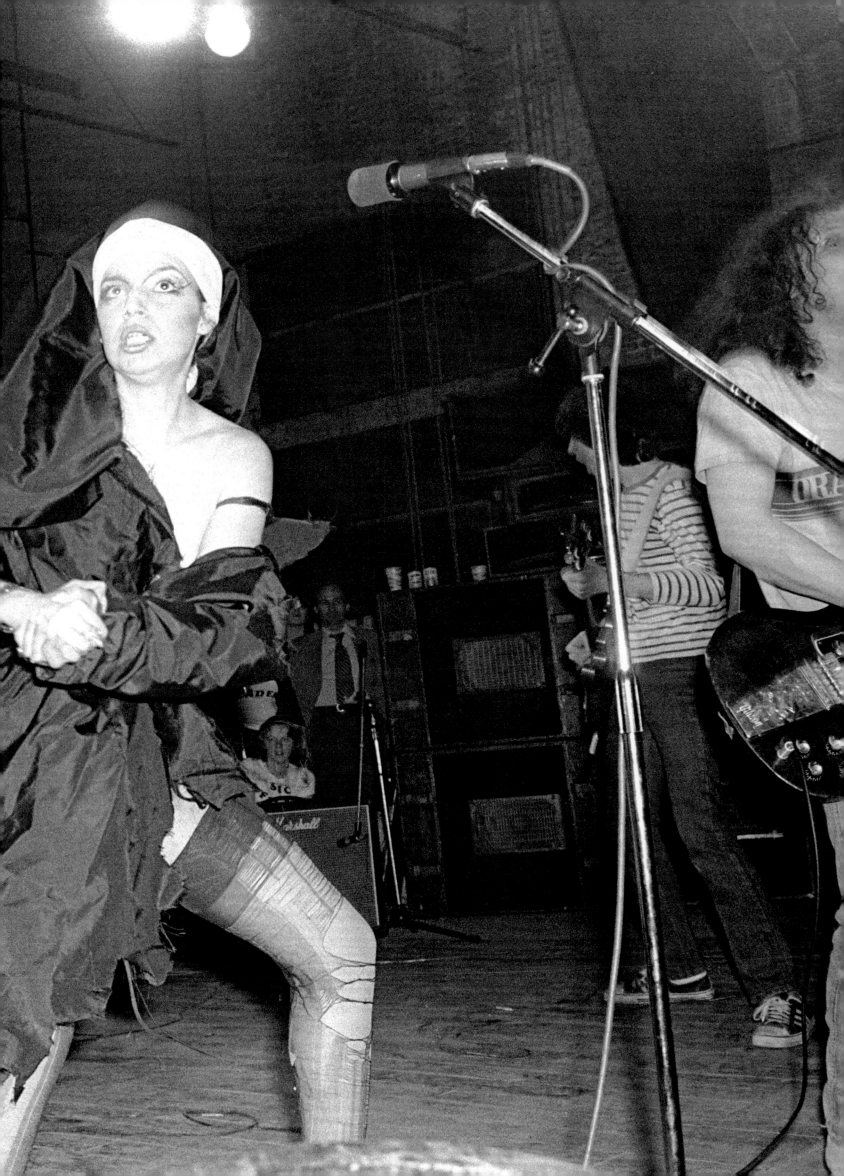

DIY ORIGINALITY

The truth is that the look of punk and new wave was fed by several stylistic streams that had one thing in common: Musicians and fans alike made it up themselves. The do-it-yourself (DIY) ethos is what made New York's music and style unique and ultimately so influential. To be sure, downtown New York had its share of strange-looking punk bands. They just weren't strange in the same way British punks were. The Plasmatics were fronted by Wendy O. Williams, who often performed in a mesh body stocking or with nothing but black electrical tape covering her nipples, and chainsawed a guitar in half as part of the act. In the band Sic F*cks, sisters Tish and Snooky Bellomo—who once sang backup vocals for the Stilettoes, a forerunner of Blondie—appeared onstage dressed as crazed nuns wearing stockings and garter belts. At the other end of the spectrum, the B-52's, fresh out of Athens, Georgia, wore retro outfits of thrift-store chic to go with the beehive hairdos that gave them their name. They played retro instruments, too—tambourine and Farfisa organ—making it hard to plug them into the same socket that powered the Ramones, the Dolls, or the Sex Pistols. Still, when they appeared at Max's Kansas City, CBGB, and a converted Polish social club called Irving Plaza, the B-52's took the city by storm and changed the way people saw new wave style.

Meanwhile, groups as disparate as Blondie and Tuff Darts dressed more like British mods from an earlier generation than like punks—with one exception. Blondie's lead singer, Debbie Harry, arguably the only mainstream sex symbol to emerge from the American new wave scene, wore an unpredictable array of outfits, ranging from pieces created by the critically adored but financially dysfunctional designer Stephen Sprouse, to simple, punkish tank tops, animal prints, and full-length dresses. And she looked great in all of it.

British punk bands like the Jam, the Clash, and the Cure are harder to peg, because they mixed street punk looks with mod styles. But Tannenbaum's 1980 photo of the Cure gives some sense of the range of their crisp styles. Still, he needed a way to set them off. "I had them in their record company's offices," he says, "but that was boring, so we went outside. I took a lot of shots, and then out of the corner of my eye I saw the cops walking down the street, and there it was."

OPPOSITE: The Plasmatics backstage at CBGB after a set.

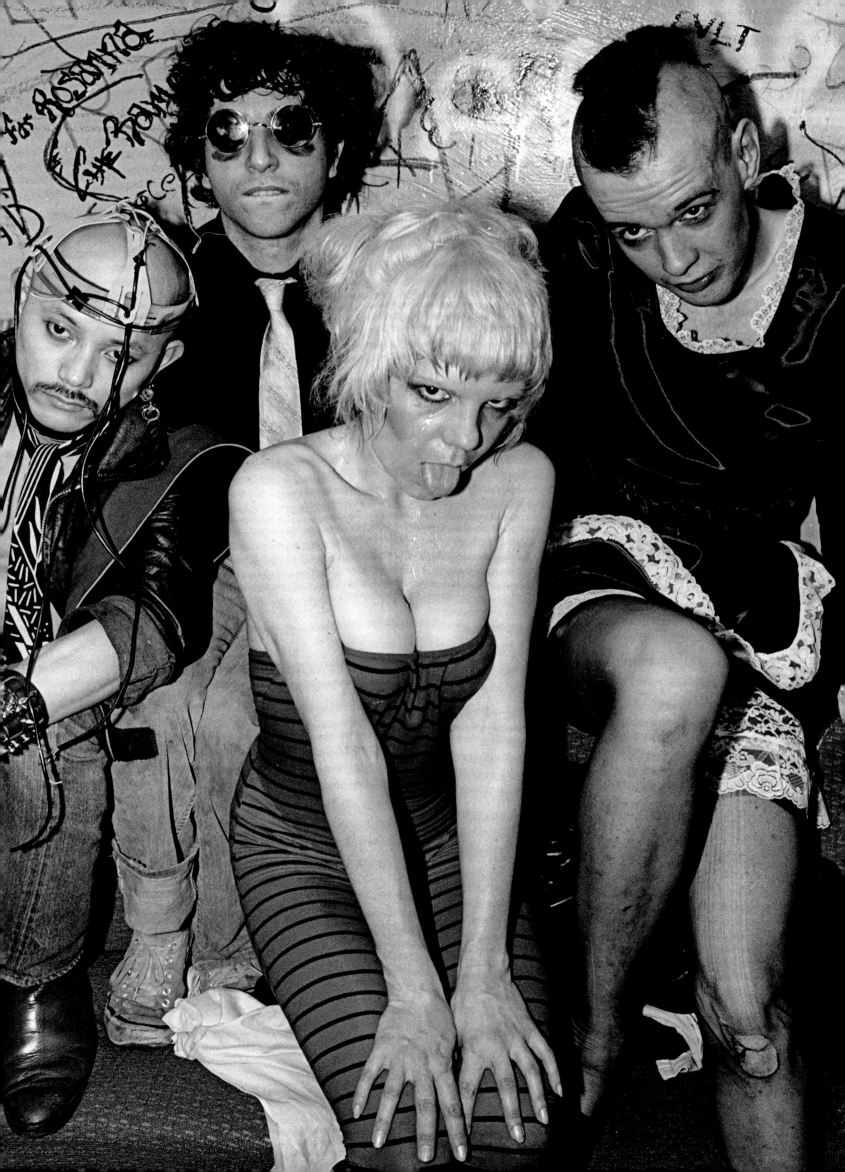

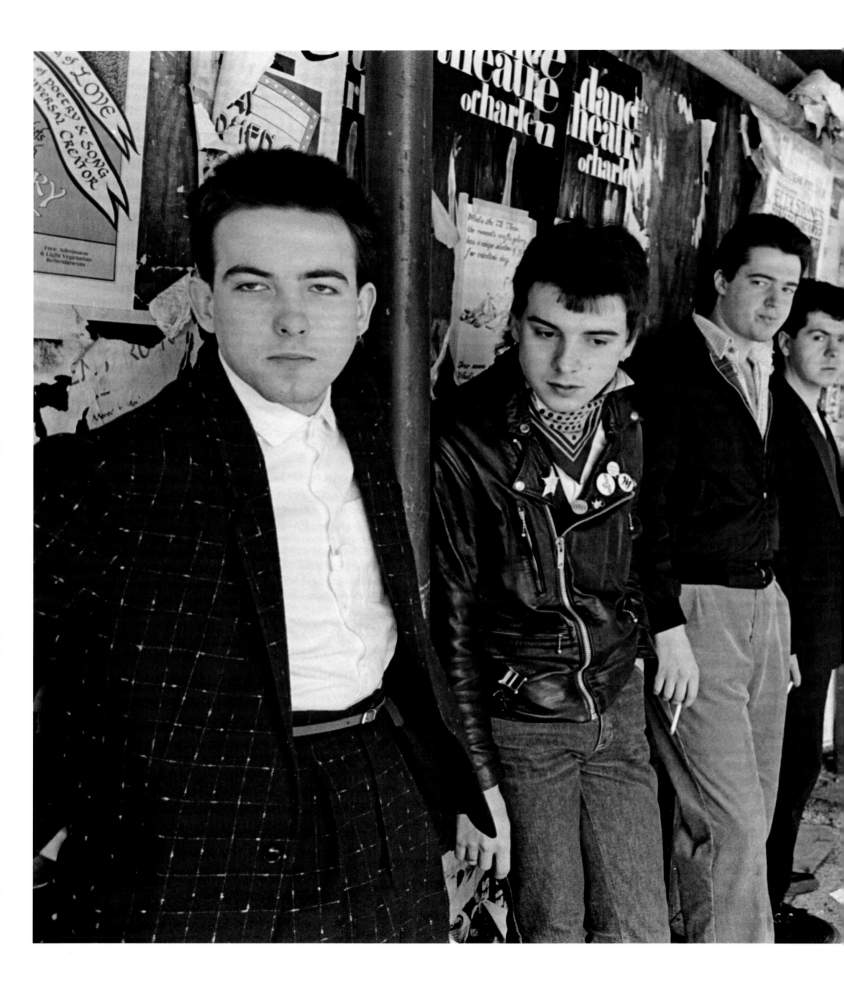

The Cure get caught on Columbus
Avenue in New York on April 11, 1980.

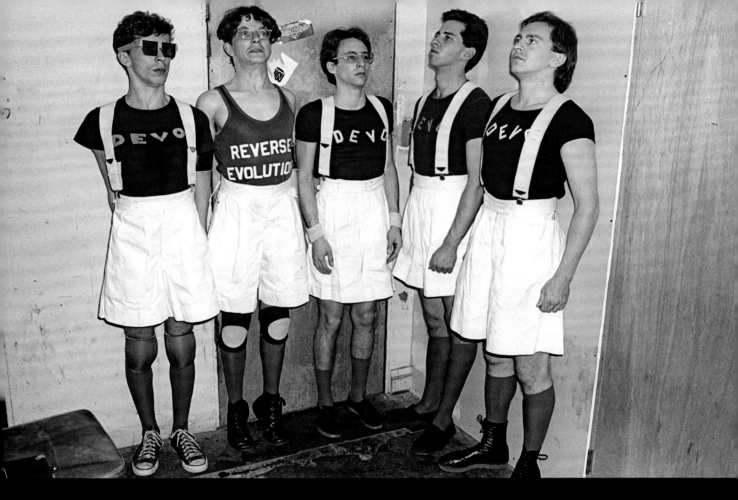

ABOVE: Devo backstage at Max's Kansas City on November 15, 1977.

OPPOSITE: Devo pose in the 182 Duane Street studio October 1981 for a *Soho Weekly News* Devo fashion feature.

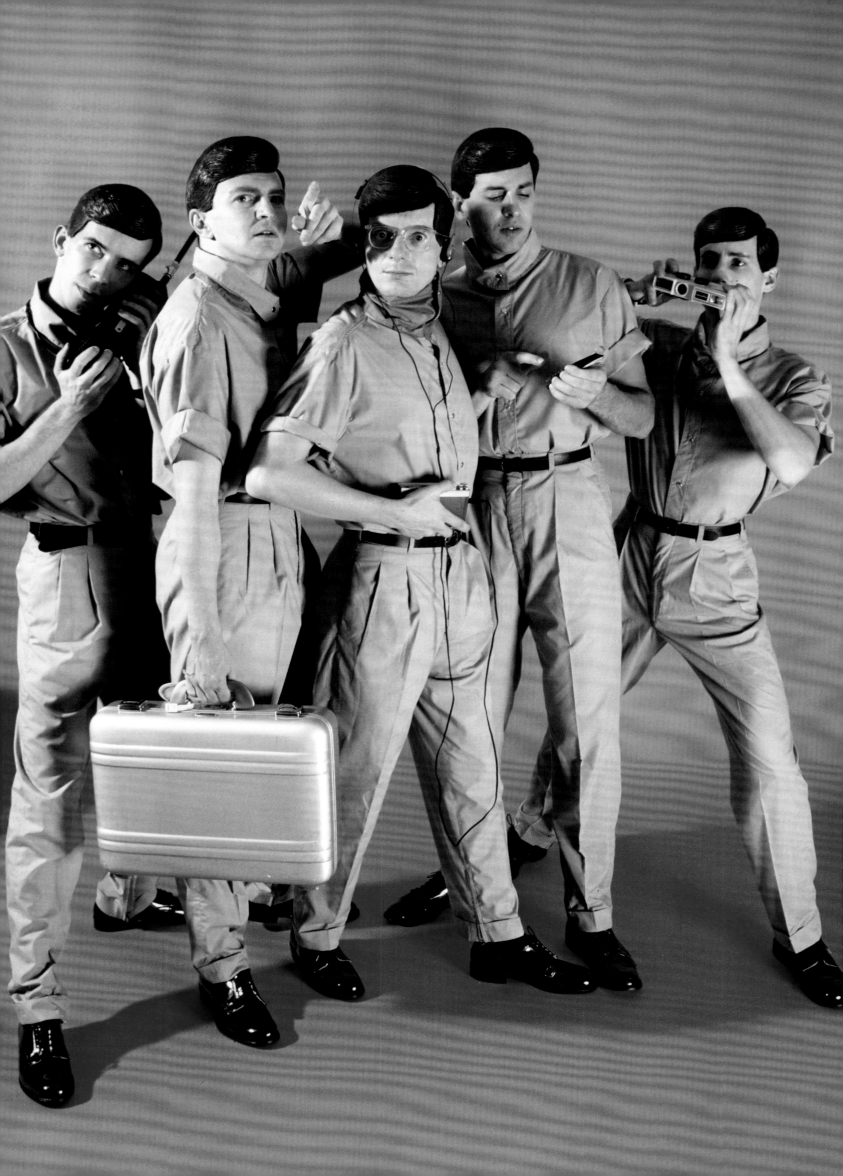

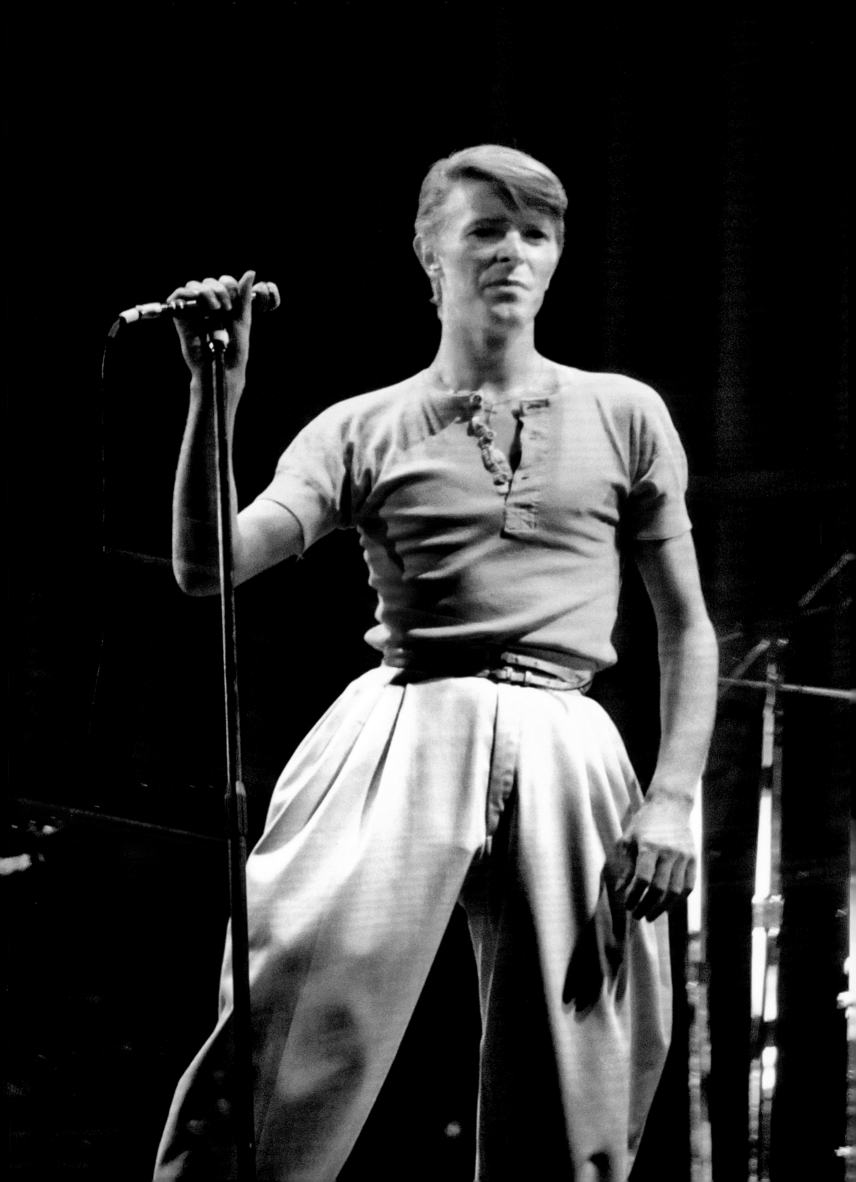

GENDER-BENDING

Androgynous clothing styles showed up on the downtown scene quite apart from the kind purveyed by the Dolls, or by cross-dressing or transgender figures like Divine, Jobriath, and Wayne/Jayne County. Poet-rocker Patti Smith often sported black trousers, a white shirt, and a loosened tie, as on the emblematic cover photo of her debut LP, *Horses*, taken by friend and sometime-lover Robert Mapplethorpe. By contrast, Patti's feminine allure jumps off the cover of her third album, *Easter*, for which she stretched languorously in a form-fitting, diaphanous chemise to emphasize her figure (in the photograph by Lynn Goldsmith). She could be playful as well, looking pure gamine in a dollish dress and barrettes with another friend and lover, Tom Verlaine of Television, at Frank Zappa's birthday party. Performance artist, violinist, and pianist Laurie Anderson, a figure on the fringes of the downtown music scene, also flaunted a kind of boy-girl style, sometimes wearing a suit and tie, almost always with her hair standing up straight (the result, she has said, of copious amounts of Vaseline).

And some bands that didn't seem to fit any '70s mold took advantage of that decade's openness to outrageous styles by creating their own distinctive theatrical looks. Devo wore quasi-robotic outfits with conical, step-pyramid hats as well as pseudo-astronaut jumpsuits, somehow managing to look at once futuristic and nerdy. The Tubes, a San Francisco–based band that came out of the mid-'70s California underground comedy scene that included the Credibility Gap, Firesign Theatre, and the Groundlings, created bizarre outfits that were meant to be funny and absurdist but weren't identifiably punk or new wave.

David Bowie, who may be the most chameleonic figure of the 1970s, both musically and sartorially, invented a spectrum of stylistic personas, from androgynous alien to elegant gentleman. Although he rose to fame while based in England in the 1970s, he lived in New York City and upstate for many years before his death in January 2016. Bowie developed the character of Ziggy Stardust in 1972, sparking the era of glam rock in England, some-what parallel to what the New York Dolls were doing in the US, but in his more stylized way. The success of his albums *The Rise and Fall of Ziggy Stardust and the Spiders from Mars* and *Aladdin Sane* led to worldwide tours in which he employed elaborate facial makeup and outrageous avant-garde kimono outfits created by cutting-edge Japanese designer Kansai Yamamoto.

ABOVE: Rocker Wayne County in drag strikes a pose backstage at the benefit for his legal bills in 1976.

OPPOSITE: David Bowie performs in an eye-catching yellow shirt and billowing pleated trousers at a concert in 1978.

ABOVE: Jobriath performs at the Bottom Line in 1975.

OPPOSITE: Mick Jagger performs at a Rolling Stones concert in NYC in June 1975.

SUBSEQUENT PAGES: The Tubes perform, featuring lead singer Fee Waybill as "Quay Lewd" in 1975.

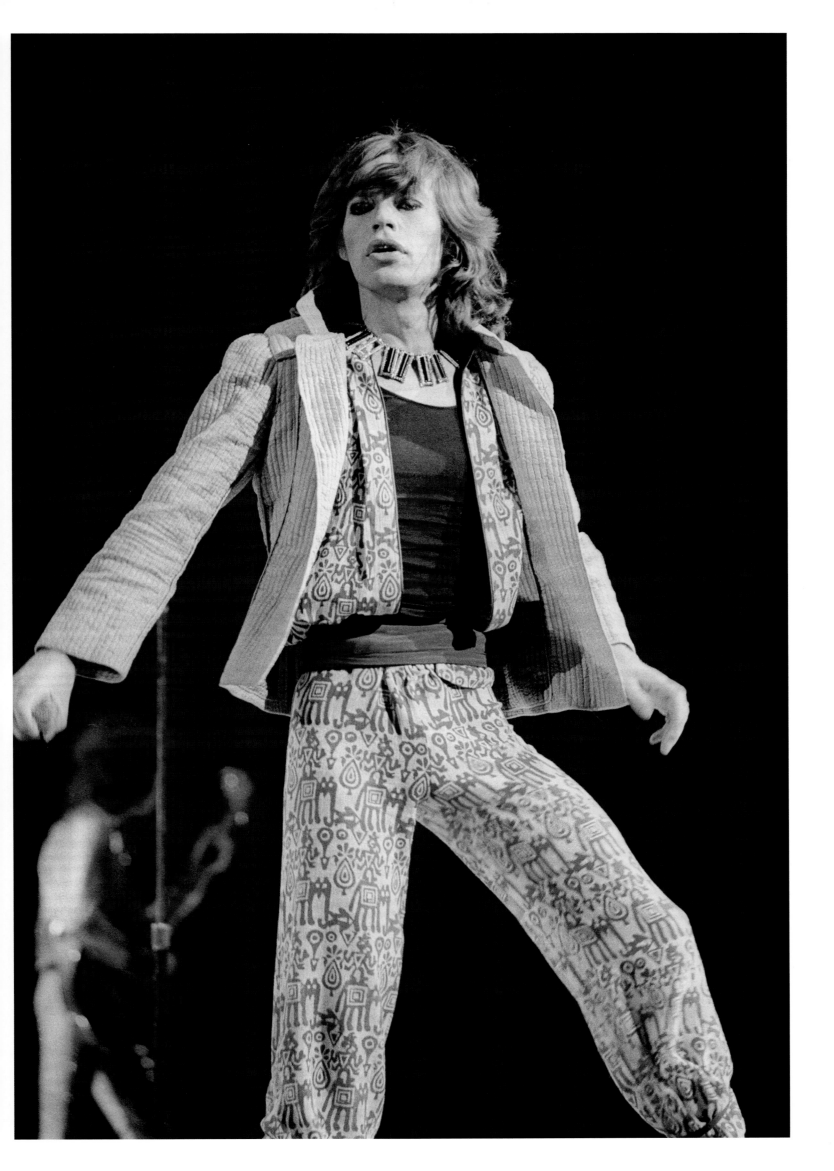

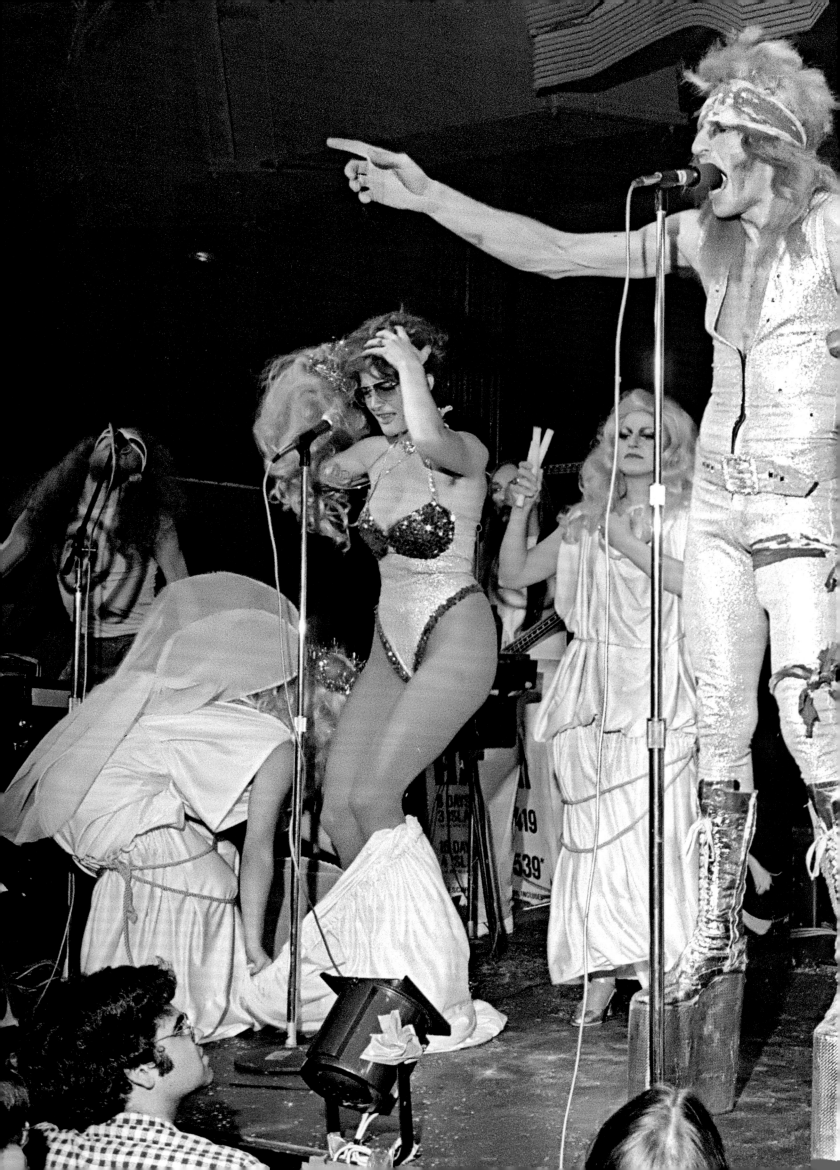

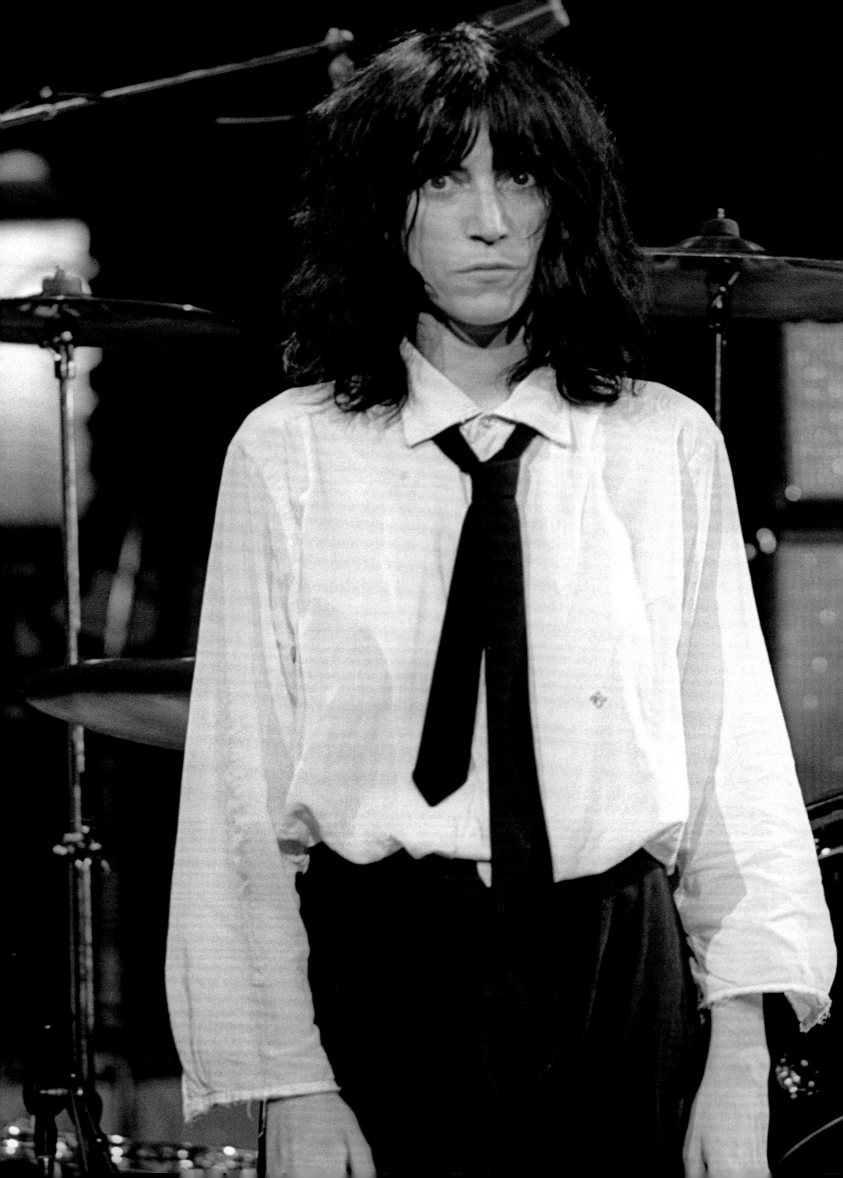

FUNKY BUT CHIC

We met over music, "Boo" Tannenbaum and me, undergrads at Rutgers, "On the Banks of the Old Raritan" in New Jersey. There weren't many counterculture types on campus then, and we all felt the gravitational pull toward one other. Al had one of the first San Francisco rock concert posters I ever saw on his wall, back when the two sixes aligned in preparation for the Summer of Love-In. I was in the Zoo, he was in Ellis Dee and the Pleasuredome (very clever!), and once, on a star-crossed night in East Brunswick, we had a nameless band together that combined both our worlds.

It was the same thing in the 1970s, when now-Allan came on the mise-en-scène as a downtown chronicler. He was the Weegee of the *Soho Weekly News*, whose dream job it was to pictorially chronicle the demimonde that had sprung up throughout lowest Manhattan, a star-spangled cornucopia of theater and fashion and street art and music, an ongoing current event that needed documentation as much as validation.

Al pointed his camera and the finder found its range. In those days—increasingly romanticized and now burnished with retro-fascination—it is hard to remember just how *local* it all was, the province of three or four nightclubs of the moment, the cast of characters that popped up and poppered up. Was it like that? Depends on who you were then, who you wanted to be, who you became and went.

I will say this. Rents never seemed cheap at the time, the great apartment always fifty or a hundred dollars out of reach; and the arts that were being made only had a marginal chance of being making-it. The city was cautionary, especially the alphabet areas only two or three blocks away from skid row where the bands were setting up their equipment. Retrospect is a dangerous narcotic, especially when you're both pusher and user.

Me, I like to hang out. I like between the sets of a band, when you stand outside CBGB or Max's or the 82 or Great Gildersleeves or the after-hours Nursery and shoot the breeze with your friends. Or those you're about to meet. When the night is still unfolding.

The music gave it all a reason to be there, style as much as sound, as much an accessoried outfit as the cut of a pant leg, the revealed back, the fabric sheen, the height of shoe. In the '70s, possibility shined on Manhattan, as new species came into beaming. Call it what you will, rhymes with "xunk," the roll call of classic names unfurled, as different in garb from each other as their shared aspirations. I was privileged to be a member of a band then and now; to participate, not only as a player, but in the audience, rooting for my friends. They—along with others who were part of the passing parade, guys and gals and guy-gals and gal-guys—are pictured here, caught somewhere between the candid shot leaning by the bar and the artful pose onstage. There they, and we, are; and so was Al's camera, catching the light.

But then, he had the lens-eye early. On Easter 1967, he took his Bolex 16mm to Central Park to record the Human Be-In, which filled Sheep Meadow. He filmed in color, because this moment was about color enhancement, unlike the '70s, which were resolutely black-and-white, except for their sprinkling of glitter. Striving for a psychedelic effect, he double-exposed the film in the camera, stereo becoming mono. And there, for a brief minute, is me, having stayed up all night to greet the new dawn, full of hope for the future, sure at that moment that love is all you need.

Then there's the first portrait I remember of his. It's of our friend Curt Roseman, blissfully stoned, offering a hit of joint. Al made it into a poster. *Smoke Burma Grass.* And the tagline: *Truly Fine Shit.*

The astral traveling of negative into positive, the picture magically appearing before your eyes, bringing you back to where you once were, freeze-framing time.

—LENNY KAYE

OPPOSITE: Patti Smith on the *Saturday Night Live* stage in 1975.

SUBSEQUENT PAGES: Steel Pulse performs at the Mudd Club in 1980 with David "Dread" Hinds on lead guitar and vocals.

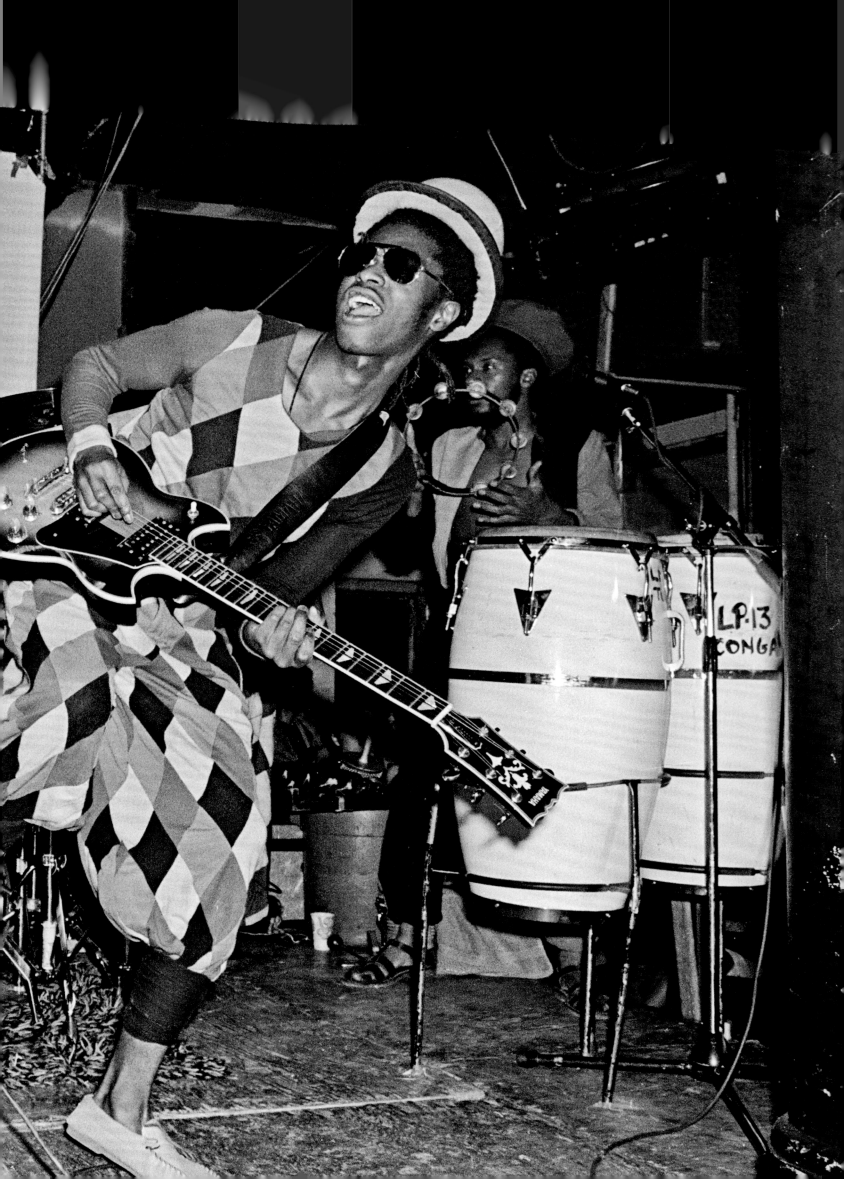

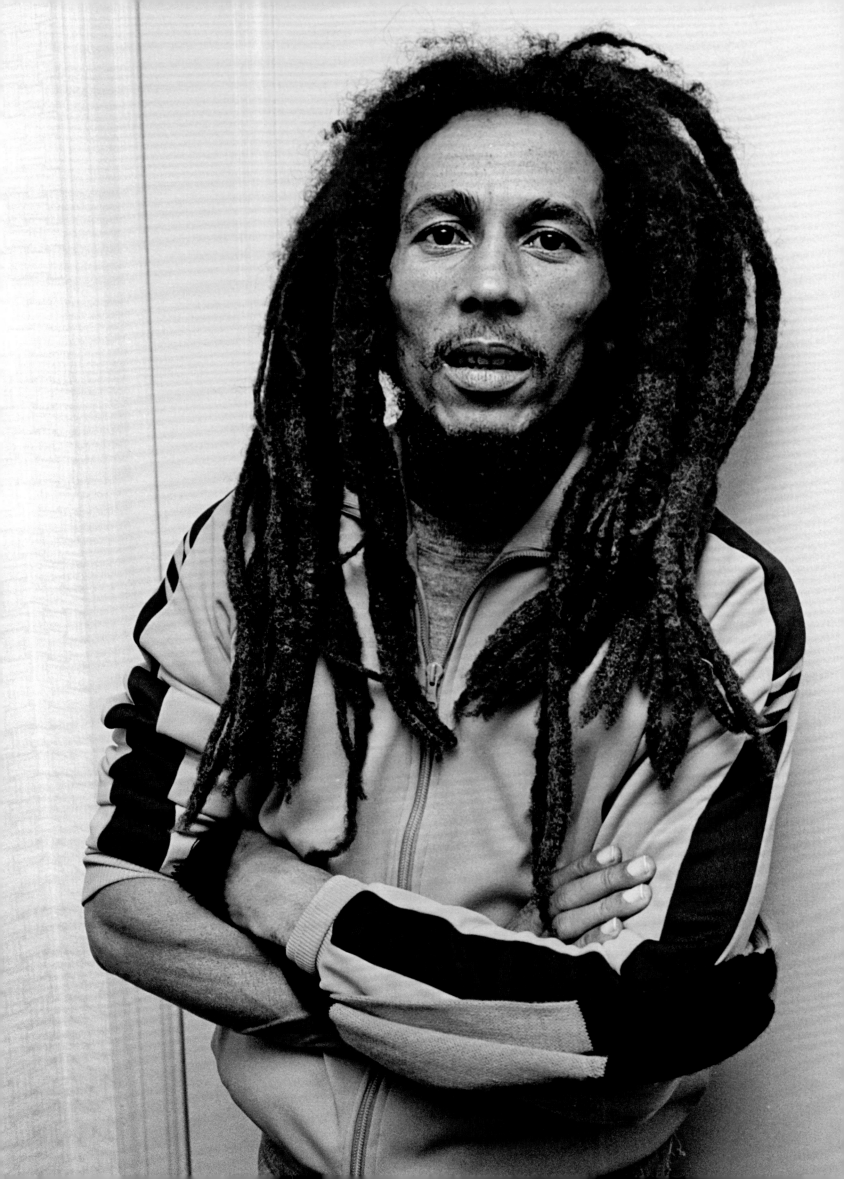

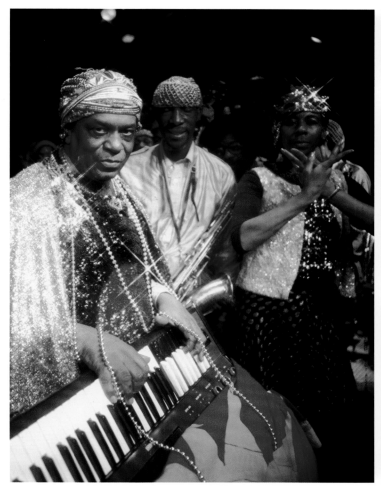
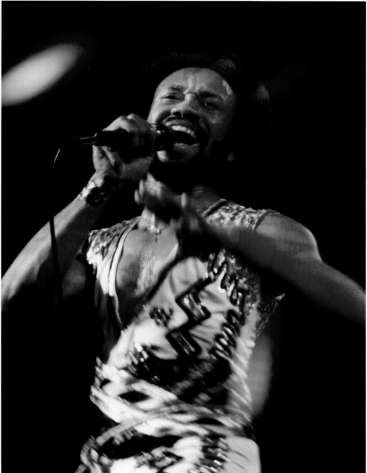

REGGAE & SOUL

New York was also a major focus of black music culture, which expanded the style palette with the sun-splashed rhythms of reggae, the exuberance of hip-hop, and the timeless sway of the blues. The connection between the spiritual world of Rastafari, the sacred herb of ganja, and the political protests of Bob Marley might make reggae seem like the quintessential '60s music. And yet its standard-bearer didn't leap onto the international stage until he left the Wailers and went out on his own in the mid-'70s, eventually relocating from Jamaica to England. A series of four concerts by Marley at New York's Beacon Theatre in 1976 was a citywide sensation, and other touring reggae bands began playing in New York, from Toots and the Maytals to Steel Pulse.

Black style showed up more demonstrably in American soul and rhythm and blues, enlivening certain clothing choices that otherwise fell flat in the '70s. The much-maligned jumpsuit, which became a cliché of women's fashion in the late '70s and early '80s, never looked better than on singer Maurice White and the other members of Earth, Wind & Fire. The same was true for James Brown, who made even leisure suits look sharp. Other looks included the psychedelic flair of George Clinton of Parliament-Funkadelic, who had a penchant for satin jackets and harem pants.

Some musicians, of course, transcend all style because they invent their own. In the world of jazz, apart from Miles Davis—whose musical style evolved as much as his dress when he went electric in the early '70s—the most idiosyncratic figure was certainly Sun Ra. Born in Birmingham, Alabama, as Herman Poole Blount, Sun Ra claimed to have been taken to the planet Saturn by aliens early in his life and told to communicate through music. He landed in New York City in the '60s, where he lived on East Third Street and played weekly at the legendary East Village club called Slugs'. Although he moved to Philadelphia in 1968, he returned regularly to play not only jazz clubs but also mainstream venues including the Bottom Line and the Brooklyn Academy of Music. Sun Ra felt a profound connection to Egyptian culture (Ra being the ancient sun god of Egypt) and he dressed himself and his Arkestra—as he referred to his sizable band, which included a couple of dancers—in elaborately colorful, futuristic costumes inspired by ancient Egyptian attire but always highlighted with glitter and often backed by light shows.

ABOVE LEFT: Jazz musician Sun Ra and his Jet Set Solar Arkestra at the Bottom Line in 1980.

ABOVE RIGHT: Lead singer Maurice White of Earth, Wind & Fire performs at Madison Square Garden on October 5, 1979.

OPPOSITE: Reggae star Bob Marley in his room in New York on October 29, 1979.

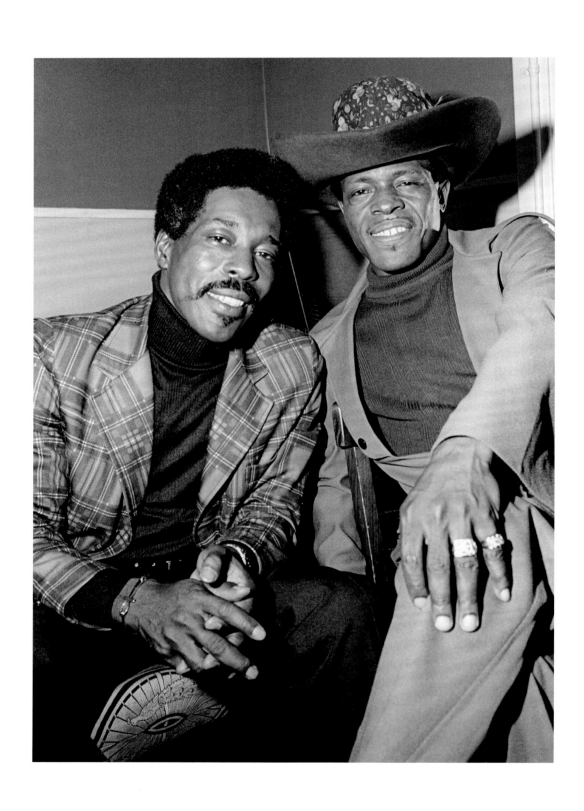

ABOVE: Blues giants Buddy Guy and Junior Wells backstage at the Bottom Line in 1976.

OPPOSITE: James Brown jumps on Broadway in 1979.

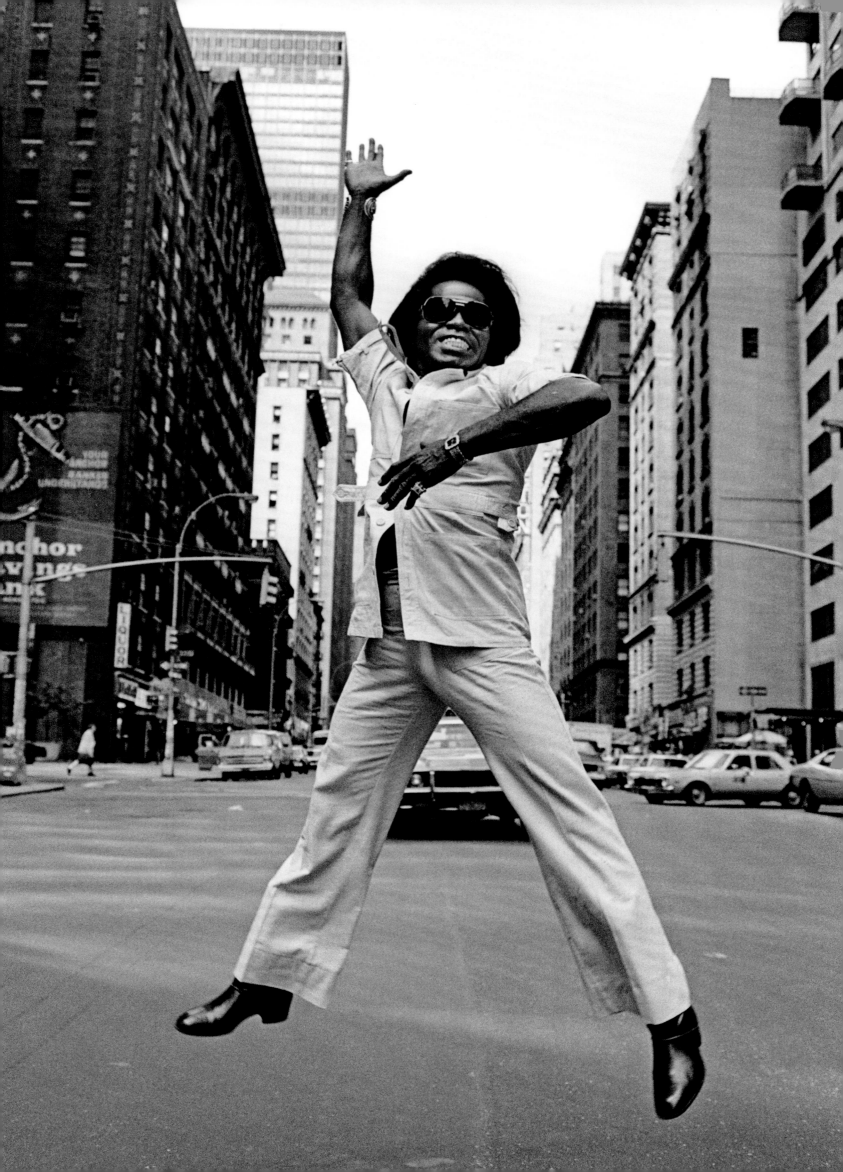

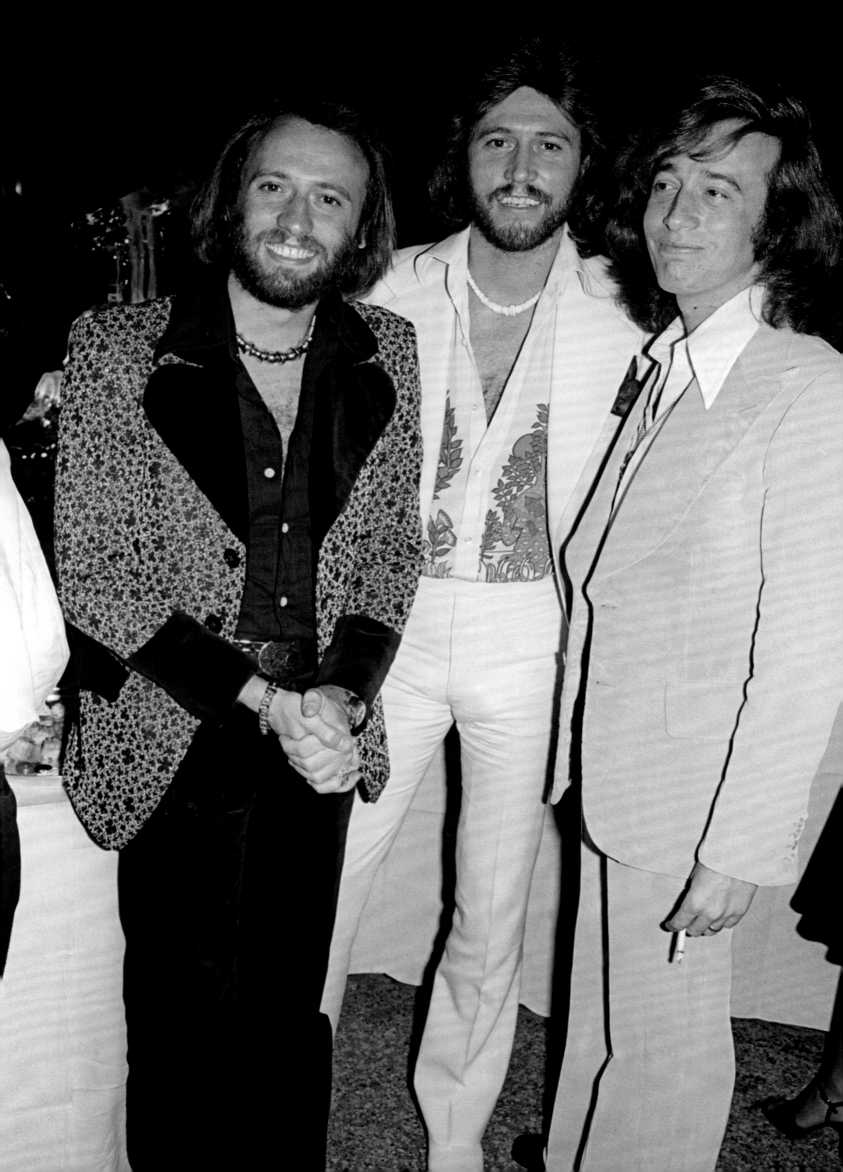

DISCO MEETS ROCK

And then there was disco. The basics of disco as music and as a social experience were already percolating among gay, African American, Italian American, and Latino communities in the late 1960s and early '70s, before it exploded onto the national scene fueled by hit disco records from Gloria Gaynor, Barry White, and Donna Summer, and the popularity of Studio 54 and *Saturday Night Fever*, both of which debuted in 1977. The argument could be made that disco was a reaction against the dominance of the same kind of undanceable arena rock that punk and new wave also rebelled against in their drive to return to the early days of rock 'n' roll as dance music without all those self-indulgent drum solos. In any case, both disco and punk satisfied the basic need to get up and boogie.

As for clothing styles, in the late '70s you could find Huckapoo shirts and Spandex pants at discos across the city, not to mention the wide lapels worn by music figures from the Bee Gees to the determinedly unfashionable owners of the Bottom Line, Allan Pepper and Stanley Snadowsky. The Bottom Line was a record company showcase that nonetheless exposed some of the hippest music outside of Max's and CBGB, from Elvis Costello and Ian Dury to Buddy Guy and Junior Wells.

A few musicians did well with both disco and rock audiences, perhaps none more so than Grace Jones, the Jamaican-born singer and model whose voice and physical presence are, to use Duke Ellington's phrase, "beyond category." Jones began her career as a fashion model in New York before moving to Paris and working for Yves Saint Laurent and Claude Montana, among others. After signing with Island Records, she made a string of distinctive recordings that were popular in rock dance clubs as well as discos, covering new wave classics like "Warm Leatherette" (by the Normal), Roxy Music's "Love Is the Drug," and the Iggy Pop–David Bowie collaboration "Nightclubbing," alongside her own suggestive "Pull Up to the Bumper;" later she recorded reggae-flavored songs with the famous Jamaican rhythm section and production team of Sly Dunbar and Robbie Shakespeare. Few women have ever looked better in a tailored suit jacket; yet even with her flattop haircut, her look has always been more ambiguous than ambisexual.

OPPOSITE: Maurice, Barry, and Robin Gibb pose at the Bee Gees' twentieth anniversary party at the Promenade Cafe in Rockefeller Center.

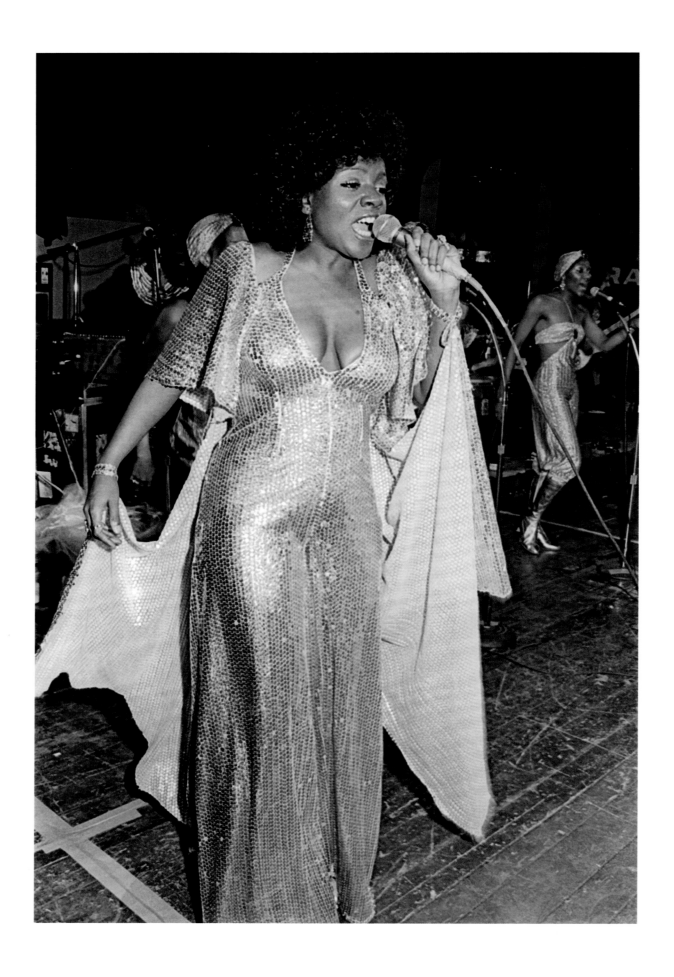

ABOVE: Gloria Gaynor performs at the Disco Convention at Madison Square Garden, November 1975.

OPPOSITE: Donna Summer performs at Roseland in white plumage.

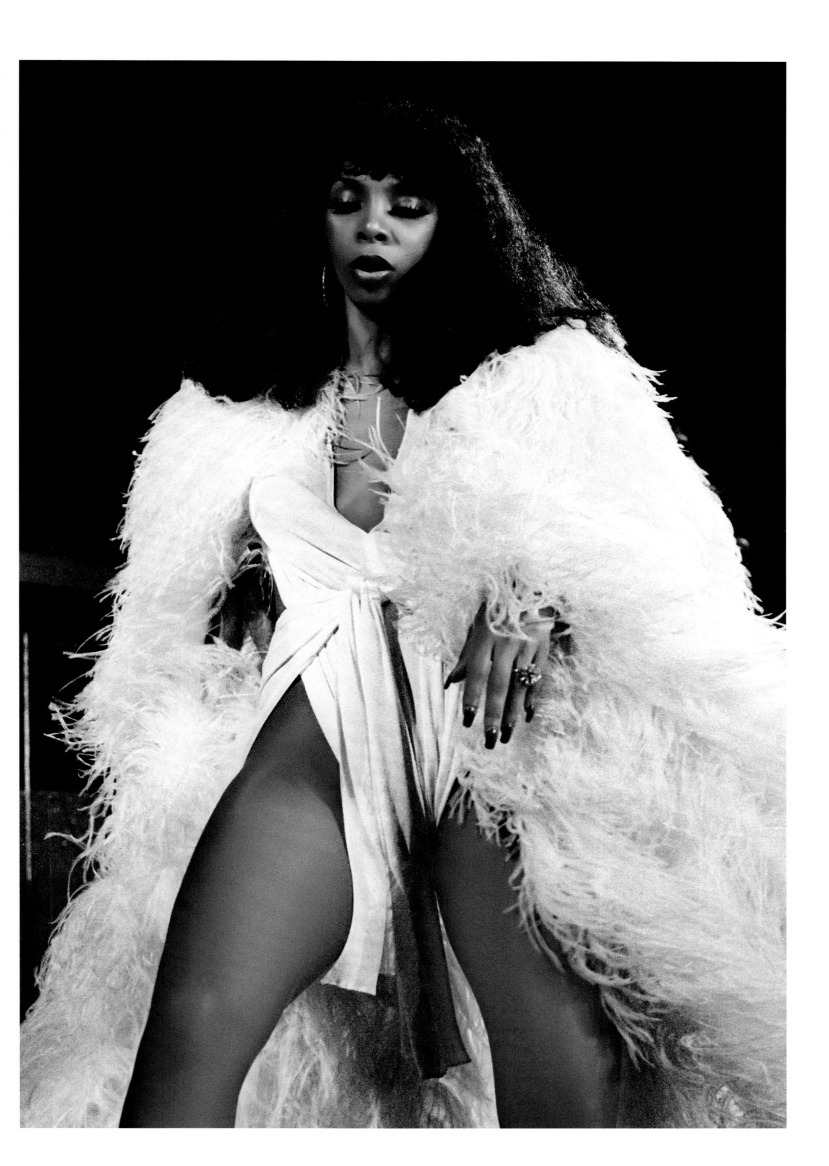

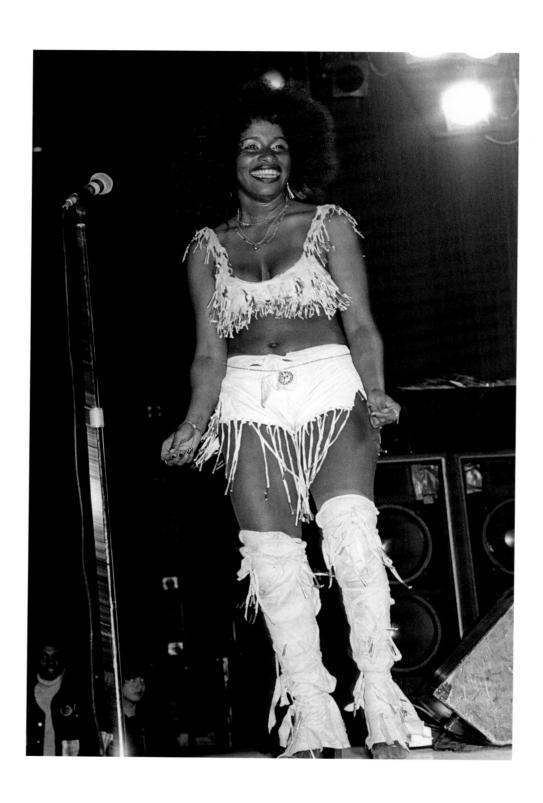

ABOVE: Chaka Khan performing with Rufus at the Felt Forum, 1976.

OPPOSITE: Disco diva Grace Jones strikes a pose on September 21, 1978.

SUBSEQUENT PAGES: The Rolling Stones, minus drummer Charlie Watts, visit Danceteria in New York City to promote their new album, *Emotional Rescue*, July 1980: (*from left to right*) Bill Wyman, Ron Wood, Mick Jagger, and Keith Richards.

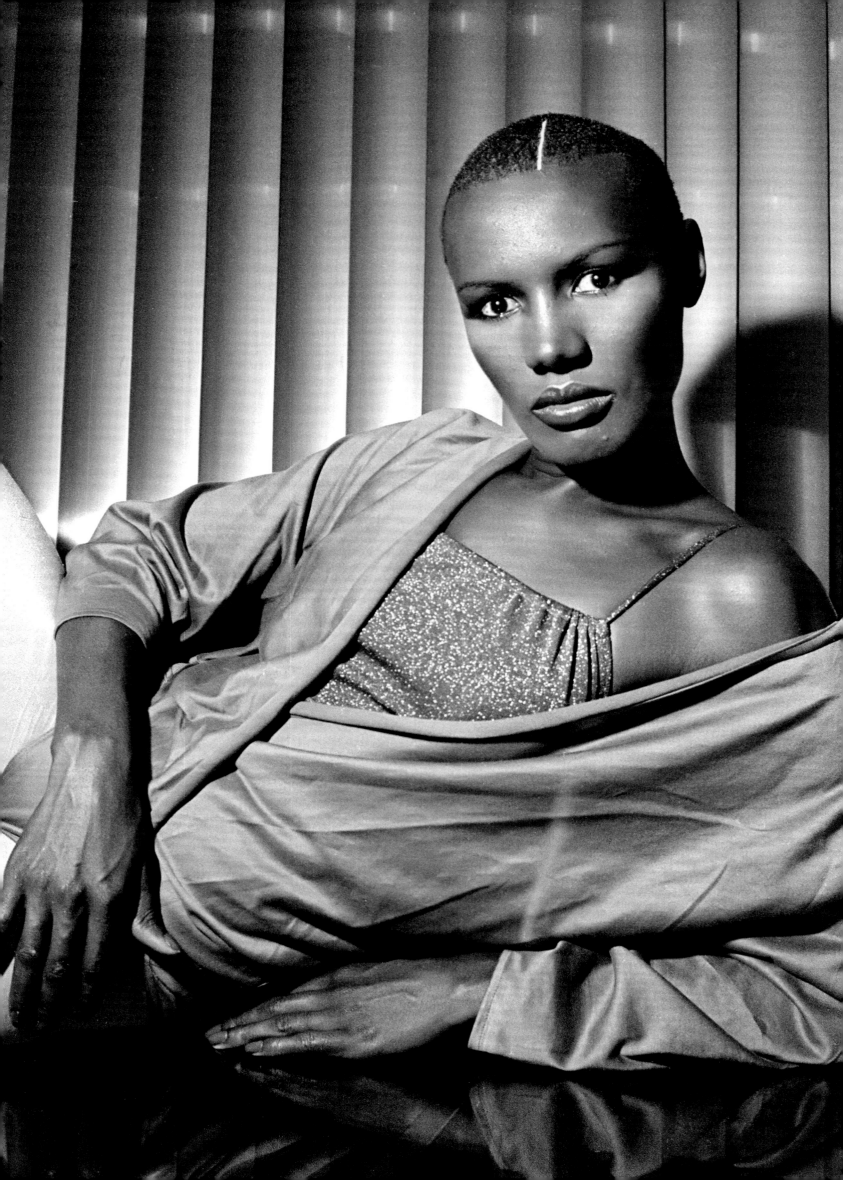

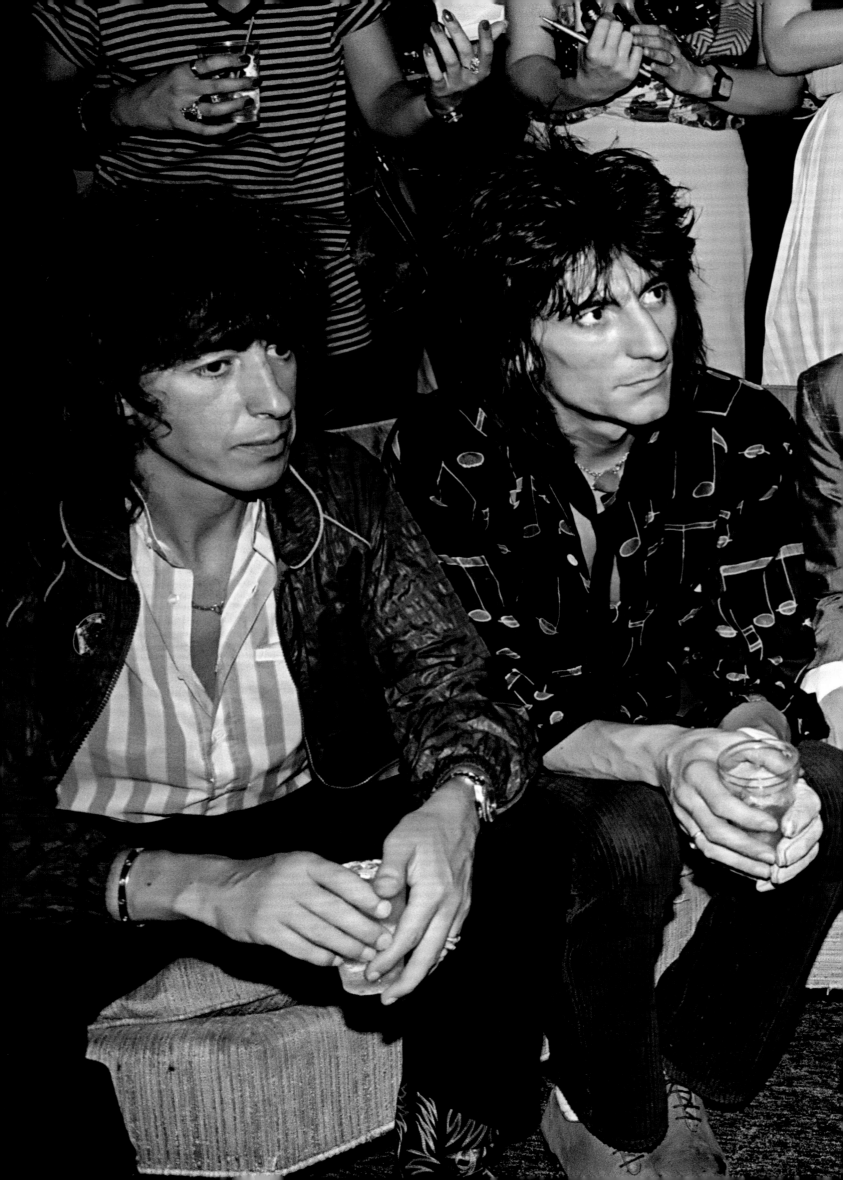

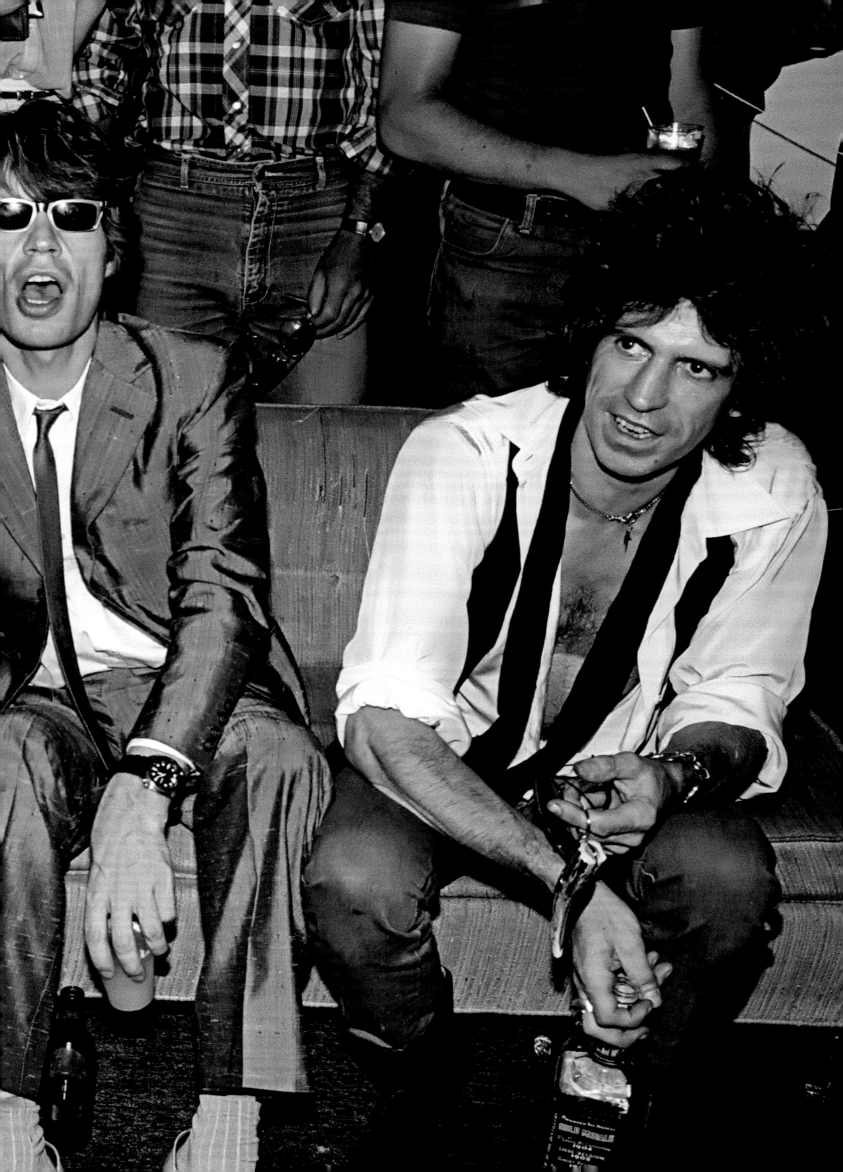

NIGHTLIFE

Punk was like nothing anybody had seen before, like nothing. —John Lydon (aka Johnny Rotten)

Disco was designed for a specific function. It was wallpaper to be used in the background of the lifestyle of the people who inhabited those disco places. And those places were basically meat racks. The function of this music was to provide this rhythmic dance texture while people went to the meat rack. —Frank Zappa

THE PARALLEL STREAMS OF MUSIC that defined New York's style in the '70s had their counterpart in the city's nightlife. Glitz and glamour gravitated to Studio 54 on West 54th Street, with its dazzling, spinning cylinders of colored light, thundering symphonic disco, and VIP room where Mick and Bianca, Halston and Jerry Hall, David Bowie and Iman, Diane von Furstenberg and Jacqueline Onassis might be seen on any given night. The glamorous look also played out in the grown-up high school fantasy allure of roller disco, from the long-lived Empire Rollerdrome of Brooklyn to the briefly flourishing Roxy in Manhattan's Chelsea district.

Downtown, at Max's Kansas City and CBGB, immaculate denim from Gloria Vanderbilt and Calvin Klein gave way to torn skinny jeans from Levi's or Lee, shrink-fit T-shirts, and motorcycle jackets (or passable facsimiles). The Ramones were arguably the biggest influence on punk rock apart from the Dolls, having influenced the British punks when they toured there in 1976 and met members of the Sex Pistols and the Clash.

Further downtown, the Mudd Club—the quintessential after-hours joint, located in a district that became known as Tribeca—reigned, however briefly, as the "anti–Studio 54." People wore whatever they wanted and somehow made it go with the music of deejays David Azarc, Anita Sarko, and Johnny Dynell, who played whatever they wanted—whether Billy Idol, James Brown, Ultravox, or Tommy James and the Shondells. The initial patrons were artist friends of the owner, Steve Mass, who ran a private ambulance service and claimed that he started the club with a budget of $15,000. Another thing that made the Mudd remarkable in contrast to most other clubs—and all discos—was the absolute barrenness of the main floor: no chairs or tables, a bar with no barstools, essentially nowhere to sit down. A few photographs lined the walls, but that was it as far as decor went. Upper floors, which required admittance by a second doorman, did have booths with chairs, occasional thematic installations, and art by Jean-Michel Basquiat, Keith Haring, and Kenny Scharf, among others. But that seatless ground floor was the heart of the Mudd Club.

OPPOSITE: A cool cat descends behind three poseurs at the 82 Club in 1974.

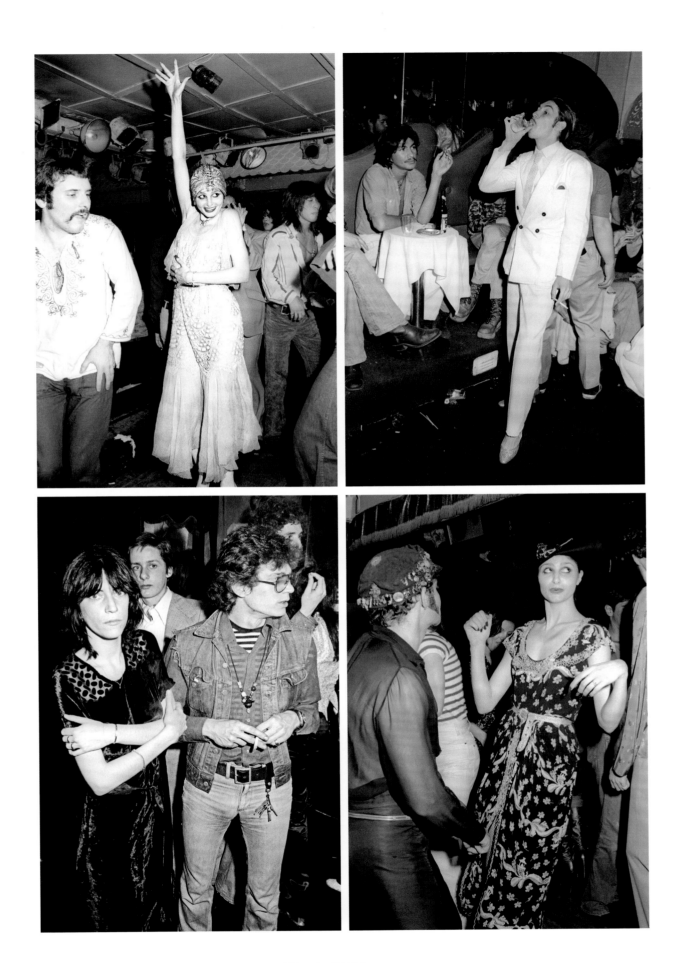

TOP LEFT: Model Apollonia van Ravenstein parties in 1974 at the 82 Club.

TOP RIGHT: Revelers enjoy the 82 Club.

BOTTOM LEFT: Rock poet Patti Smith and photographer Robert Mapplethorpe at the 82 Club.

BOTTOM RIGHT: Model Apollonia van Ravenstein dances with stylist Ara Gallant at the 82 Club.

OPPOSITE: Coming on strong on the dance floor at the 82 Club in 1974.

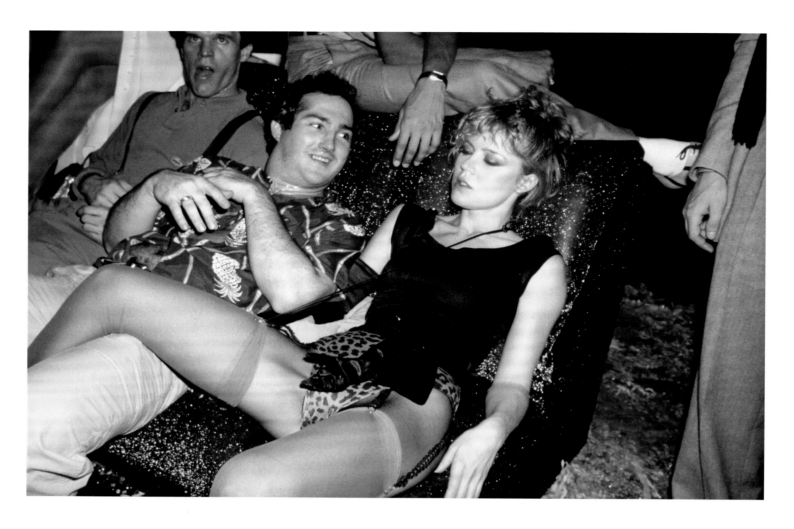

STUDIO 54 AND BEYOND

Those of us who lived through the 1970s and '80s, and even those who have merely read about them, sometimes tend to think that places like Studio 54 and the Mudd Club were long-lived fixtures, like Max's Kansas City and CBGB, and that they defined that period. But Studio 54, which kicked off the glitzy disco era, didn't open until April of 1977, and it peaked in 1979 after its creators, Steve Rubell and Ian Schrager, were arrested for skimming several million dollars from the club's receipts. (When Rubell was quoted as saying that Studio 54 had made $7 million in its first year and that "only the Mafia made more money," police raided the club and found bags of cash and alternate record books hidden in the ceiling and basement.) The club closed in 1980. After Rubell and Schrager had served just under a year in prison, they sold the place but stayed on briefly as consultants. Many of the same celebrities returned when Studio reopened in 1981, and some name bands performed live, but it didn't seem to have the same juice.

In its heyday, however, Studio 54 was unlike other discos. The building that housed it had previously been a radio and television studio owned by CBS, so it was already wired with multiple TV lighting circuits and a fly system for changing sets, which allowed the nightclub to have a constantly changing environment. Before then, most clubs were typically kept dark to create a romantic setting and privacy, but Studio 54 was able to light up the crowd and dance floor dramatically, making it a place to see and be seen, literally.

The game with nightlife was always about keeping up with changing tastes and fending off boredom—not to mention weariness. If you've been out all night and it's 3:30, you don't want to have to think too much about where to tell the cabbie to take you next. When the former Bond clothing store at Times Square was converted into an enormous dance club with live music in 1980, the news generated so much excitement that the club opened to the public before construction was fully completed. The sheer size of the place—now formally called Bond International Casino, although no betting took place on the premises—made it an ideal venue for live concerts where the audience could also dance, as when punk superstars the Clash played a memorable series of seventeen shows there in 1981.

Other clubs seemed to happen serendipitously. At 110 University Place, just a few blocks from where former Max's Kansas City owner Mickey Ruskin ran a restaurant under various names at One University Place, a bowling alley was located on the second floor of a commercial building. It was just your average urban lanes, but someone had the bright idea of turning it into the Bowling Club one night a week (I think it was Thursday). You could still bowl, but they lowered the lights, spiced up the bar, and hired a rock 'n' roll deejay. Suddenly people from the club circuit started showing up there, like columnist Stephen Saban, rocker Billy Idol, and scenemakers Klaus Nomi and Tina L'Hotsky. And then, just as suddenly, it wasn't happening anymore.

ABOVE: Makeup artist Sandy Linter relaxes at Studio 54 in 1978. Sandy was the girlfriend of tragic supermodel Gia Carangi.

OPPOSITE: A man with dressed as a baby dances with a bare-breasted woman at a Studio 54 Halloween party.

SUBSEQUENT PAGES: Jerry Hall and Mick Jagger arrive for the first anniversary party at Studio 54 in 1978.

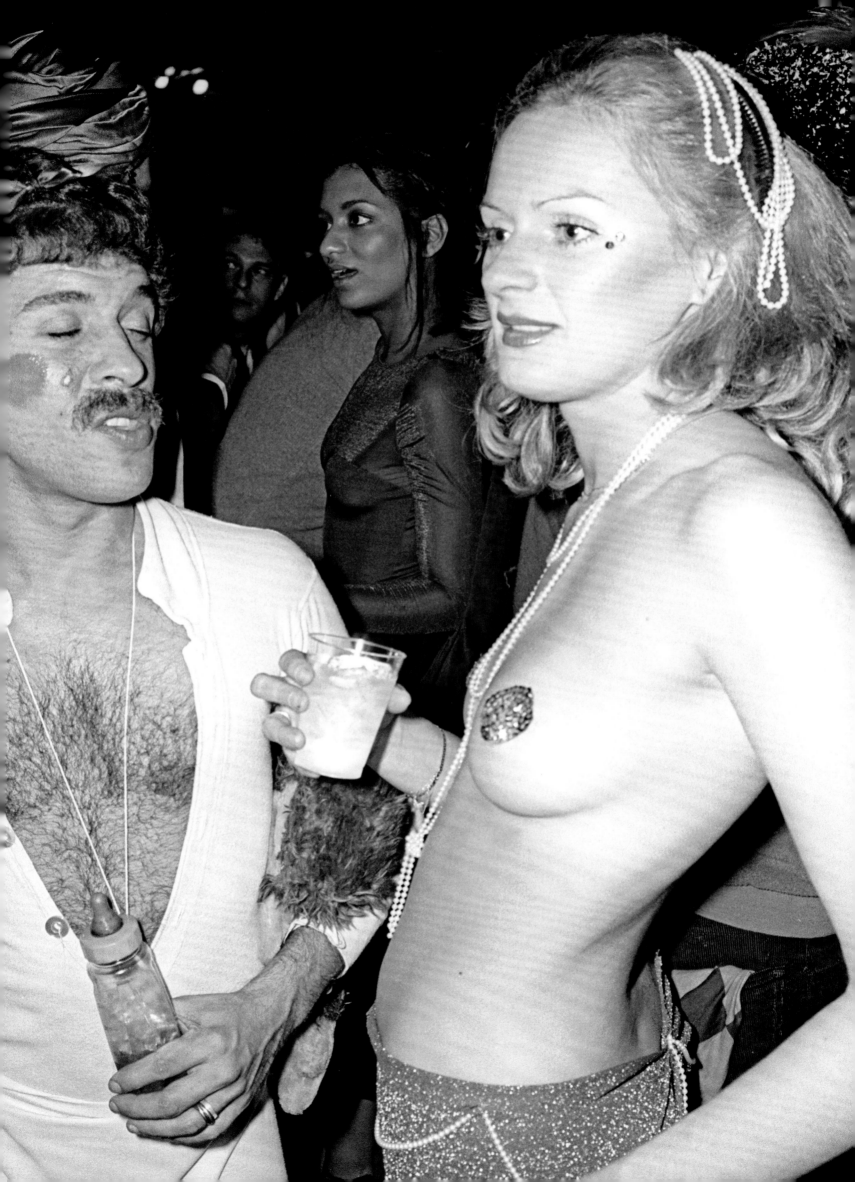

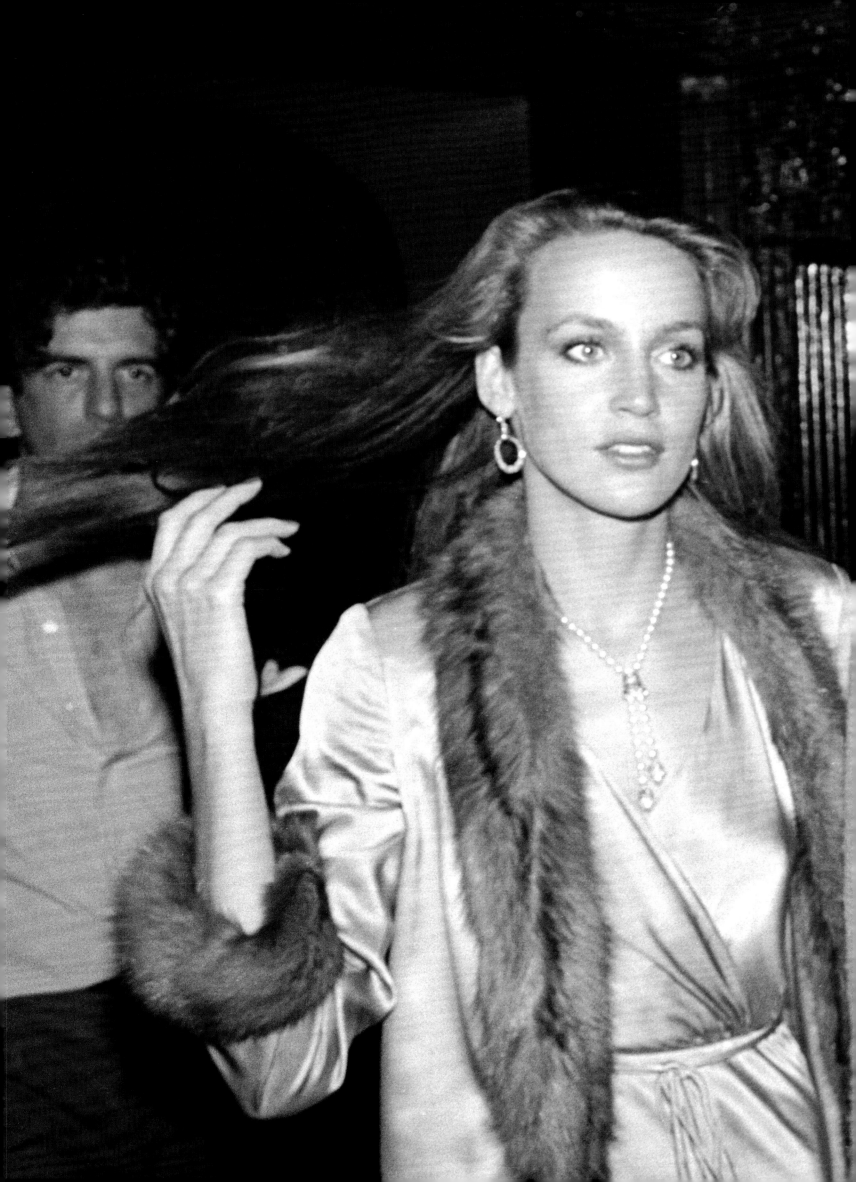

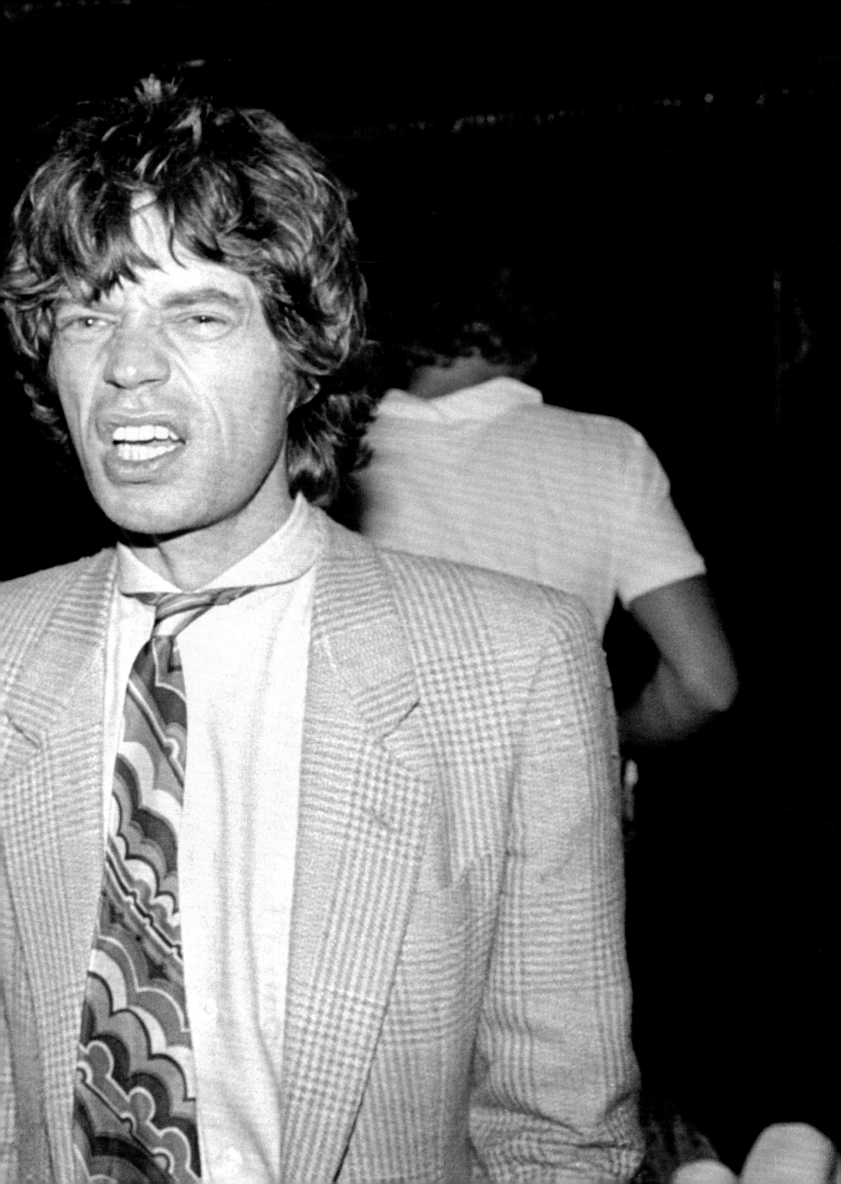

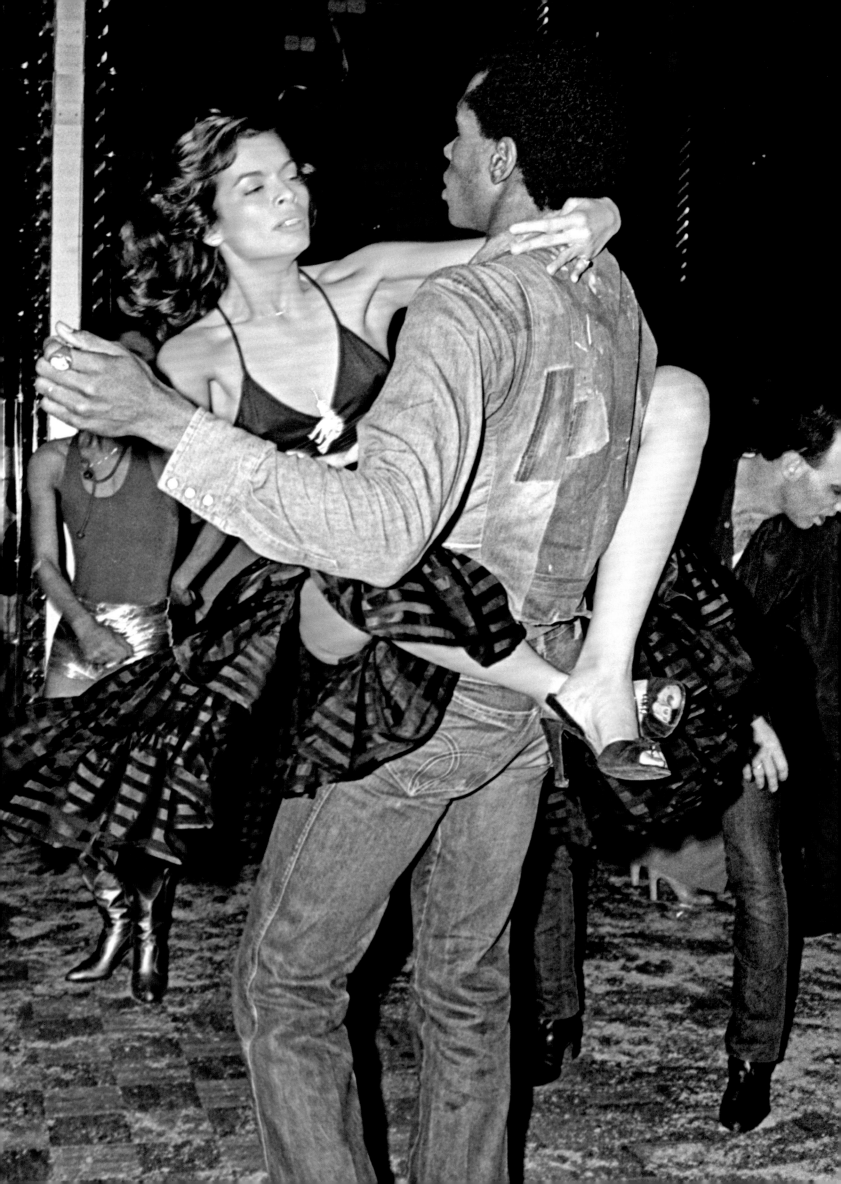

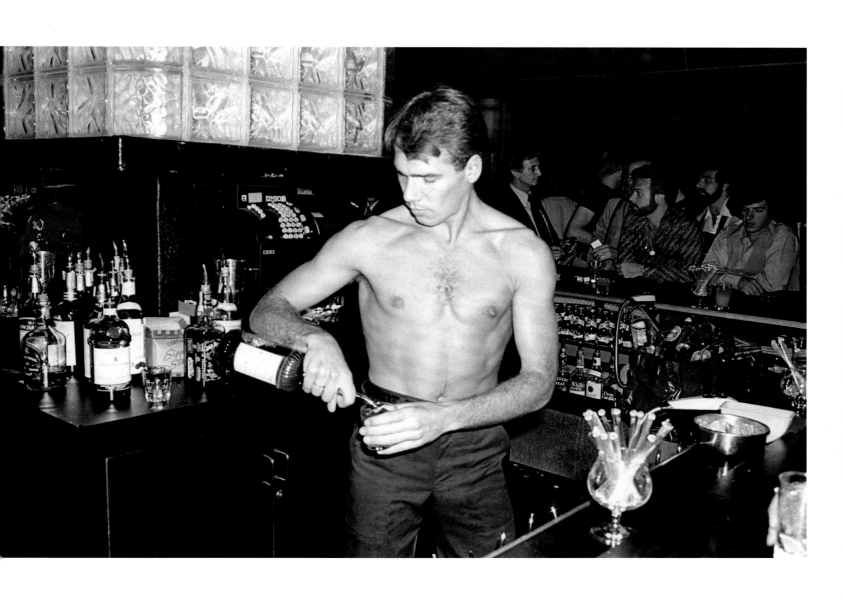

ABOVE: A bartender pours a drink at Studio 54.

OPPOSITE: Bianca Jagger dances with model Sterling
St. Jacques at Studio 54 on May 4, 1977.

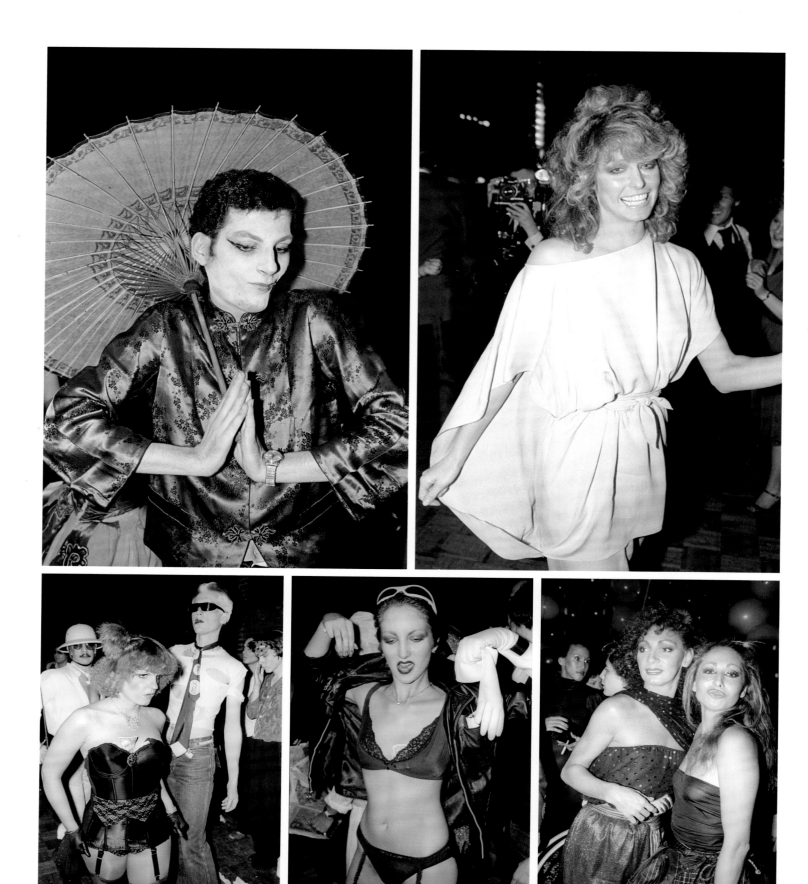

TOP LEFT: Michael Musto in Asian drag at the third Halloween party at Studio 54 in 1979.

TOP RIGHT: Farah Fawcett dances at a party for Fabergé at Studio 54 in 1978.

BOTTOM LEFT: A blasé woman dances in a bustier and garters with a punk-look guy at a Halloween party at Studio 54.

BOTTOM MIDDLE: A woman dances in garter belt and stockings.

BOTTOM RIGHT: Studio 54 regulars Daniela Morera and Sheri Slonim.

OPPOSITE: *Saturday Night Fever*–style dancers at Studio 54 in 1978.

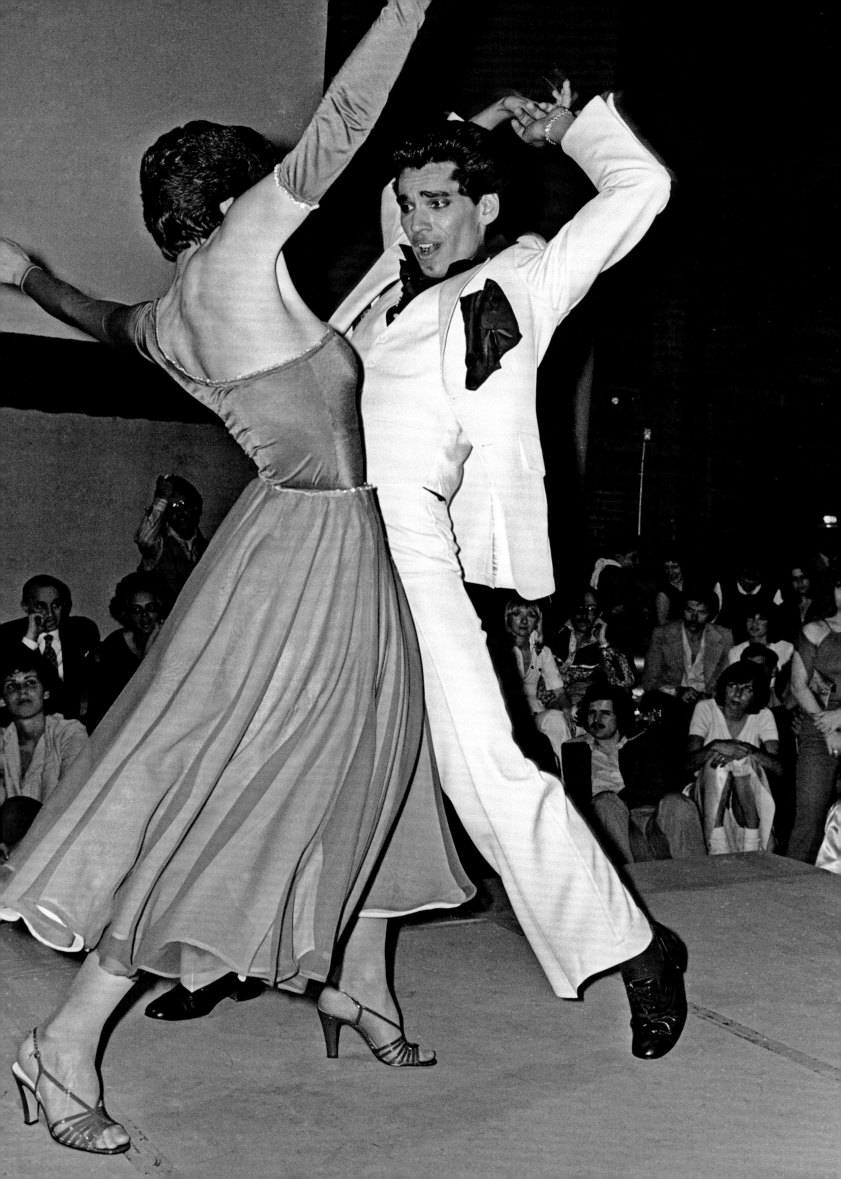

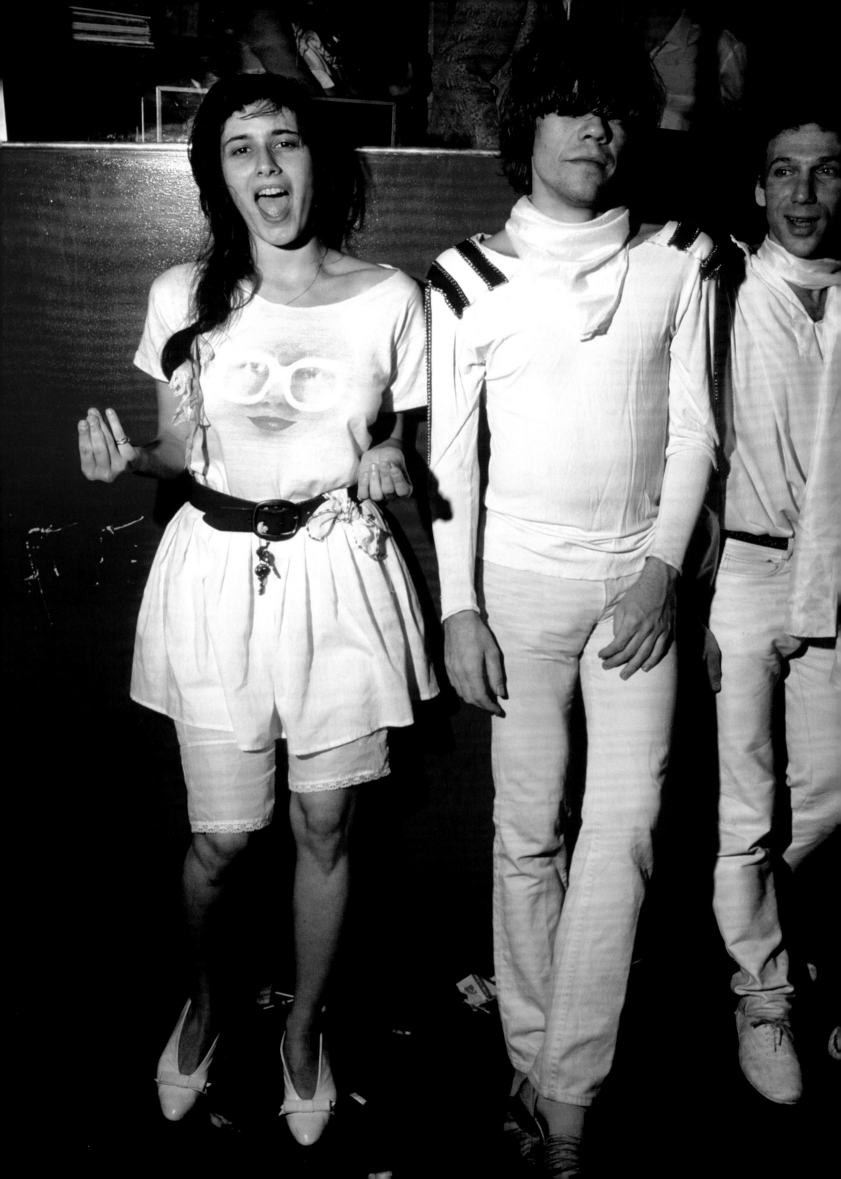

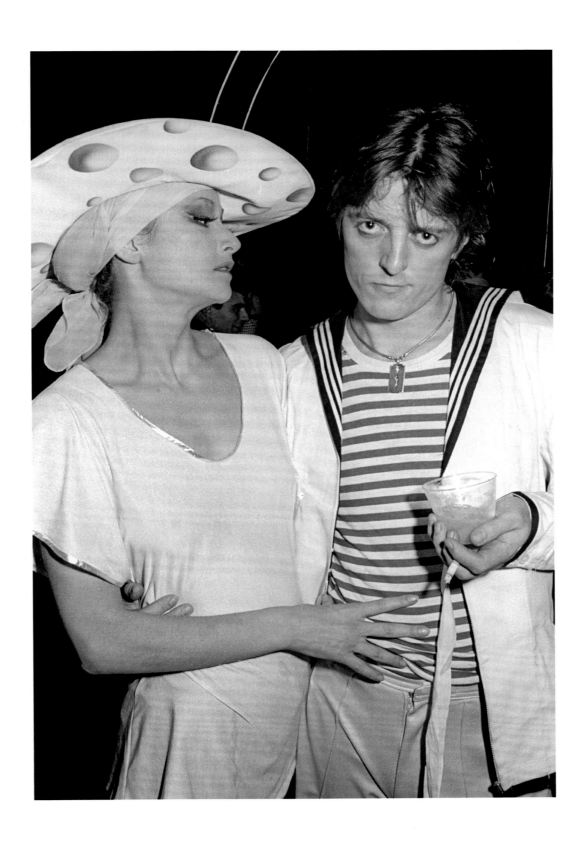

OPPOSITE: Abbie Jane, David Johansen, and Bob Gruen at the Ritz prom in 1980.

ABOVE: Re Styles and Prairie Prince of The Tubes party at Infinity after their gig.

SUBSEQUENT PAGES: LEFT: Punk rocker Billy Idol gets a bowling lesson at the Bowling Club in Greenwich Village, 1981. RIGHT: A woman in a fucshia dress prepares to bowl at the reopening of the Bowling Club.

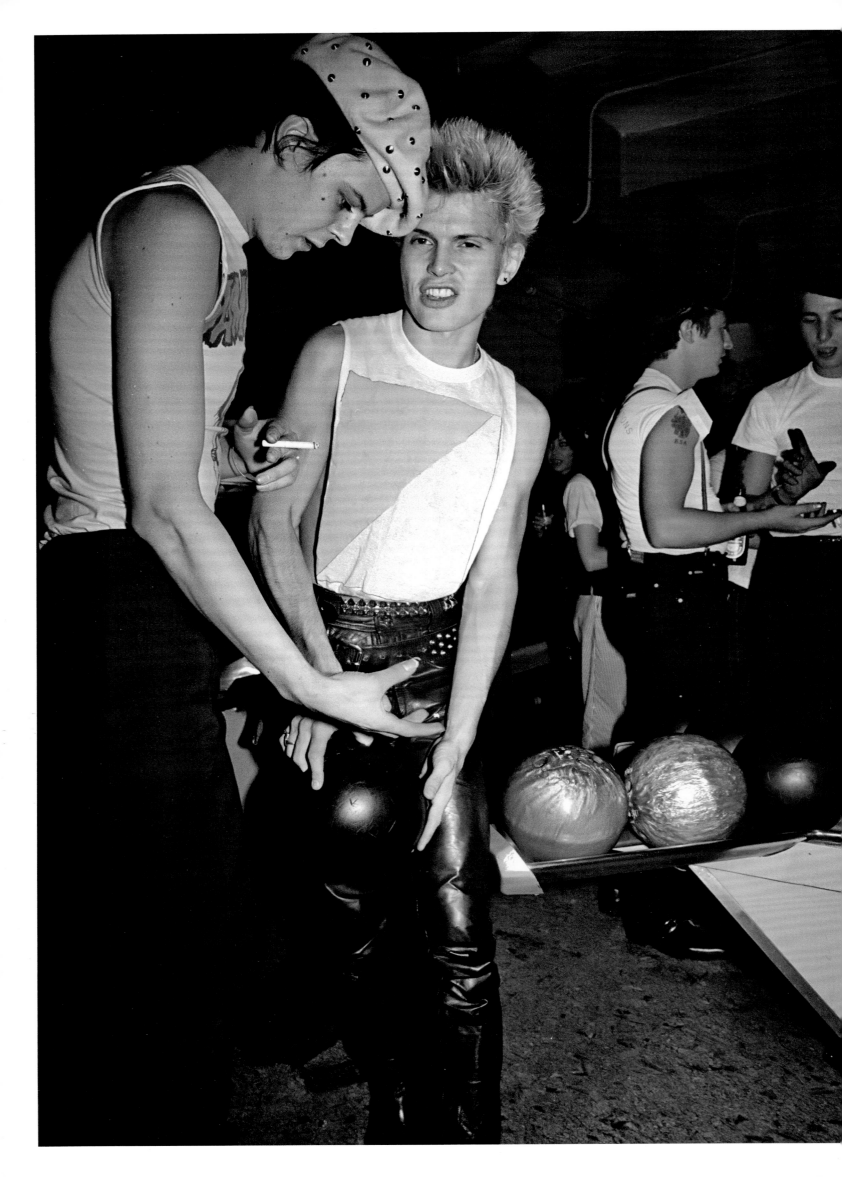

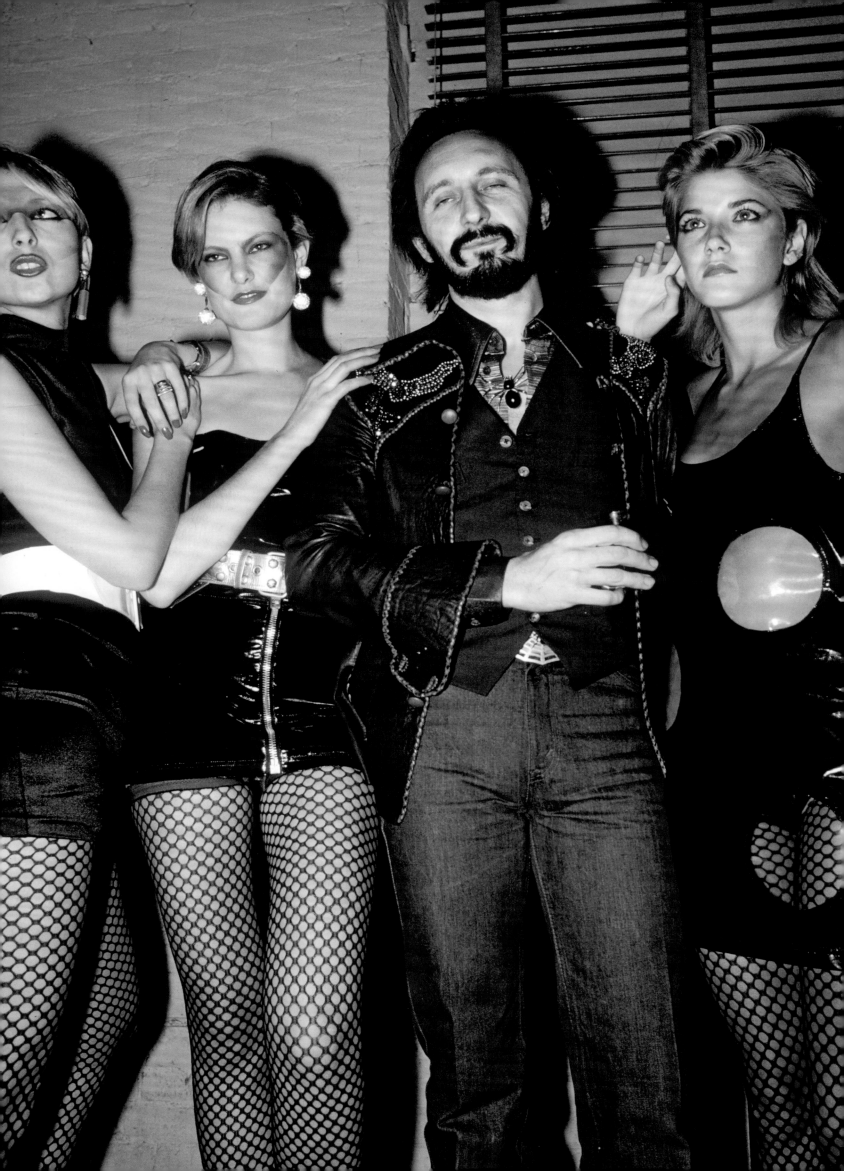

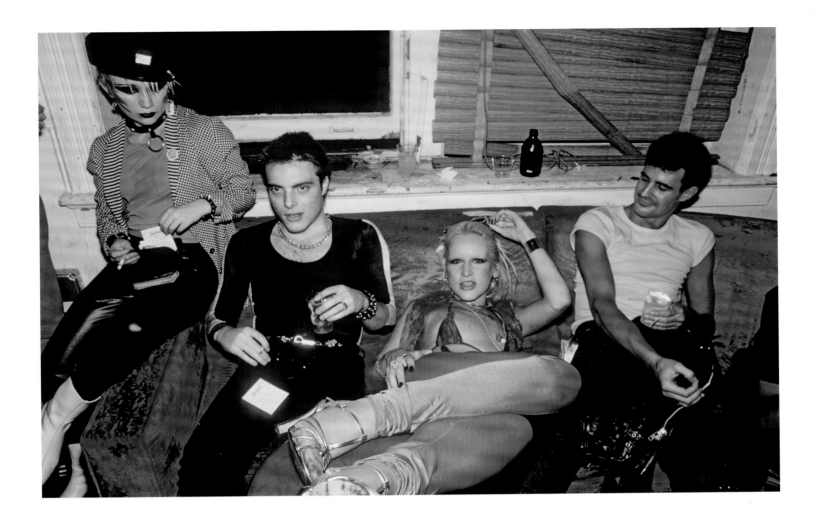

MUDD CLUB

If you had to pick one locus of creative fun at the peak of the late '70s out of all the options, it would be the Mudd Club. Somewhat like the Roxy, the Mudd had a short but glorious life. Opening a year and a half after Studio 54, in October 1978, it lasted less than five years, but in that time it served as the perfect foil for uptown glitz. The aim of Steve Mass was to create a hangout where his artist and musician friends could meet, drink, and dance if they felt like it. As mentioned earlier, the music was an eclectic mix that went with the come-as-you-are dress code. Some people showed up in jeans, T-shirts, and leather jackets; others dressed more outlandishly, or in DIY outfits they threw together with whatever was available. If a couple arrived wearing a black suit and a Marilyn Monroe gown, they fit right in.

The club had occasional theme parties, like Rock Suicide, Combat Love, Quadrophenia, Soul Night, and Catholic Girls School Night, which invited all kinds of stylish costumery. The club had live music on occasion, from Johnny Thunders and the Heartbreakers to Lydia Lunch, the B-52's, and the Bongos. Almost overlooked, though, were the frequent offbeat fashion shows. Among the most appealing were SoHo Designers, a group of

independent designers; Merchant of Venice (a downtown store featuring a wide range of emerging designers); Stagegear; Havona Fashion; and Natasha Fashions, showing the work of Natasha Adonzio. Adonzio was a punk clothing designer who once worked at an East Village store called Revenge. Credited with creating the first pair of Spandex pants, at the behest of New York Dolls bassist Arthur Kane, and Joey Ramone's leather jacket, she held the first punk fashion shows at the Mudd Club, Danceteria, Hurrah, and other New York clubs. The green leather suit that she made for Frank Infante of Blondie hangs today in the Rock and Roll Hall of Fame.

Janel Bladow, who reported on the downtown club scene in the *Soho News* and elsewhere, recalls that shows like Adonzio's were not so much fashion shows as parties, and the more outrageous, the better. "In place of the usual staid catwalk shows," Bladow says, "designers like Natasha Adonzio put on performances. The models looked a bit like Bowie's Ziggy Stardust—tall, thin, red-lipped, with smoky eyes and spiky hair. Her clothes were all skintight, made with clingy, stretchy fabric, lots of edgy short skirts, and tops that sometimes bared the models' nipples."

ABOVE: Hanging around in the second floor lounge in 1979.

OPPOSITE: John Entwistle, bass player for the Who, surrounded by revelers at the Quadrophenia party at the Mudd Club on October 30, 1979.

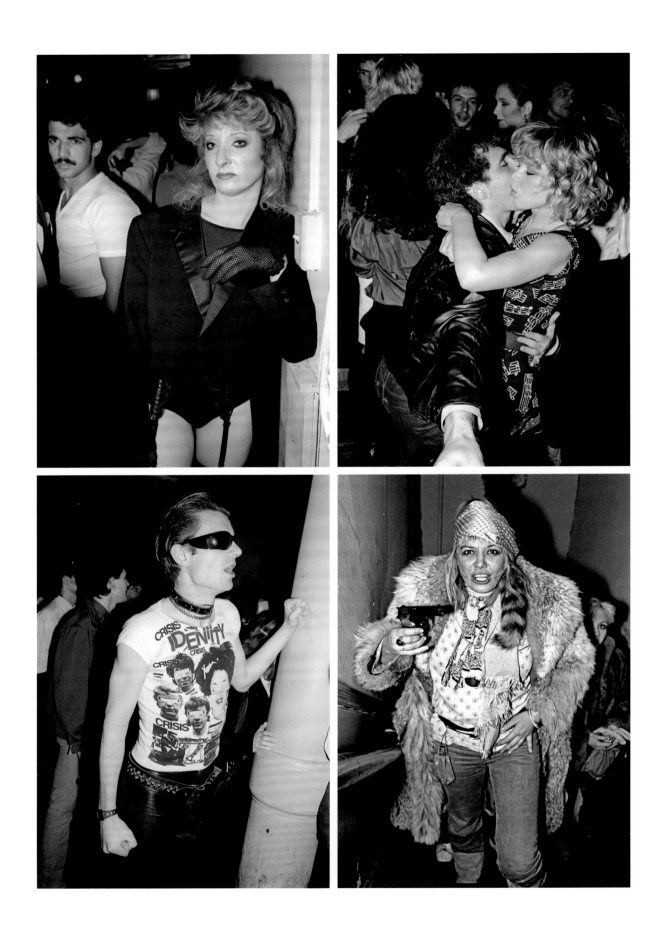

TOP LEFT: D.J. Anita Sarko combines a garter belt and stockings with a double-breasted smoking jacket.

TOP RIGHT: Makeup artist Sandy Linter, in a musical note dress, dances at the Mudd Club in 1979.

BOTTOM LEFT: Rudolf Pieper in an "Identity Crisis" T-shirt and leather jeans, in the groove at the Mudd Club.

BOTTOM RIGHT: Anita Pallenberg climbs the stairs to the VIP room with a pistol at the Mudd Club on February 10, 1980.

OPPOSITE: A dancer at the Mudd Club hikes her skirt and snaps her fingers.

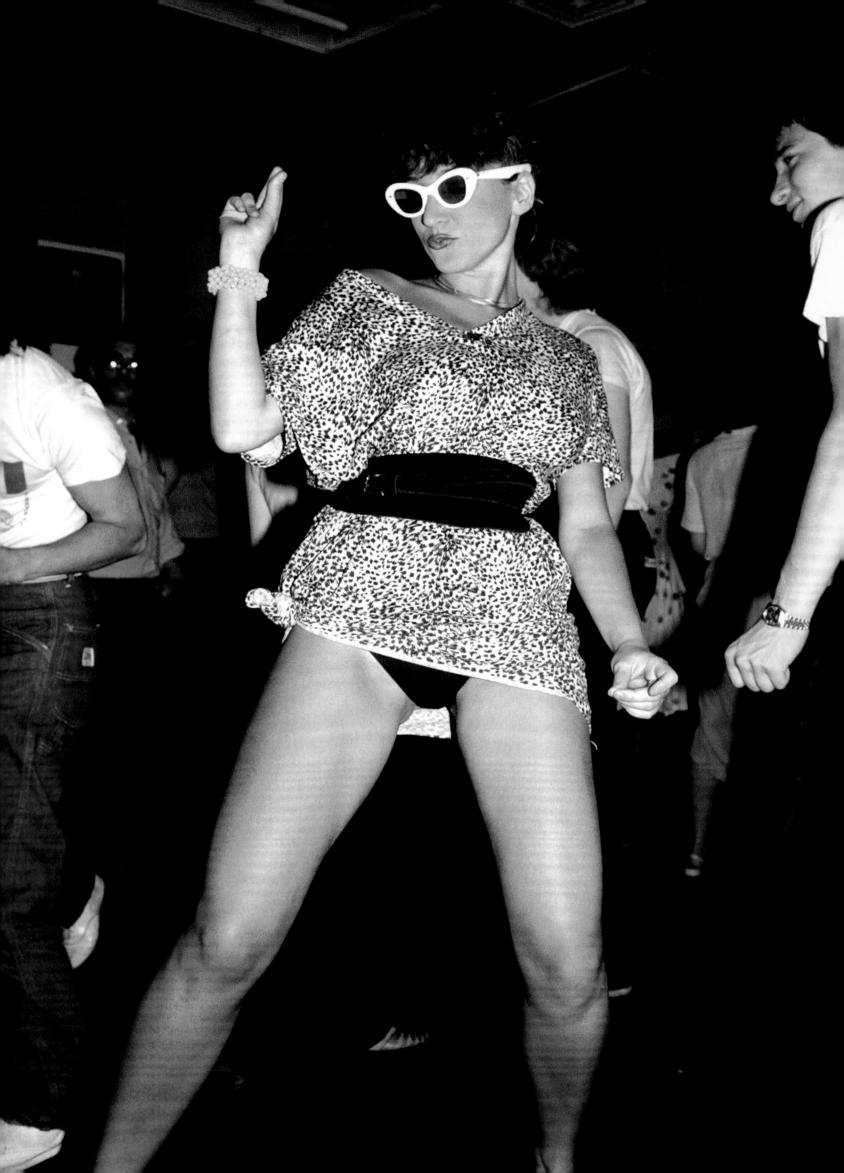

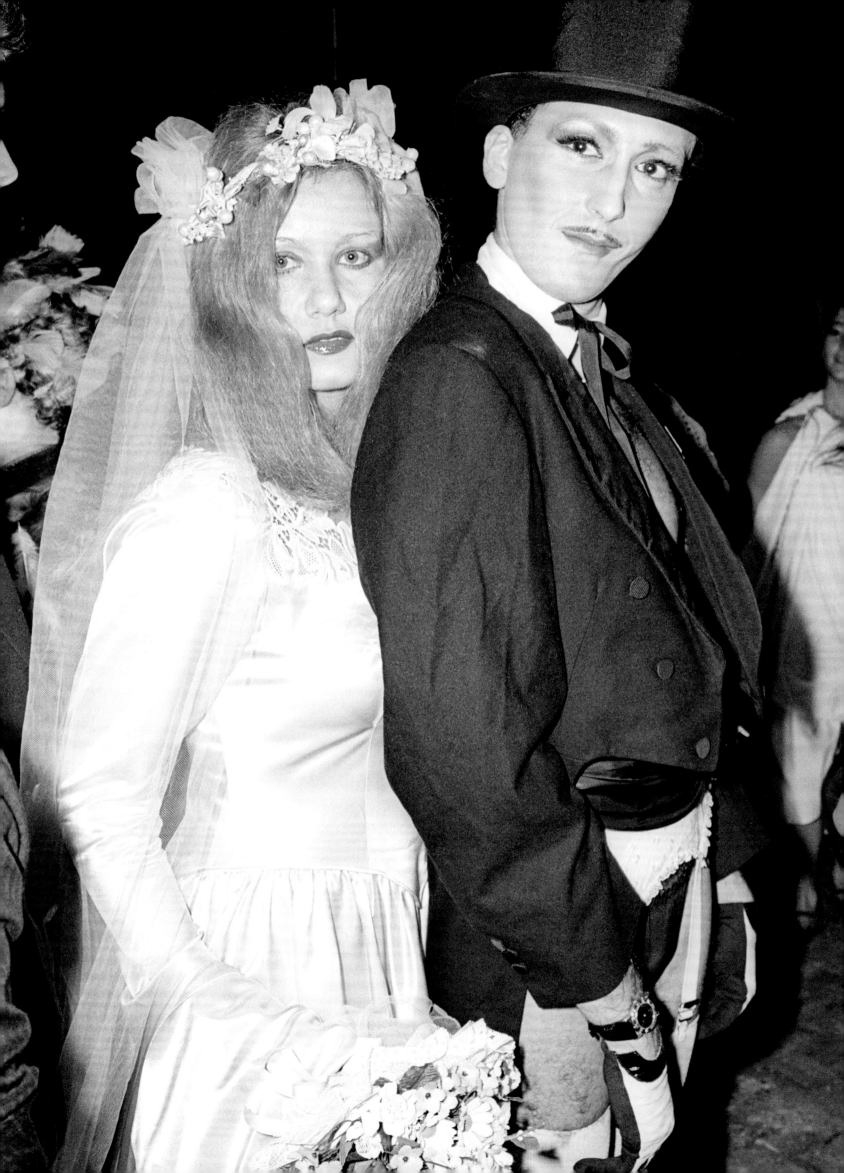

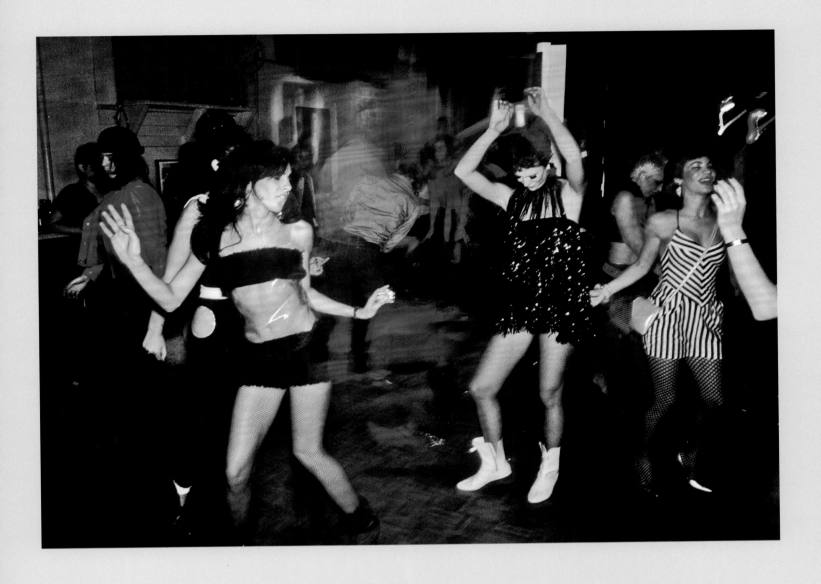

NIGHT WAS DAY

Night was day and day was night. Lower Broadway—a stretch of no man's land, unless you lived there. The Mudd Club was a couple blocks south of Canal at the corner of Cortlandt Alley and White Street. I worked the door there for nearly two years, 1979 and 1980; in my mind, at that moment, it was the only place to be. By the spring of '79 places like Max's and CBGB had long become institutions: goldmines of grit, glam, leather, and sound. Fashion in all its do-it-yourself glory lived in there; ground zero for creativity, drugs, and alcohol. Fifty-odd blocks north, Studio 54 was another world, spinning on a different axis and attitude, fueled by higher-priced Quaaludes and cocaine. The Mudd Club stood apart and did its own thing. Mothers Day at Mudd was a celebration of Joan Crawford's style and maternal instincts. The NyQuil party on the second floor—a uniformed nurse in attendance—was a 4 a.m. crash waiting to happen. A night of Combat Love with the tagline "Nuke 'em till they glow" was a military-fashion recruiting station from an alternate universe; political incorrectness, its badge of courage. Soul Night was all about afros and polyester flares, fur coats, hookers and pimps served up alongside a fried chicken buffet. The music was a soul train express and the chicken disappeared quickly. If you didn't look right or didn't know someone, you weren't coming in. If you did get in, the dance floor or the bathrooms were the places to be. Allan Tannenbaum was there, inside and outside, taking pictures. Looking at those photographs today, past turns present and we become part of that moment, again. Those late nights on White Street, Bowery, Park Avenue South, and way uptown Fifty-Fourth Street—a slice of golden time.

— RICHARD BOCH, FORMER MUDD CLUB DOORMAN, 2016

ABOVE: Carole Goldberg dancing at the Quadrophenia party at the Mudd Club in 1979.

OPPOSITE: A couple dressed as a bride and groom—the groom wearing a garter belt and stockings instead of pants—at a Halloween party at Studio 54 in 1978.

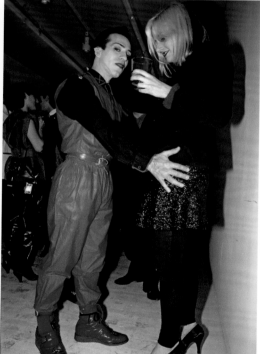

Pravda on Crosby Street in SoHo promised a radical new concept in nightlife. It stayed open one night due to improper permits and neighbors' complaints. The first event was a party for *Wet* magazine and a Fiorucci fashion show on November 8, 1979.

TOP: Three men enjoy the party.

BOTTOM LEFT: Pravda founder Rudolf Pieper and friend.

BOTTOM RIGHT: Partiers at Pravda.

OPPOSITE: Klaus Nomi *(right)* and a friend pose at Pravda.

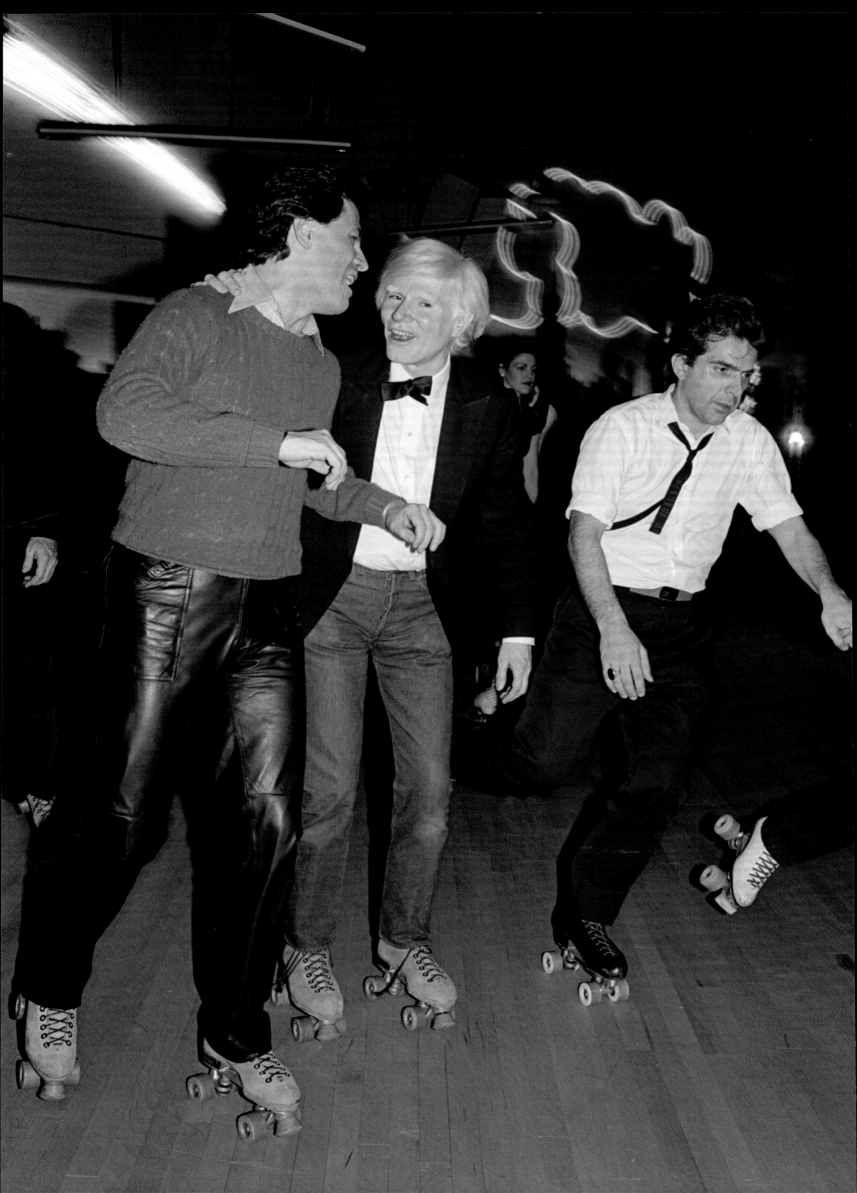

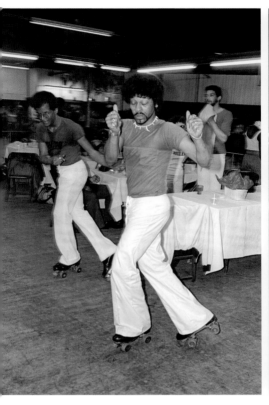
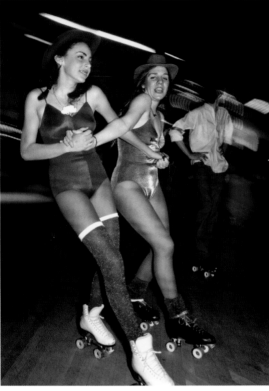
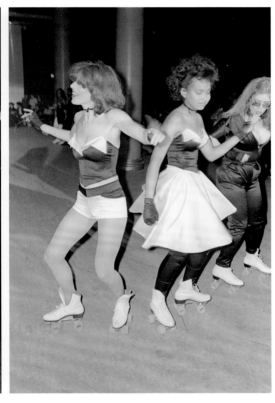

ROLLER DISCO

One of the more amusing spin-offs of the disco craze was roller disco. Roller rinks had been around for decades, homey family places where skating and roller-dancing were typically accompanied by an in-house organist. Having been embarrassed in elementary and high school by a wretched inability to skate apparently didn't prevent thousands of people from risking life and limb at the new disco versions. It seemed like a fun idea at the time, but whereas just about anyone can manage a few dance moves, you actually had to know how to roller-skate to keep from making a fool of yourself on the roller floor. The original locus of the roller disco phenomenon was Brooklyn. First opened in 1941, across the street from Ebbets Field (home of the Brooklyn Dodgers), the Empire

Rollerdrome had enjoyed a successful run as one of many such rinks in the US. During the late 1970s it was renamed Empire Roller Disco, and it became one of the first rinks to popularize skating to disco music. Certainly it was the first to replace the traditional organist with a live deejay, "Big Bob" Clayton, playing the likes of Donna Summer and Silver Convention. In 1980, they upgraded to a 20,000-watt stereo system and installed disco lighting. The new roller disco drew a crowd that was largely young, black, Latino, and Caribbean, and it became a favorite hangout of many showbiz celebrities, including Dustin Hoffman and Cher, who hosted parties and took skating lessons there. The rink also added such California amenities as plastic palm trees.

ABOVE LEFT: The scene at the Empire Rollerdrome in Brooklyn in 1977.

ABOVE MIDDLE: Suzanne Maxx and friend Virginia skate at Roxy, 1980.

ABOVE RIGHT: Betsey Johnson unveils roller fashions at Inferno in 1979.

OPPOSITE: Andy Warhol skates at the Roxy roller rink.

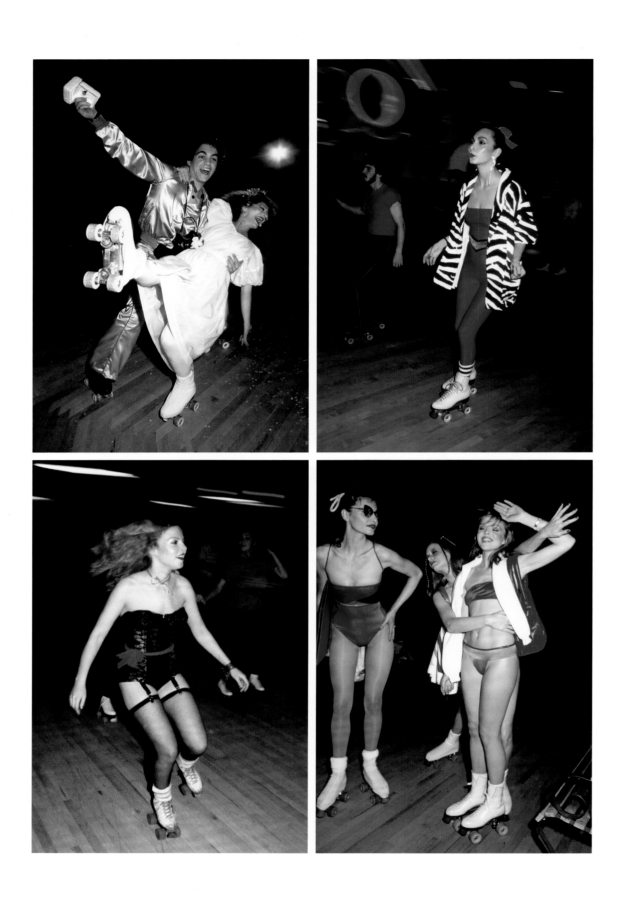

ABOVE: Various partiers and skaters at the Roxy.

OPPOSITE: Cher at the Empire Rollerdrome.

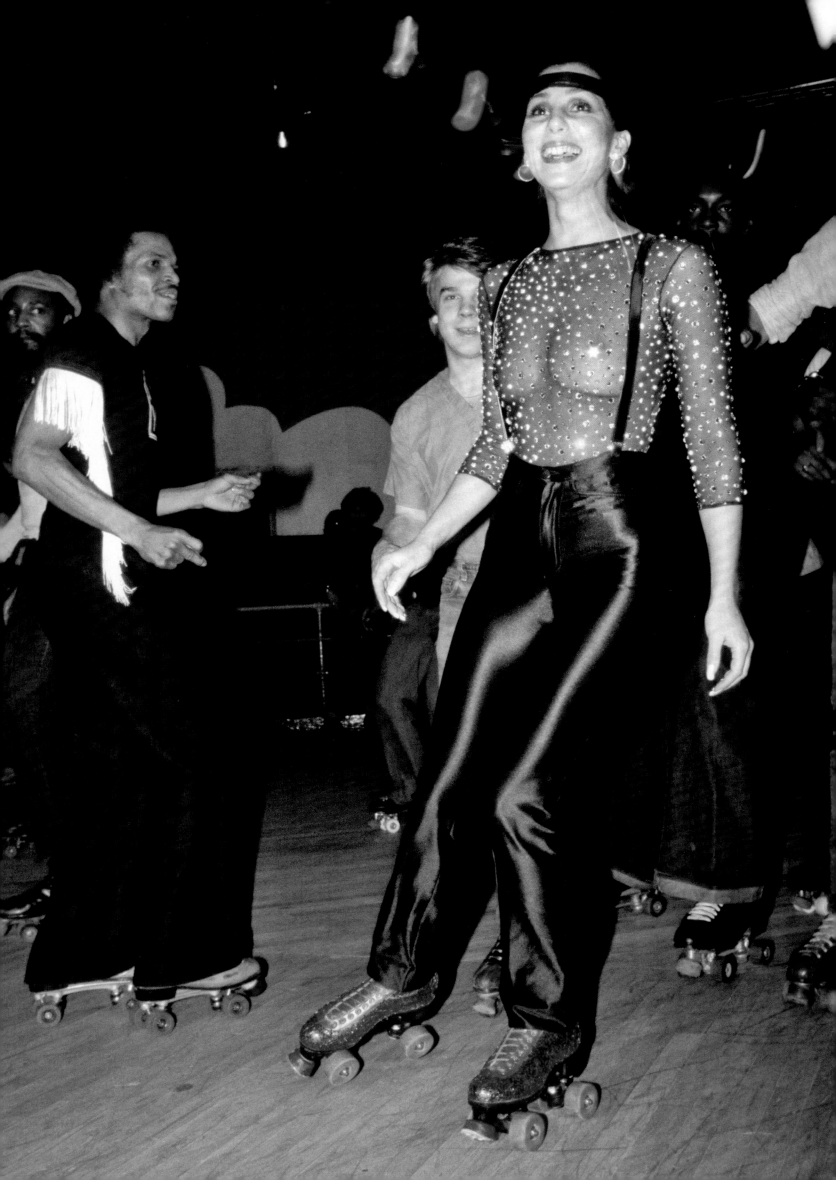

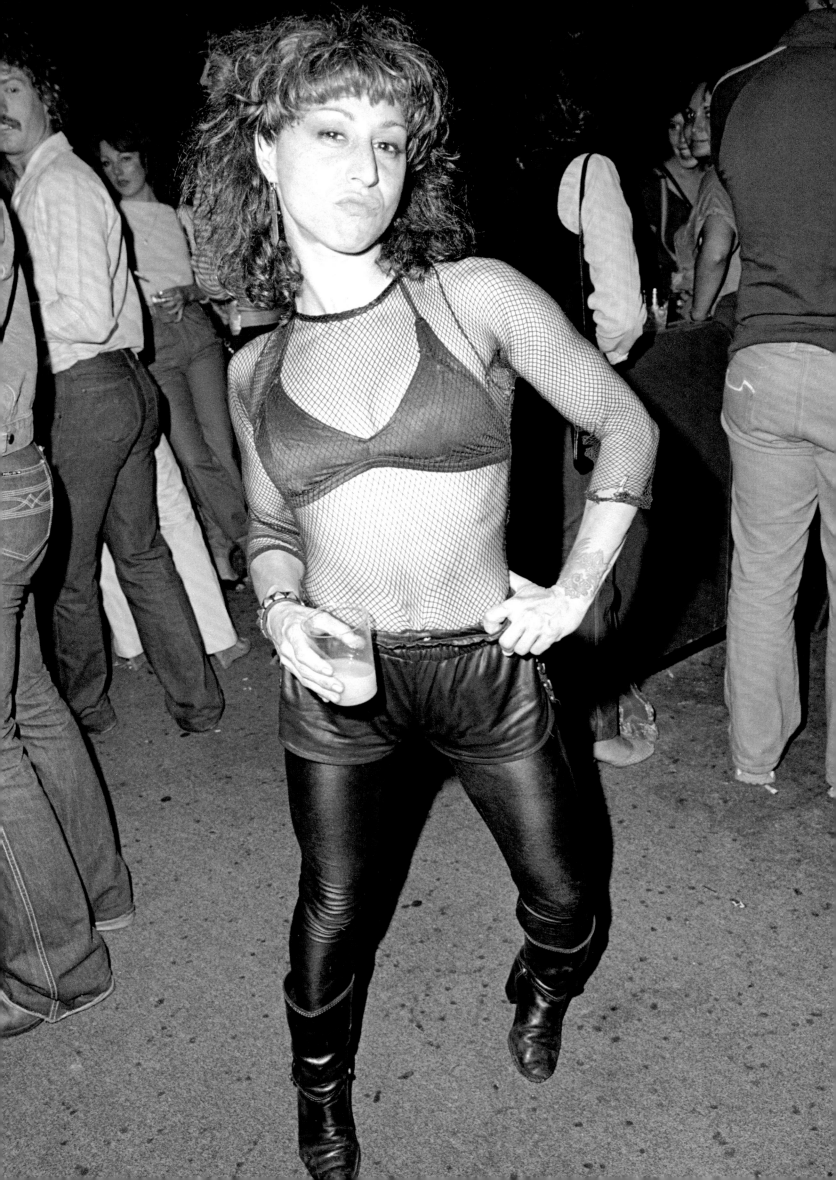

ABOVE: CBGB denizens show punk attitude in their leather jackets and skirt.

OPPOSITE: Rock singer and writer Helen Wheels dances at the Ritz in 1980.

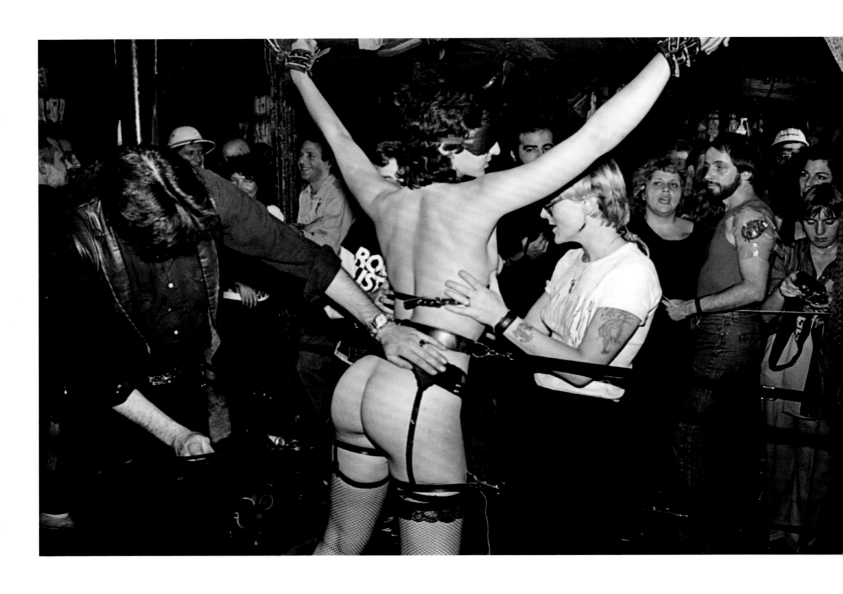

SEX CLUBS

Of course, dancing and roller-skating weren't the only activities sought by New York nightclubbers. Plato's Retreat seems like such a fixture of the sexual revolution, a haven for jaded swingers from the suburbs, that it's odd to recall that it didn't open until 1977, the same year as Studio 54. Besides its heated pool and sauna, though, it did have a disco dance floor. Meanwhile the Hellfire Club, located in the basement of a building in Manhattan's Meatpacking District, catered to BDSM (bondage, discipline, and sadomasochism). Both clubs flourished during a decadent period that followed the sexual revolution and Stonewall, but before AIDS changed everyone's lives. When the city's health department decided to close gay bathhouses in 1985 in response to the epidemic of HIV/AIDS, they also had to close heterosexual clubs because of the city's newly adopted antidiscrimination laws. (Plato's moved to Fort Lauderdale, Florida.)

ABOVE: S&M action at the Hellfire Club in the Meatpacking District in 1981.

OPPOSITE: Porn film director Gail Palmer dances with abandon at Plato's Retreat in 1978.

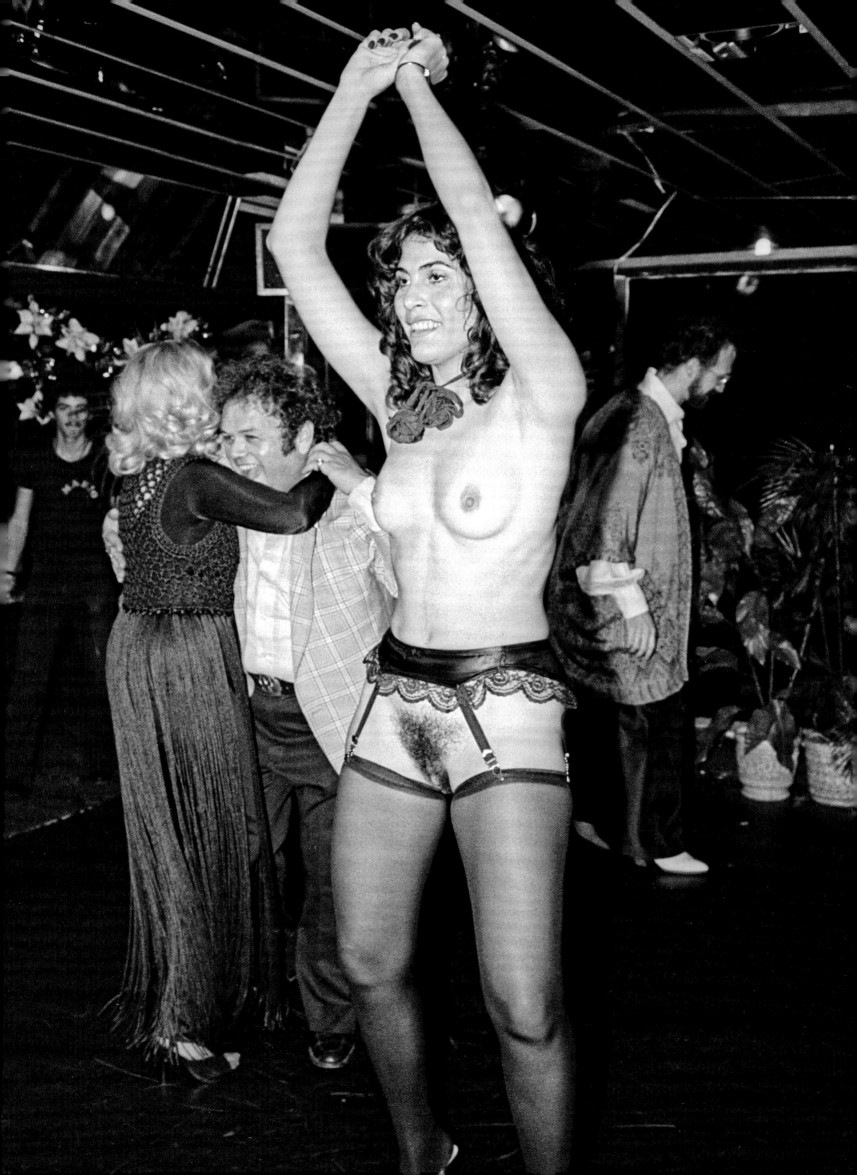

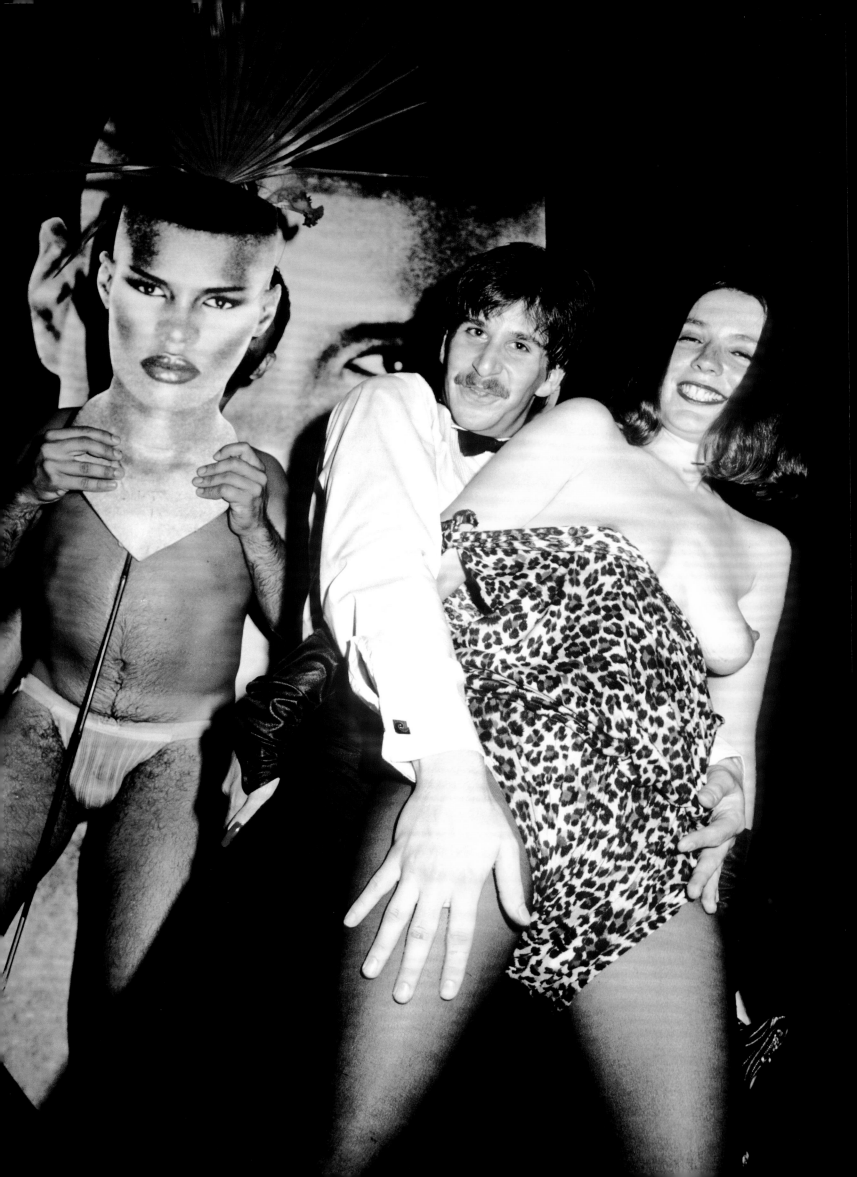

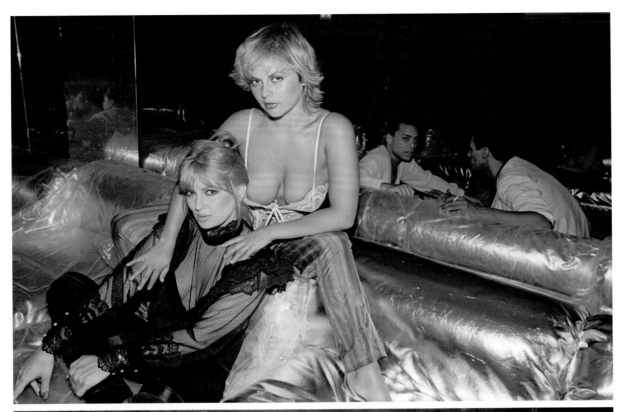

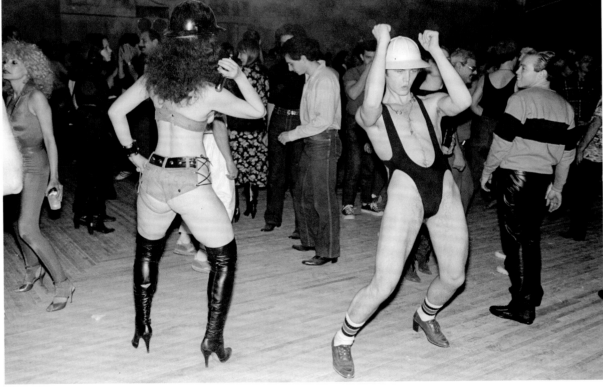

ABOVE TOP: Anneka and friend at a pre-opening construction party at John Addison's Bond International Casino, a mega-disco in Times Square.

BOTTOM: Bond construction party dancers.

OPPOSITE: Partygoers at Bond in Times Square in 1980.

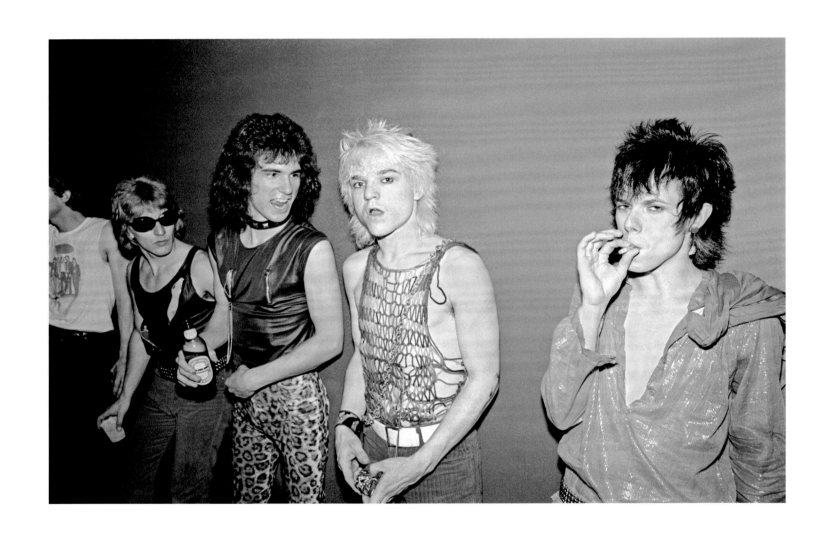

ABOVE: Guys hanging out at the opening of Heat, a new club downtown in 1979.

OPPOSITE: A couple dances at a party for the Tubes at Infinity.

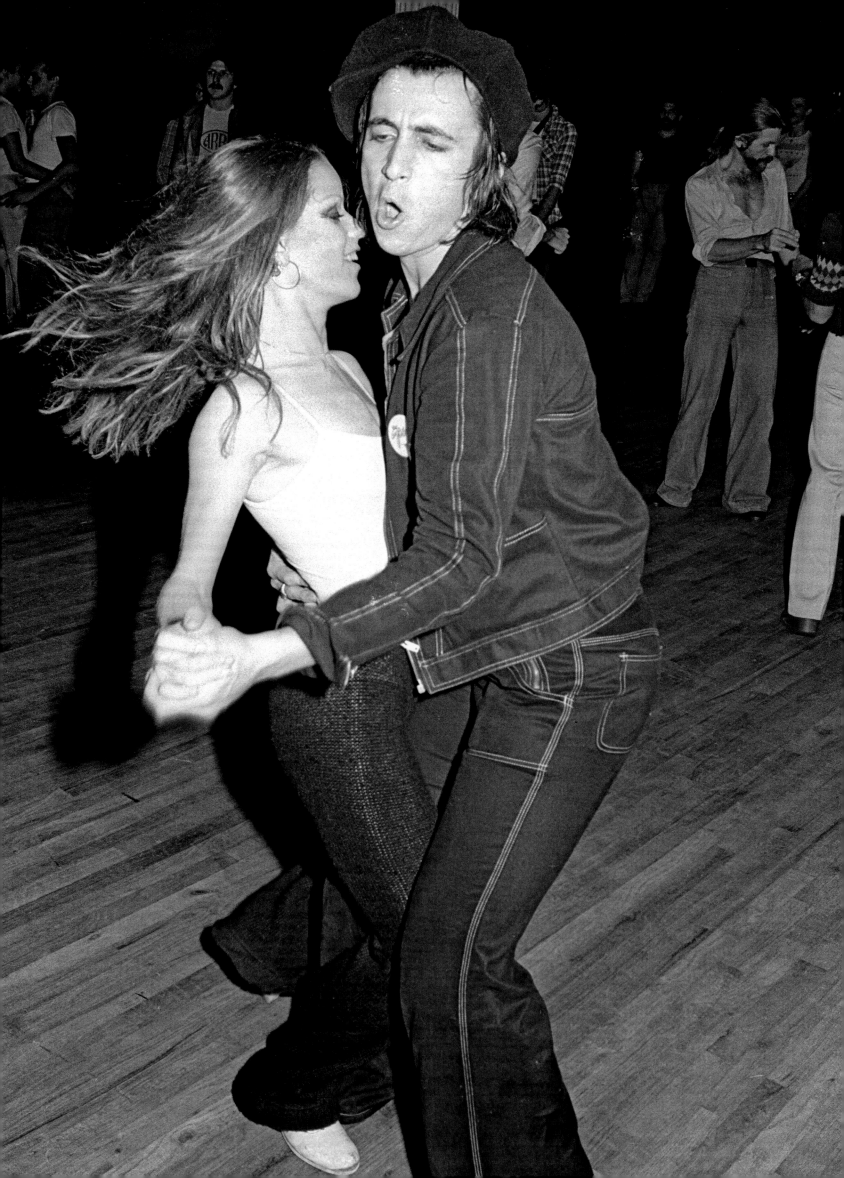

HIGH FASHION
AND LOCAL NYC STYLE

The most creative designers are generally not to be found on Seventh Avenue—where mass merchandizing and big money stunt a lot of originality—but off the beaten path. Some of the most talented but lesser-known designers are creating and manufacturing their own works for smaller and more specialized audiences. Sometimes they wholesale and/or sell directly to the public.
—Marcia Flanders, columnist for the *Soho Weekly News*, July 7, 1977

THE SECTION OF MANHATTAN that came to be known as SoHo has had a remarkable history for such a relatively small plot of land—and much of it is tied in some way to clothing and style. Going back a century and a half to 1861, it was the site of one of the first American department stores, Lord & Taylor, on Broadway at Grand Street. Years later the district was filled with stifling sweatshops, many of which were devoted to the garment trade. By the late 1960s it had attracted a number of adventurous artists, choreographers, musicians, and designers who converted industrial spaces to living and working lofts—at first on the sly and, after 1971, legally. By the mid-'70s the area had become home to any number of independent clothing designers whose work often rivaled that of their uptown counterparts. During that time it also gave birth to the *Soho Weekly News*, which launched in 1973 and would document the growth of fashion over the next decade, along with trends in music, nightlife, and the arts in general.

Manhattan's Garment District, a square mile in Midtown, had been the center for the design and manufacture of fashions in the United States since the early twentieth century. No other city in the world has had a comparable concentration of fashion businesses and talent in a single area—not Paris, not Milan. Today most of the billions of pieces of clothing churned out every year are produced overseas, mainly in Southeast Asia, and often involve the use of child and forced labor. But in the 1970s, the Garment District was at its productive and influential peak, so the fact that SoHo was home to so many creative designers is all the more impressive.

For the first few years of publication for the *Soho Weekly News*, however, the newspaper didn't have a fashion section per se. But in October 1976, a series of columns began to appear under the byline of Marcia Flanders touting local Manhattan designers and stores that were unlike anything in Midtown or the Garment District. Flanders's strength lay in discovering little-known or controversial designers, many of whom would later come into their own.

OPPOSITE: Iman with Apollonia. Born in Mogadishu, Somalia, Iman came to the United States in 1975, modeling for *Vogue* the following year and going on to work with Helmut Newton, Richard Avedon, Irving Penn, and Annie Leibovitz. Apollonia van Ravenstein came to America from the Netherlands in 1972 and received an exclusive contract with *Vogue*. Through the 1970s and '80s she modeled for Norman Parkinson, Richard Avedon, and Irving Penn. Here they are at a party at Mr. Chow hosted by John Casablancas, founder of the Elite modeling agency.

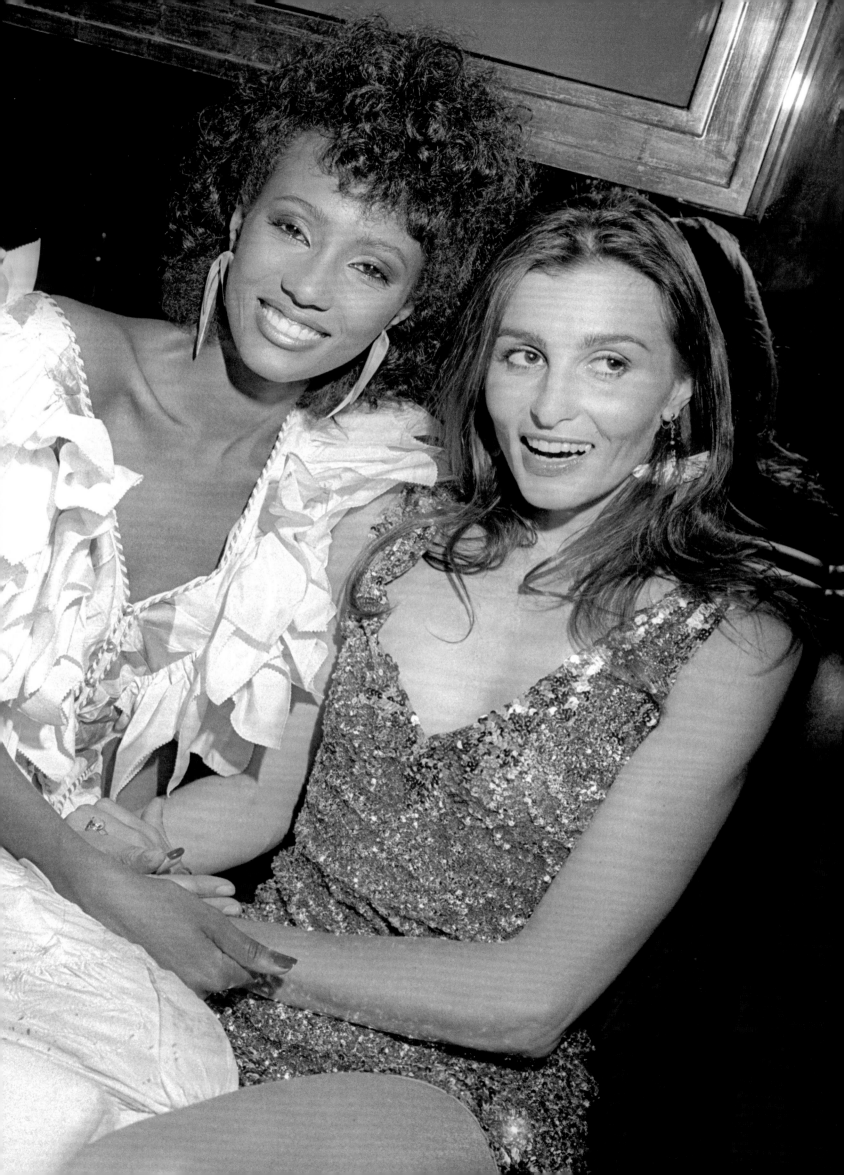

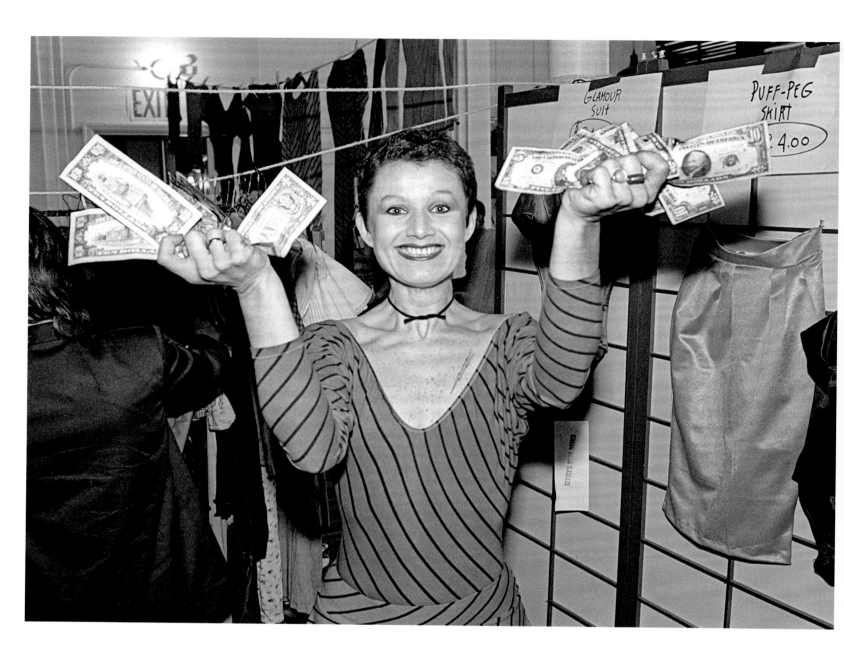

BETSEY

Before writing for *Soho*, Flanders had worked at Betsey Bunky Nini, the boutique that Betsey Johnson opened on the Upper East Side in 1969. Johnson also lived in SoHo, and in 1976 Flanders proclaimed Johnson one of the "two greatest American designers," along with James Galanos (nearly twenty years older than Johnson and on his way to becoming a "national living treasure"). In one column devoted to Johnson, Flanders ticks off the designer's achievements: being guest art editor at *Mademoiselle*; attaining early success at Paul Young's Paraphernalia (where she introduced Day-Glo fabrics, metallics, authentic football jerseys for T-shirt dresses, and eight-inch and ten-inch miniskirts); opening Betsey Bunky Nini (where Warhol star Edie Sedgwick was the house model); turning the fashion label Alley Cat, already popu-

lar with rock musicians, into a $5 million operation; and winning the Coty Award ("the Oscar of Fashion") in 1972. But Flanders also details the "superabundance of shit" Johnson had to deal with, including alleged shabby treatment by both Paraphernalia and Alley Cat.

Nonetheless, Flanders proclaimed, "To me she is the *most prolific designer* ever." Betsey Johnson's connection with Warhol's Factory (she was briefly married to John Cale, a founding member of the Velvet Underground) fueled her successful boutiques, including one she later opened in SoHo. But she did not start her own fashion line until 1978, launching a company that by the 1990s would have a celebrity client list including Jennifer Aniston, Drew Barrymore, Parker Posey, and Minnie Driver.

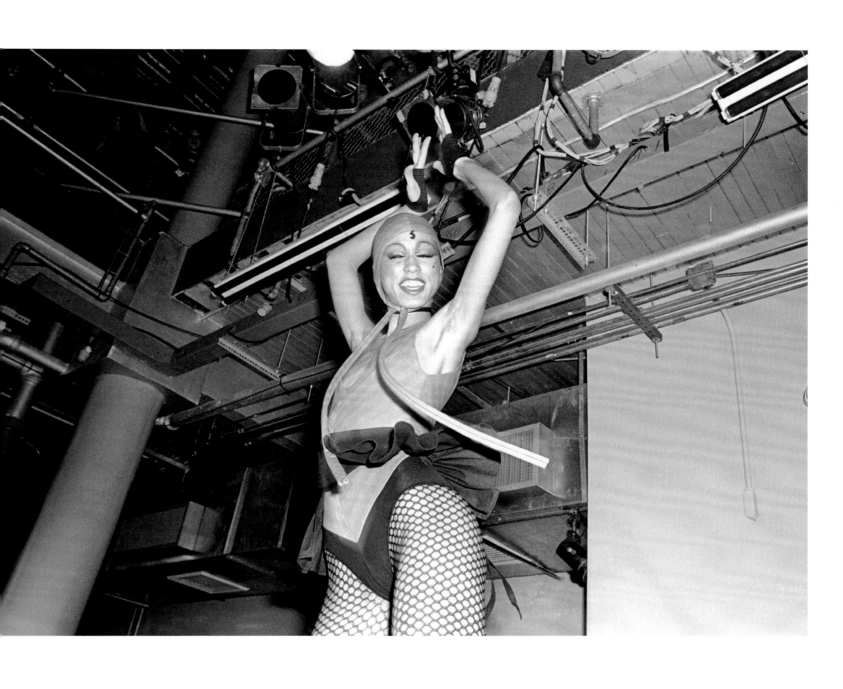

OPPOSITE: Betsey John holds a sale in her studio in 1979.

ABOVE: Johnson's latest designs are unveiled at a fashion show in 1980.

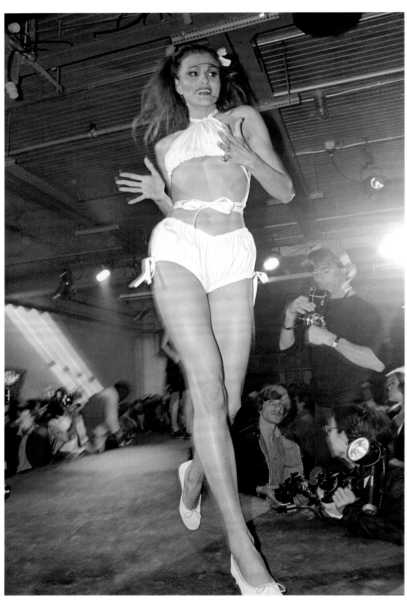

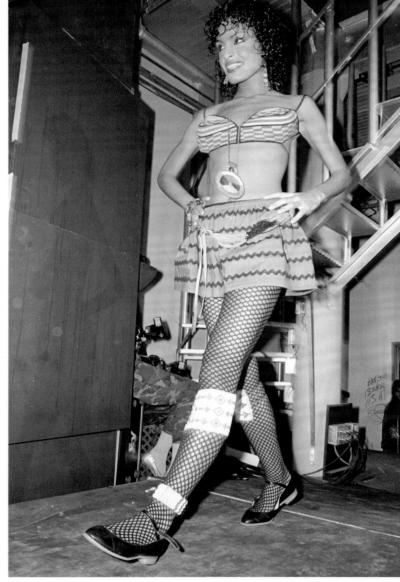

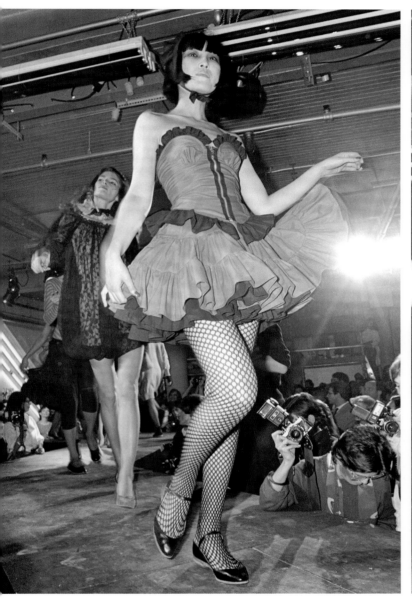 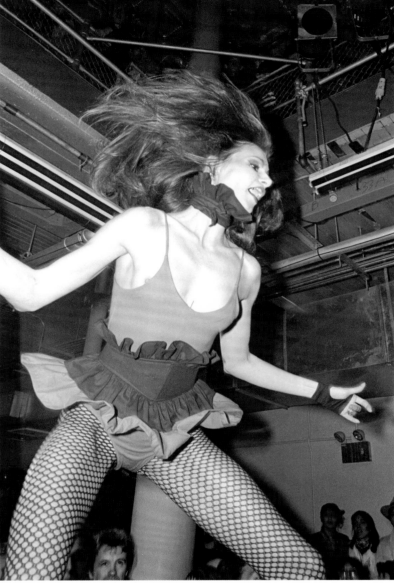

ABOVE AND OPPOSITE: Betsey Johnson reveals her latest designs at a fashion show on November 5, 1980, in New York.

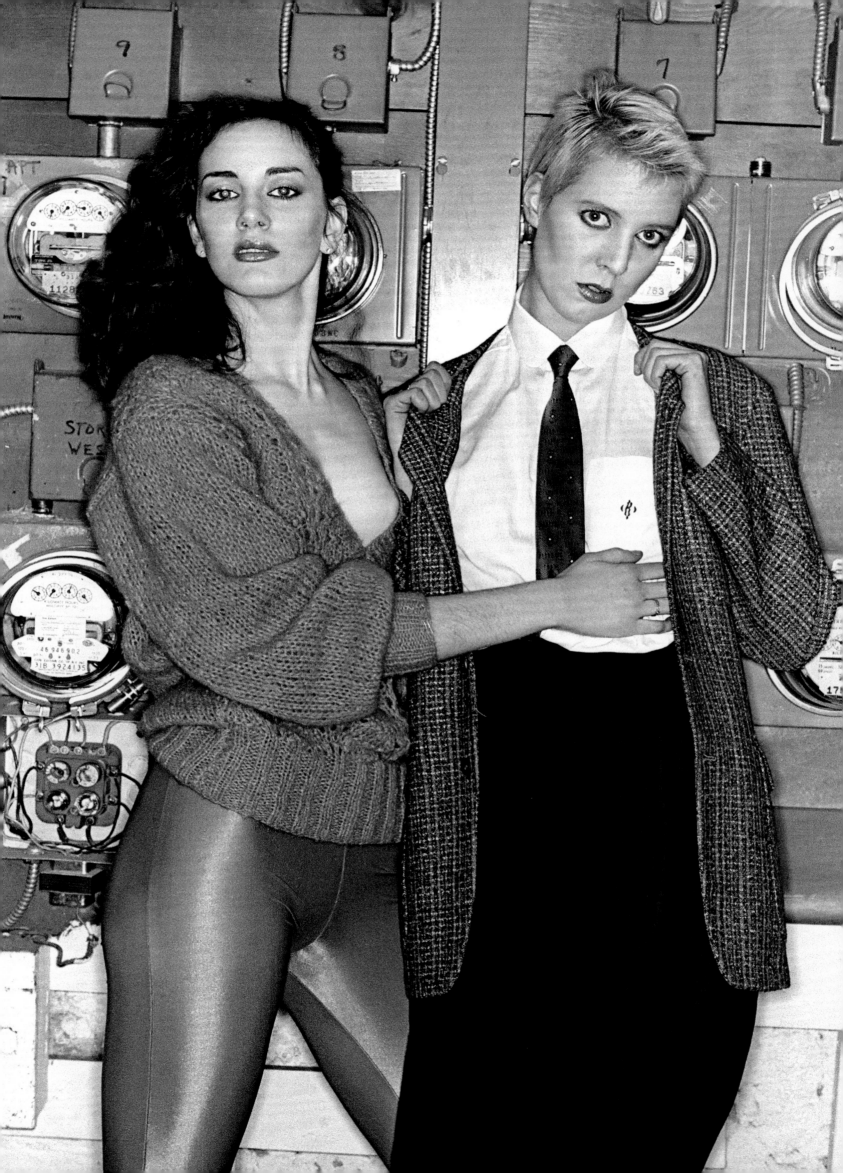

INDEPENDENT DESIGNERS

Although Flanders was conversant with the mainstream of fashion, and arrived at a time when SoHo itself was increasingly populated by "uptowners and people who saw themselves as chic," as Janel Bladow put it, she also discovered less well-known designers and shops that created and sold original clothing at reasonable prices. In one column, for example, she covered the opening of a SoHo store with the unlikely name of Tamala Design w/Bagel.

Owners Tamara Melcher and Larry Rothschild and handbag designer Mar Tannenbaum had been featured in a show at the newly opened Dianne B. boutique on Madison Avenue near 64th Street, including their "hand-painted silk kimonos and tunics with incredible combinations of color & abstract design." But Flanders revealed that the same styles could be enjoyed in comfort at their downtown shop, where a wild character named Aggie Markowitz had run a lunch counter in the back of the boutique serving bagel sandwiches, croissants, fresh orange juice, and a homemade dessert of the week, until she moved to Bleecker Street. Some of the clothes at Tamala Design were the creations of an upcoming young designer named Karl Davis, who also showed in Bloomingdale's and other more mainstream stores and was known for his hand-painted and hand-screened silk fabrics. Unfortunately, Davis died at the age of twenty-five, at the height of the AIDS epidemic that claimed so many other people in the creative arts.

Another rising young designer who died too young, Isaia Rankin, took over a shop called Merchant of Venice and turned out whimsical creations using material from sweatshirts and T-shirts to craft fun clothes—for example, a miniskirt made with sweatshirt material and a T-shirt as a large patch pocket. The clothing in all these shops was typical of the kinds of fanciful designs making creative use of unusual fabrics that you didn't usually see uptown.

OPPOSITE: Models Alejandra and Candace in fashions by Merchant of Venice.

TOP AND RIGHT: Models strut the runway at the SoHo Designers fashion show at the Mudd Club on February 26, 1979.

FASHION AS ART

Downtown wasn't the only part of New York where originality flourished during the '70s, of course. The Italian designer Elio Fiorucci threw the city for a loop in 1976 when he expanded from Milan to Manhattan and opened a store on East 59th Street, down the block from Bloomingdale's. Previously, Fiorucci had brought the style staples of jeans and T-shirts to Milan from London and New York, but his new store reversed polarities, showcasing underground trends that comprised thongs from Brazil, camouflage and leopard-skin prints, gold lamé cowboy boots, and the first stretch jeans with Lycra, as well as skintight vinyl jeans in startling colors way beyond blue and black.

Buoyed by a sharp sense of the moment, Fiorucci's store became known as the "daytime Studio 54," although its deejays played music more associated with Hurrah or the Mudd Club—the B-52's, David Bowie, Blondie, Lene Lovich, and Kate Bush—while models danced in the windows. Its clientele included Marc Jacobs, Cher, Jackie O., and a then-unknown Madonna, who performed there and whose brother Christopher worked at the store. The following year Andy Warhol sat with Truman Capote signing copies of his *Interview* magazine, which filled the store's windows. "It's a fun place," Warhol later wrote in his diary. "That's all I ever wanted, all that plastic." In 1979 the store hosted graffiti artist Kenny Scharf's first solo exhibition. The opening included a performance by Klaus Nomi, the bizarrely coifed new wave opera singer who was a fixture at New York's burgeoning after-hours club scene.

When Fiorucci first opened, Flanders (who had changed her name from Marcia to Annie in honor of the hit Broadway musical) devoted a column to it, lauding the designer's concept of a "store being a gallery" and what she called the designer's "tongue-in-cheek chic." She pointed out that Fiorucci would fly American denim to Italy, where it was "masterfully cut & sewn with Italian precision & then flown back to America."

Although Gloria Vanderbilt and Calvin Klein were born and based in Manhattan and built their empires on designer jeans—the kind that could help get you into Studio 54 when Levi's left you languishing behind the velvet rope—they were both inspired by Fiorucci. Vanderbilt is generally credited with creating the first line of designer jeans, tighter fitting than Levi's or Lee, and with her signature stitched on the rear pocket. Yet Fiorucci wasn't too humble to claim the credit: "Fashionable jeans were born in the Fiorucci house," he said. "Jeans are the most representative item. I was able to turn work clothes into something sexy."

Fiorucci popularized the store-as-gallery concept, but other designers had occasionally taken a similar approach. In 1975, Roberto Polo was working at the Rizzoli Bookstore & Gallery as a salesman and later as the Gallery Director. Motivated by his friend Charles James, the British-born designer known as America's first couturier, Polo organized an exhibition entitled *Fashion as Fantasy*. The press release for the show, composed by Polo himself, read in part:

> *Fashion as Fantasy* will attempt to create a statement about fashion within the context of an "art gallery" and an "art exhibit." It will be an exhibit about fashion, not a fashion exhibit.

In attendance were artists including Warhol and Robert Motherwell, and designers Karl Lagerfeld, Giorgio di Sant' Angelo, and Zandra Rhodes. The "designs" included costumes made from bicycle parts, a bikini worn under a white fur coat, and performance artist Colette dressed as a Victorian rag doll.

Besides Fiorucci and Rizzoli, Midtown Manhattan was the place where high-fashion designers came from all over to strut their stuff on runways alongside the locals. American designers more than held their ground there, as Betsey Johnson's iconoclastic, whimsical styles showed. And Iowa-born, Indiana-raised Halston stormed in from Chicago to become the king of minimalist glamour and the glitzy disco world. His clean, elegant designs, comfortable and flattering to most figures, often used lamé, cashmere, or Ultrasuede—a synthetic microfiber fabric invented in Japan, but for which Halston became known. Women loved the comfort and simplicity of his designs, which redefined American fashion and were omnipresent in New York dance clubs. Celebrity clients included Elizabeth Taylor, Lauren Bacall, Margaux Hemingway, Bianca Jagger, Anjelica Huston, and other luminaries to be found partying at Studio 54 on any given night, often with Halston himself.

From England, Zandra Rhodes broke fashion rules in her own way and found an enthusiastic following in New York in the late '70s and early '80s. Turning her obsession with fabrics and color into a distinctive strength, Rhodes glitzed it up with jeweled and gold safety pins when punk rock swept England. Paradoxically, she helped put London in the forefront of the international fashion industry, using designs inspired by British punks who had been turned on by the original American punk rockers. Not everyone was impressed by her appropriation of street styles, though. "Zandra Rhodes did safety pins and tatters on her dresses so quickly," John Lydon, aka Johnny Rotten of the Sex Pistols, later wrote. "It was parasitical, like a big, fat leech on your back."

Claude Montana, born in Paris to Catalan and German parents, began his career by working with papier-mâché jewelry before moving on to leather and silk. He didn't hold his first show until 1976, and started his own company, the House of Montana, in 1979. The dramatic styling of his shows made them events in their own right, and the stark, sleek qualities of Montana's line look as fresh today as they did nearly forty years ago.

Thierry Mugler emerged from the same Paris scene as Montana, and favored masculine, aggressive forms and powerful colors, but with an avant-garde flair. He had been a ballet dancer for years, and he acknowledged that his background influenced his designs. "Ballet taught me the importance of the shoulders," he told the *Soho News*, "how it gives one stature, a heroic spirit." His May 1980 show at Bond on Times Square, called "Beauties and Heroes," drew large crowds to the enormous space that was formerly the Bond clothing store—and they paid $30 a head for the experience. "Clothes of today should have nothing to do with the past," Mugler said about the show. "Today elegance doesn't mean wearing a hat with a veil. What I want to create is an elegance of now."

OPPOSITE: Two models wear designs based on bicycle parts by Karl Lagerfeld at the *Fashion as Fantasy* exhibition at the Rizzoli Bookstore in 1975.

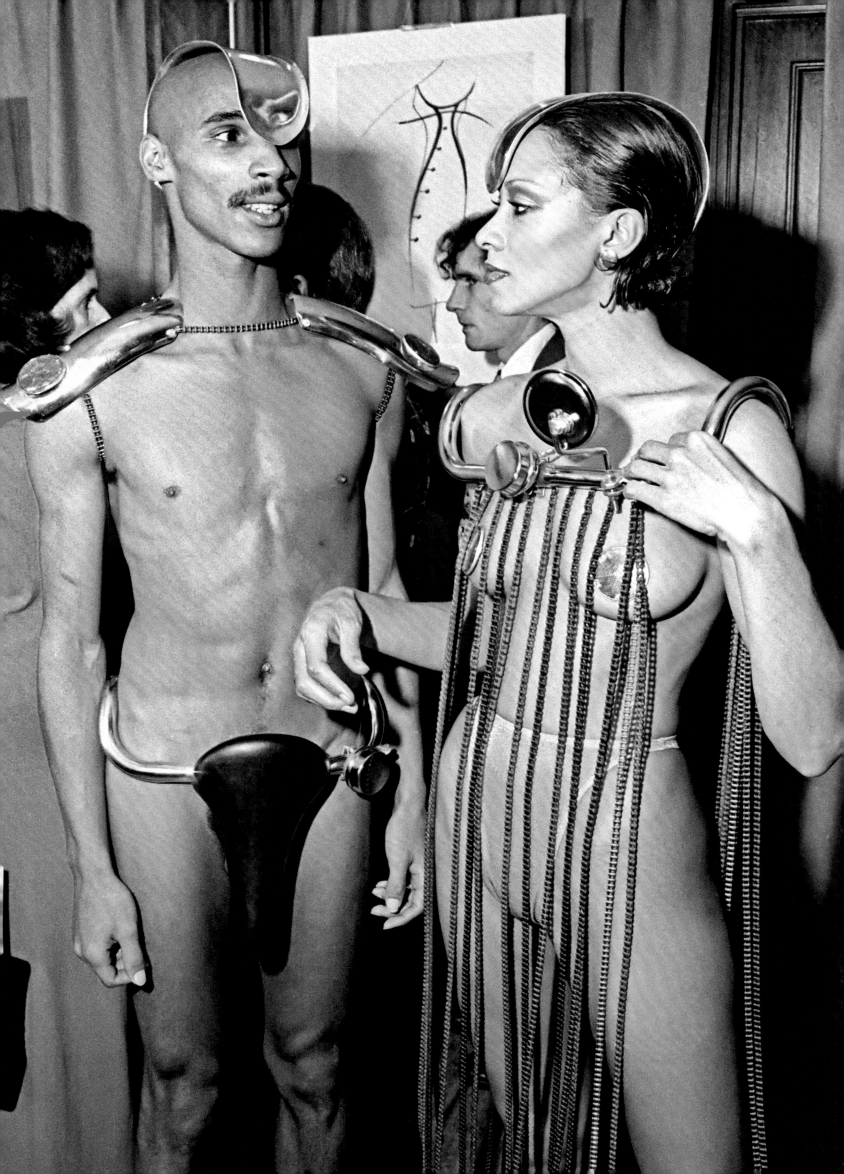

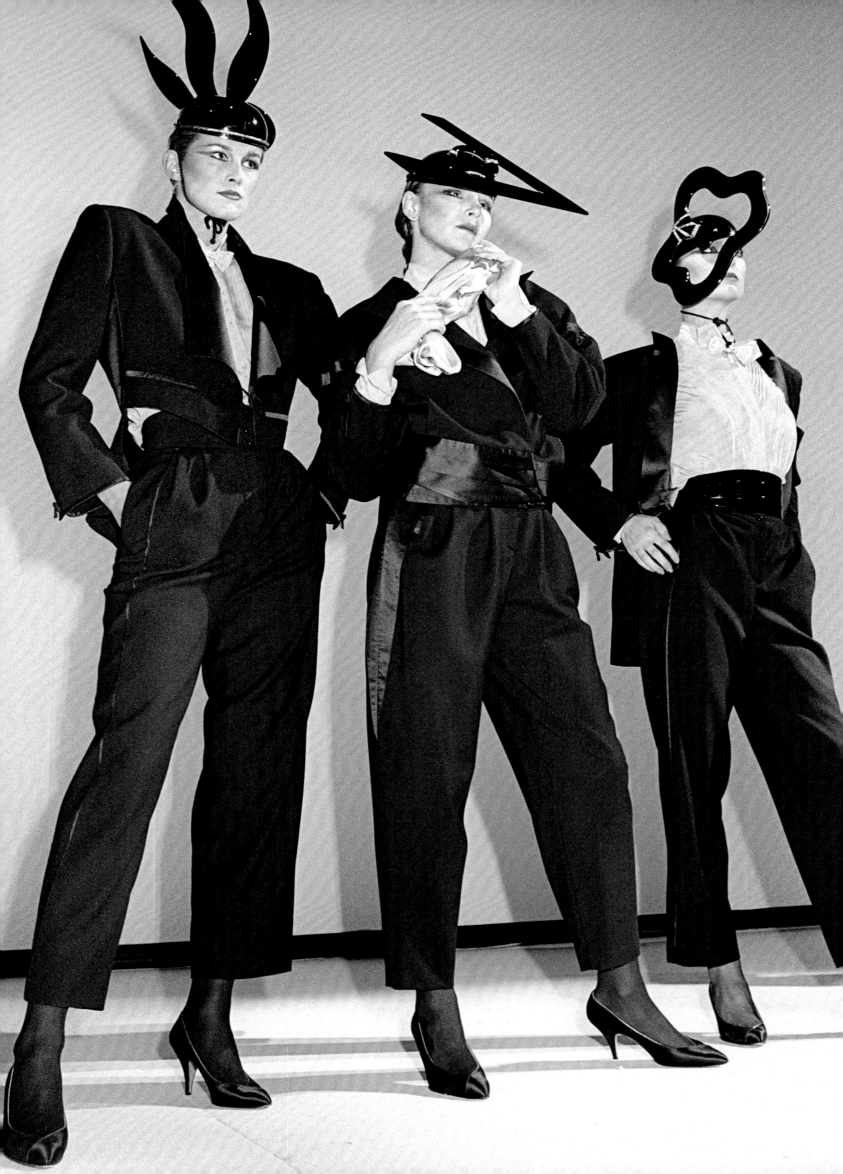

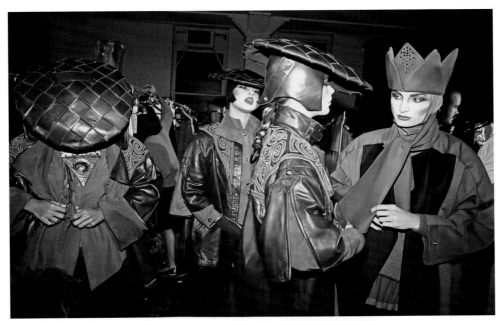

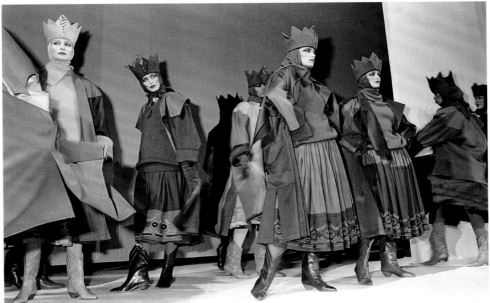

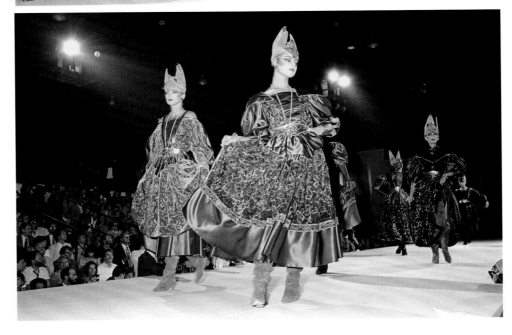

ABOVE AND OPPOSITE: Models strut at the Claude Montana fashion show at Bond in 1981.

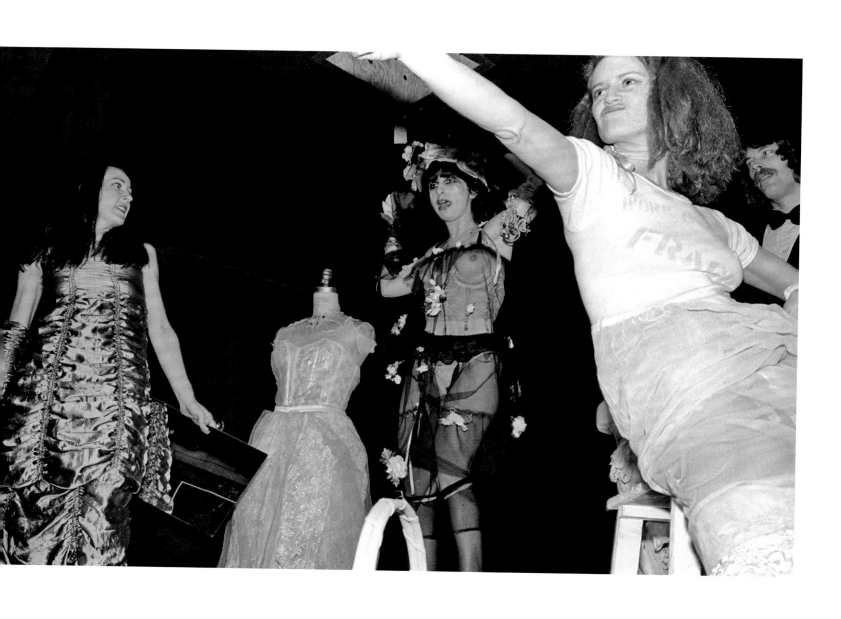

ABOVE AND OPPOSITE: Models strut the runway at the SoHo
Designers fashion show at the Mudd Club on February 26, 1979.

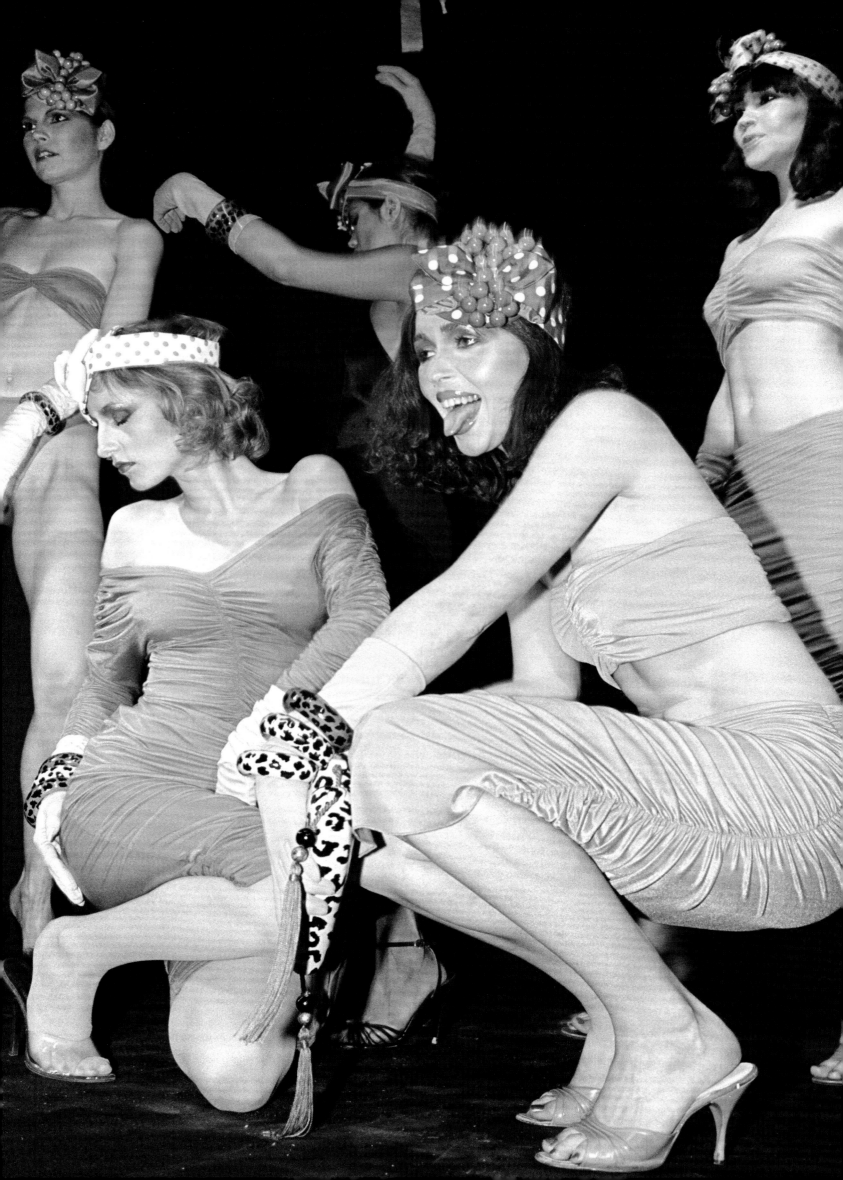

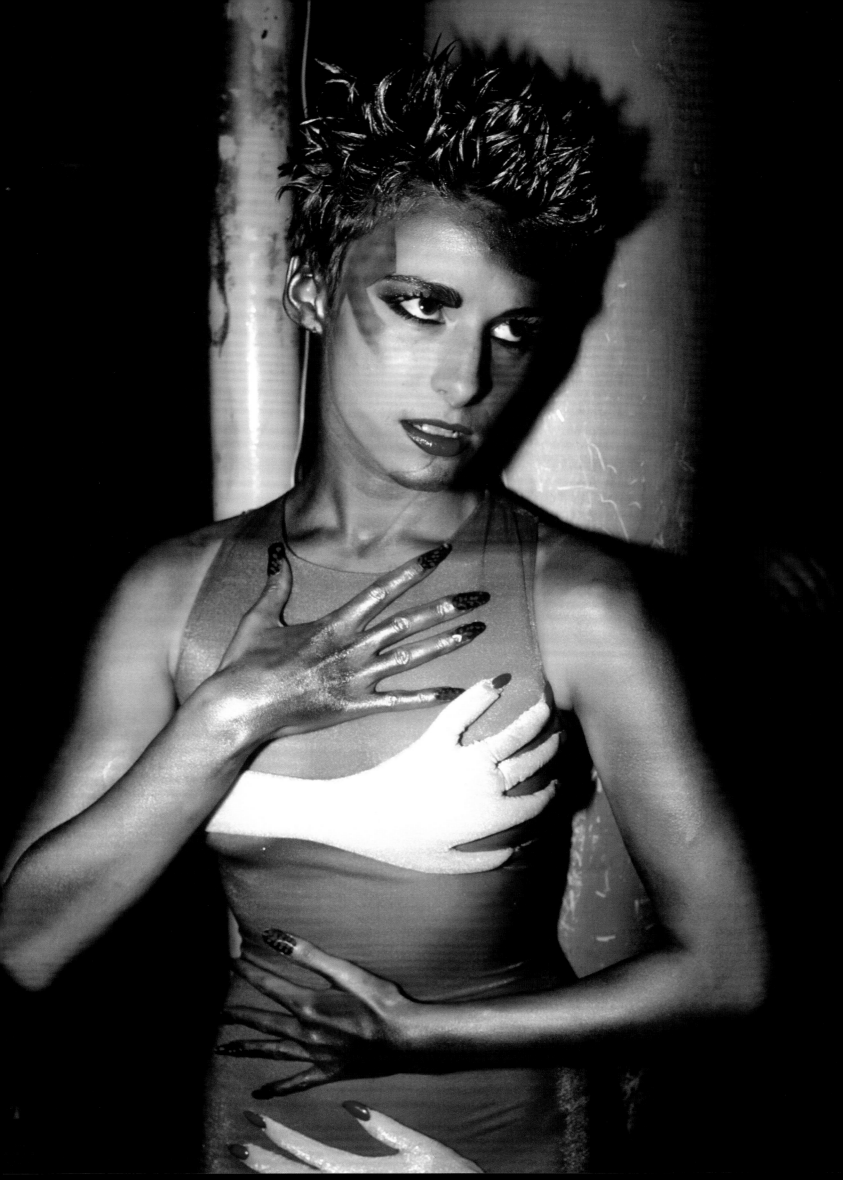

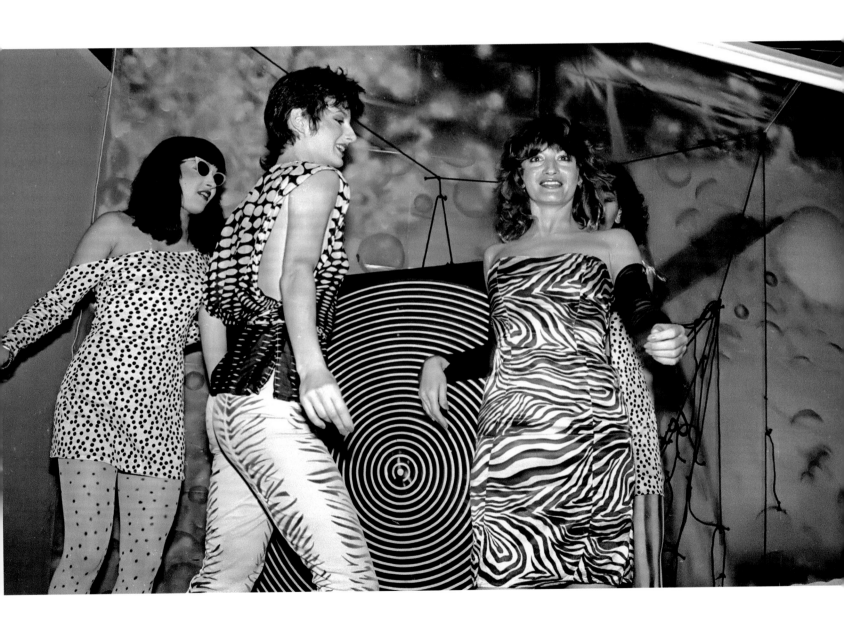

ABOVE: Fashion show by Natasha Adonzio at the Mudd Club, 1979.

OPPOSITE: Stagegear Fashion show at the Mudd Club. A model wears a hands body suit with her own hands painted gold.

ABOVE: Woman modeling a SoHo-designed skirt in 1974.

OPPOSITE: Model Betty Keane poses in a black evening dress from East Bank South in 1974.

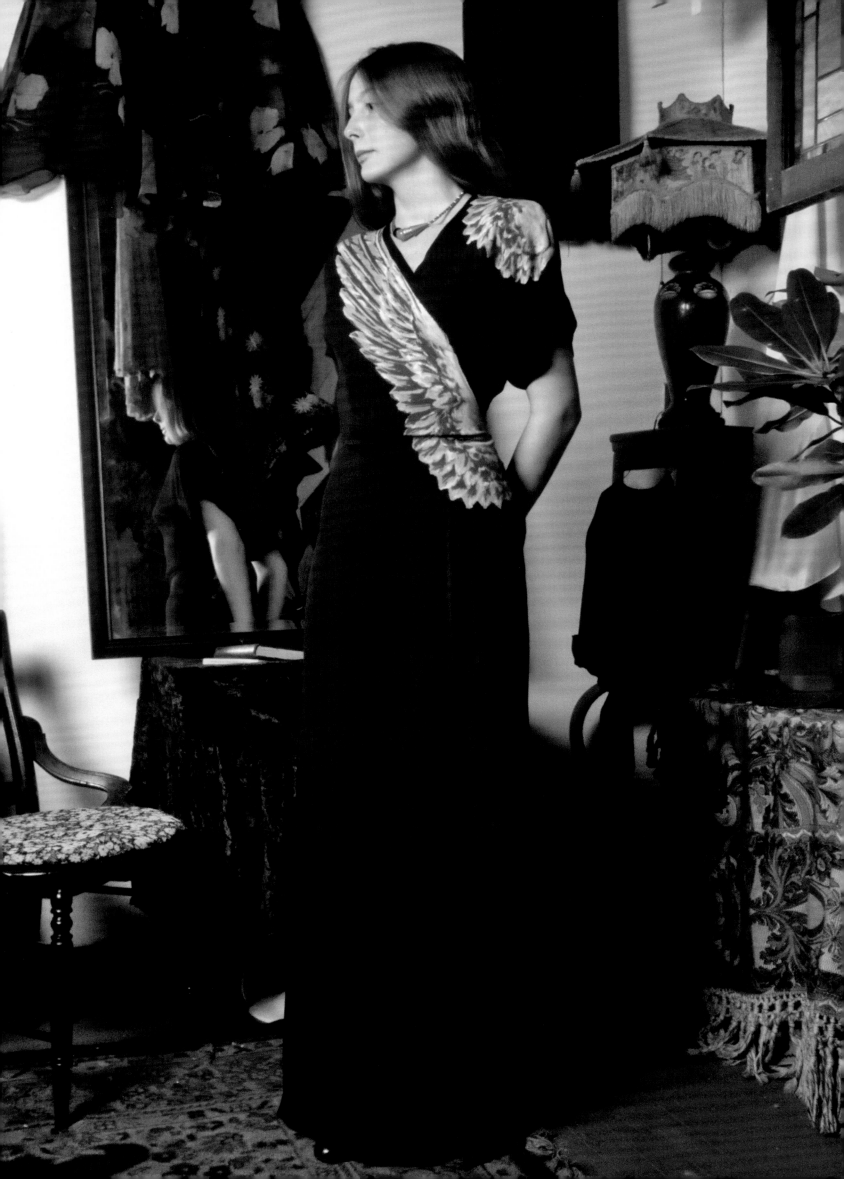

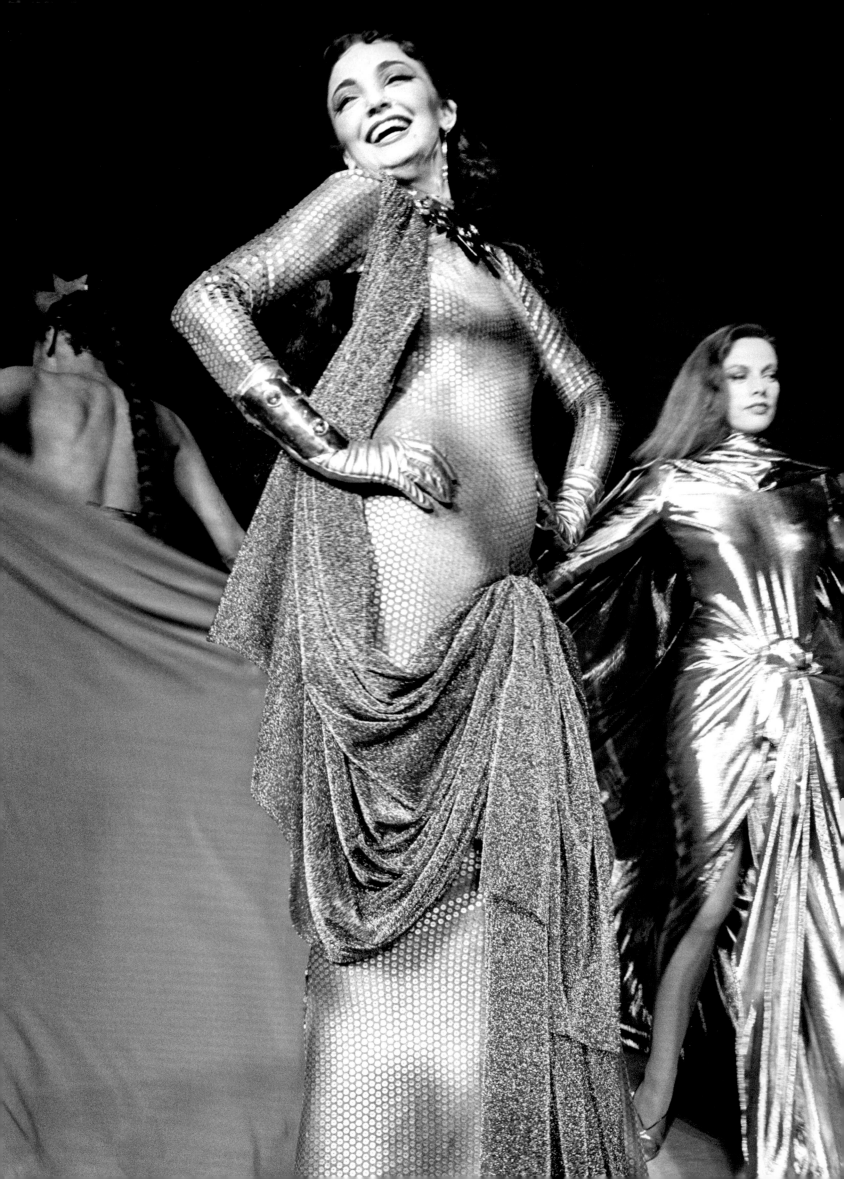

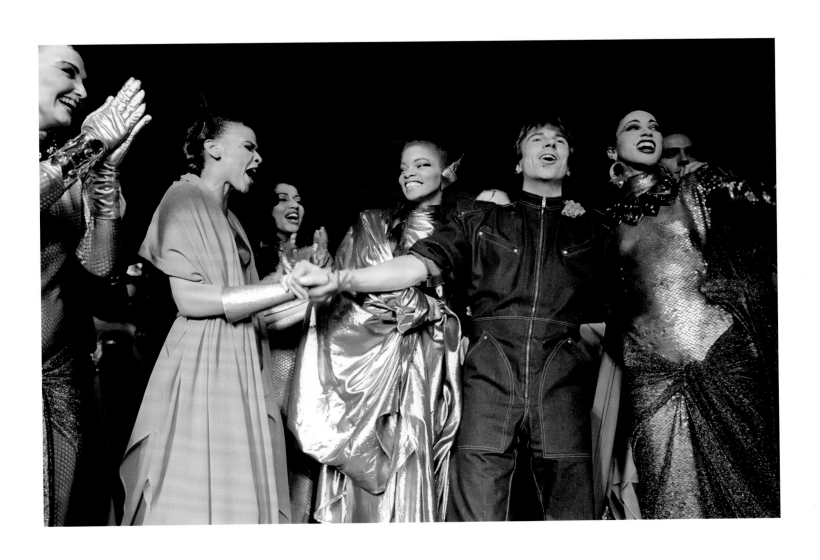

OPPOSITE: Models wear the latest Thierry Mugler fashion designs in his 1980 show at Bond in Times Square.

ABOVE: Thierry Mugler joins models on the catwalk during the finale, with Pat Cleveland on the right.

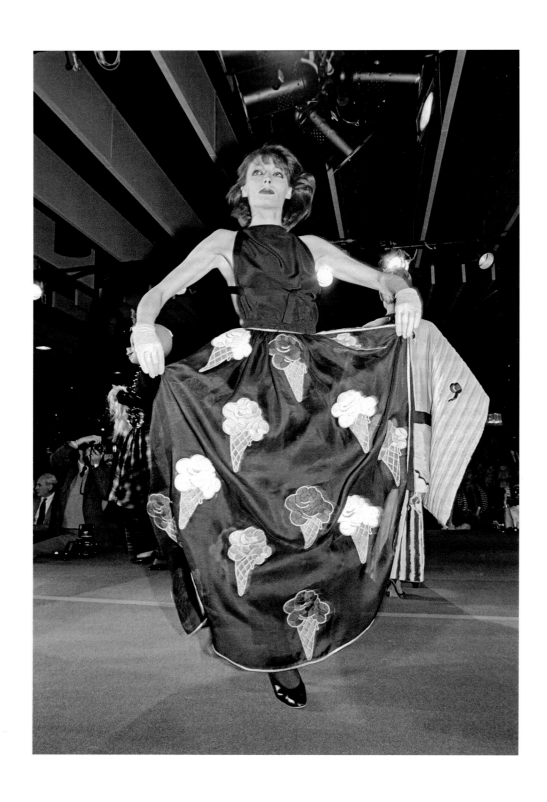

ABOVE: A woman models Michaele Vollbracht's latest designs at a fashion show on November 6, 1980.

OPPOSITE: Geri models the latest Fiorucci styles at the label's boutique in 1976.

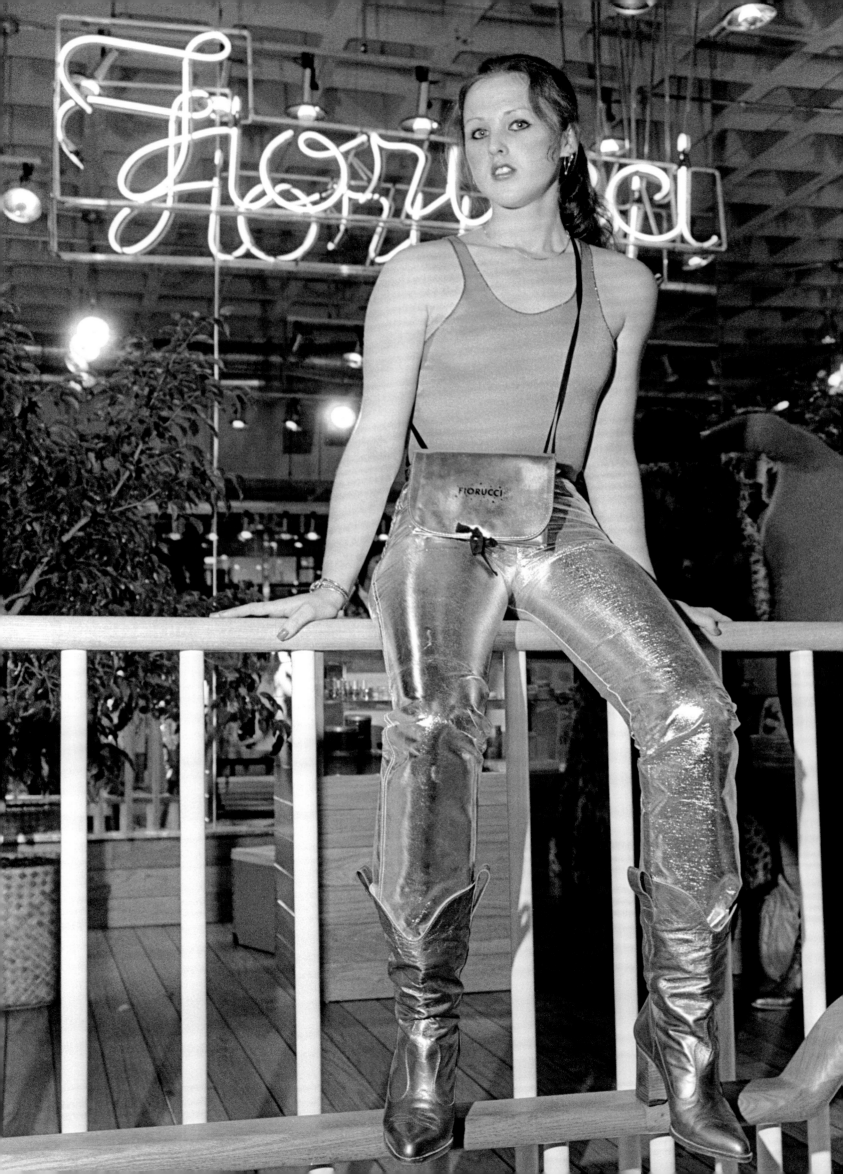

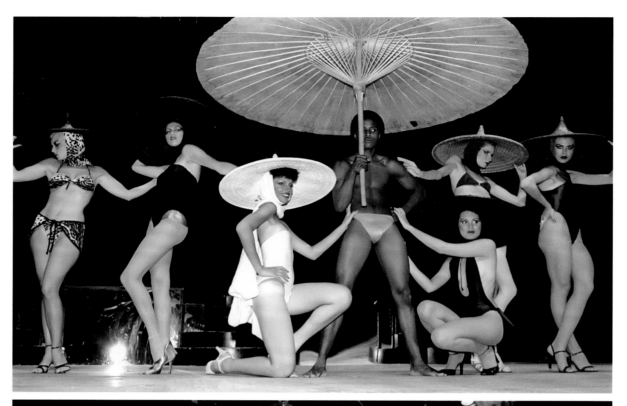

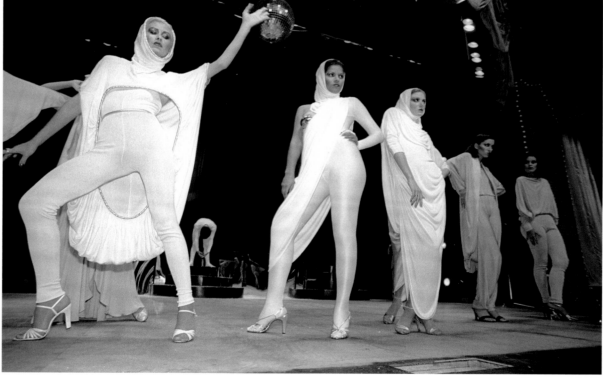

ABOVE AND OPPOSITE: Models strut the runway at the LeGaspi fashion show. New York fashion journalists including the *Soho News* were flown to San Juan, Puerto Rico, for this 1979 show.

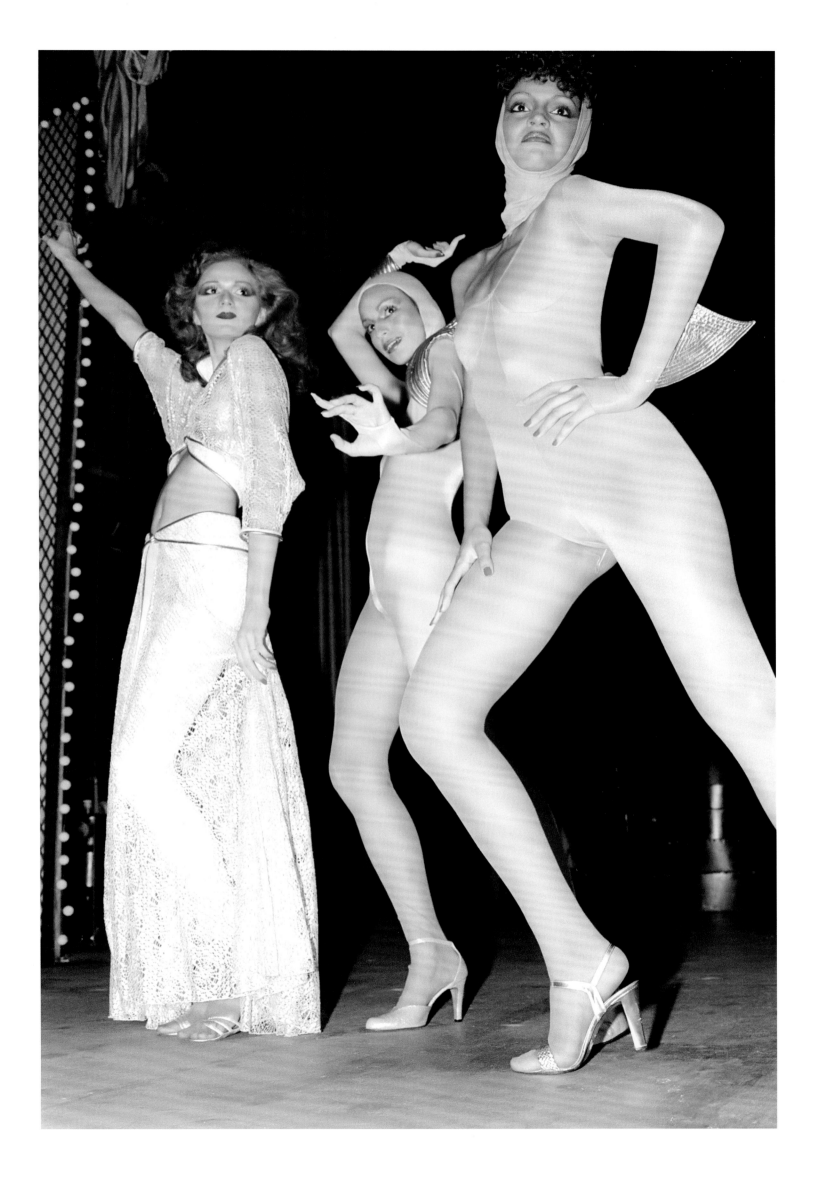

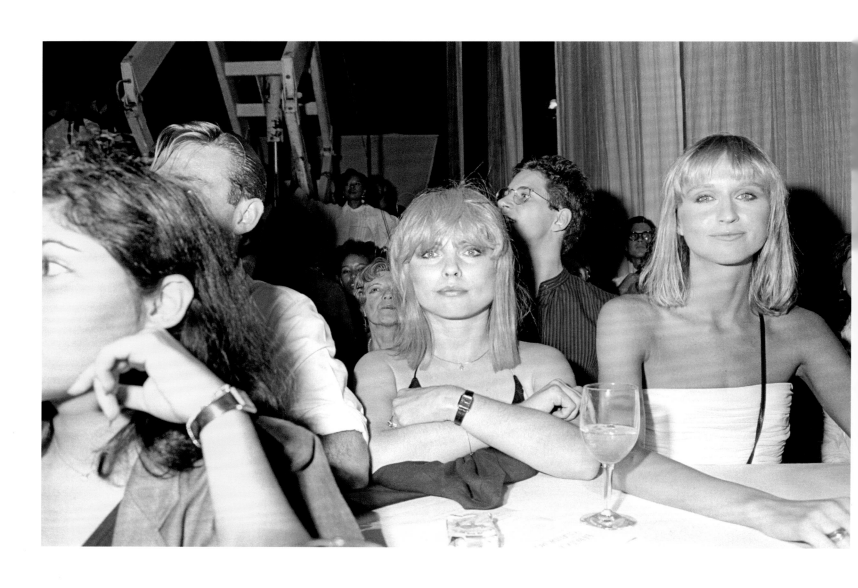

ABOVE: Debbie Harry of Blondie attends the Claude Montana fashion show at Bond.

OPPOSITE: Jerry Hall models the latest Thierry Mugler fashion designs in his show at Bond.

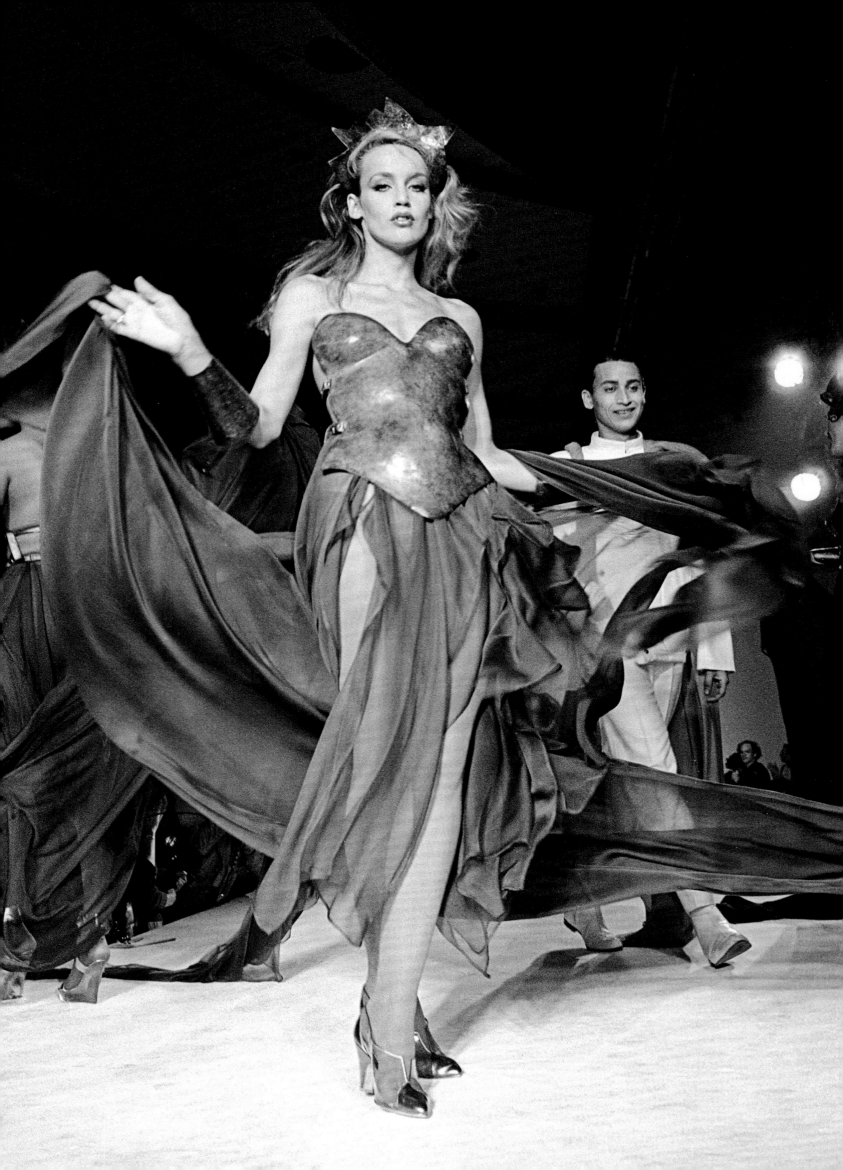

EVOLVING STYLES

As the '70s morphed into the '80s, New York continued to be a center of style innovation—including SoHo itself, which had become more expensive but no less inventive. Parachute opened its first store there in 1980, taking over a five-thousand-square-foot space that used to be a cardboard factory at 121 Wooster Street, between Prince and Spring. Clothes hung from pipe racks, and a row of white pillars separated the men's from the women's lines. Writing in the *Soho News*, Stephen Saban called the new space "very bleak, very considered, very conceptual." The styles might have been inspired partly by Larry LeGaspi's outer-space look, but some of the clothes looked as if they could have been designed for David Bowie or Tubeway Army's Gary Numan, who was fascinated by dystopian sci-fi movies and synthesizers.

Parachute had been a huge Canadian brand of clothing from a shop of the same name that opened in Montreal in 1978. Describing its take on the brand, the New York–based partner had announced, "It follows music, it follows architecture, it follows other great movements of the world." Everything had padded shoulders, or what Saban called "Instant inverted triangles. Studs, snaps, zippers. Lots of gray. Garish green. Odious orange." Think Devo meets Duran Duran. Indeed, Duran Duran often wore Parachute clothing, as did Madonna, Peter Gabriel, George Michael, and, yes, even David Bowie.

By 1979, Annie Flanders had left the *Soho News*, eventually to found *Details* magazine, and her place was taken by a pair of style editors, Kim Hastreiter and Branka Milutinovic. Having studied at the California Institute of the Arts and having come to New York to be an artist, Hastreiter picked up the thread of combining art and fashion. While she and Milutinovic were working at Betsey Bunky Nini on the Upper East Side, renowned fashion photographer Bill Cunningham recommended that the paper's publisher hire them to run the style section as a team.

"The art world was kind of conservative in those days," Hastreiter says now. "I saw a scene coming out of the clubs that was so much more vibrant than the art scene. The hip-hop kids would take the Gucci logo and put it all over their sweatshirts, like saying, 'Fuck you, I can't buy Gucci but I can put it all over my sweatshirt, or on my front tooth.' That was genius to me, but the art world doesn't take the rest of culture into account."

When she saw that the men in her classes at CalArts got into galleries while none of the women did, she decided, "Maybe I wasn't cut out to be in the art world." She found it more exciting to be working for the *Soho News*, and brought in photographers including Robert Mapplethorpe and Timothy Greenfield-Sanders to shoot for the style section. She also credits the London scene with influencing American punk style, through Malcolm McLaren and Vivienne Westwood. "They started punk, not New York. But we did it our own way. Betsey Johnson was inspired by Biba," she adds, referring to the popular London fashion store of the 1960s and '70s, "but then she did it her own way."

By then it was clear that downtown style had been absorbed into the mainstream, as T-shirts began to appear reflecting punk or hip-hop style in ways that often felt like appropriations. Of course, this is what designers like Zandra Rhodes had done with punk styles in London, borrowing ideas from fashion innovator Vivienne Westwood as well as from punks on the street and in the clubs. Perhaps the most blatant example of co-optation was the appearance of punk T-shirts in the windows of Macy's department store in Herald Square. Nonetheless, punk style has gone on from its earliest days in Downtown Manhattan and London to influence the latest designs by many couturiers and houses, including Karl Lagerfeld, Martin Margiela, Comme des Garçons, and many more.

OPPOSITE: American fashion designer Charles James relaxes with model Nina Gaidarova at the *Fashion as Fantasy* show at Rizzoli Bookstore.

SUBSEQUENT PAGES: Models strut the runway at the SoHo Designers fashion show at the Mudd Club on February 26, 1979.

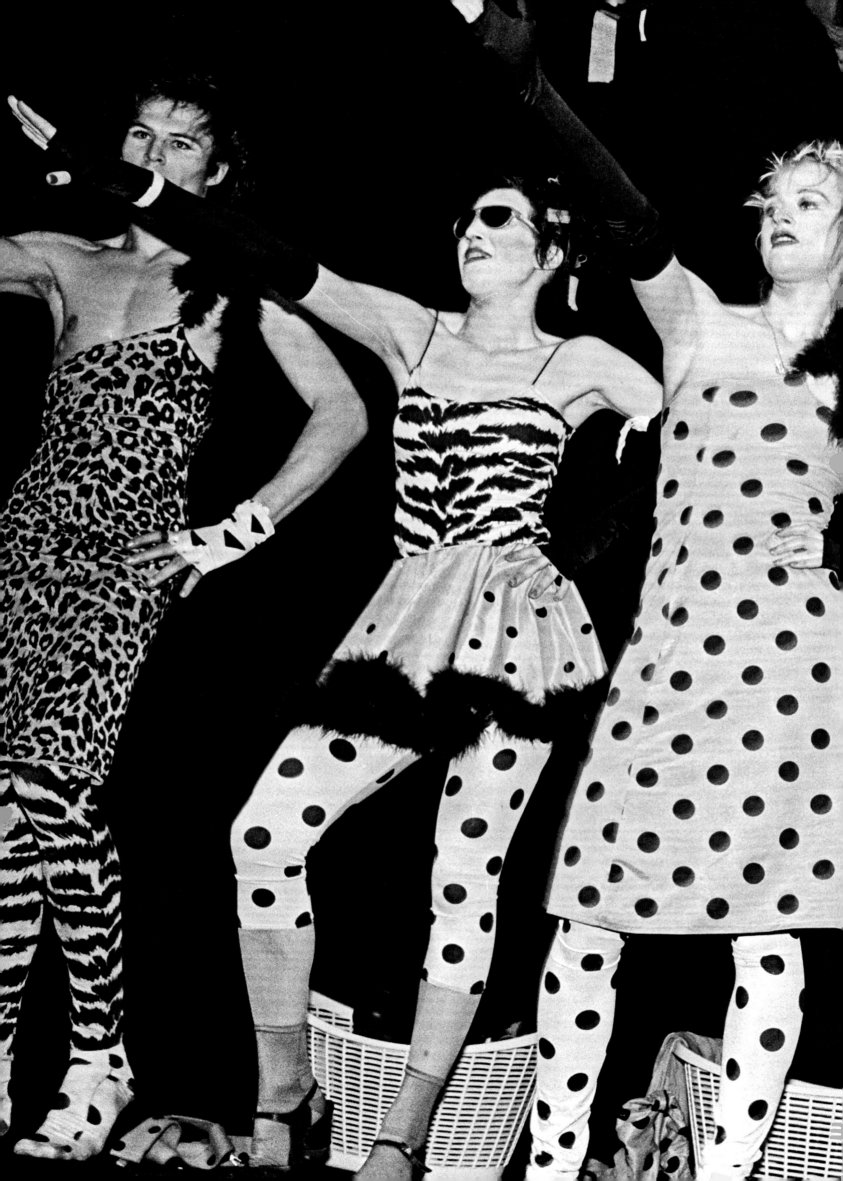

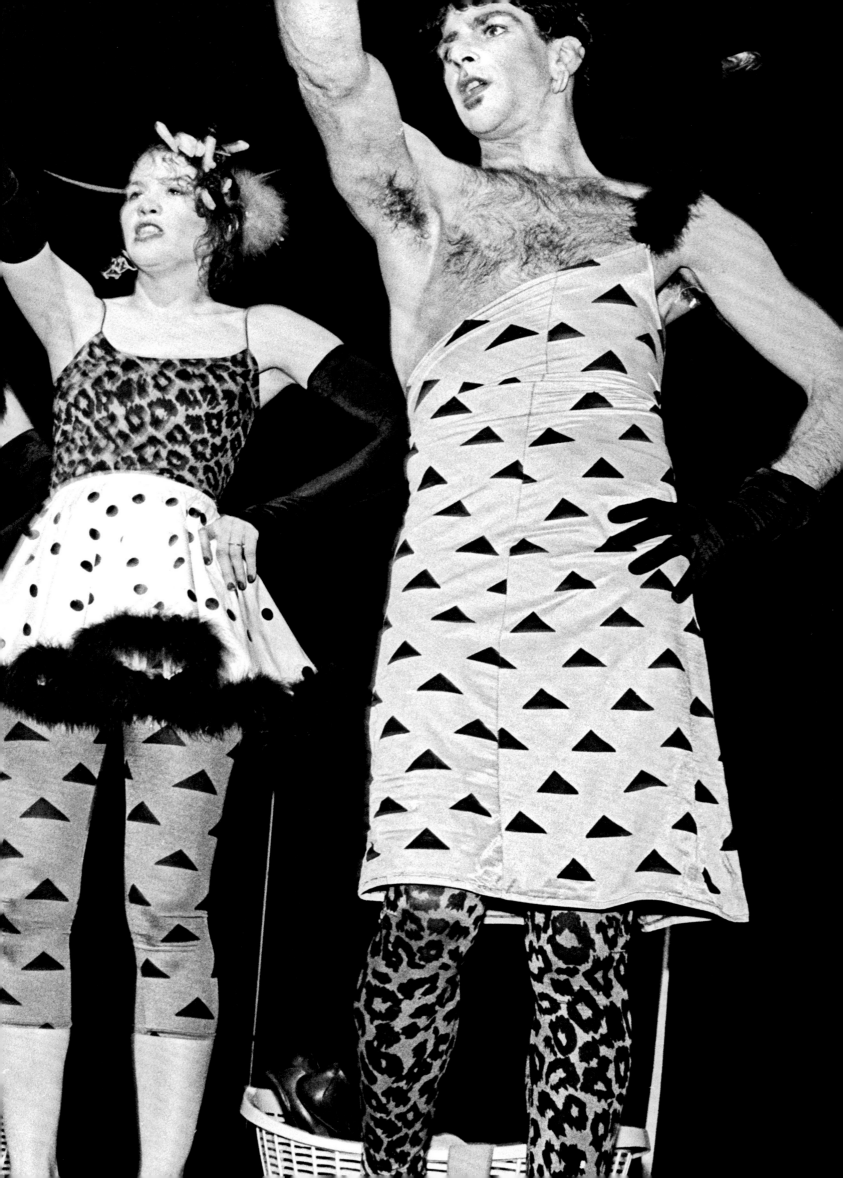

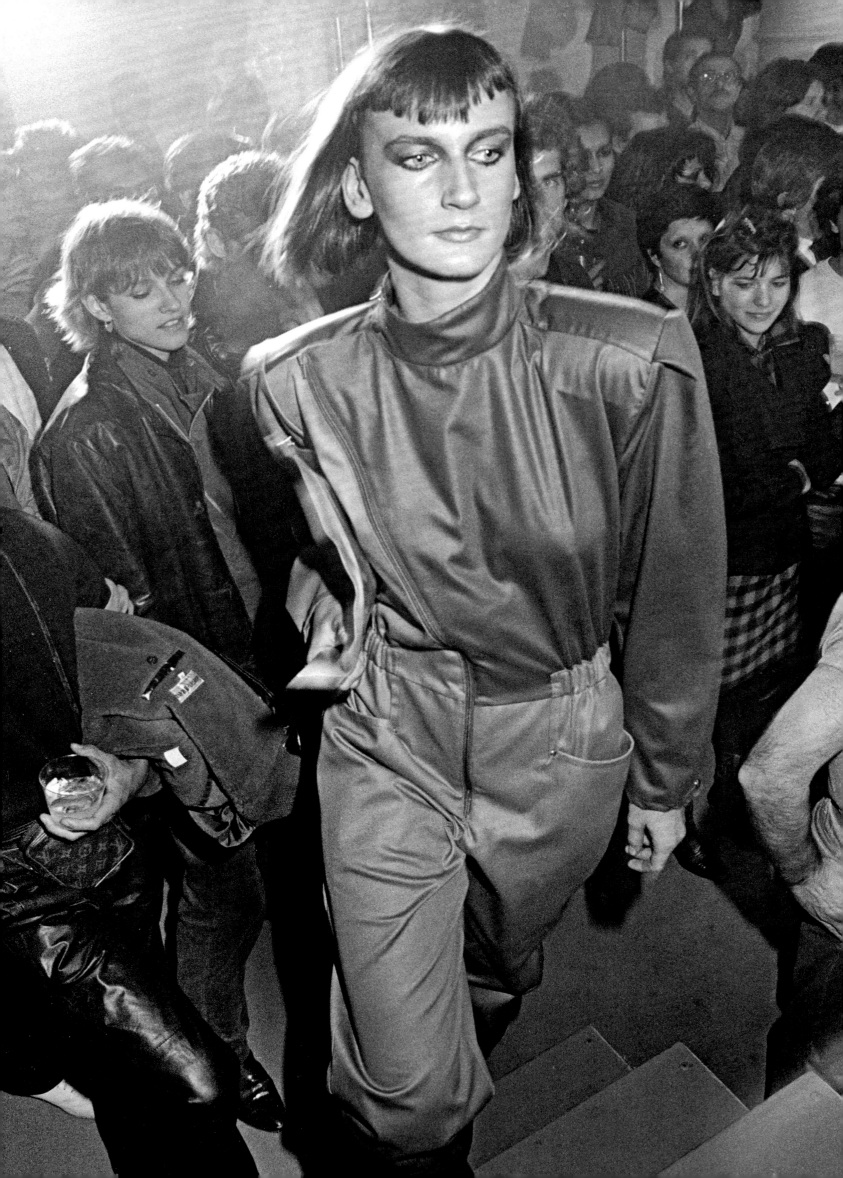

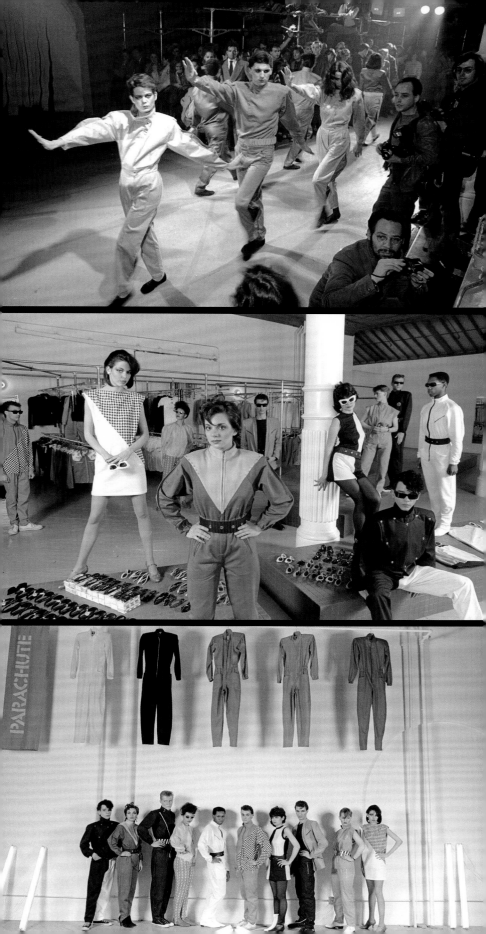

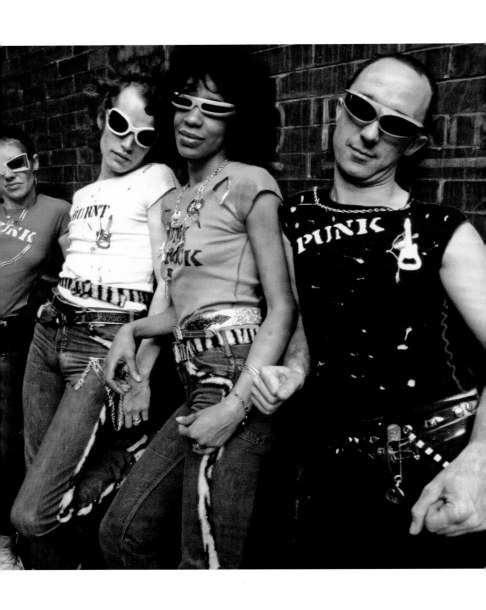

M LEFT: A model ascends the steps at a 1980
odels parade in a line at the SoHo Designers show
wear some of the fashions at the Parachute store in
umpsuits at Parachute.

he label "Startling Stuff" by British designers Pam
O'Connor. Their friends Craig and Marsha help
1977.

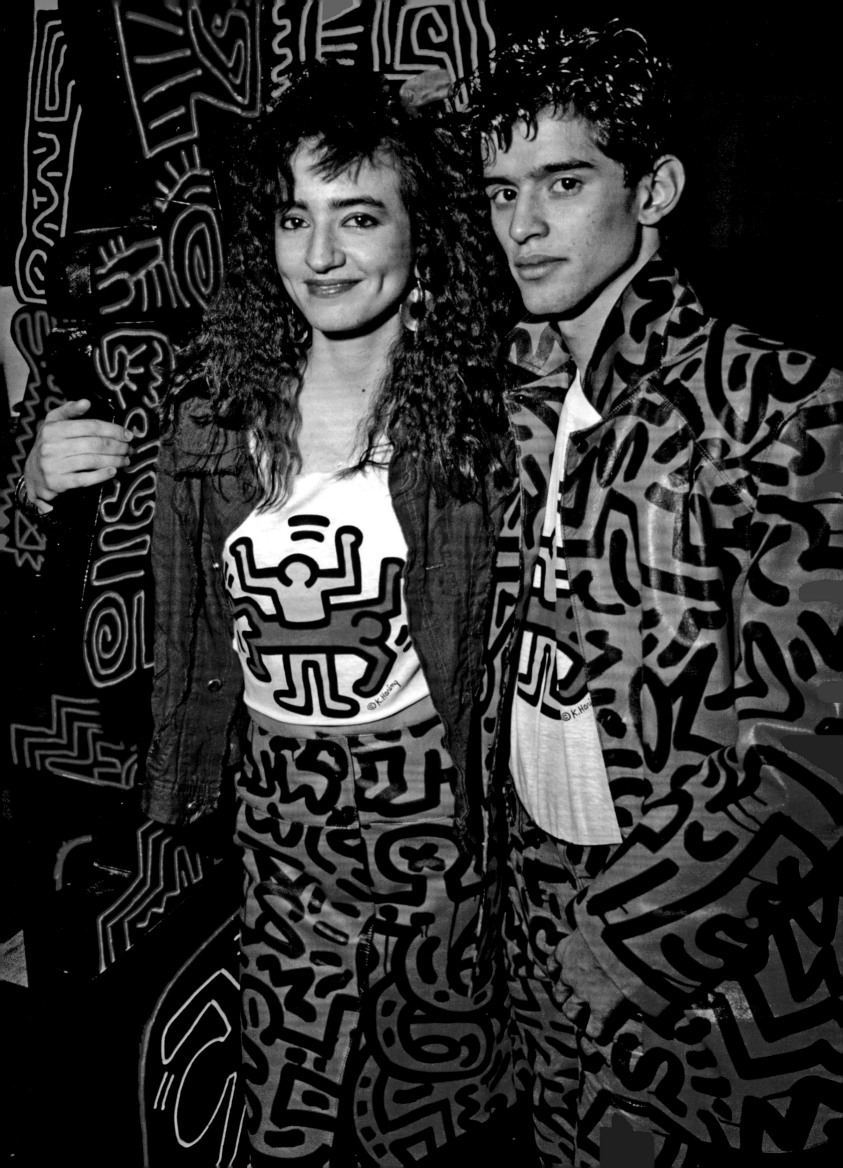

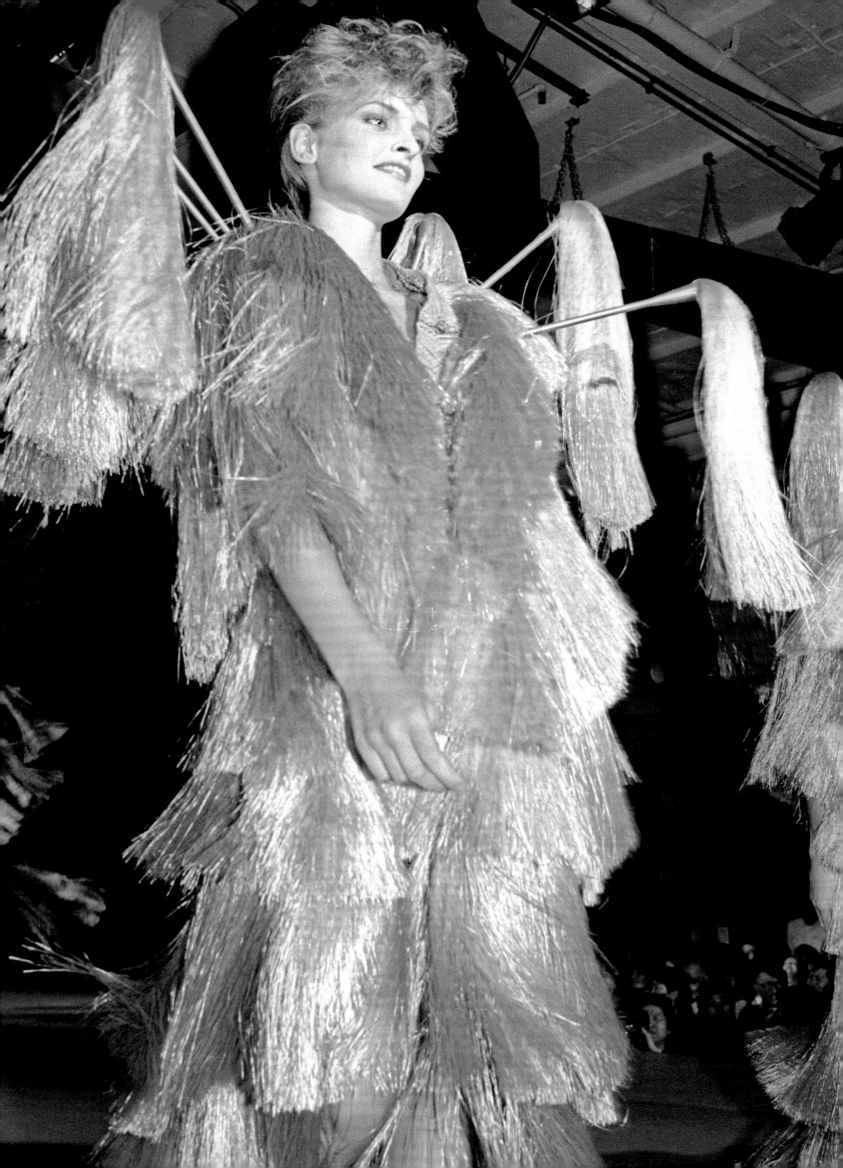

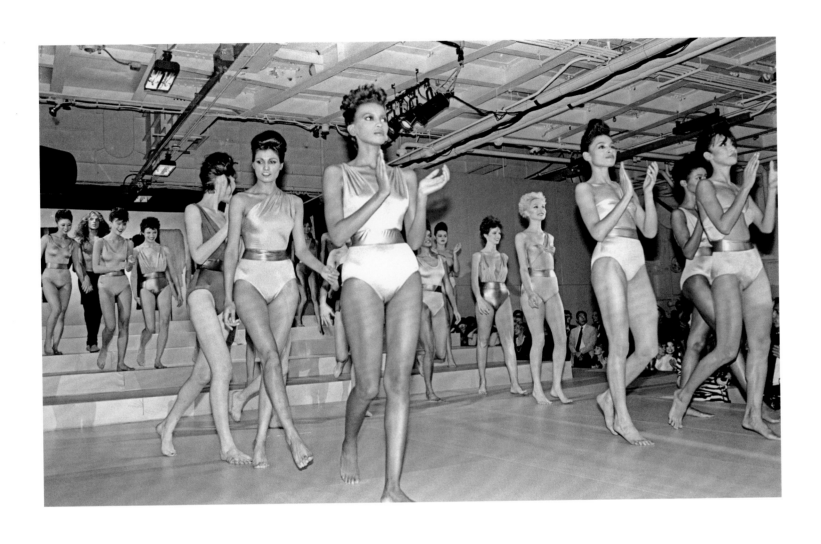

ABOVE AND OPPOSITE: Fashion designer Issey Miyake presents his spring collection in a show at the Intrepid Sea, Air & Space Museum on November 11, 1982.

ROLE MODELS

In 1973, Lauren Hutton signed a contract that allowed her to earn $250,000 a year working for Revlon founder Charles Revson's Ultima II, making her the first model signed to an exclusive contract with a cosmetics company (and with one photographer, Richard Avedon), as well as the first to be featured on the cover of *Newsweek* (along with a record-setting forty-one *Vogue* covers). Hutton's contract marked the turning point when fashion modeling became big business, paving the way for high earners including Jerry Hall, Iman, Pat Cleveland, Brooke Shields, and Apollonia van Ravenstein. Her charmingly "imperfect" gap-toothed face was seen everywhere in New York City in the '70s. Hutton would fill the gap in her teeth with mortician's wax, but finally went back to her natural look: the girl next door with It. In that sense she exemplifies this book's theme of parallel style lines—Studio 54 and the Mudd Club, Bowie and the Ramones, Halston and Betsey Johnson.

We offer these photos as a tribute to the women on whose achievements all the legendary designers depend.

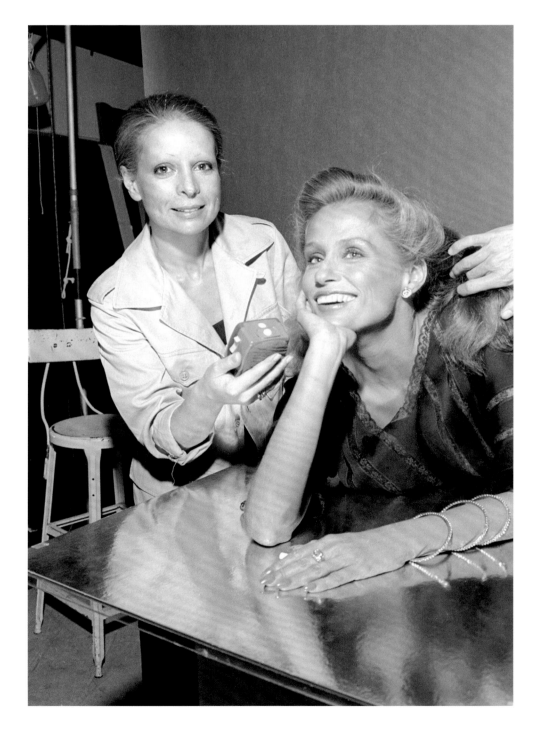

LEFT: Fashion photographer Rebecca Blake prepares to shoot model Lauren Hutton in her studio in 1978.

OPPOSITE: Pat Cleveland in gold Fiorucci shorts at the East Fifty-ninth Street store in 1977.

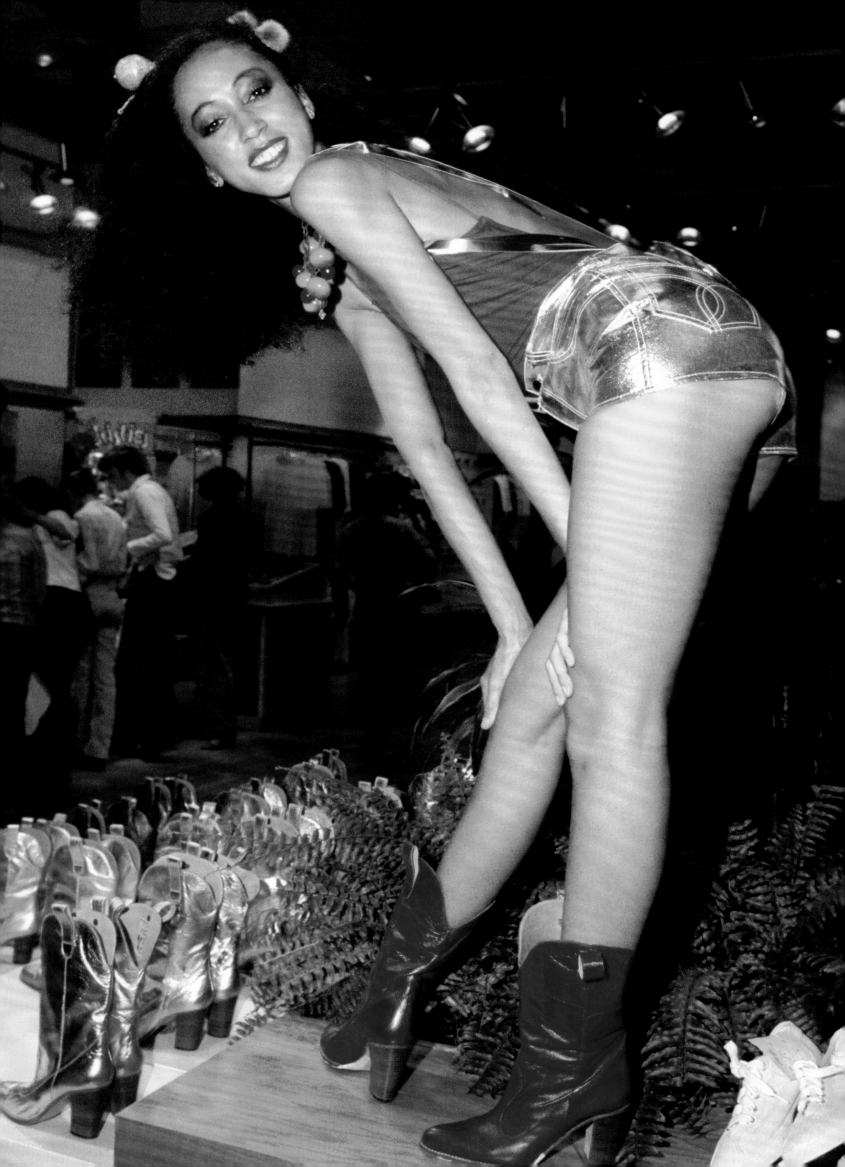

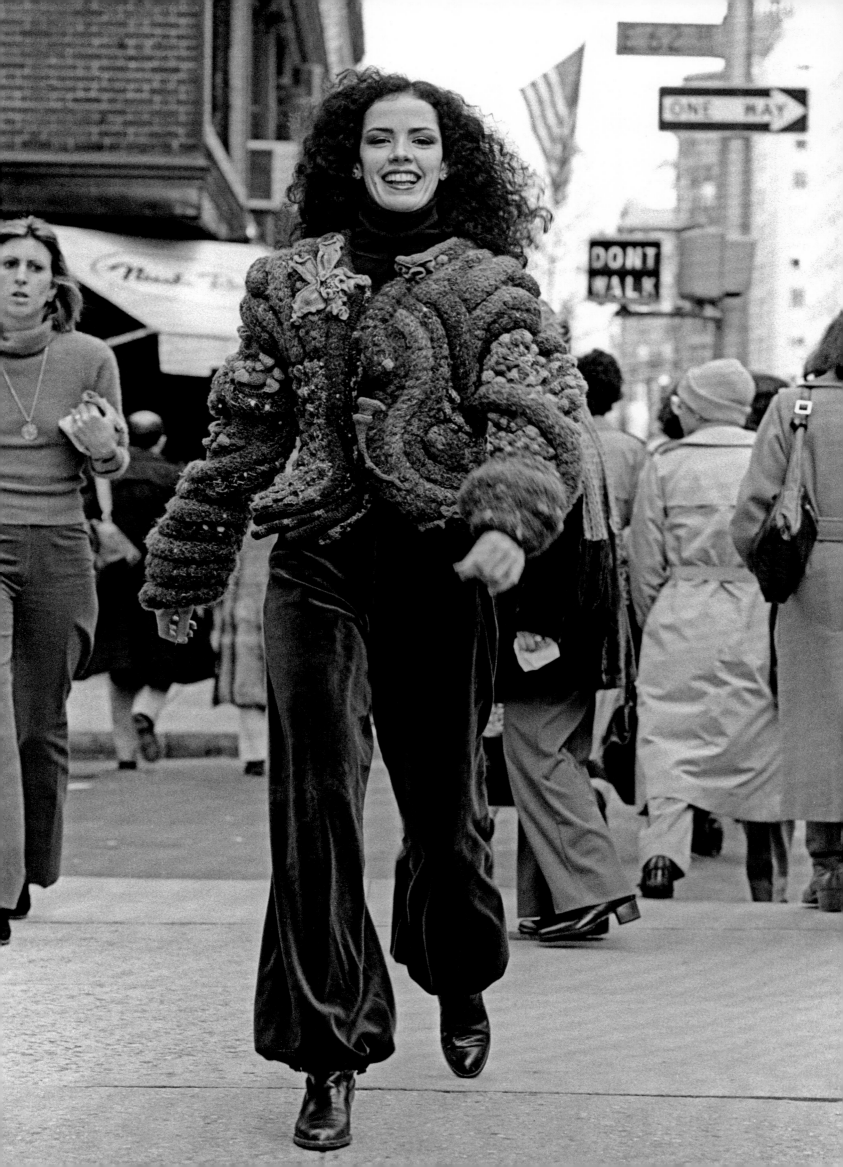

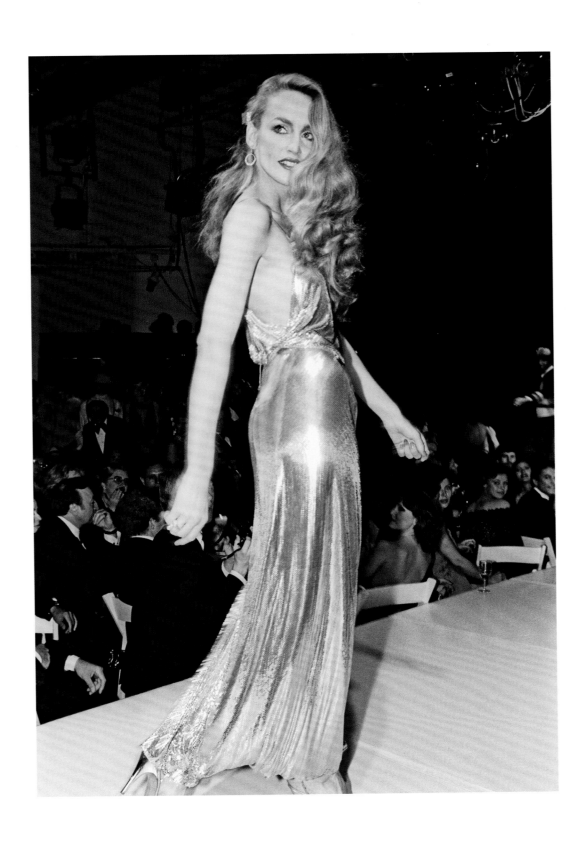

ABOVE: Jerry Hall models in the Fashion Makers show at Studio 54 in 1978.

OPPOSITE: Kristen Kirkconnell in wearable art by Julie: Artisans' Gallery on Madison Avenue.

SUBSEQUENT PAGES: Grace Jones, Lauren Hutton, and Pat Cleveland at the Issey Miyake show at the Intrepid Sea, Air & Space Museum in 1982.

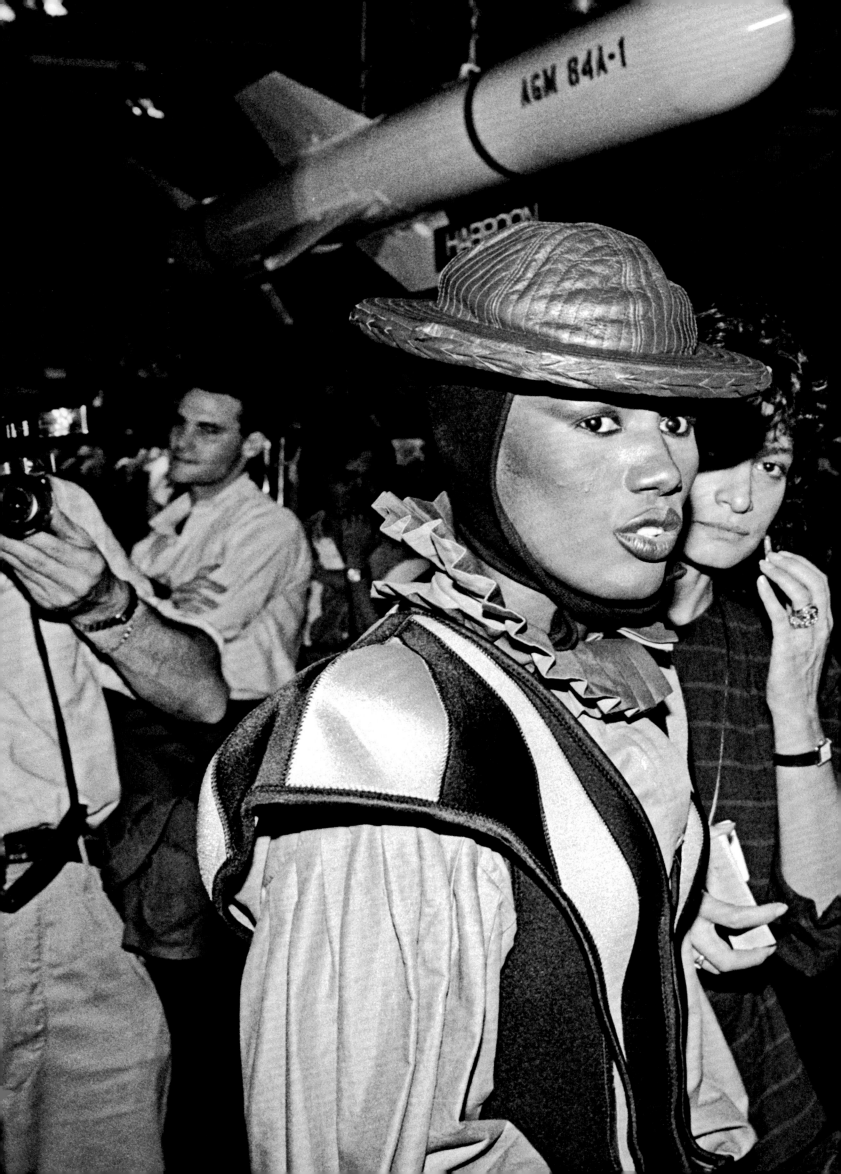

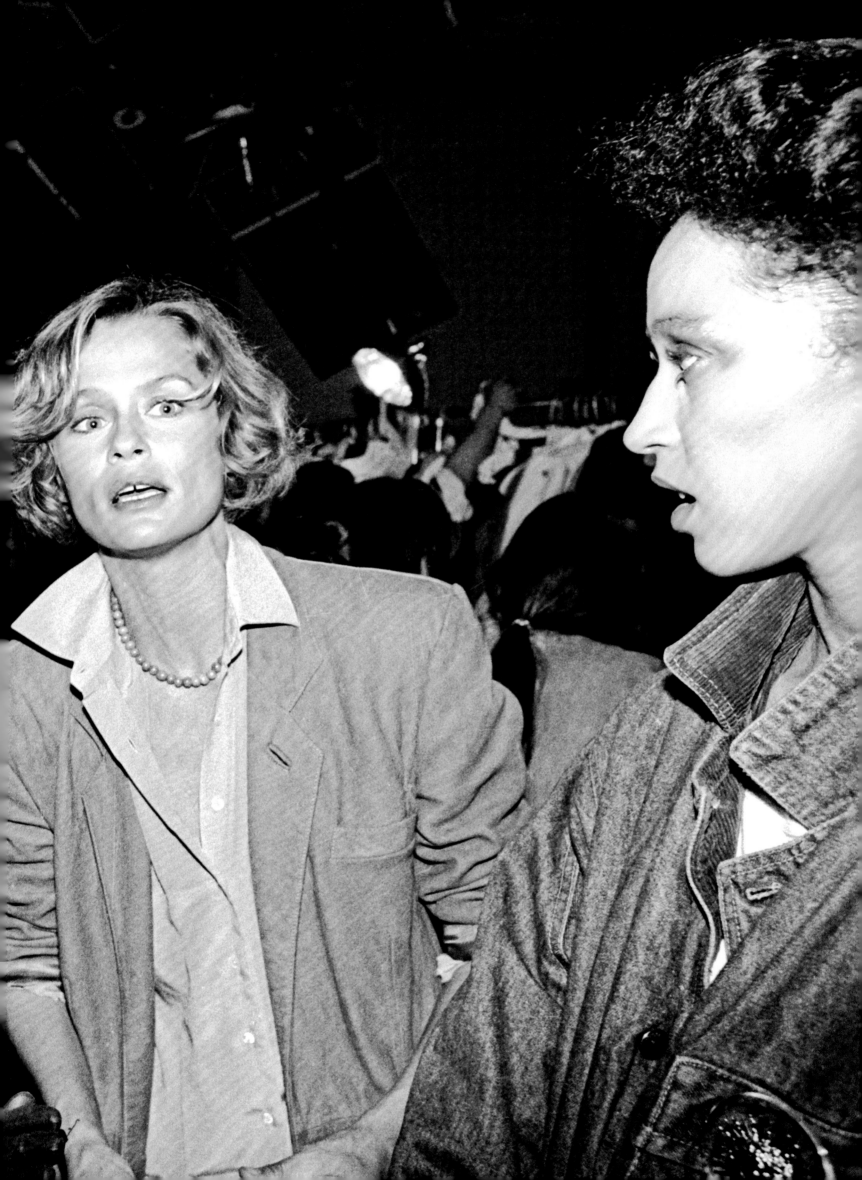

FASHION IN THE '70S

The free-spirited, bohemian 1970s have been my favorite time in fashion as well as my source for inspiration in my current collections and personal style.

I was lucky to be a teenager in the early '70s. The teenage years are when one experiments, developing a sense of individuality and personal style. During those days, my strongest impressions of self-expression came through music trends: folk, rock 'n' roll, folk rock, reggae, and jazz.

The way pop culture affected my generation was so profound that it's no wonder that the '70s are sometimes referred to as the second renaissance in the postmodern world.

My aesthetic and my personal style were influenced by images of artists like Joni Mitchell, Jane Birkin, and Patti Smith. These artists were outspoken, strong women, carrying with them a defined sense of personal style and voice. Their style was honest, laid-back, and unpretentious. I admired their seamless mixing of elements of Americana, bohemia, romance, and military. An obvious reflection of the times, these aesthetics continue to influence my collections.

I would look at these icons endlessly, listening to the voice of Joni Mitchell, unaware of the influence she would later have on me. I experienced a similar effect from countless images of Patti Smith, and even Jim Morrison and Cat Stevens, who were captured in photographs wearing sheepskin embroidered coats, guitars by their sides. The images and the music blended into one ongoing and growing culture that was to provide some of my most profound inspirations.

Four times a year, I design collections and create aesthetic narratives that reference these personal impressions of mine. So often do I incorporate the energy of the bohemian, free-spirited 1970s.

We express ourselves through the clothes we wear, reflecting our style, mood, or attitude. I believe every young woman should start creating her personal style at a very young age. It takes years to get to know your preferences. By experimenting with clothing, we learn what makes us feel good and in which clothes we feel at home.

The 1970s are the years when Allan Tannenbaum, working as chief photographer for a hip downtown newspaper, flourished while reporting from behind the scenes of the New York bohemian lifestyle. In addition to the art world and music scene, he explored the burgeoning fashion scene in all its variety, from couture to mainstream to punk. He also announced to the world his own take on the personalities he encountered. These personalities have such a story to tell in their costumes, hair, gestures, and intimacy, which, from today's perspective, seem like something out of a fairy tale. Tannenbaum's cameras captured the freewheeling exuberance of fashion shows such as Fiorucci at Studio 54, Claude Montana at Bond, and SoHo Designers at the Mudd Club; he also documented the excitement and tension of the dressing room preparations and the styles and faces of the people who came to see the shows.

When I research photo albums in preparation for a new collection, I always go back to the '70s, even just for a minute. It is my way of reminding myself how exciting those times were from an artistic, innovative, and self-expressive point of view. In the search for clues to the puzzle, the importance of the photographer, like Allan Tannenbaum, is priceless. He captured truth in his photographs—images that transcend boundaries of time and distance. These images will continue to inspire, even through future changes in how people communicate and the evolving new media.

—NILI LOTAN

OPPOSITE: Alexa Hunter photographed in a Mary McFadden gown at her home for a feature titled "Downtown Girls Do Uptown Clothes" in the *Soho Weekly News*. Besides being a designer, Hunter was the vocalist in a band called Disturbed Furniture, as attested by the instruments and pile of demo cassettes on the floor.

SUBSEQUENT PAGES: Models bare their chests and wear gas masks at the Designers of the '80s fashion show at Xenon in 1979.

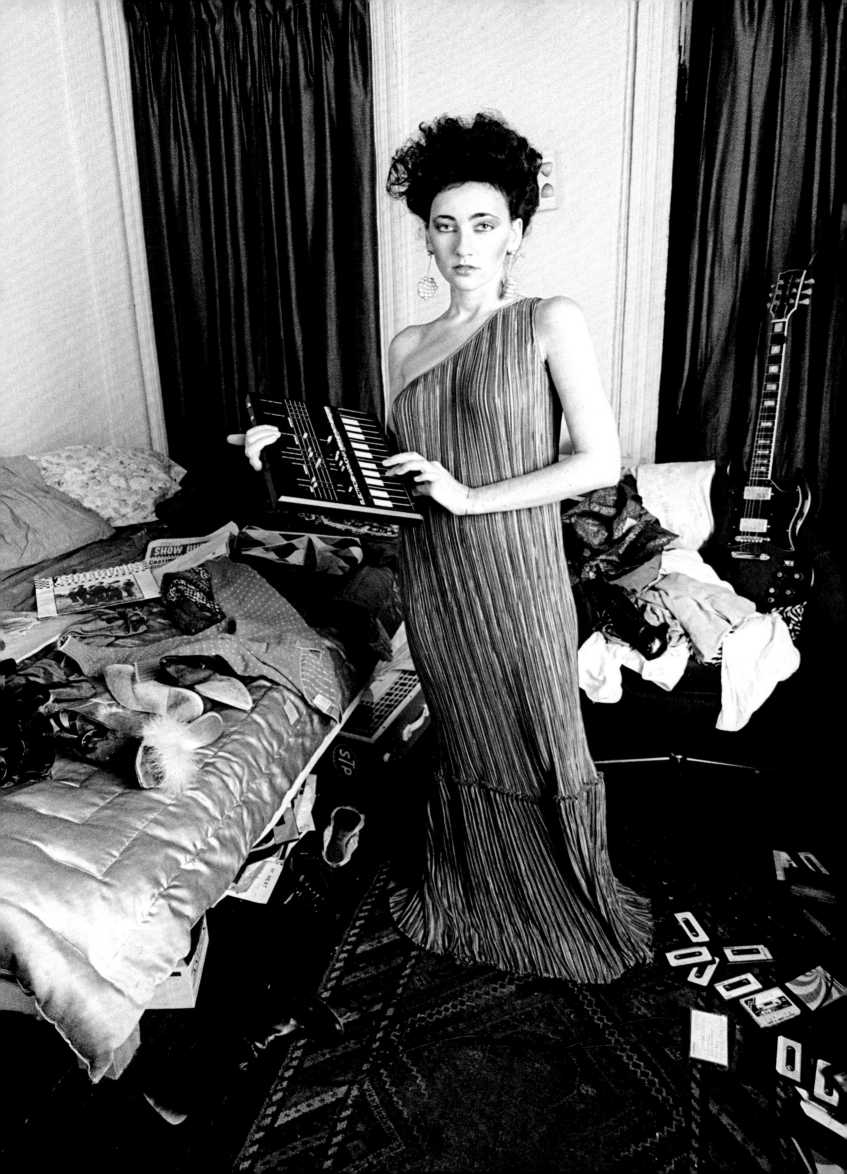

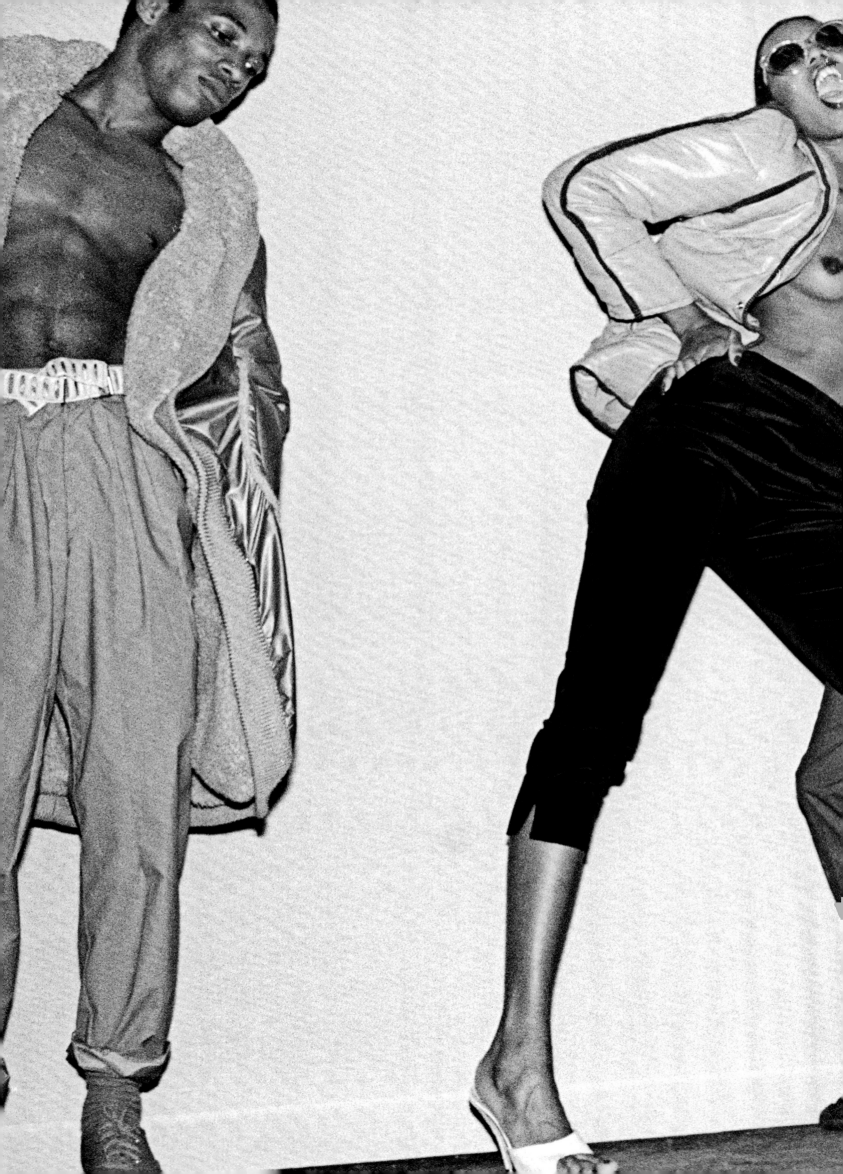

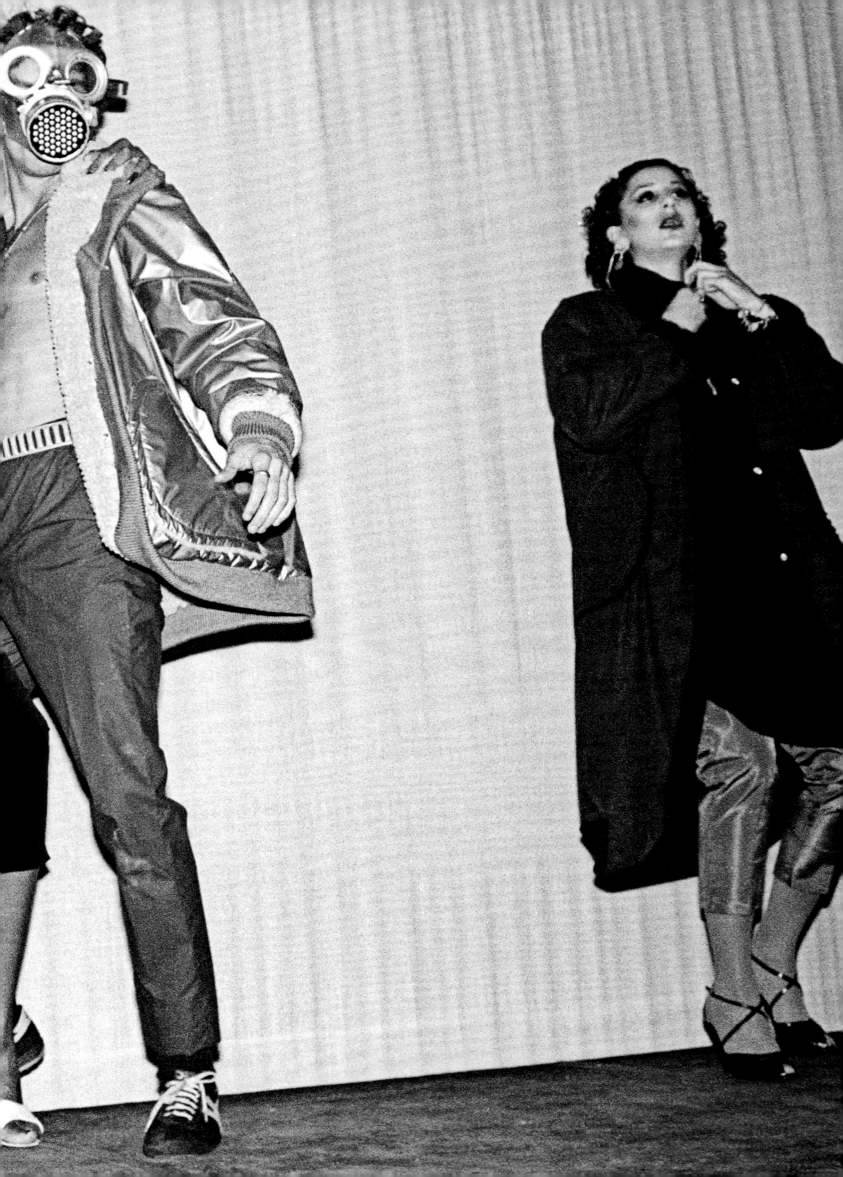

ARTS AND ENTERTAINMENT:
A WEEK IN THE LIFE

BEING THE PHOTO EDITOR for a small weekly newspaper had its blessings. For one thing, Allan Tannenbaum could have his pick of assignments, choosing the most compelling subjects and assigning the rest (although he covered his share of city council meetings too). But working at a small-scale publication also had its drawbacks. In the early years, the *Soho Weekly News* had two offices on Spring Street, both with limited darkroom space. The first office had only a small space in back with "a mechanical processor and terrible paper." The second office, at 111 Spring, had a basement in which the publisher, Michael Goldstein, installed one of those metal storage barns you still see in suburban backyards as the paper's darkroom, which gave the photo editor greater flexibility. When the paper moved to a much larger space in a former industrial building at 514 Broadway, a proper darkroom was built into it with plumbing and lighting and a small refrigerator for film. (You remember film, right?) In the days before digital photography, Allan did most of his processing and printing in that darkroom and the one in his loft on Duane Street, but color transparencies had to be brought to Duggal, a film processing center on West 20th Street.

Keeping up with what was happening, when and where, was also more challenging in the era before cellphones and mobile devices. "I had an answering service called the Green Room and a beeper," Tannenbaum says. "The pager was so primitive that it just beeped—no phone number or information—and I would have to find a phone booth and call the answering service to get the message." When the Rolling Stones announced that they were giving a press conference at the Fifth Avenue Hotel for their 1975 American tour, that was how he found out. "No sooner did I get to the hotel than we were told to go outside, where a flatbed truck suddenly drove by and turned onto Fifth Avenue." The Stones were on board, drum kit, amplifier stacks, and all, and they were playing at full blast. The caravan rolled down Fifth Avenue toward Washington Square Park, attracting crowds along the way. It made for an effective mobile press conference, announcing their tour and a concert at Madison Square Garden, but it was all kind of last-minute, and you had to be there to get the photos.

OPPOSITE: With any celebrity, the photographer runs the risk of feeling nervous or intimidated, especially if they haven't met before, so Allan looked for ways to make a connection without seeming in awe. "You know they're a star but you want them to be at ease, and so you need to be at ease yourself," he says. "When I went to photograph Jack Nicholson, I knew he was from New Jersey, so while I was setting up my lights I said, 'You're from Neptune, New Jersey, right? Well, I'm from Passaic.' And Jack said, 'Ah, Passaic, the Wonder Team!' In the 1920s, Passaic High School had a championship basketball team that was known as the Wonder Team for years afterwards. So we talked about Jersey, that led to other things, and it established a connection."

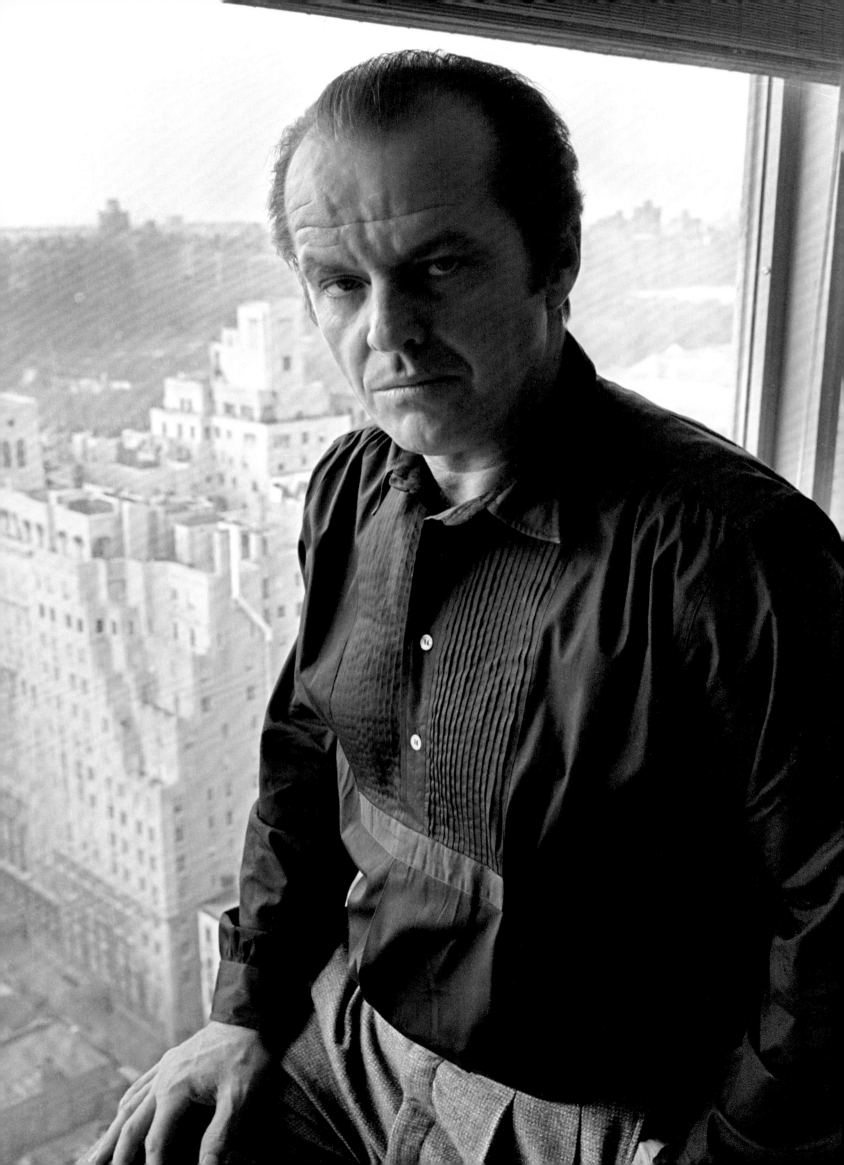

YOKO AND JOHN

Allan photographed Yoko Ono for the cover story that I was writing about her in the fall of 1980. Her landmark album with John Lennon, *Double Fantasy*, had just been released and they were giving interviews to only a few major publications, like *Playboy* and *Rolling Stone*, so I decided to ask for an interview with Yoko by herself—without John. I wanted to talk to her about her career as a conceptual artist and pioneering performance artist before she ever met Lennon, and how her life had changed since then. The cover would be a portrait of Yoko, but it had to be a striking one. When she arrived at Tannenbaum's studio, she was wearing a leather jacket, a cap, shades, and blue jeans—looking cool but distant. "She didn't want to change that look," he says. "So I started taking a few pictures with my Hasselblad and strobe."

What he was seeing in his viewfinder wasn't exciting: She was giving off the vibe of the mystery woman many people had accused her of being. "I said, 'Yoko, look, this is for the cover, and I need you to be engaging. But with this leather jacket and these shades, you're not really making contact.' So she took off the sunglasses and the jacket, and then she made that one little gesture where she put her hand on the zipper of her jeans, like maybe she was about to get undressed. And bang! That was it. But I had to coax her gently into doing something like that to make it happen."

The photo was provocative enough to evoke some of her unconventional performance pieces from the '60s, which was the perfect frame. The headline was "YOKO ONLY," a clever line that turned out to be sadly prophetic when John was murdered a few days after the paper came out; it was still on the stands as the city and the world mourned his loss. But John had read the story the day the paper hit the stands, and had liked that she was finally getting recognition for her career as an artist and performer in her own right. So he asked Yoko to invite me to meet him in the studio where they were rerecording a song that had been left off the album, an eerily infectious dance track called "Walking on Thin Ice." I was fortunate enough to spend several hours chatting with John while Yoko recorded new vocals for the song. Lennon was friendly, open, and engaging, the furthest remove from a rock star attitude that I could imagine. But Allan was even more fortunate; John and Yoko invited him to photograph them together in a variety of settings, walking in the park near their Dakota duplex and in the studio.

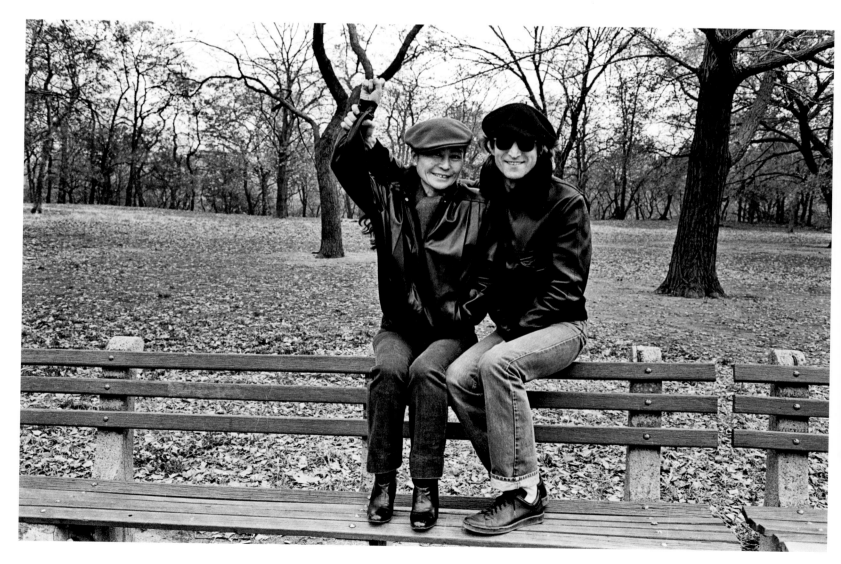

ABOVE: John Lennon and Yoko Ono wear leather jackets, blue jeans, and cloth caps on a stroll in Central Park on November 21, 1980.

OPPOSITE: John Lennon wears a silver coat and Yoko Ono wears a fur jacket while filming a video for their new *Double Fantasy* album in Central Park on November 26, 1980.

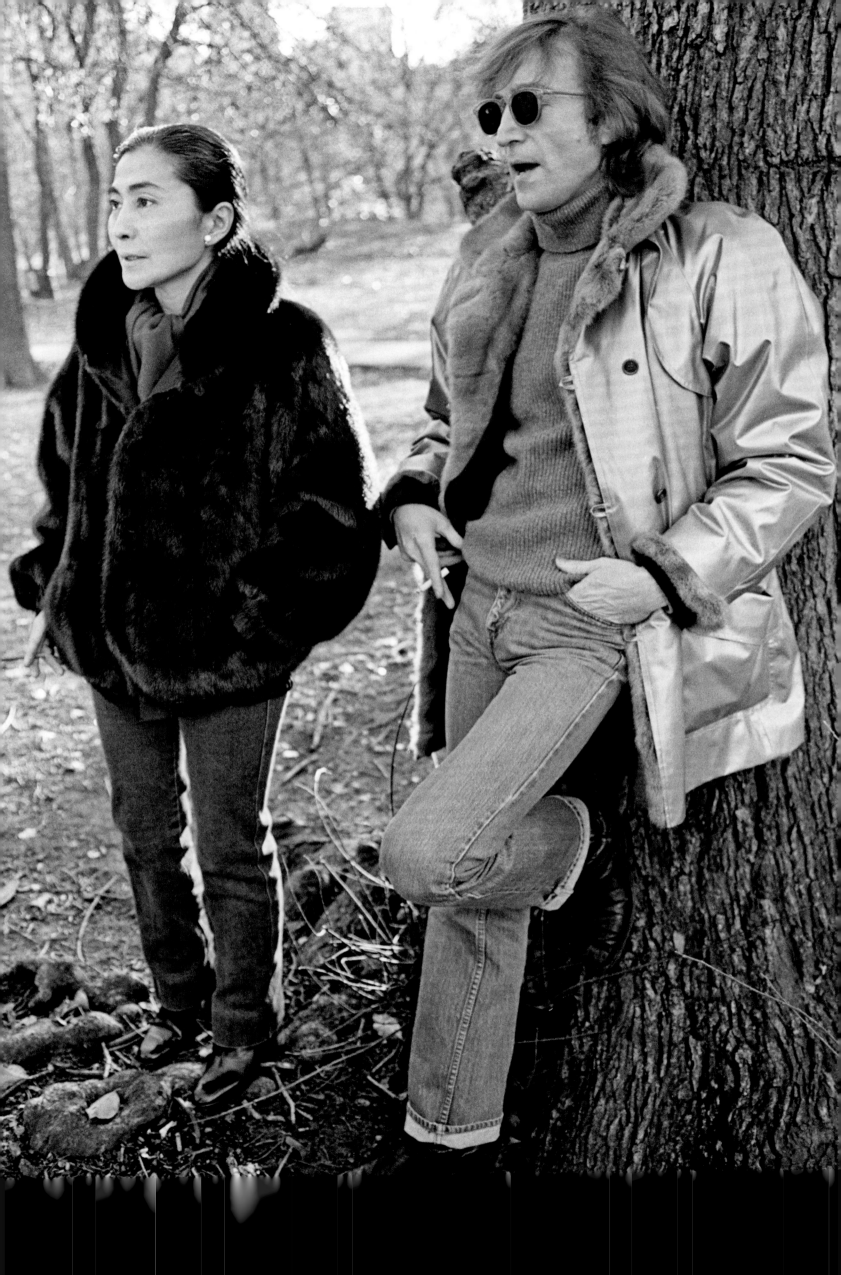

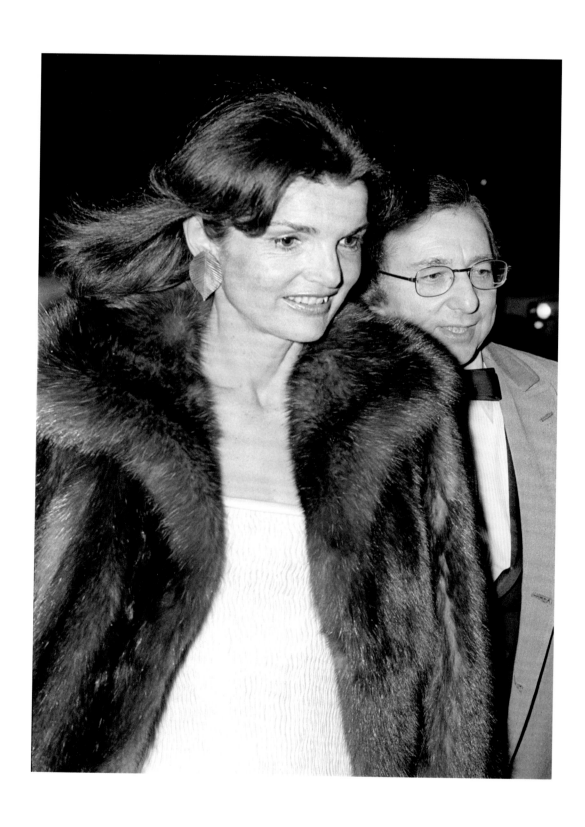

ABOVE: Jackie O. arrives at the Russian costume exhibition at the Metropolitan Museum of Art in 1976.

OPPOSITE: Muhammad Ali wears a fur coat in a men's fur fashion show at the Market Bar in 1977.

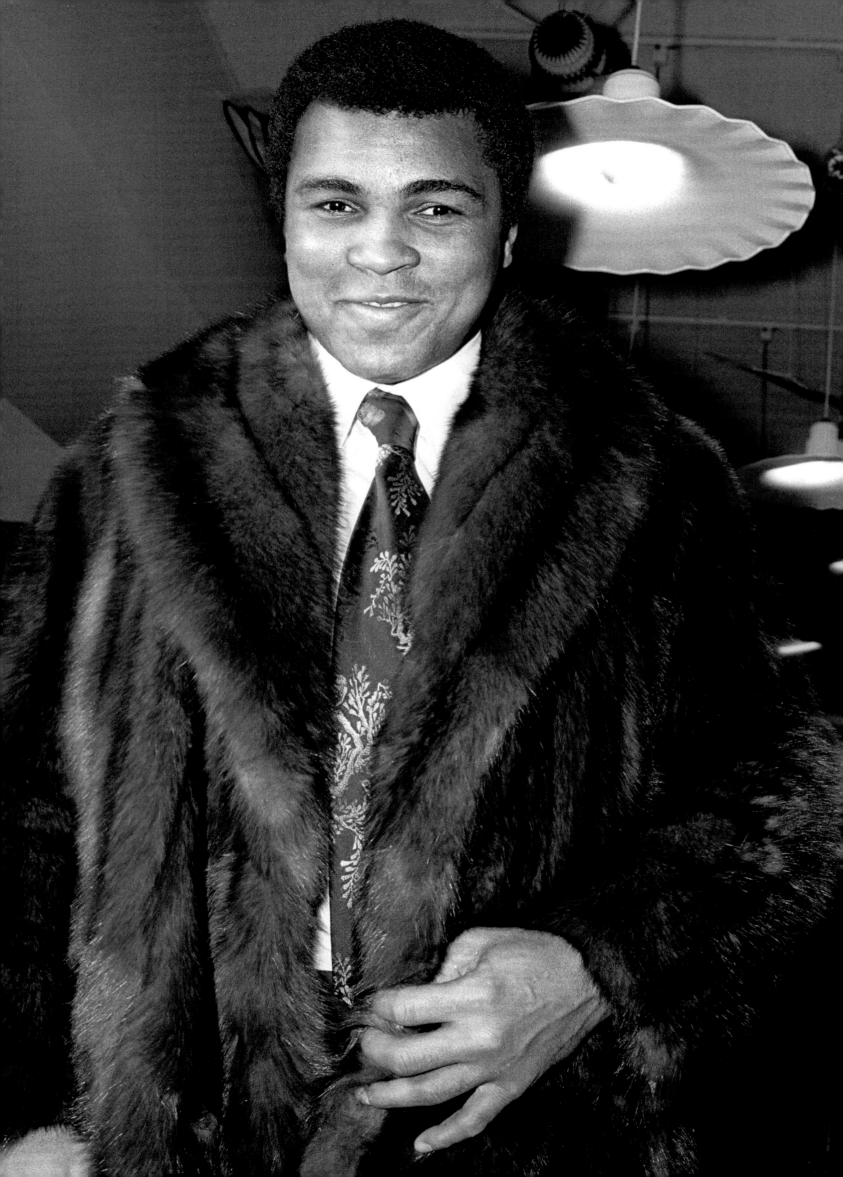

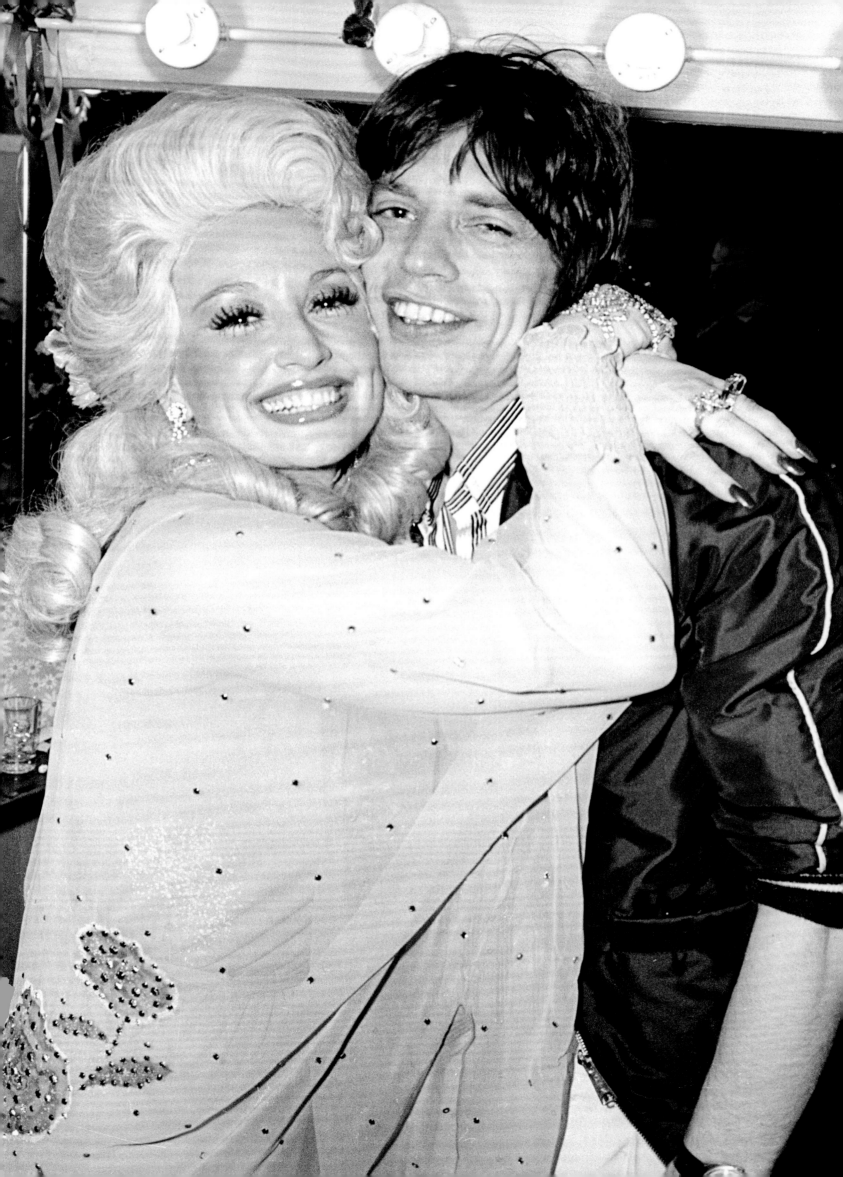

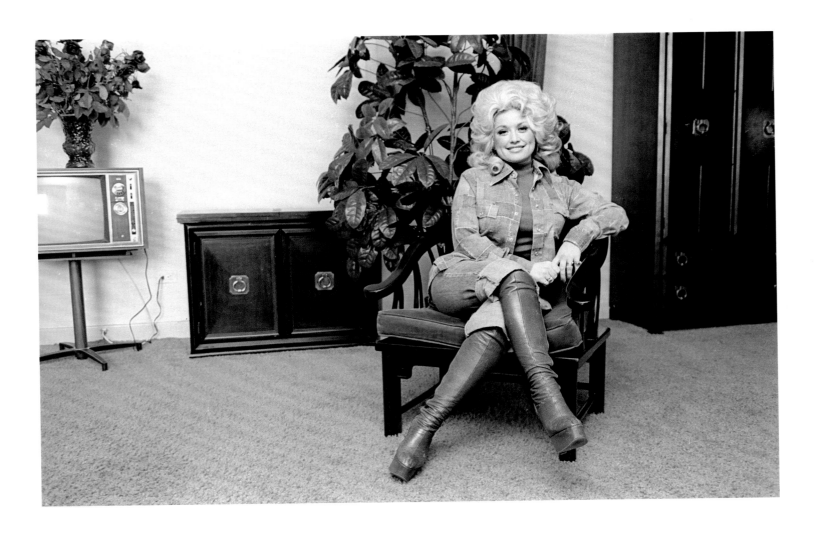

DOLLY AND MICK

A few years earlier, in May 1977, our paper had been doing a cover story about Dolly Parton's attempt to cross over from country music to the mainstream. Dolly was playing the Bottom Line, a popular club in the West Village that was also a record company showcase for breaking new acts and ramping up established ones. A lot of stars played there at some point in their careers, from Springsteen and Mingus to Elvis Costello and Blood, Sweat & Tears, and it was an ideal venue for her label, RCA Records, to break Dolly out to a non-country-and-western audience. Allan planted himself in front of a column in the middle of the room so that he would avoid obscuring patrons' view of the stage while he photographed Dolly. From his vantage point, toward the end of her performance he noticed Mick Jagger slipping into the club through a side door and heading to the far corner, where the kitchen was. Allan waited for the audience to file out and then for the other photographers to leave. "None of them had seen Mick at this point, but I watched him go backstage. I knew the guy manning the stage door, and he let me in. When Dolly saw my

camera, she grabbed Mick and gave him a big hug and flashed that warmhearted smile of hers. And I got an exclusive shot."

RCA pulled out all the stops with her crossover campaign, throwing a lavish press party at Windows on the World at the top of the World Trade Center. It was the only press party where I've ever seen Dom Pérignon served by the case. Celebrities including Terry Southern, Eric Idle, John Belushi, and Andy Warhol attended—and so did Jagger. "I was afraid that Dolly and Mick would connect again and that the other photographers would be able to duplicate my shot of the two of them," Allan says. "It can be very cutthroat sometimes, very dog-eat-dog. And it's a funny business because there are times when you need to keep information to yourself and other times when you need to share and have information shared with you by other photographers. I was proud that mine was the only photo of those two great performers from different worlds sharing an intimate moment. As a photographer, your job is to be an observer and to anticipate things. If you're not ready when the picture happens, you'll miss it."

OPPOSITE: Country music star Dolly Parton hugs Mick Jagger backstage after her Bottom Line concert in New York on May 14, 1977.

ABOVE: Dolly Parton relaxes in her hotel room the day after her Bottom Line concert and party at Windows on the World.

SUBSEQUENT PAGES: Elizabeth Taylor, Halston, and Bianca Jagger arrive for Elizabeth Taylor's birthday party at Studio 54 in 1978.

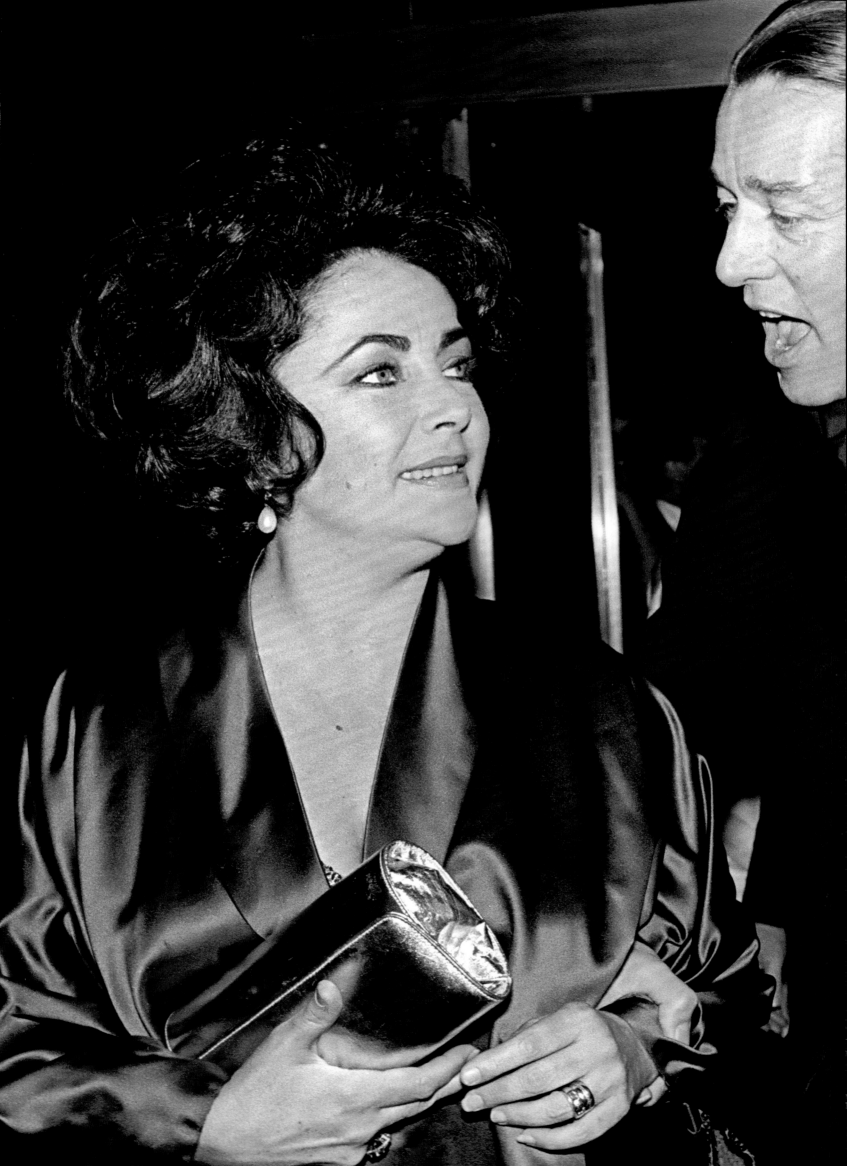

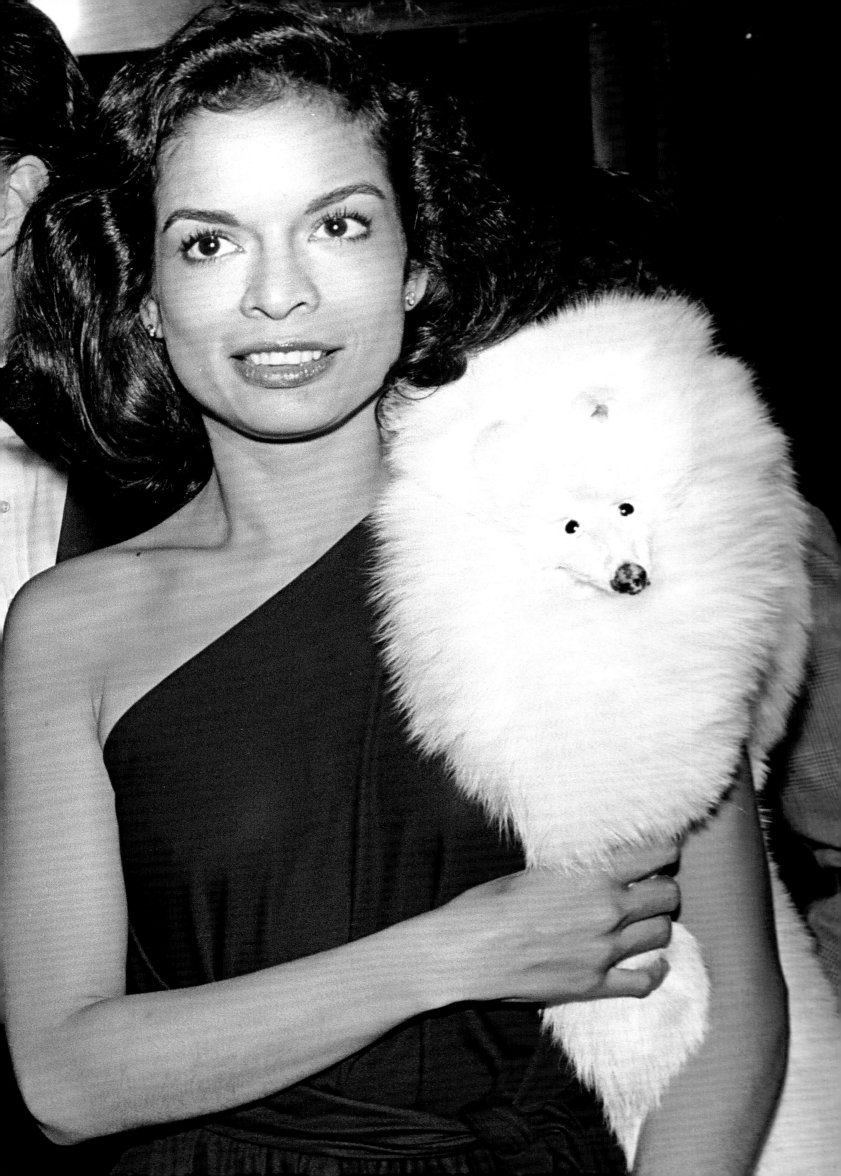

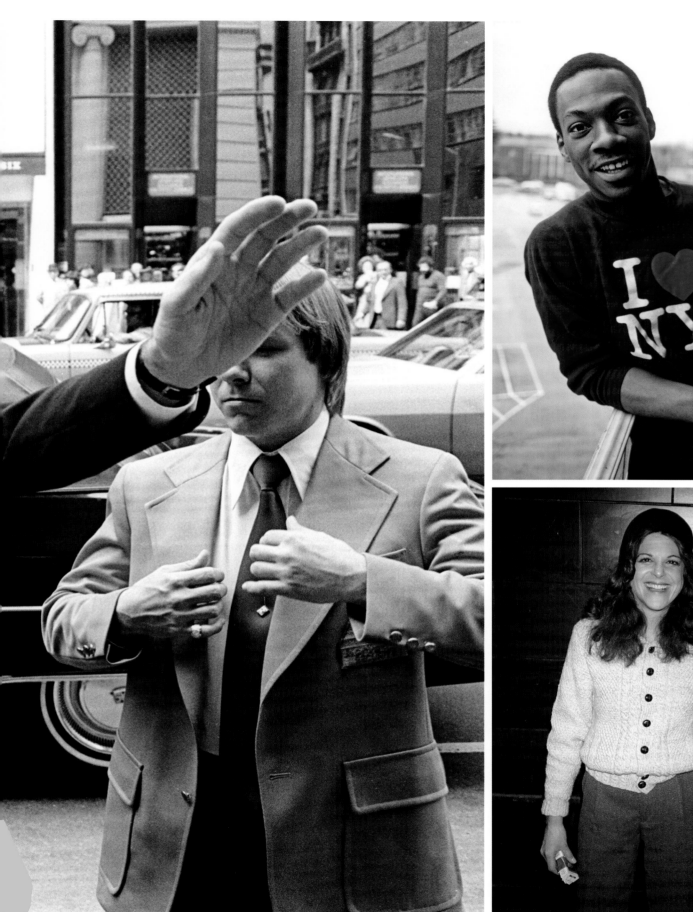

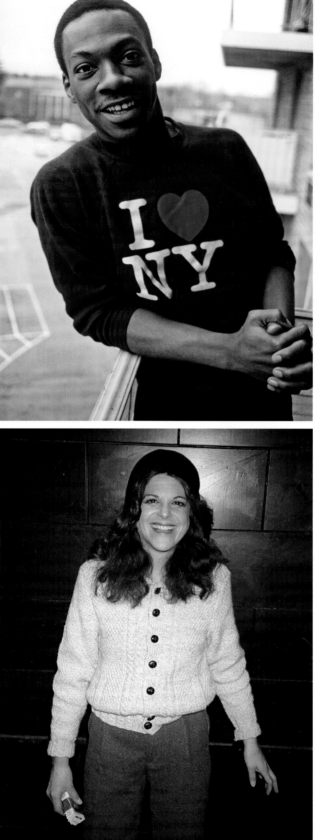

ABOVE: Steve Martin is a wild and crazy guy arriving for a promotional event at a Fifth Avenue department store in 1977.

TOP RIGHT: *Saturday Night Live* star Eddie Murphy at his mother's house in Hempstead, Long Island, in 1982.

BOTTOM RIGHT: Gilda Radner holds a pack of cigarettes on the set of *Mr. Mike's Mondo Video* in 1979.

WEEKEND WAKE

Eric Emerson, who had appeared in several key Warhol films and was a member of the Magic Tramps, a "glam punk" band, died in May 1975, just short of his thirtieth birthday. The cause of death was officially listed as a hit-and-run, although nobody was ever charged, and some maintained the accident scene was staged to cover up his death by heroin overdose. In any event, Max's Kansas City owner Mickey Ruskin hosted a wake that lasted all weekend, and was attended by many in the Warhol Factory circle, including David Johansen, who may have set out to prove that his elaborate drag costumes with the New York Dolls were just part of his stage persona.

ABOVE: Actress and model Jane Forth, who had a relationship with Eric Emerson, holds their son Emerson Forth.

OPPOSITE: Cyrinda Foxe and David Johansen.

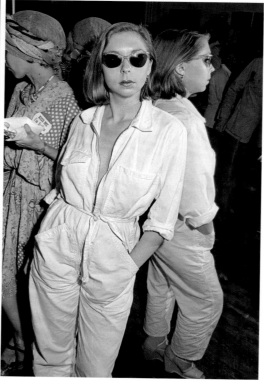

ABOVE AND OPPOSITE: Friends attend the wake for Eric
Emerson, who appeared in a number of Warhol films.

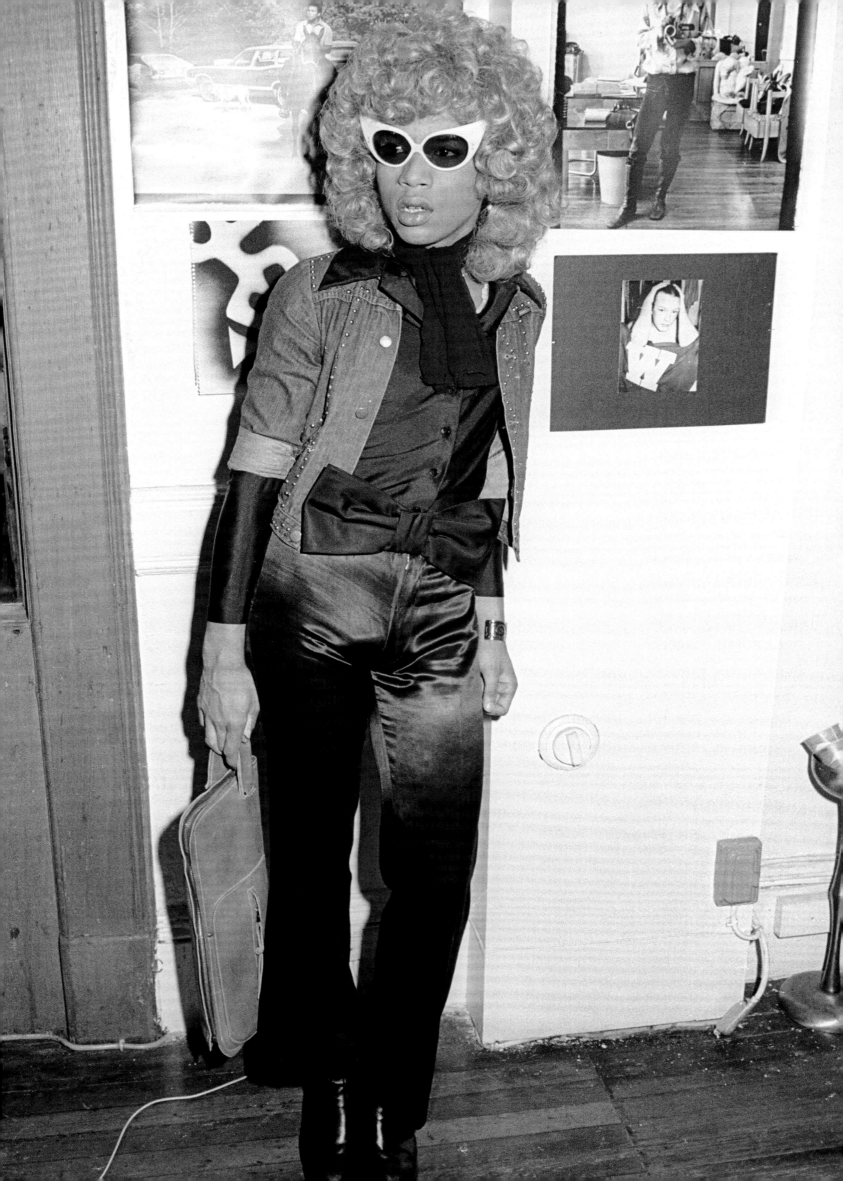

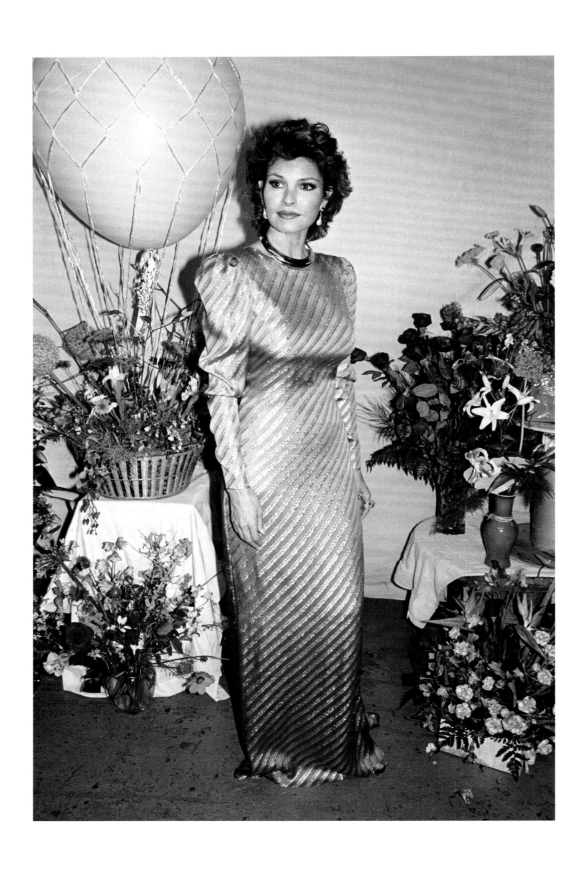

ABOVE: Raquel Welch attends a party after appearing in the premiere of *Woman of the Year* on Broadway in 1982.

OPPOSITE: Performer Divine on May 30, 1976.

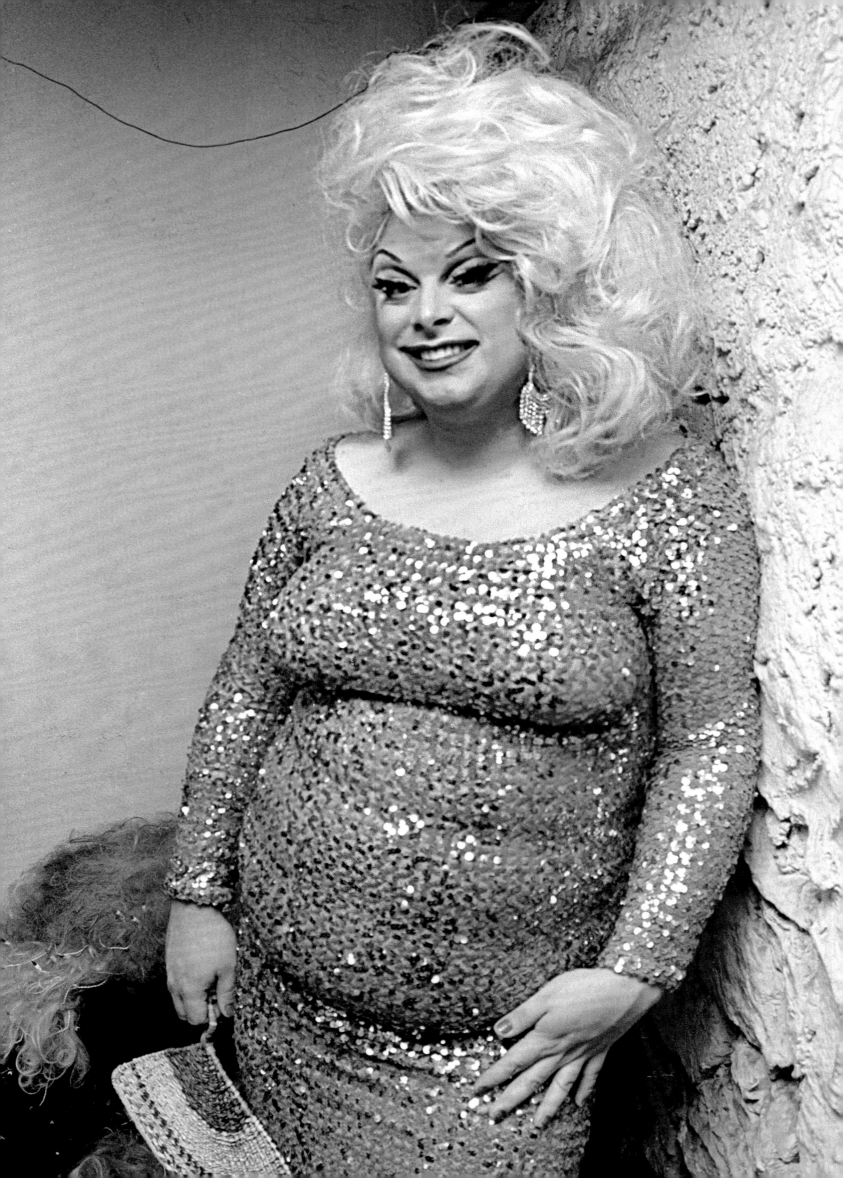

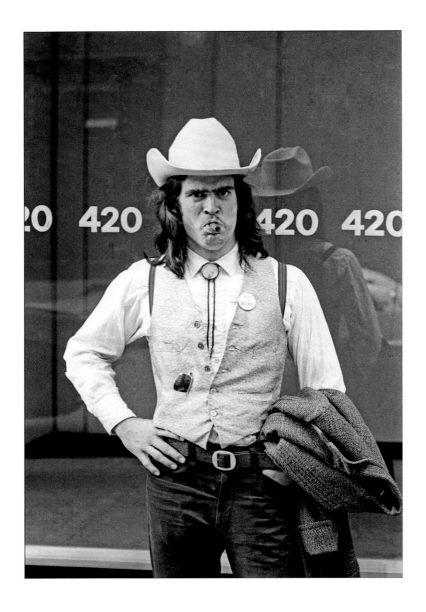

DAILY LIFE

A lot of Tannenbaum's time was taken up with the scut work required of most professionals in the newspaper world—making and returning calls to publicists, press agents, and managers, among others. And then writing it all down. He kept logbooks, which in retrospect make him wonder how he managed to cover as much as he did. Having city-issued press plates reading "NYP" allowed him to park in a number of marked spaces throughout the city, which was a saving grace. And you needed a car because taking taxis and subways wasn't going to work when you were carrying all that camera gear. A typical entry from his log shows how much cross-city traveling was required:

> Oct 29, 1979. Monday. 7 AM Antinuke demonstration at the New York Stock Exchange. 1 PM: Press conference with Bob Marley. 5 PM: Boat People news conference at St Patrick's Cathedral.

The contrast was sometimes amusing, if labor-intensive. "One day I began by shooting Tony Scotto, a local politician, at City Hall," Allan recalls. "Then I drove uptown to meet Mark Knopfler of Dire Straits at his hotel. The setting in his room was boring, so I talked him into going outside and posing as a cabdriver to get a different kind of shot." Having driven a cab himself early in his career, Tannenbaum felt comfortable approaching the driver, and used a similar setting with Joe Strummer of the Clash. In the same week he shot a portrait of Kiki Kogelnik, the abstract artist who was also a stylish dresser, then covered a casting call at the Lunt-Fontanne Theatre. His notes don't detail which play that was for or even who he photographed, but it was all in a day's work.

ABOVE: A cigar-smoking cowboy in front of 420 West Broadway in 1974.

OPPOSITE: Dire Straits lead guitarist Mark Knopfler poses as a New York City taxi driver in 1979.

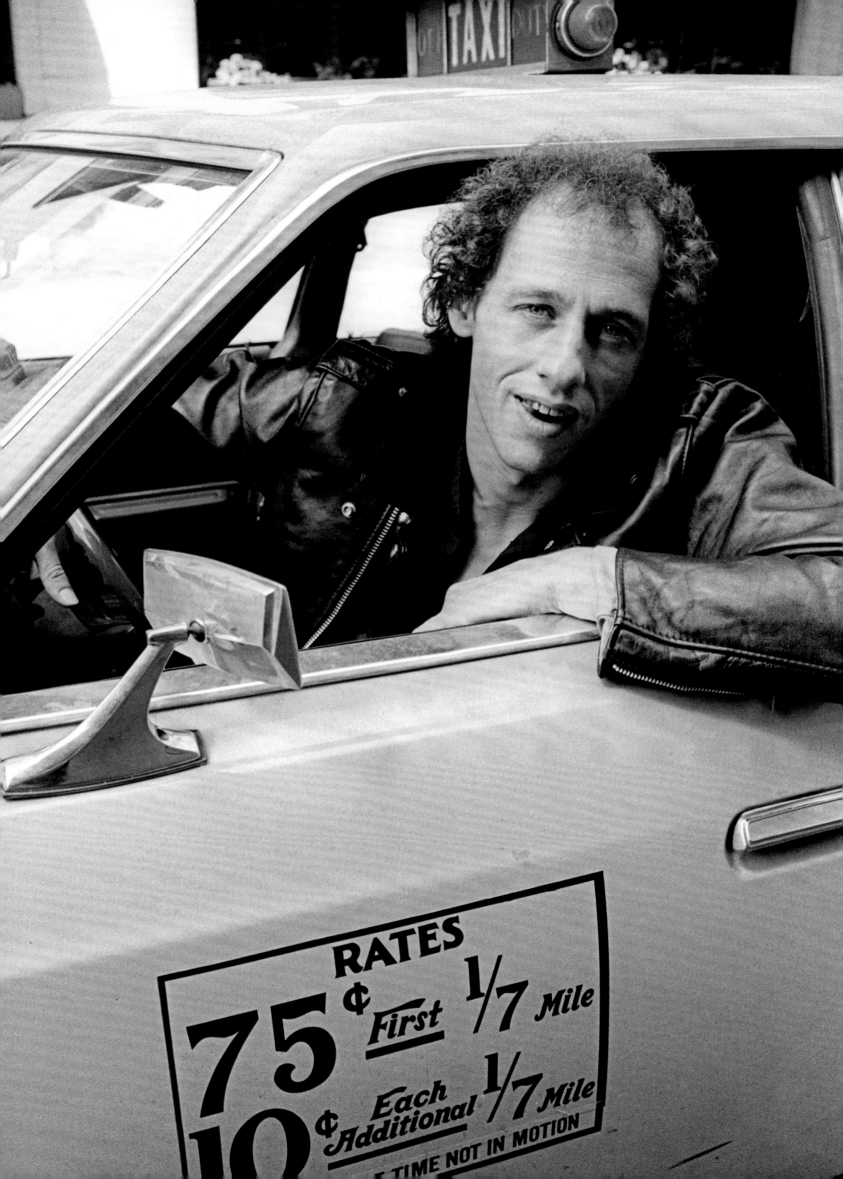

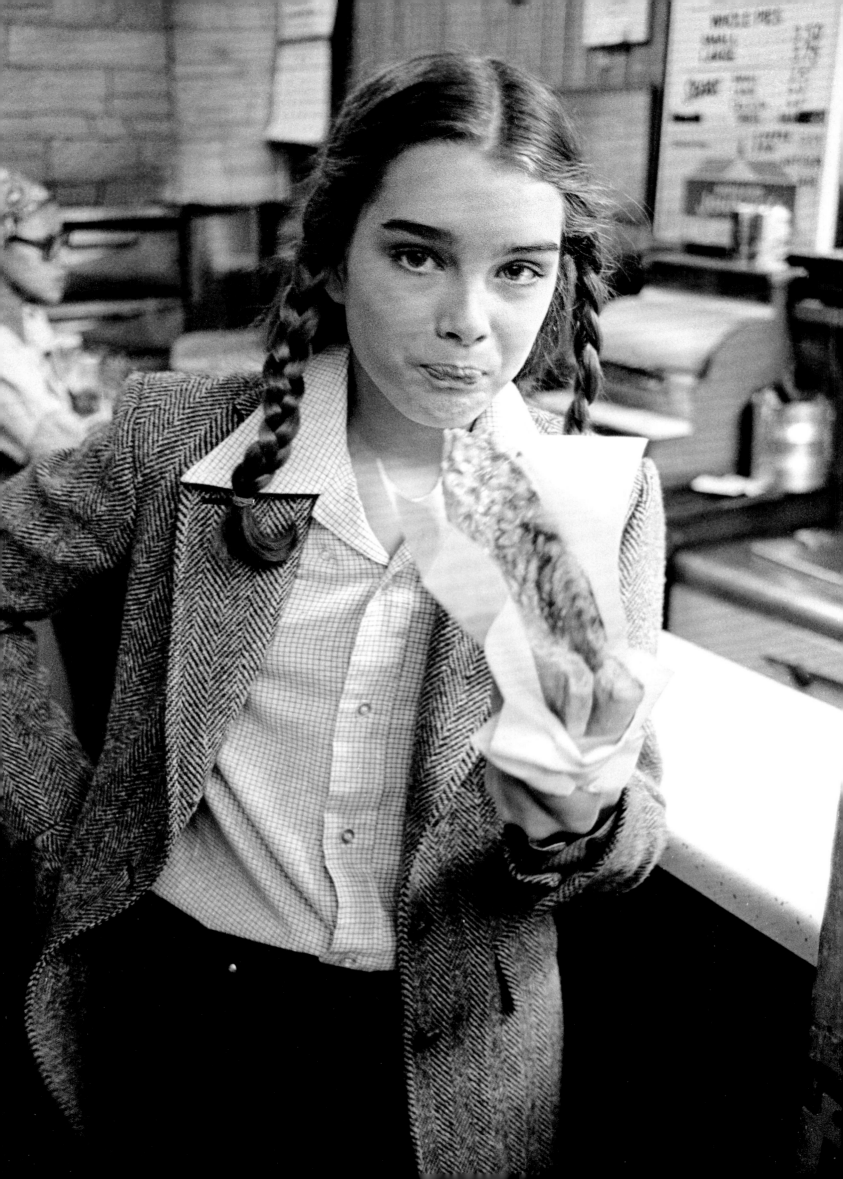

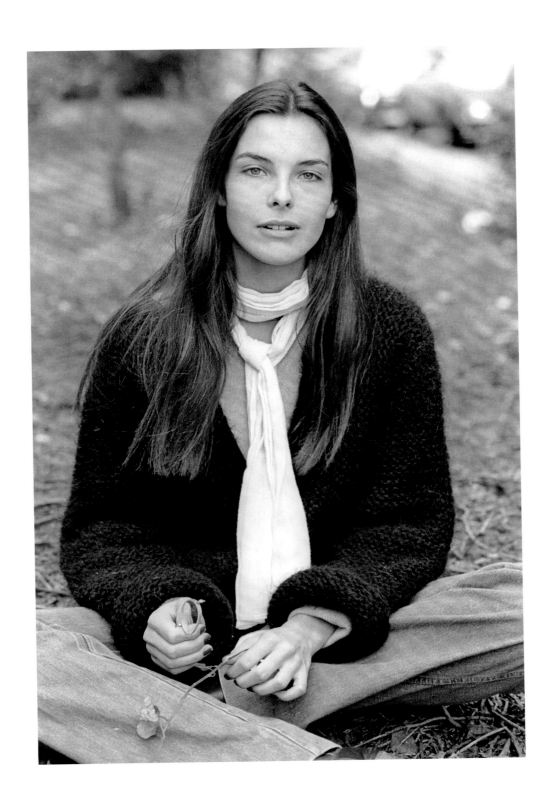

OPPOSITE: Brooke Shields takes a pizza break in her street clothes while playing Tita in *King of the Gypsies*, 1978.

ABOVE: French actress Carole Bouquet in New York for the premiere of the 1977 film *That Obscure Object of Desire*, directed by Luis Buñuel, in which she starred.

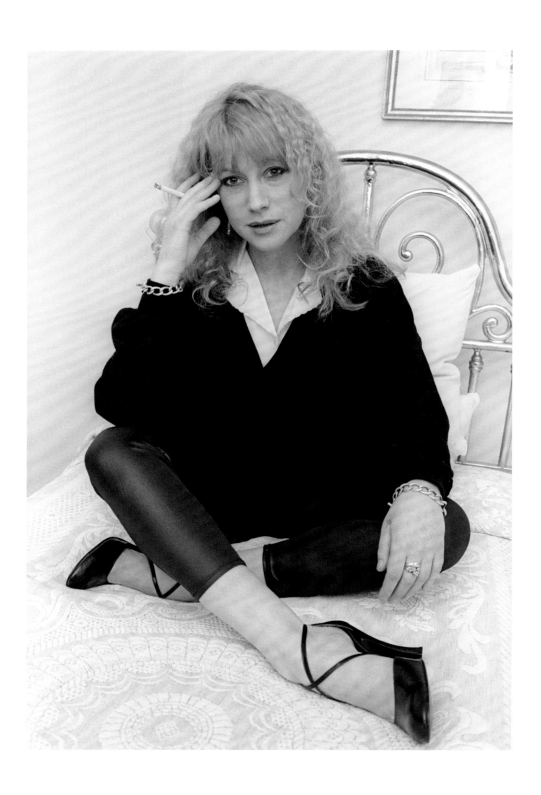

ABOVE: In town with the Royal Shakespeare Company in 1979, Helen Mirren mentioned to Tannenbaum that the renowned British theater troupe disapproved of her wearing stretch fabric in public. (No Spandex please, we're British?) And yet she looks not only beautiful (we knew *that*) but also relaxed and totally natural in what may seem like a thrown-together outfit of black V-neck sweater over a white scalloped blouse and defiant Spandex pants.

OPPOSITE: This 1981 candid shot of actress Dominique Sanda taken on the roof of the RCA building is an intriguing photograph: Sanda's hair, caught by the updraft, resonates with the verticals of the Empire State Building and World Trade Center in the background. Her casual style, combining a tailored suit with a splashy floral shirt and simple scarf, looks all the more striking against that classic skyline.

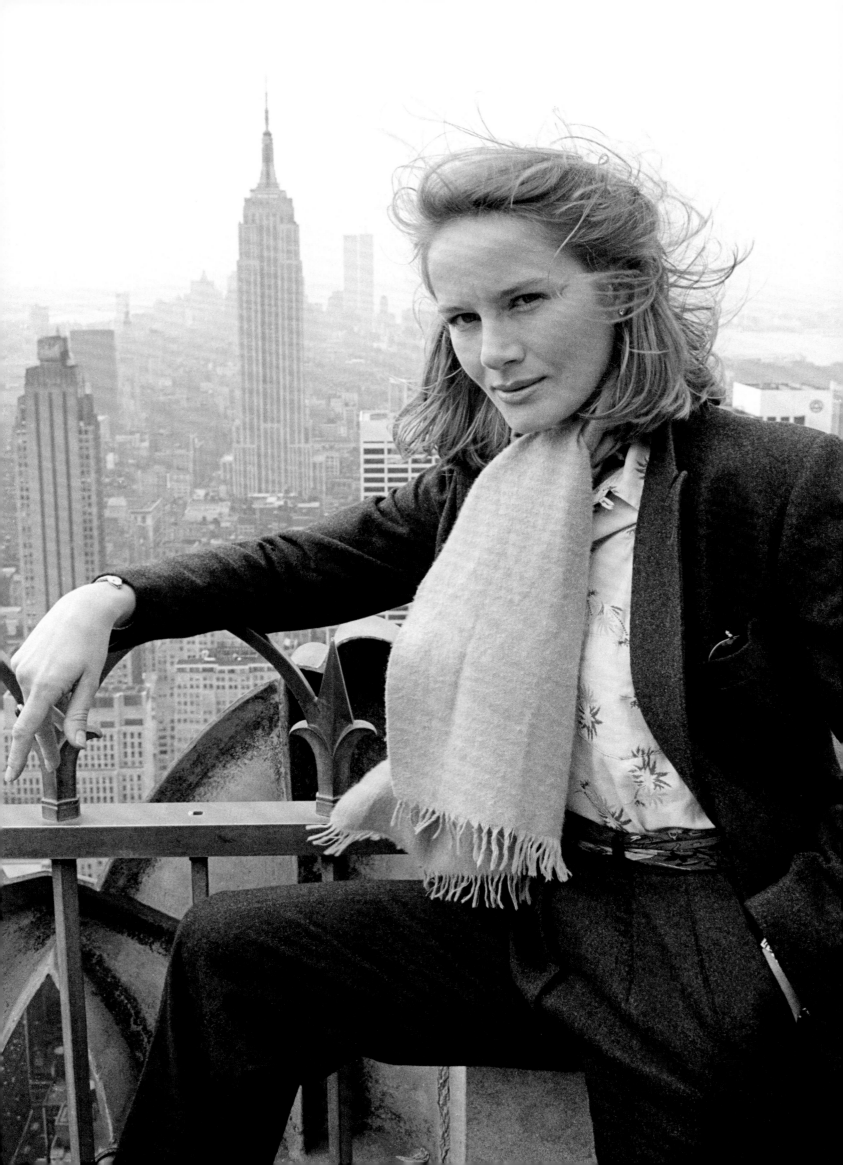

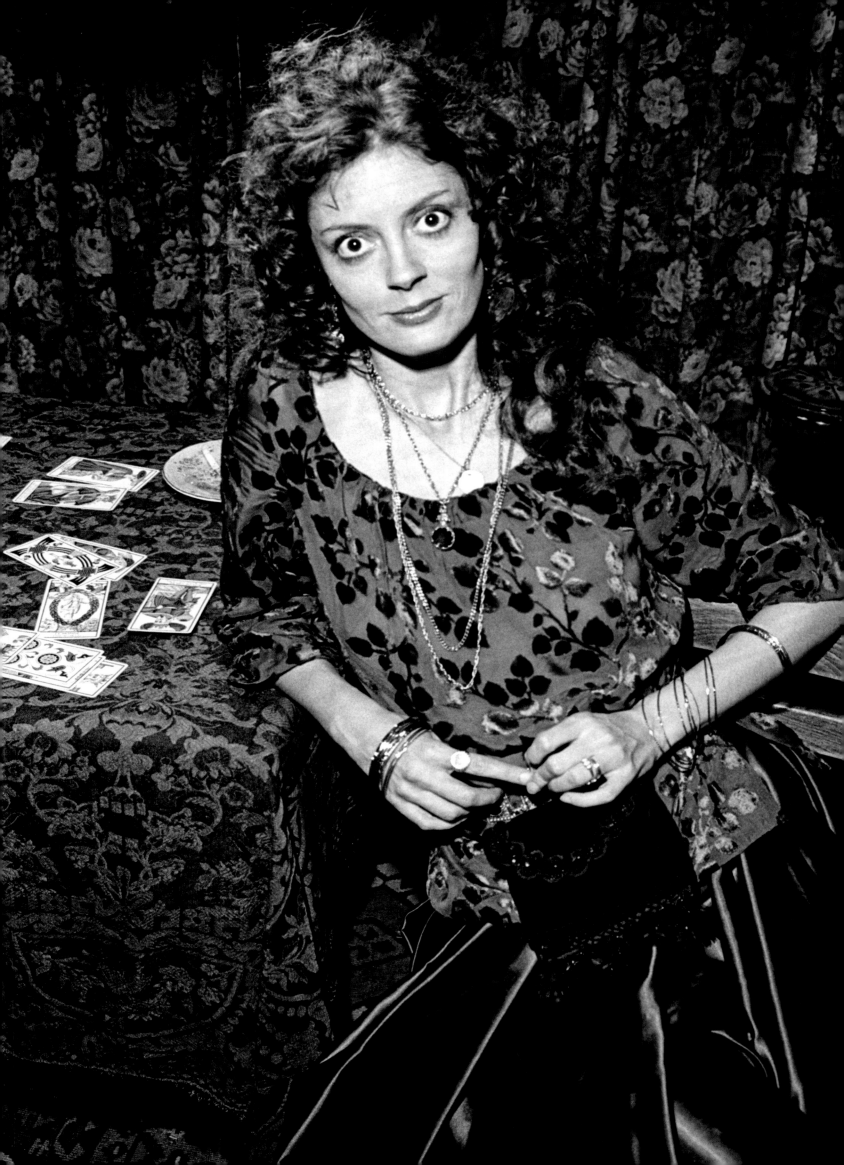

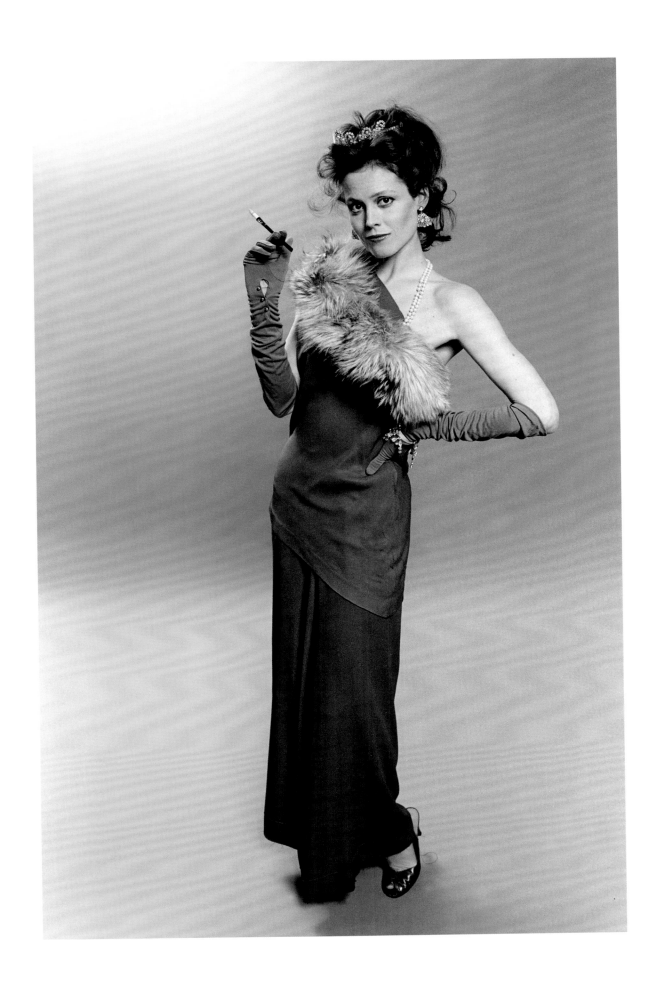

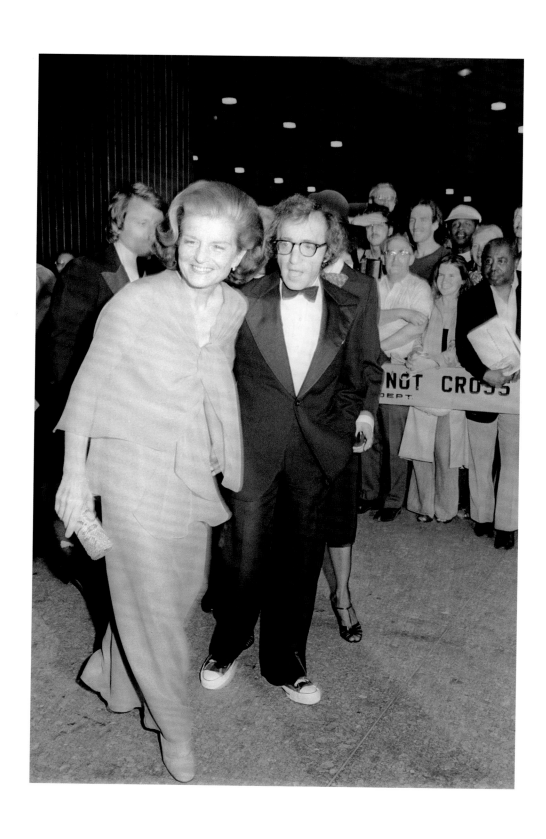

ABOVE: Woody Allen escorts Betty Ford to the 1975 opening of Martha Graham's *Lucifer*.

OPPOSITE: Director Francis Ford Coppola at the camera on the East Village set of *The Godfather, Part II* in 1974.

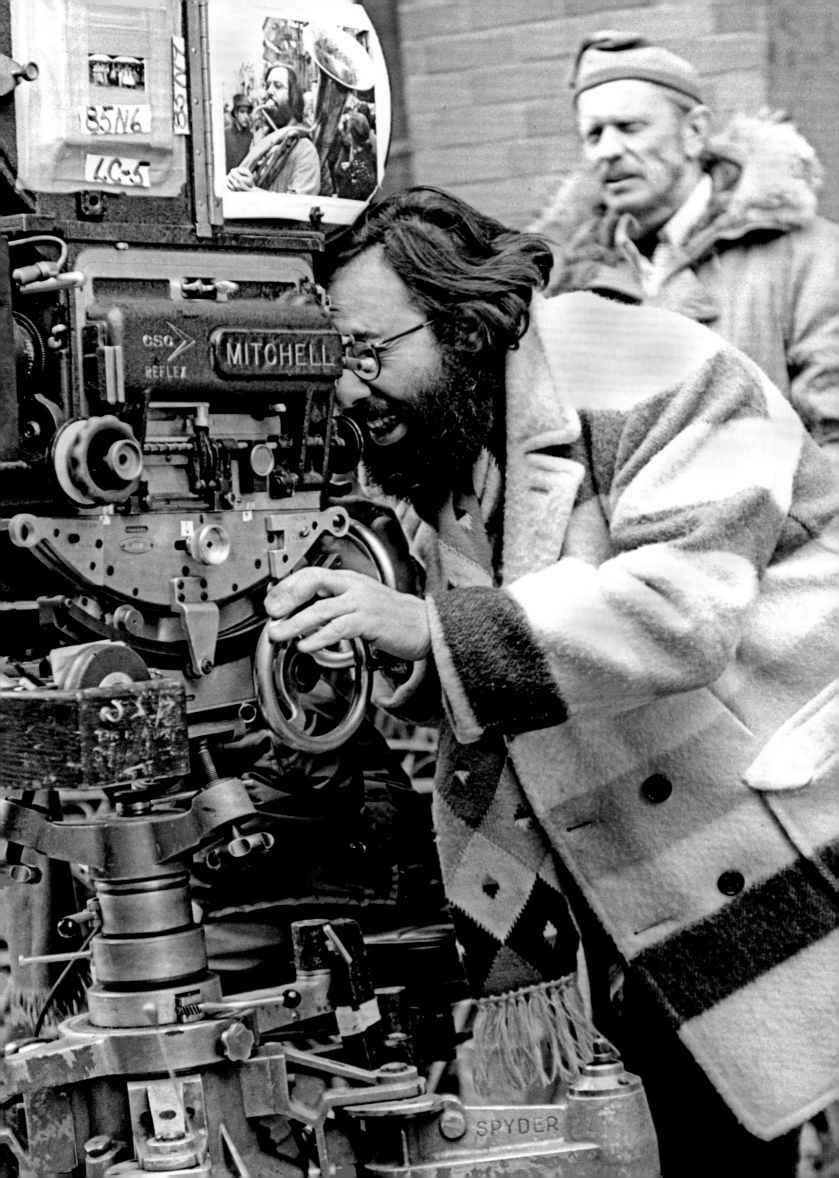

OPPOSITE: Meryl Streep attends a benefit gala in support
of nuclear disarmament on June 7, 1982.

ABOVE: Steven Spielberg during an interview in 1975.

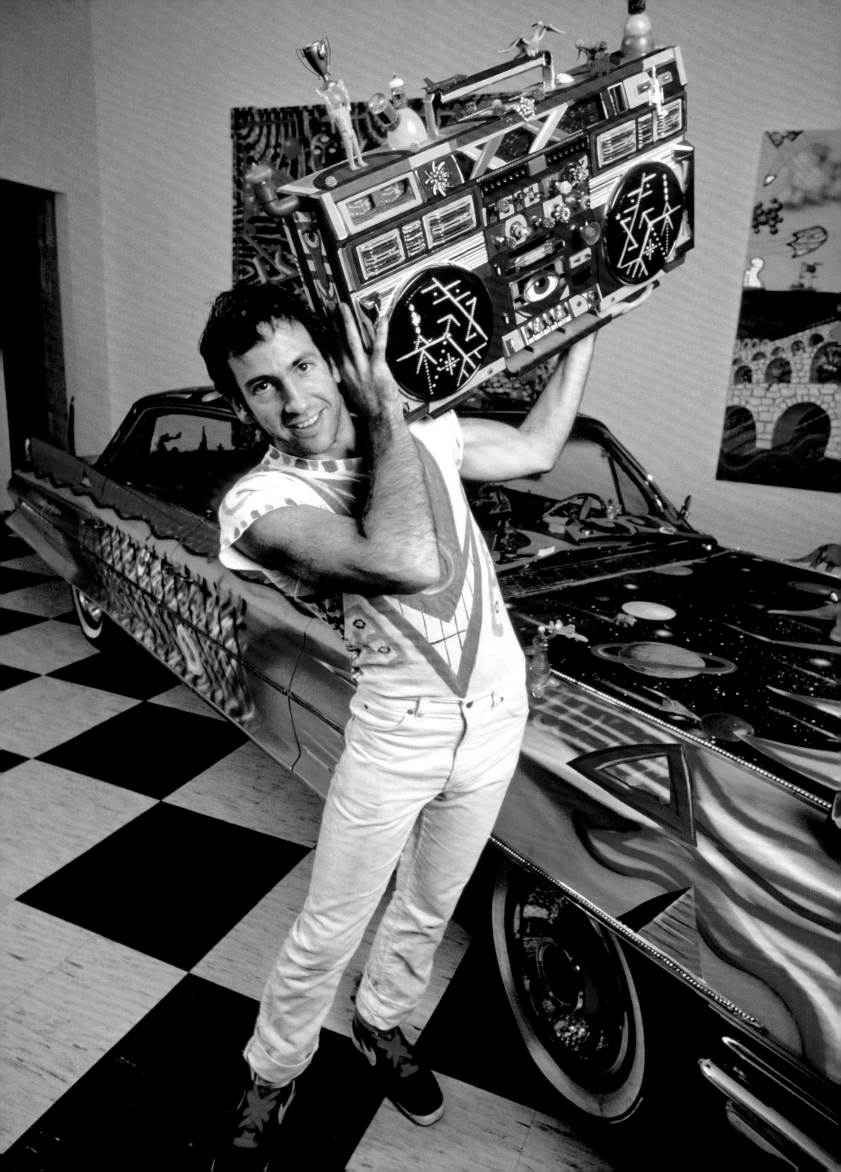

THE VISUAL ARTS

You might expect that most visual artists, with their strong sense of color and form, would be ideal subjects for photographic portraits. Indeed, most of the New York artists who made history in the 1950s through the '70s, as Abstract Expressionism dominated the art scene, were known for their extraordinarily bold, color-rich paintings: Jackson Pollock, Willem de Kooning, Hans Hofmann, and Mark Rothko. Yet by and large they weren't stylish dressers. They were known to show up at parties in paint-smeared overalls, as if they couldn't be bothered to change—or else wanted everyone to know they were artists.

Sculptor Forrest "Frosty" Myers, born in Long Beach, California, was a member of the pioneering Park Place Gallery on what is now LaGuardia Place, just north of SoHo, which preceded even the Paula Cooper Gallery, generally considered the first in Downtown Manhattan. Along with Myers' creations, the gallery showed work by future luminaries including Mark di Suvero, Sol LeWitt, Brice Marden, and Eva Hesse, and held performances by Steve Reich and Philip Glass, among others. Of all these present and future stars, Myers may have been the sharpest dresser, as is apparent from his zebra-striped suit with ruffled shirt and string tie; he is pictured with his wife, Debra Arch Myers. Perhaps his eye for exciting outfits can be traced to his prior marriage to Tamara Melcher of Tamala Design.

Another exception to the rule of plain-dressing painters was Robert De Niro Sr. (also known as Robert Henry De Niro). Robert De Niro Jr. enjoyed such a meteoric rise as a film star throughout the '70s—with his award-winning roles in Martin Scorsese's *Mean Streets*, *Taxi Driver*, and *Raging Bull*, as well as *The Deer Hunter*—that people often forget that his father had established a career as an artist dating back to the 1950s. De Niro Sr. lived with his wife in Greenwich Village, where they enjoyed a circle of friends that included the writers Anaïs Nin, Henry Miller, and Tennessee Williams. His work, which combined abstraction with representational references, is now in the collections of the Metropolitan Museum of Art, the Butler Institute of American Art, the Corcoran Gallery, and the Hirshhorn Museum—but he wasn't especially successful during his lifetime. He was also gay at a time when homosexuality was nowhere near as accepted as it is now.

It's easy to see the resemblance to his son, and the sense of boldness we've come to expect from De Niro Jr. is apparent in Dad's choice of a striking checked jacket, black turtleneck, and black Stetson hat at this opening at the Landmark Gallery in SoHo.

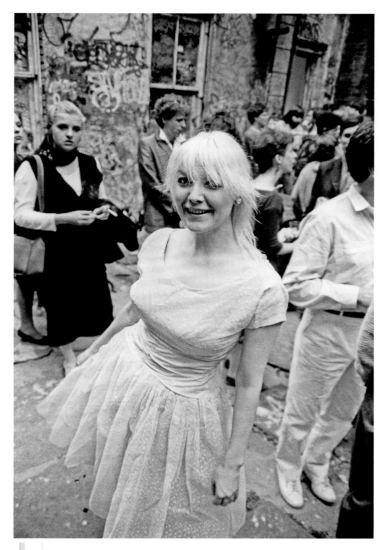

TOP RIGHT: Patti Astor in the backyard of her FUN Gallery in the East Village during a group show opening.

BOTTOM RIGHT: Artist Robert De Niro Sr. attends an exhibition opening at the Landmark Gallery in SoHo.

OPPOSITE: Kenny Scharf poses with his painted boombox and psychedelic Cadillac at the Tony Shafrazi Gallery in SoHo in 1983.

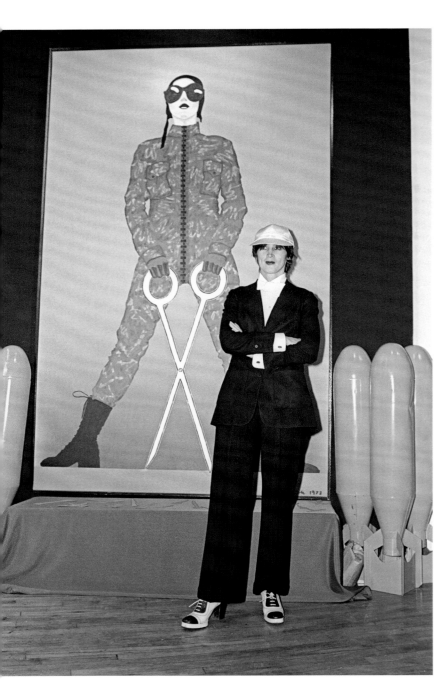

Austrian painter, sculptor, and printmaker Kiki Kogelnik studied art in Vienna and came to New York in 1961, where she spent time with fellow Abstract Expressionist Sam Francis. There Kogelnik joined a circle of renowned Pop artists including Roy Lichtenstein, Claes Oldenburg, Tom Wesselmann, Joan Mitchell, Robert Rauschenberg, and Jasper Johns. Back then, Pop was not only the latest art form but also a way of life, and Kogelnik frequently became a happening wherever she went. Witness her outfit consisting of satin baseball cap, wild two-tone stacked-heel shoes, and dark suit with formal white tie and cufflinks—the perfect foil for her own artwork.

In the early 1980s, the East Village was challenging SoHo as the happening new art center (and soon-to-be-gentrified slum). FUN Gallery, cofounded by Patti Astor and Bill Stelling, was the first of a series of East Village galleries that showcased the work of emerging graffiti artists Fab 5 Freddy, Lee Quinones, and Keith Haring, along with Kenny Scharf, Jean-Michel Basquiat, Lady Pink, and Futura 2000. Before starting her gallery, Astor had been a ballet dancer, spent several years as a member of the revolutionary group Students for a Democratic Society (SDS), and later acted in underground films by the likes of Jim Jarmusch and Eric Mitchell, as well as in Charles Ahearn's breakthrough film about hip-hop and graffiti culture, *Wild Style*. At a 1983 screening in the backyard of FUN, she looks luminous in a flouncy, girly cotton voile dress.

As a part of that emerging East Village scene in the early 1980s, Kenny Scharf painted pop culture icons in a science fiction world, or anthropomorphic, sometimes imaginary creatures in explosive colors. Because of his friendship with Keith Haring, Scharf is often lumped in with the graffiti artists of that era, and he did show at Astor's FUN Gallery. But he was born in Hollywood and spent years in Brazil, and perhaps as a result, his work has a sunnier aspect than a lot of graffiti art, evoking comic books and Walt Disney fantasies more than subway cars and urban grit. That playful spirit is apparent in a photograph of his hand-painted boombox and psychedelic Cadillac at the Tony Shafrazi Gallery in SoHo in 1983—right down to the sneakers and shirt that are styled to go with his art.

ABOVE: Artist Kiki Kogelnik attends a reception in her honor at One Fifth in 1977. OPPOSITE: Artist Frosty Myers, in a zebra pattern suit, and his wife Debra attend the PS1 Prom in 1976.

SUBSEQUENT PAGES: The women of Michael Oblowitz's new wave film *Minus Zero* pose for a studio photograph during a break from shooting. Standing *(left to right)*: Tina L'Hotsky, Jo Shane, Sue Williams, and Lisa Rosen. Seated: Leila Gastril and Rosemary Hochschild, 1978.

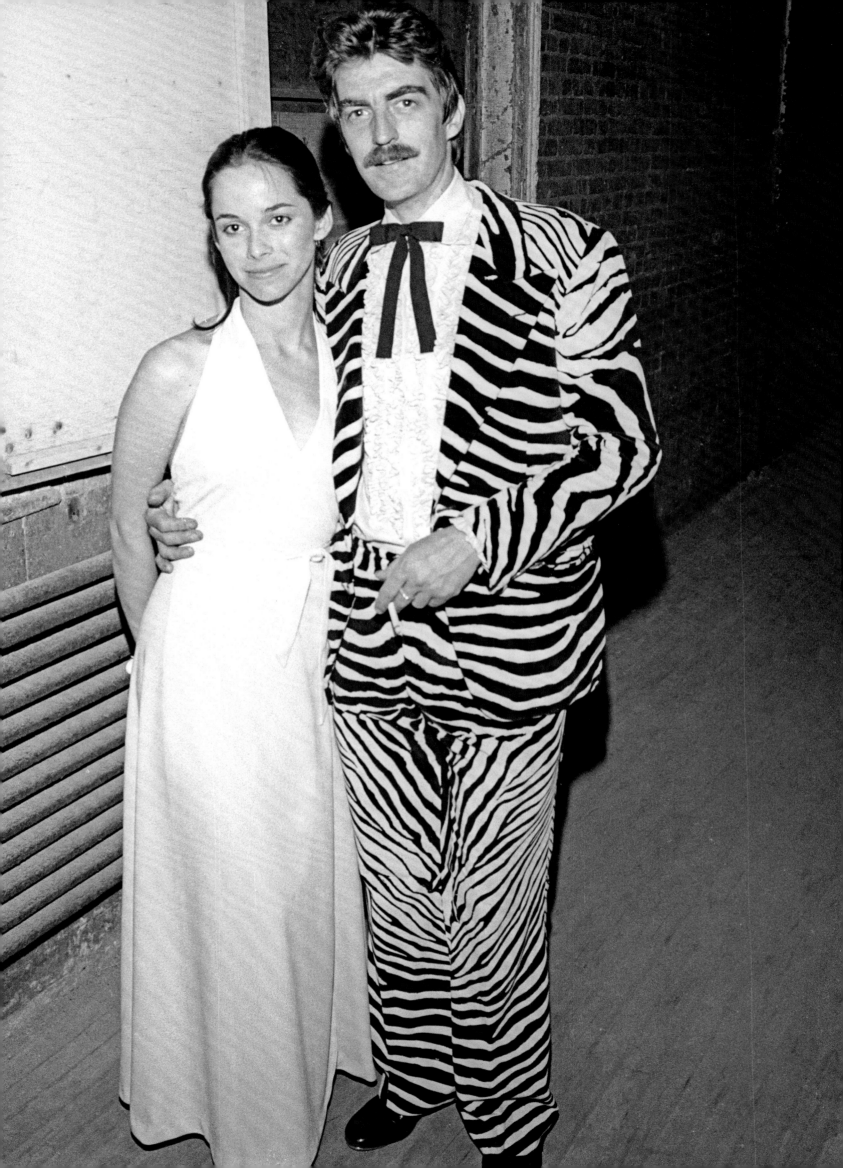

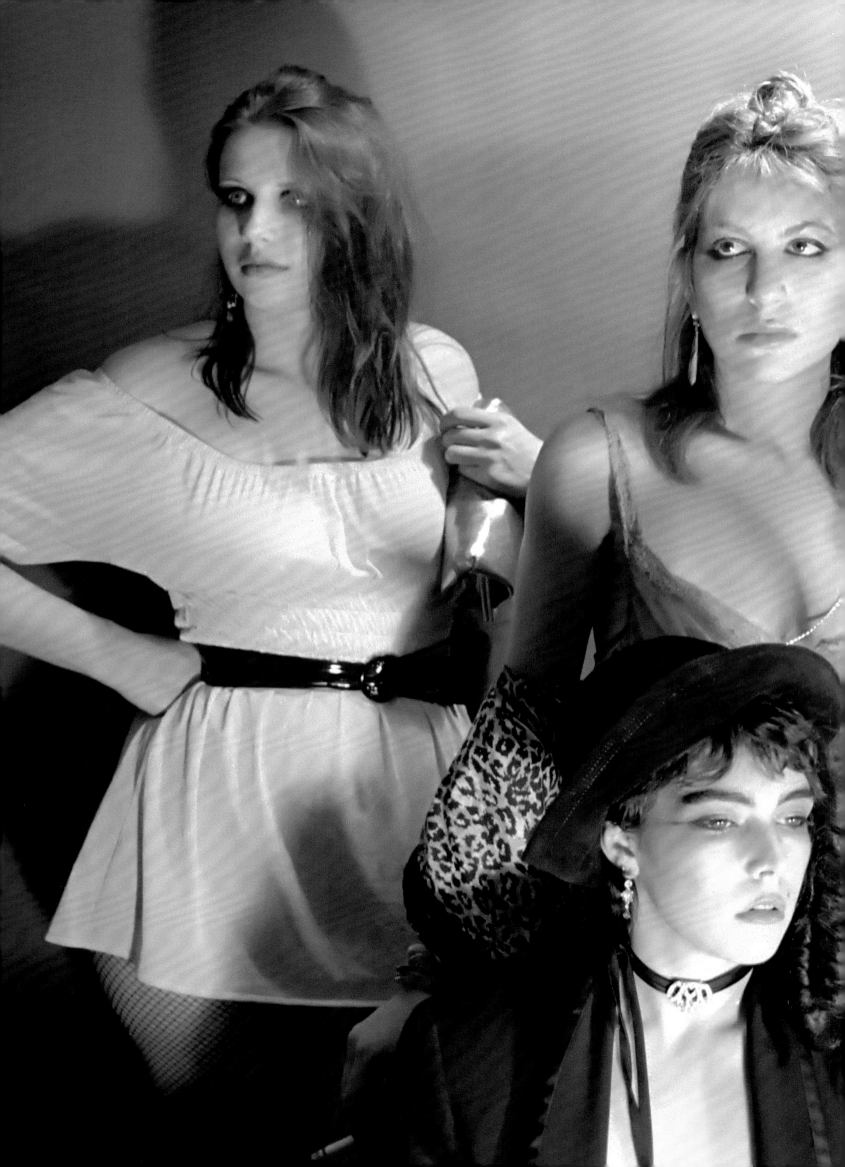

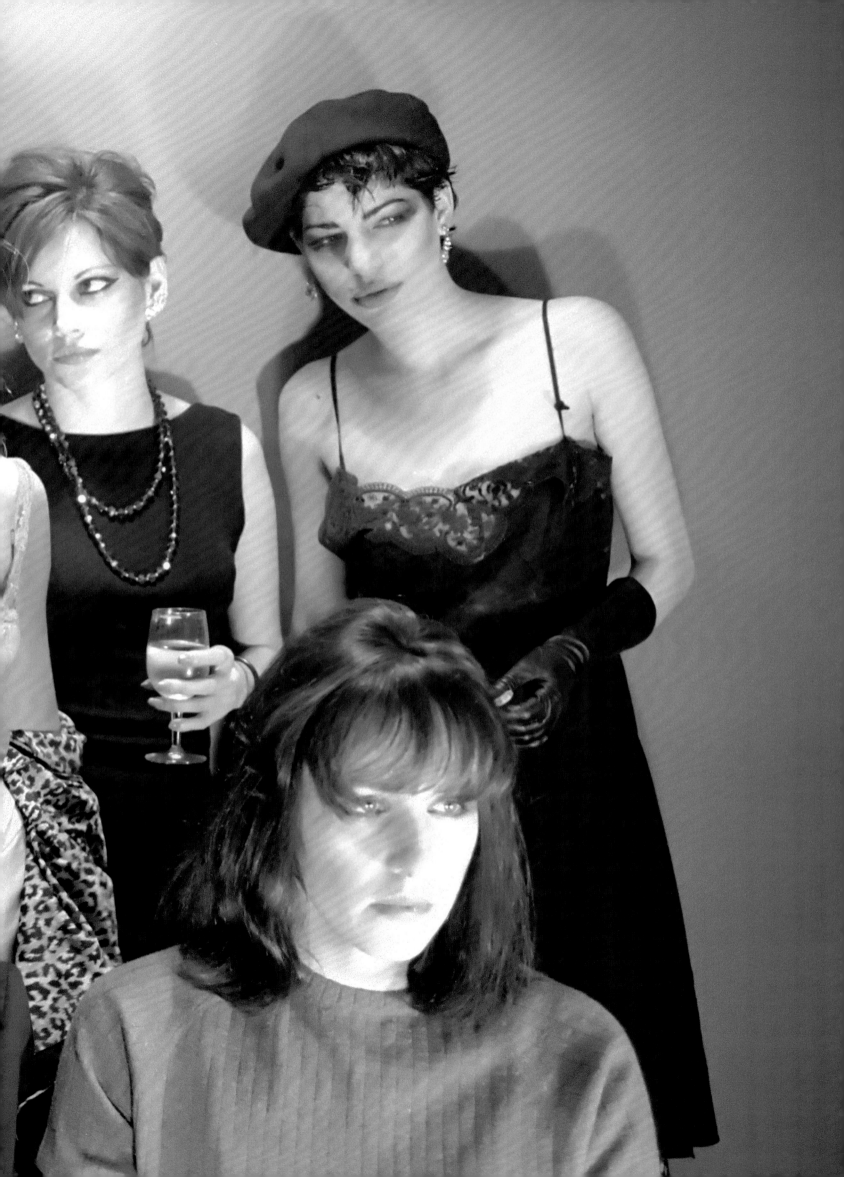

MOVIE STYLE INSPIRATION

I first came across Allan Tannenbaum's arresting photographs when I was designing the costumes for the film *American Hustle*. The film was set in New York in 1978, and I watched dozens of films and searched through hundreds of photos to immerse myself in the mood of the period. The film's writer and director, David O. Russell, had created characters who lived large, impassioned lives—they were wildly imaginative and wholly unique, and so I wanted their clothes to be equally compelling. I realized that I had to avoid any clichés or obvious choices. For inspiration, I continued to mine a wide array of resources, but it wasn't until I discovered Allan Tannenbaum's work that my imagination was truly ignited.

Allan's photos capture the wondrously expressive nature of how *real* people present themselves to the world, the complex and often contradictory choices that people make with their clothing every day. As a costume designer, I have a passion and a fascination for the messages that people give out to the world with their clothes, both consciously and unconsciously. Using tones, textures, and silhouettes, we all express who we are, and what makes us unique.

When I saw Allan's revealing photographs of New York arts and entertainment luminaries from the 1970s and early '80s, one word jumped into my head: *individuality*.

Today, celebrities live in fear of ending up on the Worst Dressed List, having unflattering paparazzi photos blasted across the Internet within minutes for public "entertainment," or having their personal style lambasted by snippy TV hosts. But Allan's New York captured the exuberance, the rakish confidence and explosive expressiveness, of the period's clothes. Through his photos, I developed such a passion for the era, when ideas were big; people took risks and didn't give a damn about the consequences. Today, we're so much more conservative; we hide in our clothes rather than using clothes to express ourselves. In Allan's hedonistic world, there are so many different silhouettes and styles. There's an authentic diversity, a sense that there's something for everyone, with so many exciting fashion choices to make.

In Allan's photos, as in *American Hustle*, the passions are as spectacular as the flaws. Everything surges with life, with an odd sense of romance, despite the heightened and often gritty realism. And so the sleek style of Al Pacino and the swagger of John Travolta inspire Bradley Cooper's character, Richie, the wild-eyed FBI agent who hungers to learn the art of the con to snare his leads, only to be caught up in the delirium of power. Christian Bale's character, Irving, a suburban con artist from Long Island who longs to be worldly and sophisticated, is a curious mashup of Woody Allen, Serge Gainsbourg, and Hugh Hefner. Amy Adams's fiery character, Sydney, is a creator of multiple identities: a mélange of Jerry Hall, Bianca Jagger, and Faye Dunaway.

I have to admit it was the women in Allan's photos that made the most lasting impact on me—I was struck by the new spirit in the clothes for American women in the late 1970s. It was clearly a time when there were new freedoms in fashion—less underpinnings, less structure, and bold, streamlined shapes. I wanted to convey the sense that Amy's character was constantly treading the razor's edge between supreme confidence and fragile vulnerability. With her low-cut, body-hugging costumes, she is going out on a limb, with very little between her and the world— she is in an emotionally raw, dangerous, and exciting space.

I studied the complex women in Allan's photos, one minute full of New York bravado, then as vulnerable and as lost as abandoned young girls. In the film I tried to capture this with a mixture of high-end vintage designer pieces (Halston, Gucci, Diane von Furstenberg, Missoni, Ossie Clark, Sonia Rykiel, Bob Mackie, Yves Saint Laurent) and lower-end everyday clothes. I was also drawn to using fur in this film because it's such a strong signifier of the mood of the period: to a modern politically correct audience, nothing creates a sense of lushness, a whiff of taboo, a raw sensuality as strongly as fur does.

I urge you to enjoy the delicious details of Allan's photos of the glorious arts and entertainment personalities of New York in the 1970s and early '80s. And at the same time, let the attitude of the photos' subjects inspire you to walk tall, be comfortable in your own skin, and let it shine.

—MICHAEL WILKINSON

OPPOSITE: Women dance at a party for the Tubes at Infinity in 1975.

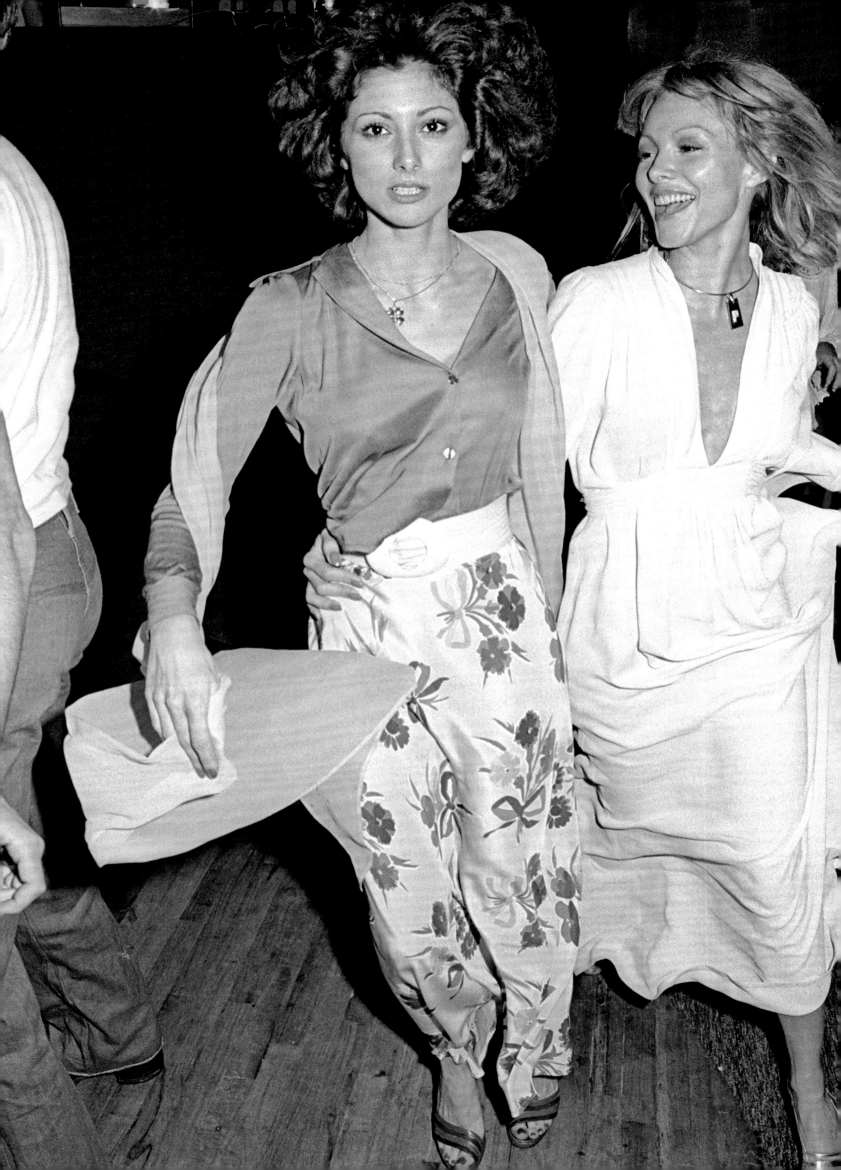

STREET STYLE

I hate the term, I think it's a stupid term, "street photography." I don't think it tells you anything about the photographer or work. On the subject, I have a book out called *The Animals.* Call me the same, I'm a zoo photographer. I mean it all really doesn't make any sense to me, you know? —Garry Winogrand

ALLAN TANNENBAUM HAS SAID that he was profoundly influenced by seeing Michelangelo Antonioni's 1966 film *Blow-Up.* The film, Antonioni's first entirely in English, followed a fashion photographer played by David Hemmings; Hemmings was based in part on the London photographer David Bailey, one of a trio of photographers now credited with creating the "Swinging London" scene combining fashion and celebrity chic. In the film, the Hemmings character comes to believe he may have unknowingly photographed evidence of a murder—hence the need to continually enlarge his prints to discern exactly what he has captured with his camera. The sense of mystery that drives the film made such an impression that Tannenbaum saw it three times and decided that he wanted to be a photographer. He even went out and bought a Hasselblad, the high-end Swedish camera that Hemmings uses in the film, and a favorite of fashion photographers. "I call it the movie that ruined my life," he says.

The unwittingly captured murder is never solved in Antonioni's movie (which also featured a soundtrack by jazz pianist Herbie Hancock and a rousing club appearance by the Yardbirds). That very sense of unresolved mystery raises the question of whether we can find a significant difference between street photography, social documentary photography, and photojournalism. The photojournalist sets out to record particular events for purposes of documentation, usually on assignment. By contrast, street photographers aim to capture chance encounters and random accidents in public places, which need not be actual streets or even outdoors. The key to classic street photography is catching people off guard in ways made famous by the likes of Henri Cartier-Bresson and Garry Winogrand.

OPPOSITE: Conrad and B.J. as pimp and hooker for a feature article entitled "Save Our Sleaze" in the *Soho Weekly News* in 1978.

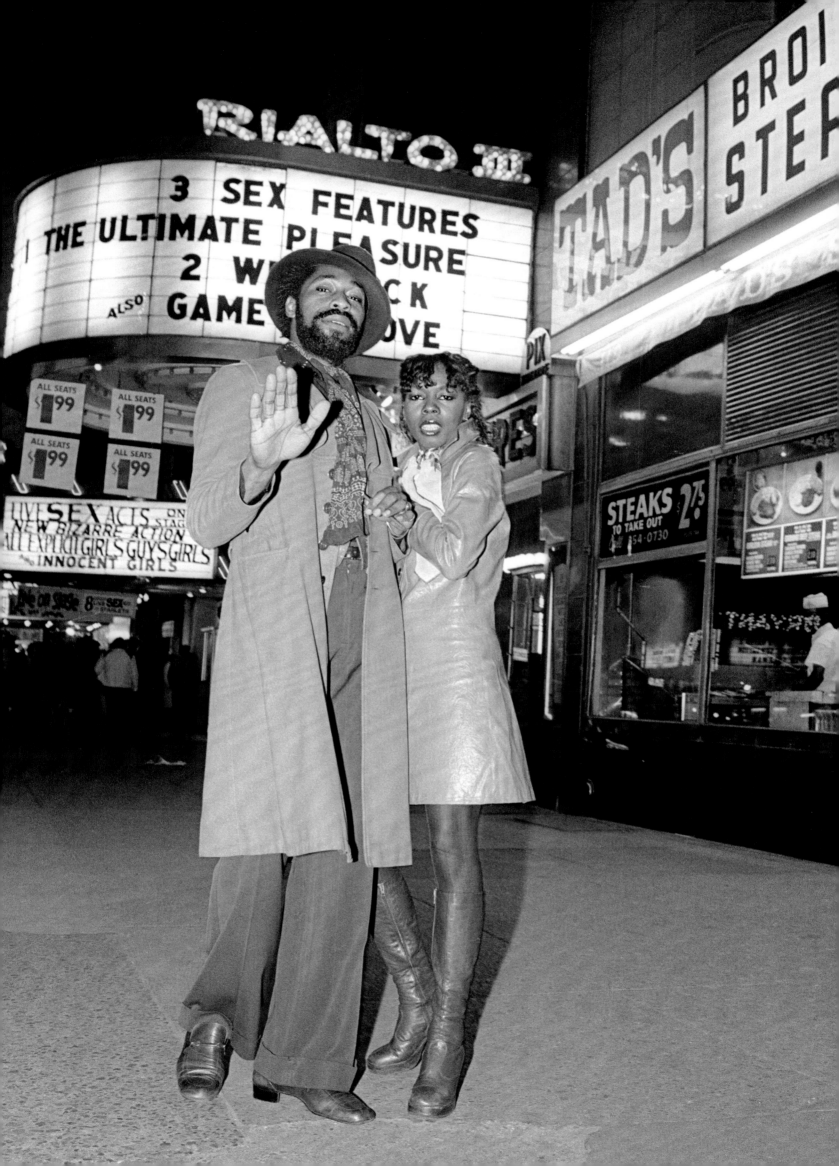

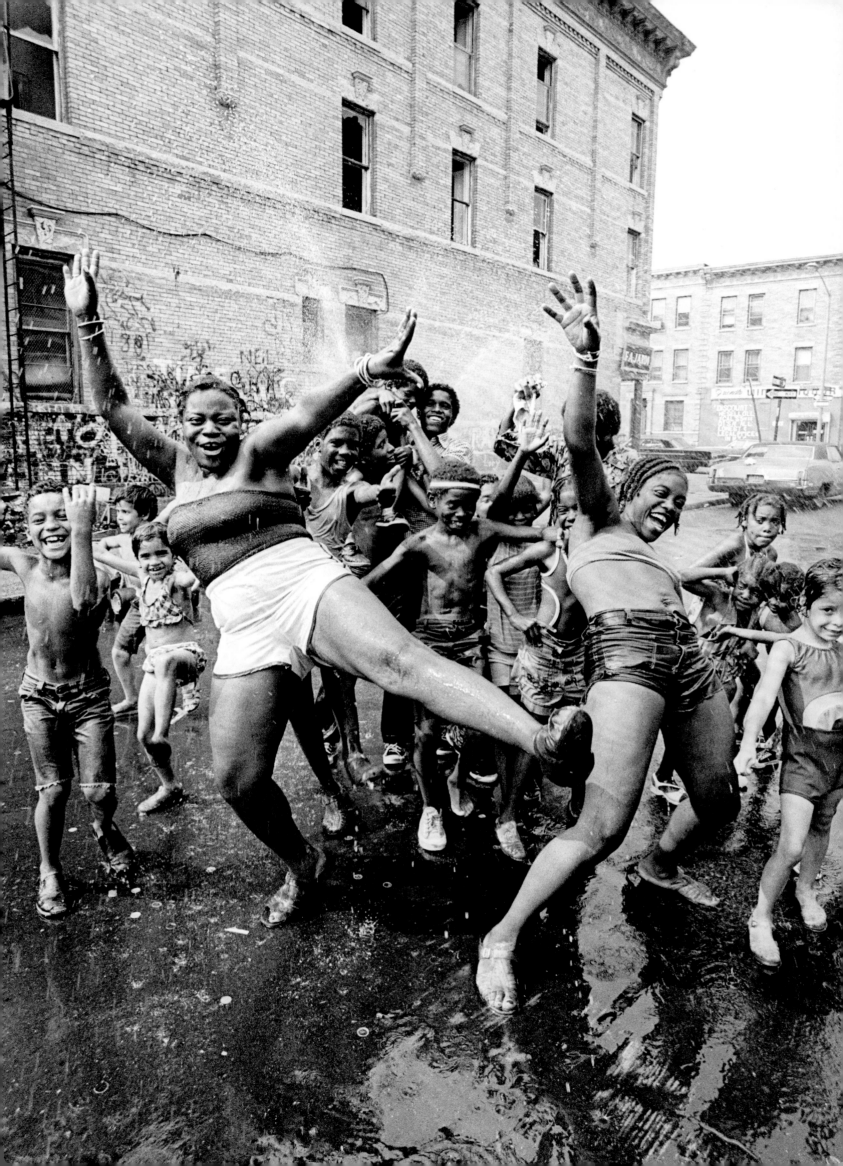

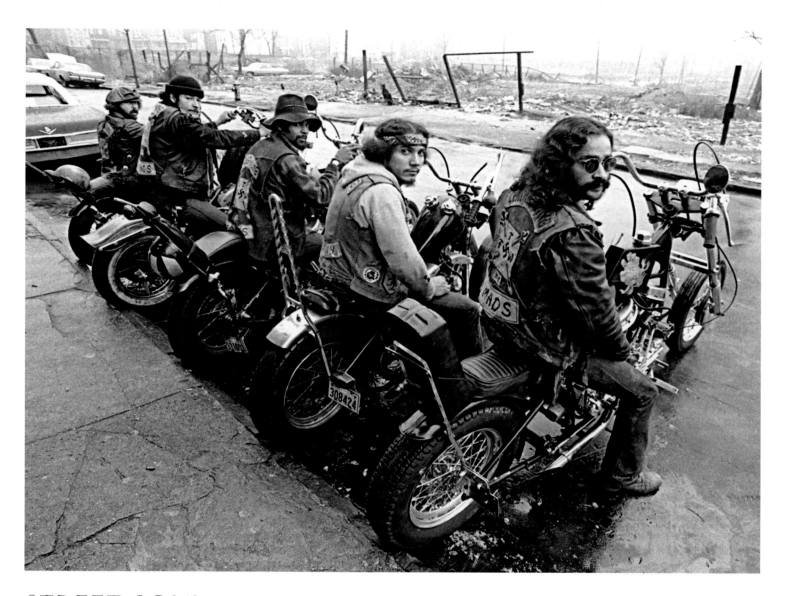

STREET SOUL

When people compare these forms of photography, they often imply that street photography tends more toward "fine art" than the other forms. Tannenbaum defined his own approach in a talk he gave in March 2016 to a class in advanced street photography at the International Center of Photography in Manhattan, describing how he started photographing in the streets of the Bay Area while studying filmmaking at San Francisco State University because he liked being outdoors and watching people. After he was hired as photo editor of the *Soho Weekly News*, however, he discovered that he was drawn to photojournalism even more.

> I asked myself, What is street photography, and what is it about street photographers that I like? A lot of their pictures had an air of mystery about them. A lot of them were visually clever, but that wasn't the kind of direction I was going into. I realized that as much as I like to go out in the street and take pictures, it's not primarily to make art. The pictures I liked to do were when I had an assignment, when I had a story to do, or when there was an event. And I like to tell the story. It's pretty much straight-ahead documentary. I find myself to be a kind of classicist when it comes to composition and tonality. Everyone develops his own style. As the photographer Ralph Gibson told me, "The work will show you the way."

Tannenbaum occasionally answered calls to cover unfolding events, like the apparent murder by Sid Vicious of his girlfriend, Nancy Spungen, at the Chelsea Hotel, and the former Sex Pistol's subsequent arrest and death by overdose. More often he responded to a particular assignment, as he has described in the section of this book concerning figures in the world of arts and entertainment. But on some days he simply grabbed his camera and went wandering through the streets of SoHo, the West Side, or Central Park, in search of whatever caught his eye.

The photos he shot on the streets of New York exhibit many of the styles and ethnic currents percolating in the world's most famous melting pot in the 1970s. These sights range from Chinese New Year and St. Anthony's Feast in Little Italy to the Gay Pride and Legalize Pot parades; the celebrated Ninth Avenue Street Fair and flea markets; motorcycle gangs from the South Bronx to Alphabet City; Guardian Angels and Hare Krishnas; denizens of the old Times Square; and sometimes just artists wandering the same SoHo streets that Tannenbaum frequented. Some elements of this vast diapason of social and aesthetic groupings inspired designers. who turned their looks into couture. More important, people on the street were creating their own styles, just as so many of the musicians and nightlife habitués profiled throughout this book had done.

OPPOSITE: Women cool off with boys and girls under spray from a fire hydrant sprinkler in Bushwick, Brooklyn.

ABOVE: The Ching-a-Lings were a Puerto Rican motorcycle gang living rent-free in a city-owned building in the South Bronx in 1975.

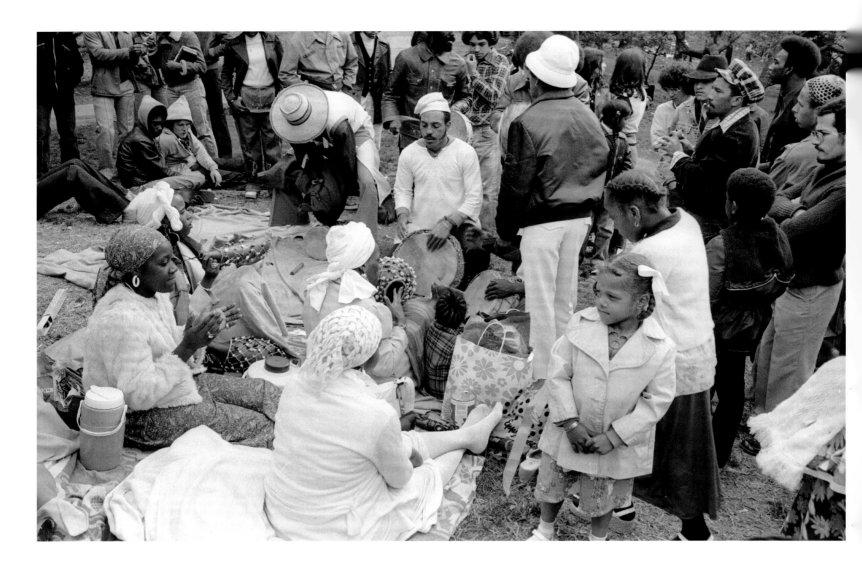

CENTRAL PARK

The 1970s were certainly a good time to be roving the city with camera in hand. New York was going through a period of desperate economic troubles, leading to the infamous *Daily News* headline of October 1975, "Ford to City: Drop Dead." Ford denied that such a sentiment was his intent; in fact, according to the *New York Times*,

> Only two months after saying or meaning or merely implying "drop dead"—or, perhaps, resorting to tough love by holding the city's feet to the fire—Mr. Ford signed legislation to provide federal loans to the city, which were repaid with interest.

But the image had already been created of a city on the brink of default, and to many New Yorkers it *felt* as if the city was a mess and that quality of life was at a low ebb. Uncollected trash bags often lined the streets and subway cars were filled with garbage (as well as being covered with graffiti, which was eventually recognized as a legitimate—and salable—art form), yet no-

body seemed to care. Contrary to the general consensus that the '60s were the most creative decade in recent memory, the '70s were probably an even more creative time, although the creativity wasn't always the kind that winds up in museums; indeed, it struck some residents and visitors as downright undesirable. *Soho News* publisher Michael Goldstein sent Tannenbaum to cover the scene in Central Park, especially around Bethesda Fountain and the nearby Naumburg Bandshell, where city folks and tourists alike went to relax on weekends. Although some New Yorkers found the mixture of music and clothing styles there an emblem of the city's vitality, for others the crowds of hippies smoking pot, Latinos playing conga drums, and gay couples strolling openly arm in arm represented everything that certain city residents or visitors from Topeka didn't want to see.

The candid photographs that Tannenbaum took in different parts of the park revealed the face of New York as it existed then, when the

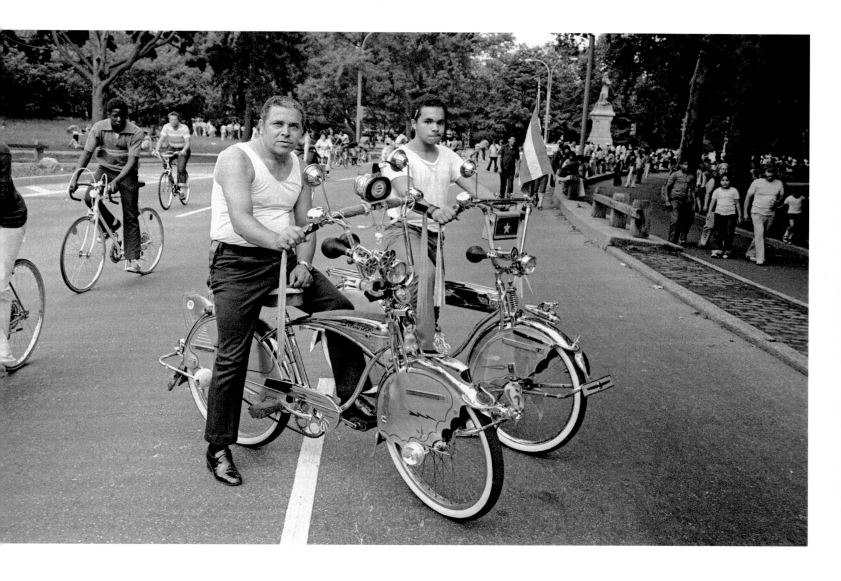

park was vibrant and genuinely multicultural—before that became an academic buzzword. He also photographed Times Square in the years before the corporate cleanup that turned the area into a vast tourist shopping mall. But somewhat like David Hemmings's character in *Blow-Up*, Tannenbaum has taken photographs that can convey information he may not have been fully aware of at the time. Pablo "Yoruba" Guzmán had been living in the city at that time and viewed the scene in the park from an insider's perspective. In the early 1970s, Guzmán was a founding member of the Puerto Rican activist group known as the Young Lords, a branch of the original Young Lords of Chicago that took shape in the Bronx and later became known as the Young Lords Party. The Lords' protests led to clashes with New York police, and Guzmán wound up serving nine months in federal prison for his part in those protests. Nonetheless, he later went on to a successful career as a news reporter for New York TV stations including WNEW, WNBC, and WCBS for many years.

The Young Lords in the Bronx had disbanded by the late '70s when Yoruba approached me about writing music reviews for the *Soho News*, which is how we met. Looking at Tannenbaum's photos now, Guzmán, who was born in the Bronx of Puerto Rican and Cuban descent, sees nuances that might not be immediately apparent to someone less familiar with Latino culture in New York City in the 1970s. "Back then, people were more into 'styling,' into making a statement on the street, than they are these days," Guzmán says. "It was grungy and it was dirty, but what jumps out at you from these photos is that people were rising above that. In what Puerto Ricans call *Loisaida*—the Lower East Side, the barrio—it was clearly a ghetto, but you still saw people struttin' their stuff. It's like when you see a flower growing up through a crack in the sidewalk."

OPPOSITE: Caribbean families enjoy Sunday in Central Park in 1974.

ABOVE: Two bicyclists show off their heavily chromed custom Schwinn bikes in Central Park in 1977.

PREVIOUS PAGES: Styles can be mixed and matched in surprising ways. Commenting on the group gathered at the Naumberg Bandshell near Bethesda Fountain in the park in 1977, Yoruba says, "The guy in the bandanna clearly looks like he hung out in the Village and not just the South Bronx—although a lot of this style would seep back to the South Bronx. When I was in high school in the Bronx in the late '60s, only a few guys had that Jimi Hendrix look, or were even *into* Hendrix. In the Black community, a lot of people were not into Hendrix because they thought he played white music. It took a while for that to start breaking down. But in the '70s that all went out the window."

ABOVE: Women and men enjoy Sunday in Central Park in 1974.

OPPOSITE: A cyclist from Harlem takes a break from riding in Central Park, 1977.

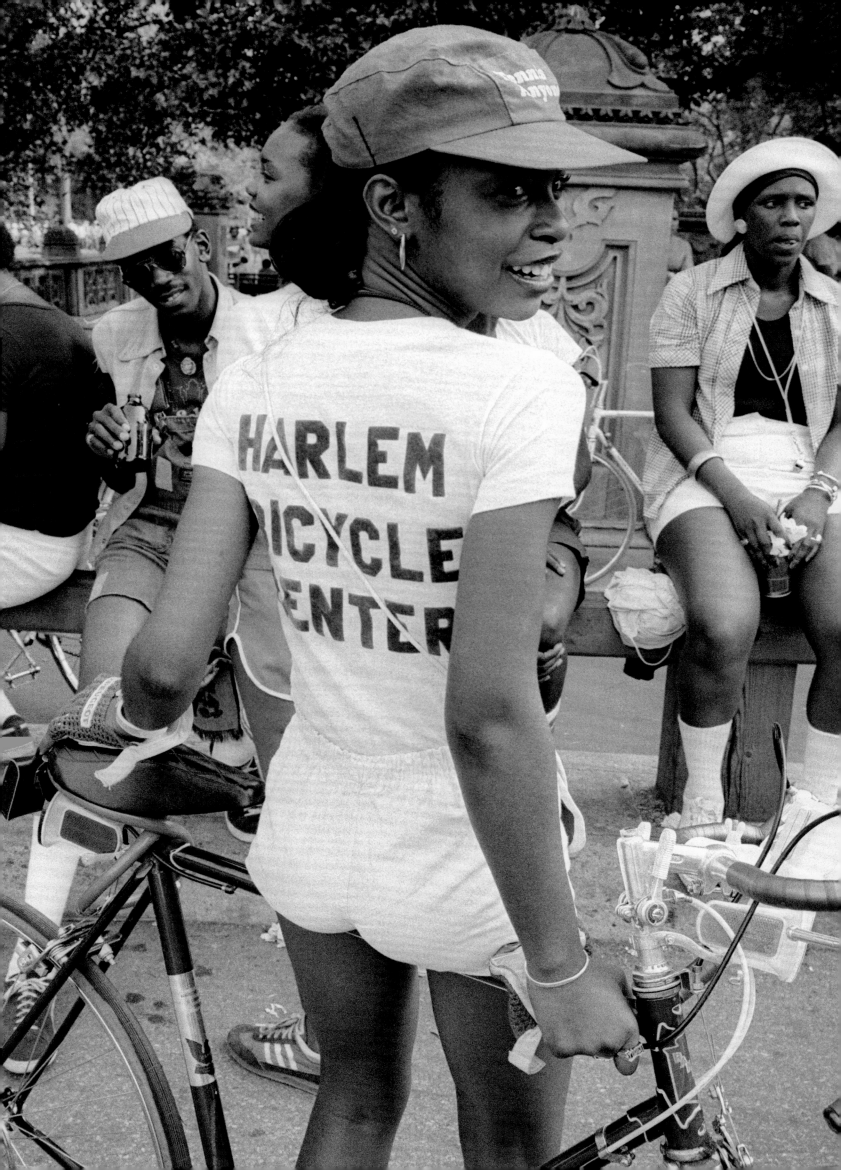

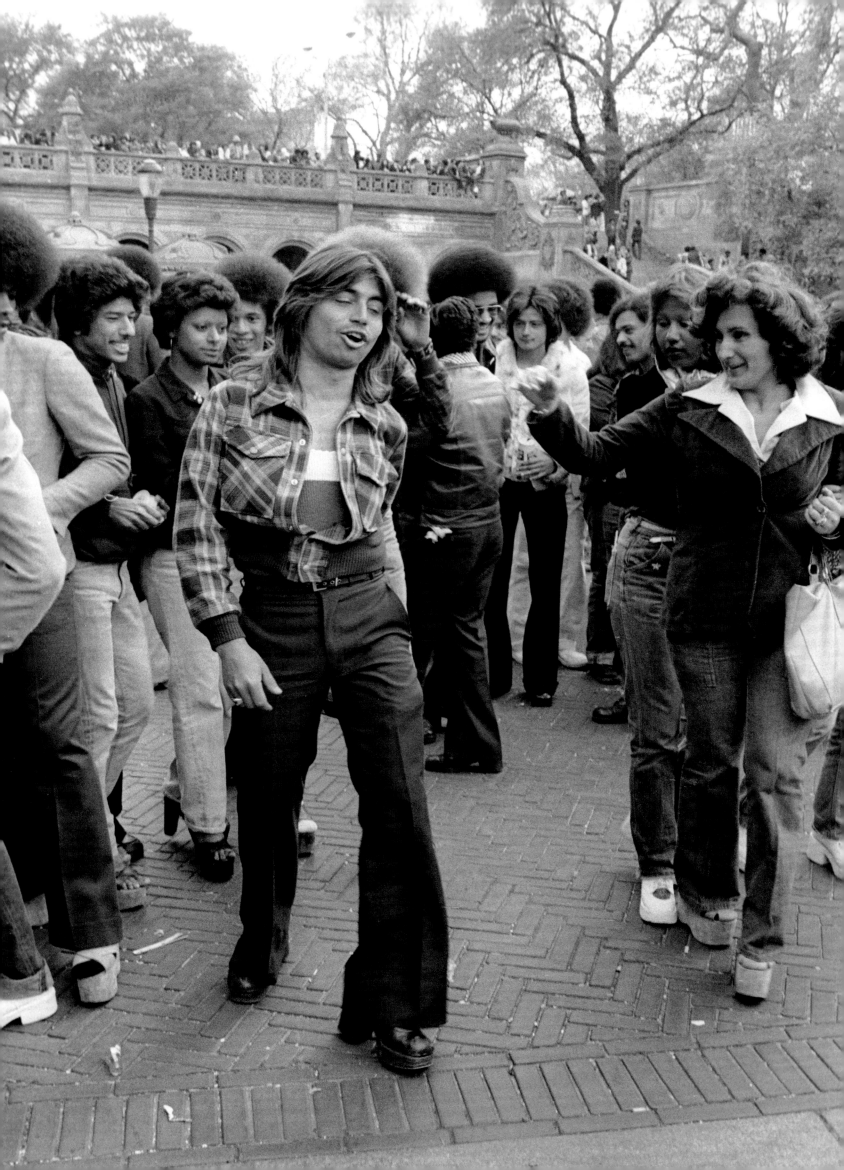

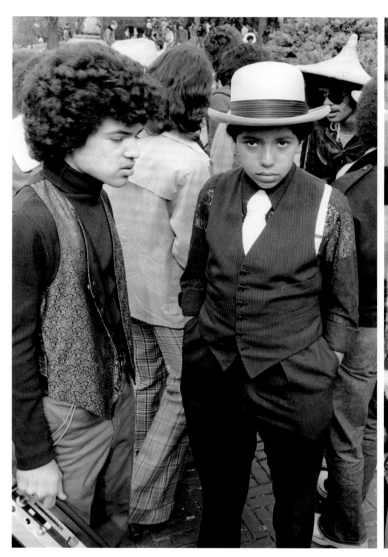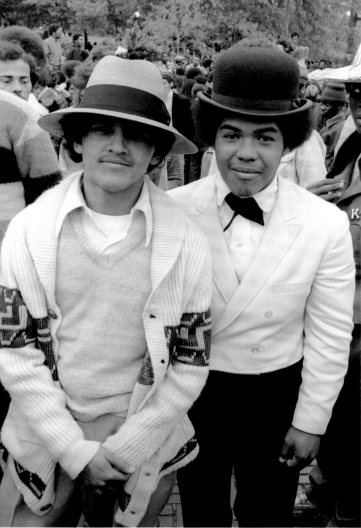

ABOVE: These photos show the street style of young Latino men wearing a variety of derbies, a three-piece suit sans jacket, and elements of formal wear pieced together in true DIY style. "It's like they're inventing their own gang in *The Warriors*," Guzmán adds, referring to a popular movie from the '70s. "Not just the hairstyles, but the swagger. It's almost defiance, like, 'Here I am.'" Rather than simply a Latino attitude, "it really is a New York thing," he adds, noting that "it doesn't matter what neighborhood you go to. The rest of the country knows it, and as New Yorkers we piss them off. We don't give a fuck what you think."

OPPOSITE: A man enjoys stepping out Sunday in Central Park in 1974.

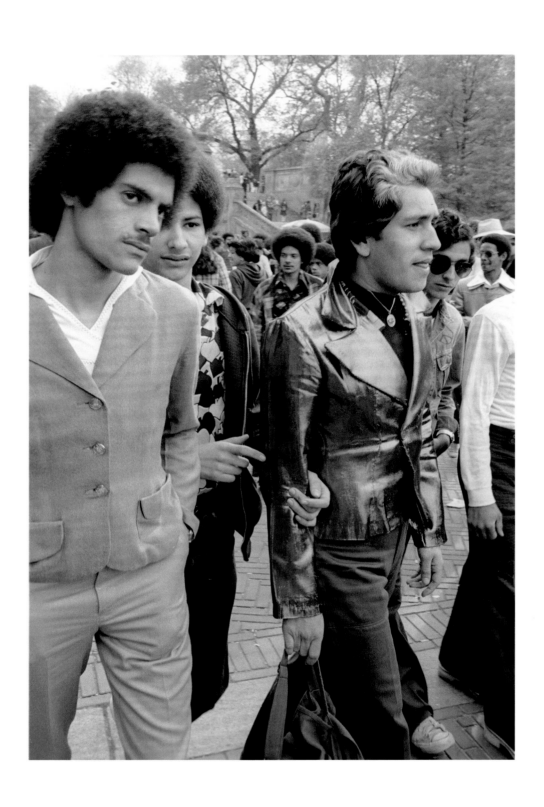

ABOVE: Guys enjoy Sunday in Central Park in 1974.

OPPOSITE: "Central Park in the '70s," Yoruba says, "was where some of the best *congeros* gathered to trade licks and riffs. Those grooves were straight from Africa, so the 'code' was unbroken." Also striking about this photograph is the extent to which the crowd—the audience, in effect—is so completely engulfing the conga players that they seem like part of the group. The viewer senses no appreciable distance between musician and listener, which may say something about the role of music in Latino culture—even twenty feet or more from the drummers, people's faces are fixed intently on them. Every aspect of the crowd, from the five different styles of headwear to the prominent Afros, which were a matter of cultural pride at the time, tells a story of that time and place in true documentary fashion.

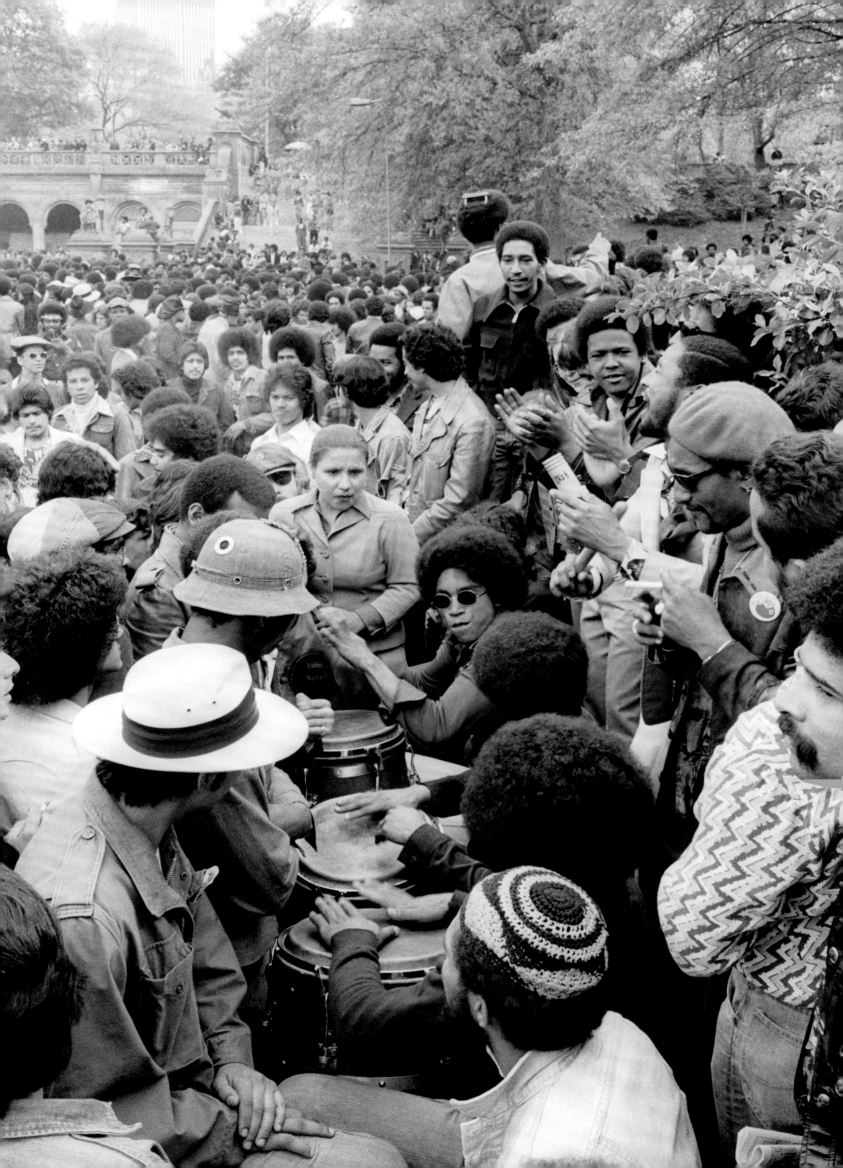

ACROSS THE CITY

The 1970s in New York saw the initiation of traditions that have continued to this day. The first Gay Pride parade took place in the West Village in 1970, in the wake of the Stonewall riots of 1969, and became an annual event that went national, then international. The march to Legalize Pot also began in the early '70s, although we hardly thought it would take four more decades to begin decriminalizing marijuana—or that so many people would rot in jail for the victimless crime of buying and selling what is now recognized as a medical marvel.

The Ninth Avenue International Food Festival, the oldest and largest continuous food festival in the city, was initiated in 1973 to bring attention to what is arguably New York's most diverse ethnic neighborhood—Hell's Kitchen, stretching from Thirty-fourth to Fifty-ninth Streets, and Eight Avenue to the river (although the festival itself ran from about Forty-second to Fifty-seventh Streets). Some came to eat and drink, but much of the neighborhood simply enjoyed the spectacle while flaunting individualized outfits constructed of seemingly mismatched elements that somehow fit together. Athletic gear had been around for a while; Lycra and other stretch fabrics were introduced by designers from Elio Fiorucci to Natasha Adonzio, but Hell's Kitchen had its own take on these styles. The group pictured on page 194 combines stretch and sports tops, stylish (if not designer) jeans, and an ethnic or peasant skirt, sewn onto or worn over jeans, with a Beethoven T-shirt. And lots of "big hair," '70s style.

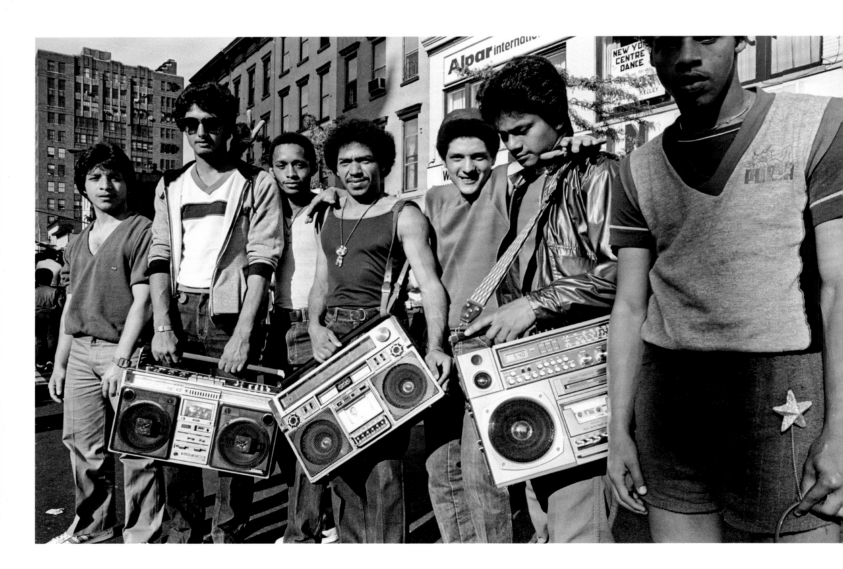

ABOVE: Young men show off their cassette boomboxes at the Ninth Avenue International Food Festival in Hell's Kitchen in 1982.

OPPOSITE: A couple on bicycles enjoying the food at the street fair.

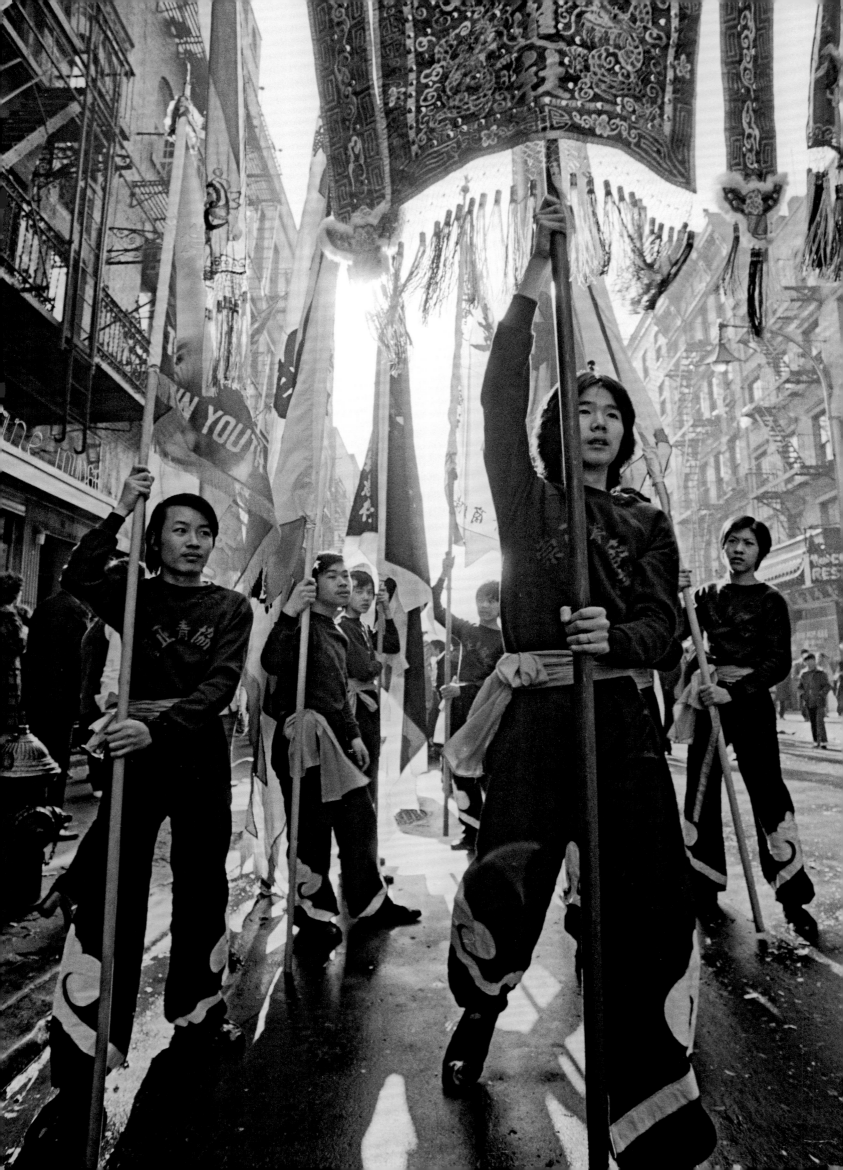

OPPOSITE: Young residents of Chinatown celebrate the Year of the Tiger with banners, marches, and fireworks in 1974.

ABOVE: Marching band banner bearers pose before the 1980 St. Patrick's Day Parade begins.

ABOVE: Artist Peter Reginato on Greene Street with friends during SoHo Artists Day.

OPPOSITE: Rosemary Hochschild and Michael Oblowitz on SoHo Artists Day on May 21, 1977.

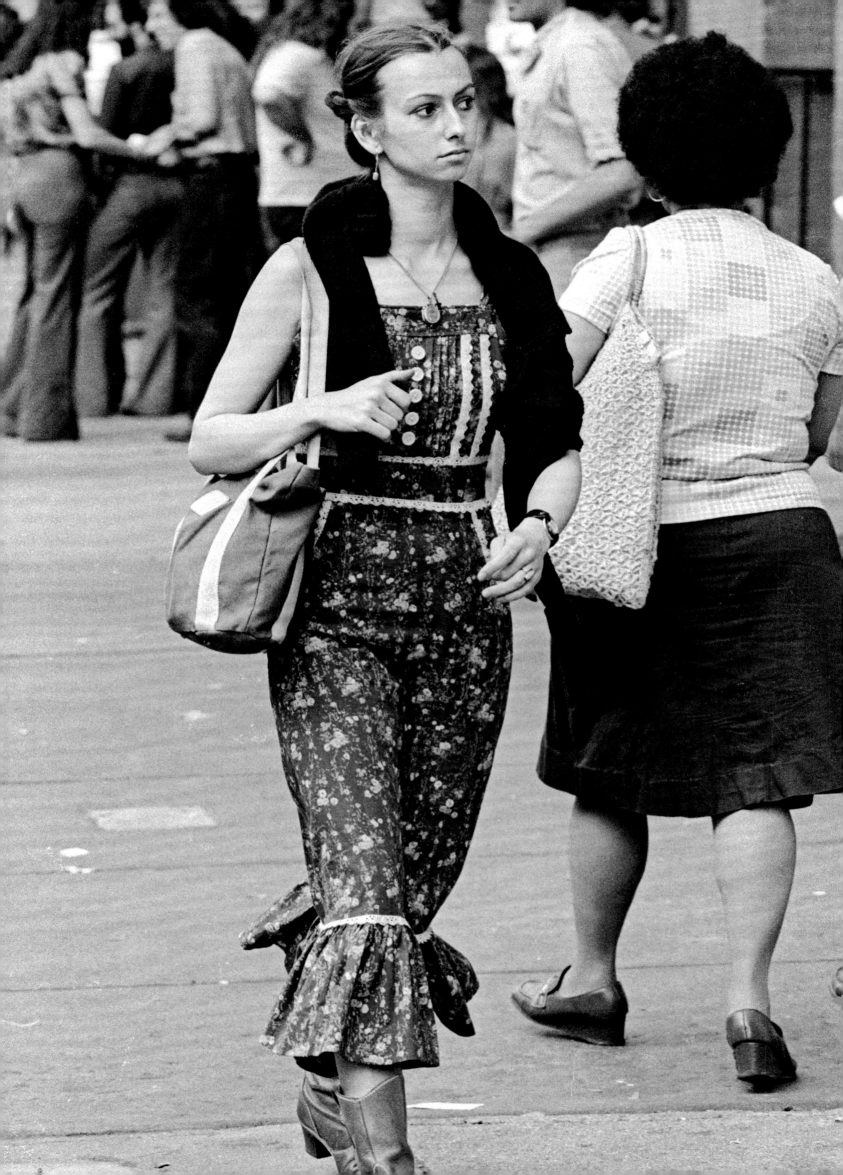

STREET STYLE

The streets of New York have always been where it's at . . .

It must be something in the air, something like the rush of a drug going straight to your head, the feeling that anything could happen out here. It must be something in the hard concrete, in the sound of heels pounding the pavement while the wind whips through your hair and the flow of energies from hundreds and thousands of people going on their way to who knows where. It must be something in the water; something that goes straight to the blood, for it is in the streets of New York that style is born.

The photographs of Allan Tannenbaum capture the streets of New York as an everyday thoroughfare for the stylish folk at a time when originality and innovation were all the rage. As Tannenbaum remembers, "In the '70s, you didn't need a lot of money. People did more with less. The DIY energy of the city sparked creativity." It was this creative energy that gave birth to a city that proved when the going got tough, the tough made art.

As artists moved into SoHo, it became a vital community for artists, galleries, performance spaces, magazines, bars, and restaurants, all supporting each other, creating a synergy within the art world. It became that rare enclave: It was a community. The streets were filled with a distinctive mix that made them an ideal place to take street photographs. From his home base at the *Soho News*, Tannenbaum would set out to cover the stories of the day, while also shooting people on the street who caught his eye and captured his imagination. He remembers, "You never knew what to expect, what would happen, or what you would get. Some days it was really good."

Like Weegee before him, Tannenbaum walked the streets with his camera, always on the scene, capturing the decade as it unfolded throughout the city. Tannenbaum's New York is not that long ago, but it is so very far away. It is a New York that gave birth to the punk, disco, and hip-hop cultures at the same time. It is a city that was populated by a pioneering spirit that braved the brutality of "benign neglect," a city filled with artists and activists who revealed that the instinct for survival is deeply intertwined with style.

Whether photographing the early Gay Pride parade or the Ching-a-Ling motorcycle gang in the South Bronx, Tannenbaum's work reveals the way in which empowerment and protection had become some of the strongest means to bring together the larger community. By using the street as a vehicle for their needs, each community was able to showcase their style with equal parts panache and ease.

Delving into his archives once more, Tannenbaum has unearthed a treasure trove of never-before-seen gems. The photographs featured in the Street Style section will bring you back to a time that has come and gone, and what remains are the photographs and the memories.

—MISS ROSEN

OPPOSITE: A woman walks down the street on SoHo Artists Day in 1977.

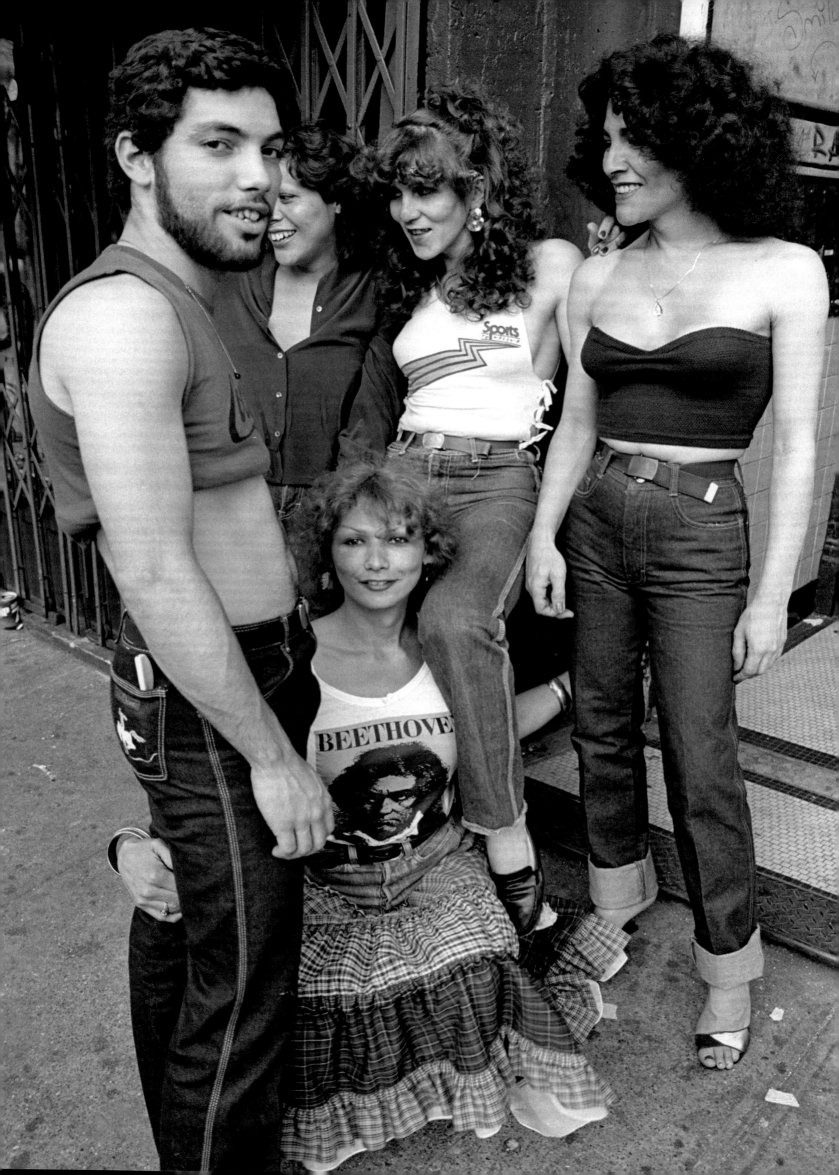

ABOVE: Onlookers on Fifth Avenue watch one of the earliest Legalize Pot marches on its way to a Central Park smoke-in, 1974.

OPPOSITE: The 1982 Ninth Avenue International Food Festival in Hell's Kitchen.

SUBSEQUENT PAGES: Puerto Rican gangs on the Lower East Side, the Katos and Young Dynamite, display their gang colors.

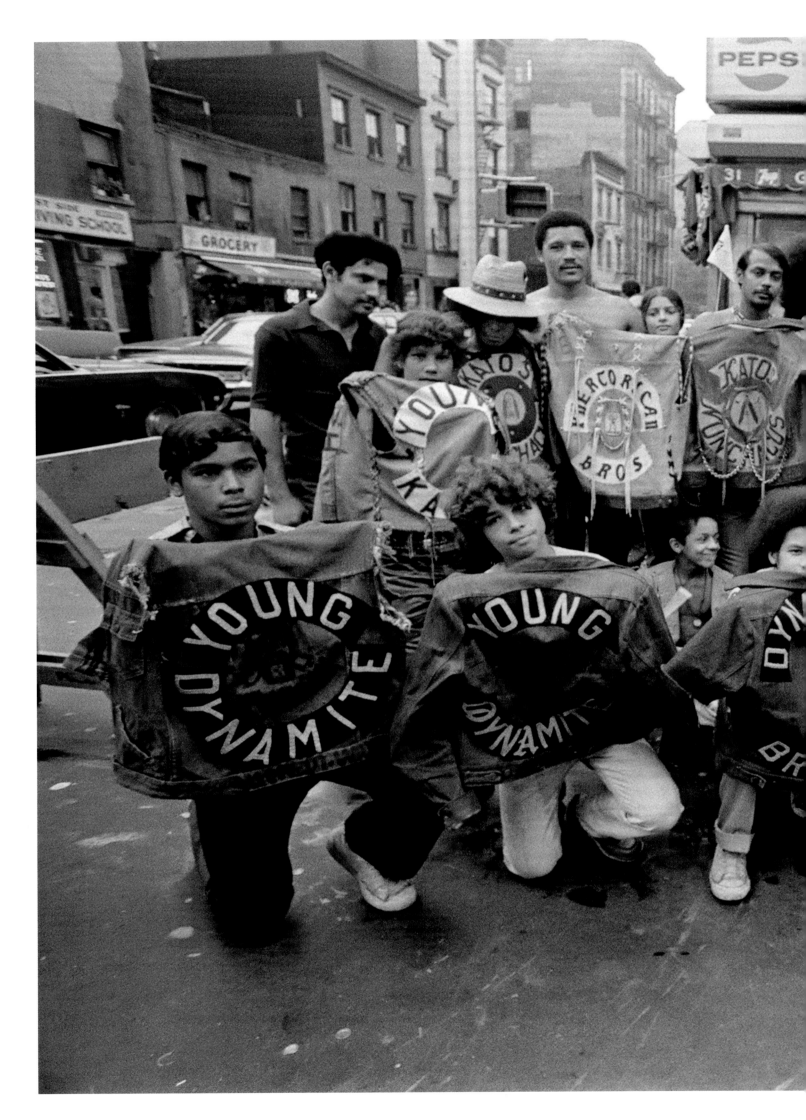

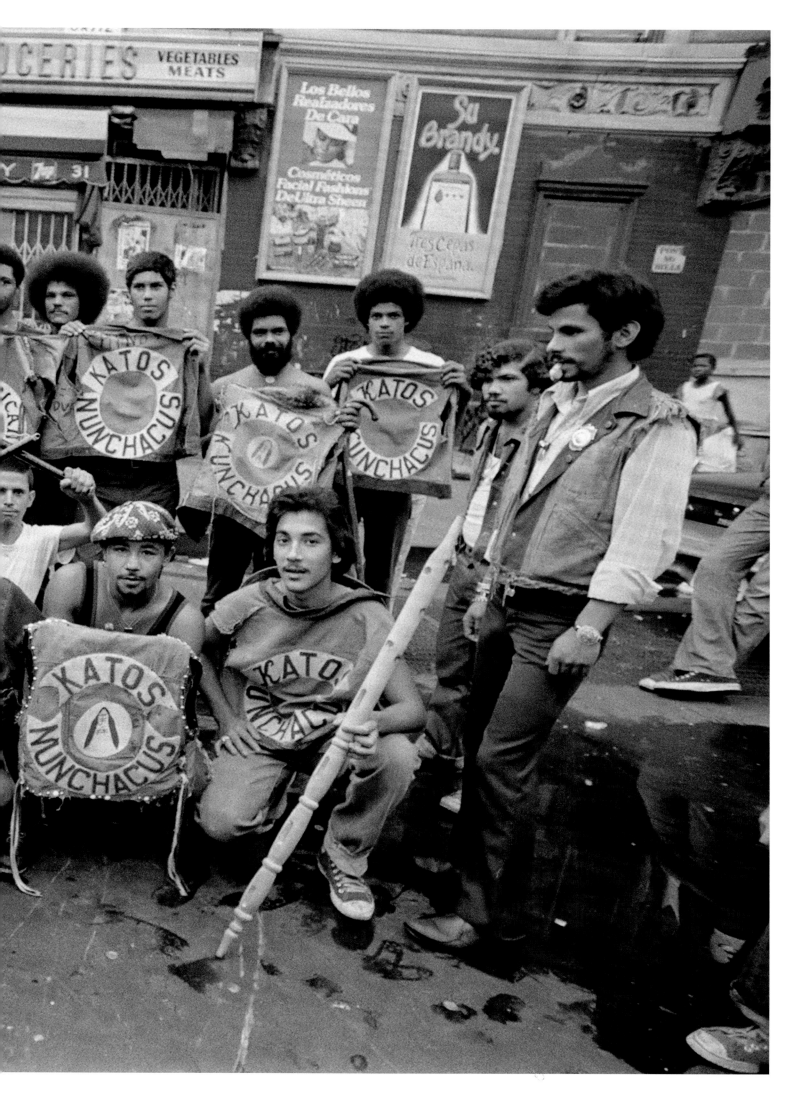

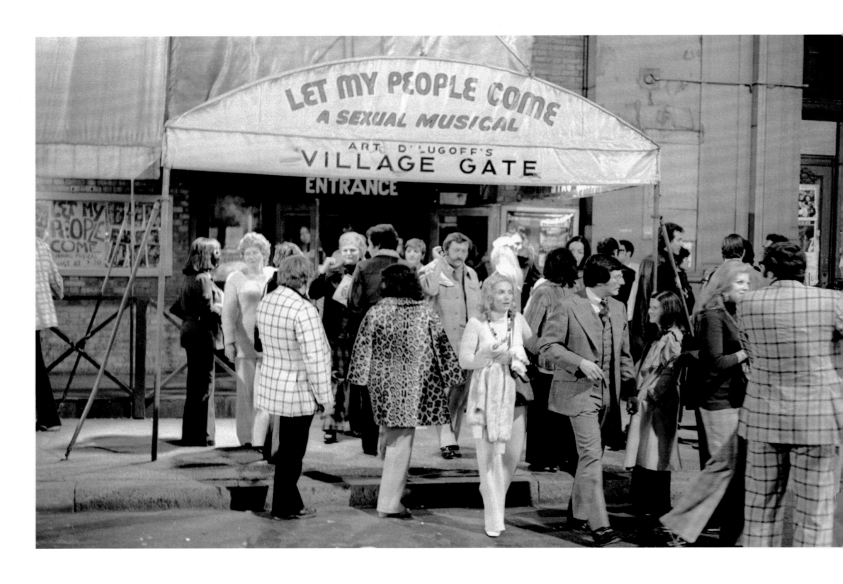

THE WEST VILLAGE

Walking through Midtown Manhattan or the Theater District in the 1970s, a visitor might have gotten the impression that everyone dressed pretty much the same. From three-piece suits to leisure suits to women's pantsuits, businesspeople and tourists reflected the trends of the past decade and the kinds of predictable clothing that were available in department stores across the country. This was true even when they swung through Greenwich Village in search of entertainment. The explicit "sexual musical," *Let My People Come*, debuted at the longtime jazz club the Village Gate on Bleecker Street, which had previously hosted *National Lampoon: Lemmings*, a satire about the Woodstock generation. Onstage nudity and songs with titles like "The Cunnilingus Champion of Company C" and "I'm Gay" created a post-'60s sense of sexual freedom that drew overflow crowds who were definitely not from the neighborhood. The standard-issue checked suits, ladies' flared pants, and faux leopard coat give a good idea of what designers, independents and established couturiers alike, were seeking to improve on.

ABOVE: Theatergoers outside the Village Gate on Bleecker Street after a performance of *Let My People Come* in 1974.

OPPOSITE: The blacktopped surfaces of parts of the city's parks made for fine bicycling and roller-skating, which brought out bicyclists showing off their tricked-out bikes and athletic couples trying out their skating moves.

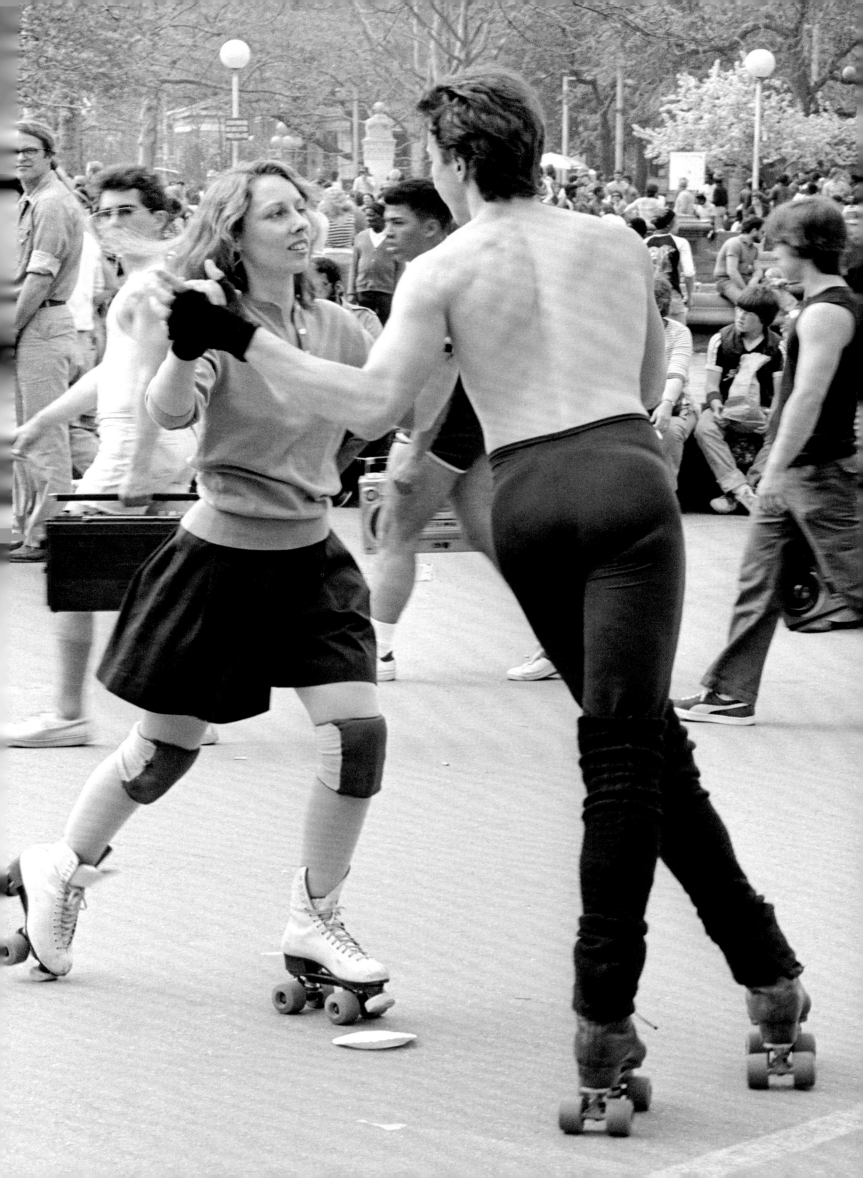

THEN AND NOW

At the end of the 1960s, while Andy Warhol was churning out silk-screen prints and films and hosting infamous parties for artists, socialites, and celebrities at his Factory on Union Square, and the Velvet Underground played as the house band at nearby Max's Kansas City, a very different scene was brewing less than twenty blocks away. A group of artists, dancers, musicians, filmmakers, and others were pioneering the area just south of Houston Street. —Lydia Yee, "When the Sky Was the Limit"

THE SECTION OF MANHATTAN KNOWN AS SOHO, where Allan Tannenbaum's career as a photographer first bloomed, was setting trends from the day it was named by Chester Rapkin, the pioneering urban planner who dreamed up the acronym in 1962. In doing so, Rapkin began a naming convention that led to acronyms for arbitrarily created Manhattan districts including Tribeca (Triangle Below Canal) and Nolita (North of Little Italy). That he got the idea for the name from the Soho district of London's West End, an entertainment zone that for much of the twentieth century was renowned for its nightlife and as a base for the sex industry, merely shows that Rapkin was a visionary on more than one level. A 1979 guidebook to the district exuberantly proclaims that SoHo "may be the first neighborhood in the history of the Western world for which prospective residents are required, as an article of municipal law, to convince the authorities that they have some plausible claim to the label 'artist.'"

Once zoned exclusively for small industry, shipping, and warehousing, the area had been nicknamed Hell's Hundred Acres based on the high incidence of accidental fires. For more than a decade in the early nineteenth century, it had been the population center of Manhattan, and in 1861 it was the site of Lord & Taylor, one of the first American department stores, on Broadway at Grand Street. Between 1860 and 1890, the area thrived as the center for the city's mercantile and dry goods trade, and numerous sweatshops there were devoted to the garment business. But within a decade of being named SoHo, a change to the zoning laws made it legal for "artists in residence" who provided sufficient certification to live and work there. On January 20, 1971, with the backing of Mayor John Lindsay, the city planning commission voted to legalize the residential use of manufacturing lofts by artists in the forty-three-block area that ran from Broadway to West Broadway, and from Houston to Canal Streets. And so it was that a part of Manhattan that had been Indian territory, farmland, and an industrial wasteland was transformed into what *New York* magazine in 1974 was calling "the most exciting place to live in the city."

OPPOSITE: Looking South on West Broadway in SoHo on a rainy day in 1973.

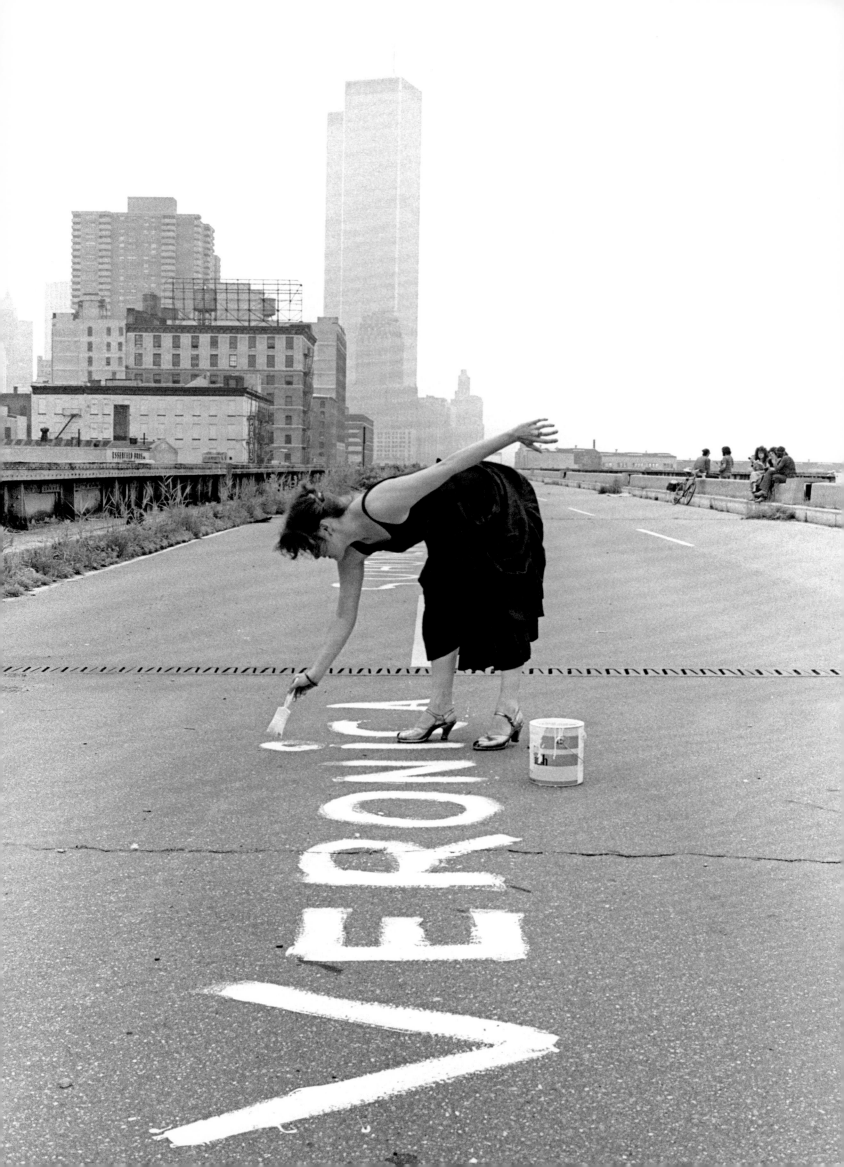

Coincidentally, 1974 was the year I started writing about music for the *Soho Weekly News*, just a few months after Allan Tannenbaum had joined the nascent staff as photo editor in October 1973. Founded by Michael Goldstein, who had once been the press agent for Jimi Hendrix, the newspaper focused on two kinds of coverage: news relating to New York City in general and SoHo in particular; and the arts, at first divided into visual art, performance art, music, dance, theater, books, and film. And then there was Style. In most periodicals in the 1970s, this section was called Fashion. But the first editor of the section, Annie Flanders, disliked that word and its association with the fashion industry, and felt that *style* was more expressive of how people dressed themselves—following their own taste, creativity, and instincts.

One of the best places to eat there in the early '70s created its own style as an artists' restaurant—located a block away from the newspaper's early offices on Spring Street. In 1971 the artists Gordon Matta-Clark, Carol Goodden, and Tina Girouard founded FOOD on the site of a failed Latin restaurant. FOOD was a different kind of restaurant, and not only because they insisted on using all caps for the name on the sign and on their flyers and menus. Matta-Clark and his friends wanted a restaurant that took culinary chances with such offerings as a meal made of bones and another made of living brine shrimp swimming in egg whites, called *Alive*. They also served sushi and had what may have been the first salad bar in Manhattan.

Among the factors that drew so many artists to the district, even before living lofts became legal, was that SoHo was home to the largest concentration of full and partial cast-iron facades in the world—139 in all. As historian Stephen Petrus has written:

> Cast-iron structural technology profoundly influenced the development of the skyscraper. Architects used cast iron for building fronts and interior columns. Due to the advent of internal steel skeletons in the mid-1880s, the load-bearing wall technique for support became obsolete, and the employment of the alloy declined.

Cast-iron buildings ceased to be constructed, but those that were already in place, mainly in SoHo, have had a long, useful lifespan. The construction technique allowed for larger window spaces that let in more light—helpful for manufacturing, but also desirable for making art of all kinds. By 1973, boutiques had become a staple of the neighborhood, selling clothing, furniture, and jewelry. Retail stores rapidly commercialized ground floors of industrial buildings, outbidding not only manufacturers but also the artists who were now allowed to live there legally. Ivan Karp, who had left the Leo Castelli Gallery on East Seventy-seventh Street between Madison and Fifth Avenues in 1969 to open his upscale gallery OK Harris on West Broadway in SoHo, predicted that the craze would end. "There must be a limit to the plunder," he said. "Many artists, perhaps fifty or more, are getting together and buying their own buildings." Notwithstanding Karp's forecast, the "plunder" continued unabated. By 1978, sixty-five shops and twenty-six restaurants lined the streets.

Visiting SoHo today, you might have difficulty imagining how empty it looked in the early 1970s. Streets that now teem with international tourists patronizing high-end boutiques and furniture emporiums were often abandoned at night. Walking from the newspaper's offices to the rough-hewn jazz club Ali's Alley on Greene Street—one

of the few places where you could get a drink and something to eat until the wee hours—you might see only a handful of people. Broadway, the widest street in SoHo, was lined with army-navy surplus stores, vintage (read "used") clothing marts, and fabric, hardware, and kitchen supply stores. As early as 1970, New York's major uptown art gallery owners—Leo Castelli, Ileana Sonnabend, and André Emmerich among them—had opened galleries in the SoHo area, following the lead of pioneering Paula Cooper, who eschewed Midtown and opened what is often considered the first gallery in Lower Manhattan in 1968. (In 1965, the Park Place Gallery had moved to 542 West Broadway, on what is now LaGuardia Place, not technically part of SoHo because it's north of Houston Street.) Although new galleries were joining in regularly, and might be crowded for an opening reception, most days the traffic was light. Not that it was risky to walk there after dark; SoHo overlapped Little Italy, one of the safest residential districts in the city, what with the police and the mob both keeping an eye on things.

And yet, by 1979, *Anderson & Archer's SoHo: The Essential Guide to Art and Life in Lower Manhattan* was already bemoaning how the district had become, "inevitably, rich. And success had been accompanied by a certain draining away of the original energy and set of intentions that made the place." As time went by, artists and journalists looked back fondly on a SoHo that no longer existed. Michael Kimmelman wrote in the *New York Times* in 2011:

> It's not hard to admire the youthful, messianic energy that derived from the knowledge that anything was possible there because nobody was really paying very much attention. . . . What good experimental art came from the early days of New York's SoHo had little to do with the climate of upward mobility, not because artists back then weren't ambitious, which they were, but because there seemed to be nowhere in particular to go. The work was engaged with what was at hand, namely a downtrodden slice of the city, because that's all artists had at the time. And it turned out to be plenty.

Much the same could be said of the adventurous independent designers who lived and worked there in those early years. Their impact on the current uptown fashion world may be more subtle and harder to trace than the influence of the punk rockers, hip-hoppers, graffiti artists, and, yes, street photographers. But they were also part of that creative mix.

If it wasn't just the cheap rents, the spacious, well-lighted lofts in those historic cast-iron buildings, or the propinquity of creative souls from so many different fields—visual and performance art, design, architecture, dance, film, rock 'n' roll, jazz, and journalism—what was it that made this area of Manhattan such a hothouse of new visions and ideas? There doesn't seem to be any single, simple answer. It may be a combination of all those factors, paradoxically fueled by the down-and-dirty living conditions. The performance artist Laurie Anderson, as idiosyncratic as any of the artists who made SoHo what it was, put it simply: "I was lucky. It was a weird time, which I haven't really seen again."

OPPOSITE: An artist named Veronica paints her name on the disused West Side Highway in Tribeca. The World Trade Center looms in the background.

SUBSEQUENT PAGES: The Garment Center in midtown Manhattan was and still is a vibrant clothing design and manufacturing area. This garment worker, pulling a clothing rack down the street, shows a style all his own in 1979.

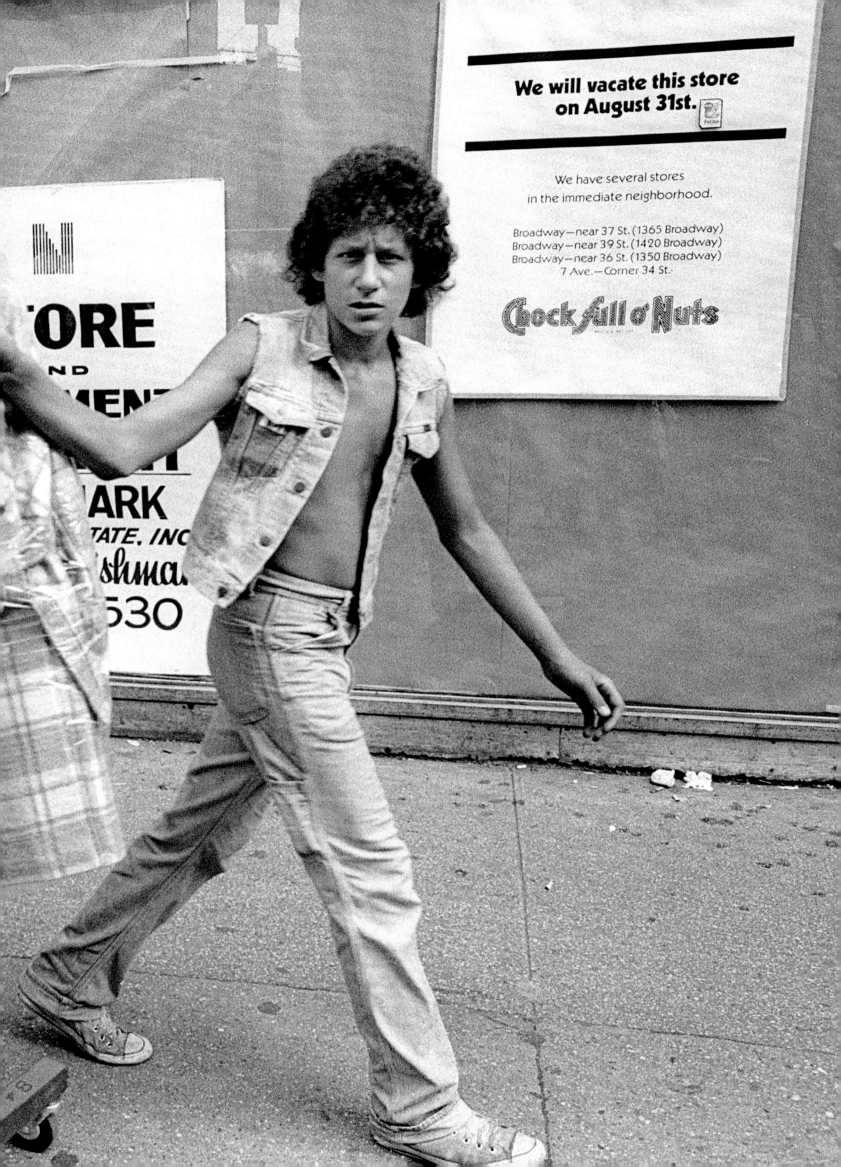

BIBLIOGRAPHY

Anderson, Alexandra, and B.J. Archer. *Anderson & Archer's SoHo: The Essential Guide to Art and Life in Lower Manhattan*. New York: Simon & Schuster, 1979.

Antonia, Nina. *Johnny Thunders: In Cold Blood*. London: Cherry Red Books, 2000. (Originally published 1987 by Jungle Books.)

Barbiaux, John. "The Difference Between Street Photography and Photojournalism." Photolisticlife.com, March 26, 2015.

Boardman, Mickey, and Elizabeth Thompson. "Remembering Elio Fiorucci with Former Shop Boy Joey Arias." Paper, July 20, 2015.

Bolton, Andrew, ed. *Punk: Chaos to Couture*. New Haven: Yale University Press/Metropolitan Museum of Art, 2013.

Cheren, Mel. *Keep on Dancin': My Life and the Paradise Garage*. New York: 24 Hours for Life, 2000.

"Designer Turns Fantasies into Fashion." *Gadsden Times*, May 13, 1979.

Di Carcaci, Charlotte. "In the Air: Glam Rock." *T: The New York Times Style Magazine*, December 6, 2015.

Dunne, Dominick. "The Fall of Roberto Polo." *Vanity Fair*, Sept. 15, 2008.

Flanders, Marcia (Annie). "Fashion Free." *Soho Weekly News*, 1976–1977.

Flinker, Susan. "We Can Be Heroes." *Soho Weekly News*, May 21, 1980.

Graves, Tom. "My Long-Ass Interview with Frank Zappa (1987)." *Tom Graves' Blog*, January 4, 2005.

Harrington, Douglas MacKaye. "Dianne Benson: Gardening Stylista Turned Website Entrepreneur." Hamptons.com, June 29, 2009.

Horyn, Cathy. "The Queen of Extreme." *New York Times*, February 14, 1999.

James, Charles. "Fashion as Fantasy." Press Release, Rizzoli International Bookstore and Gallery. http://www.robertopolo.com/media/polomedia/documents/art_documents/8.pdf

Kennedy, Randy. "When Meals Played the Muse." *New York Times*, February 21, 2007.

Kimmelman, Michael. "When Art and Energy Were SoHo Neighbors." *New York Times*, April 28, 2011.

Kristal, Hilly. "The History of CBGB & OMFUG." CBGB.com.

Kuczynski, Alex. "Diane von Furstenberg." Wmagazine.com, November 2012.

Laneri, Raquel. "Wannabes Have Ruined Fashion Week." *New York Post*, February 8, 2016.

McNeil, Legs, and Gillian McCain. *Please Kill Me: The Uncensored Oral History of Punk*. New York: Grove Press, 1996.

Musto, Michael. *Downtown*. New York: Vintage, 1986.

Petrus, Stephen. "From Gritty to Chic: The Transformation of New York City's SoHo, 1962–1976." *New York History*, Winter 2003.

Pollack, Ellen Joan. "Studio 54, Where Are You?" *Soho Weekly News*, April 9, 1980.

Polo, Roberto C. "Fashion as Fantasy." Press Release, Rizzoli International Bookstore and Gallery. http://www.dianamarahenry.com/FashionasFantasyatRizzoliBookstore.htm

Reed, Paula. *Fifty Fashion Looks That Changed the 1970s*. London: Conran Octopus, 2012.

Roberts, Sam. "Infamous 'Drop Dead' Was Never Said by Ford." *New York Times*, December 28, 2006.

Robinson, Lisa. "Rebel Nights." *Vanity Fair*, November 2002.

Soyer, Daniel, ed. *A Coat of Many Colors: Immigration, Globalism, and Reform in New York City's Garment Industry*. New York: Fordham University Press, 2005.

Spellen, Suzanne. "Past and Present: The Empire Rollerdrome." Brownstoner.com, May 16, 2014.

Steele, Alexxis. "Interview with Natasha Adonzio, Legendary Punk Clothing Designer." Music 101 with Alexxis Steele, 2013.

Stephenson, Lauren Benet. "The History of the New York City Garment District." Zady.com, October 2013.

Trebay, Guy. "Peter Hujar and the Lost City." *New York Times*, March 6, 2016.

Wells, Steven. *Punk: Young, Loud & Snotty*. New York: Thunder's Mouth Press, 2004.

Wilcox, Claire. *Vivienne Westwood*. London: V&A Publishing; New York: Harry N. Abrams, 2004.

Wills, David. *Seventies Glamour*. New York: Dey Street Books, 2014.

Wilson, Lois. "Tatty Threads!" *Q, Special Edition*, 2002.

Yee, Lydia. *Laurie Anderson, Trisha Brown, Gordon Matta-Clark: Pioneers of the Downtown Scene, New York 1970s*. Munich: Prestel/Barbican Art Gallery, 2011.

ACKNOWLEDGMENTS

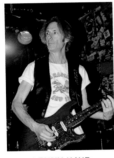

LENNY KAYE RICHARD BOCH NILI LOTAN MICHAEL WILKINSON MISS ROSEN

THERE ARE MANY PEOPLE who enabled me to take these photographs and realize this book to whom I am very grateful. I must first thank Michael Goldstein for founding the *Soho Weekly News* and hiring me as chief photographer, and the late Jaakov Kohn for his wisdom and inspiration. Collaborating with staff members such as Peter Occhiogrosso, Cynthia Heimel, Stephen Saban, Michael Longacre, Michael Shore, Chris Oliver, Lesley Vinson, Janel Bladow, Susanna Cuyler, and Michael Musto provided a stimulating and fun environment in which to create the paper every week. I greatly appreciate the incredible energy of our Style editors, first Annie Flanders and Joanna Dendel, and then Kim Hastreiter and Branka Milutinovic. Thanks also to Debbie Harry, John Varvatos, Michael Wilkinson, Nili Lotan, Richard Boch, Lenny Kaye, and Miss Rosen for their contributions to the book. Thank you to Sophie Brill, who helped to digitize most of the images in this volume. Thanks also to R. Couri Hay, Neke Carson, Anton Perich, Kosmo Vinyl, Julia Gruen, and Pablo "Yoruba" Guzmán.

Thank you to the wonderful people at Insight Editions for publishing my work in this beautifully produced book. Raoul Goff, Robbie Schmidt, Vanessa Lopez, Ramin Zahed, Christine Kwasnik, Jon Glick, and Kelly Reed have all been great to work with.

Most of all, I want to thank my lovely wife Debora, whose love has sustained me through it all. Without her spiritual help, not to mention her time spent in digital imaging, this book would have not happened.

To see more photographs from this fabulous era please visit www.sohoblues.com
To purchase limited edition fine art prints please visit www.sohobluesgallery.com

This book is dedicated to my muse and soulmate, my beautiful and loving wife, Debora.

IN MEMORIAM: BILL CUNNINGHAM 1929–2016

To a dedicated photographic follower of fashion, whose pictures brilliantly
documented decades of New York City style, and a true gentleman, whose
work and personality will always be an inspiration to me.

—Allan Tannenbaum, 2016

INSIGHT
EDITIONS

PO Box 3088
San Rafael, CA 94912
www.insighteditions.com

Find us on Facebook: www.facebook.com/InsightEditions
Follow us on Twitter: @insighteditions

Library of Congress Cataloging-in-Publication Data available.

ISBN: 978-1-60887-819-2

Publisher: Raoul Goff
Co-publisher: Michael Madden
Acquisitions Manager: Robbie Schmidt
Art Director: Chrissy Kwasnik
Designer: Jon Glick
Executive Editor: Vanessa Lopez
Project Editor: Kelly Reed
Editorial Assistant: Warren Buchanan
Production Editor: Rachel Anderson
Production Manager: Thomas Chung

ROOTS of PEACE REPLANTED PAPER

Insight Editions, in association with Roots of Peace, will plant two trees for each tree used in
the manufacturing of this book. Roots of Peace is an internationally renowned humanitar-
ian organization dedicated to eradicating land mines worldwide and converting war-torn
lands into productive farms and wildlife habitats. Roots of Peace will plant two million fruit
and nut trees in Afghanistan and provide farmers there with the skills and support neces-
sary for sustainable land use.

Manufactured in China by Insight Editions

10 9 8 7 6 5 4 3 2 1

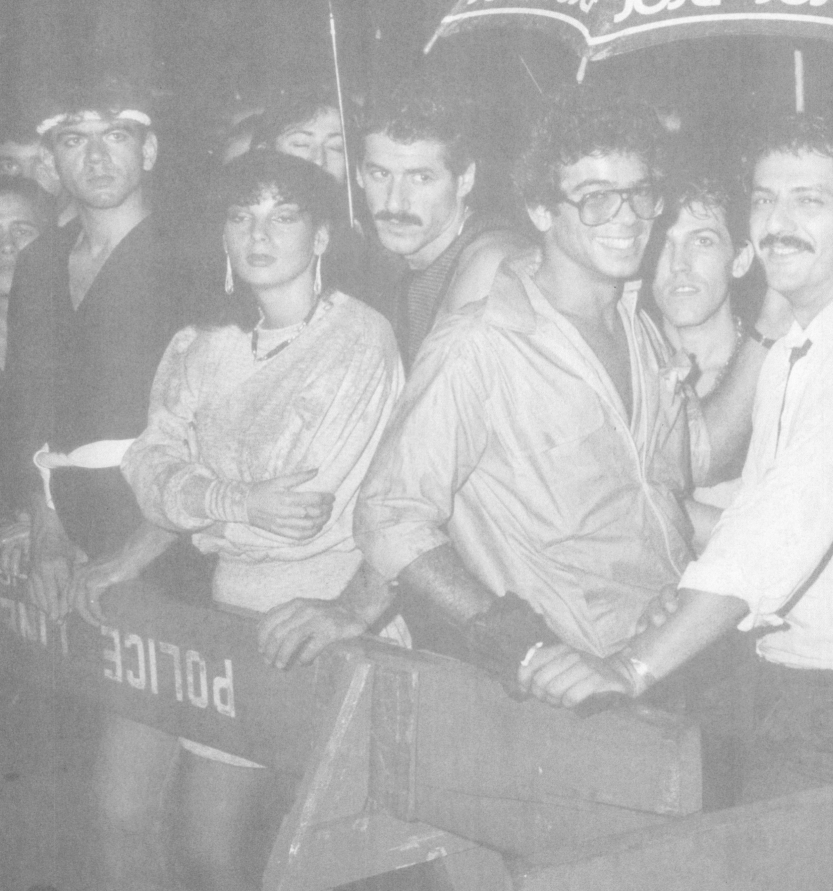